WOMEN'S RIGHT

Tess Gill is a solicitor empl_____
eral Municipal and Boilerm____ ____ Union, where her work in-
cludes taking equal-pay and sex-discrimination cases, and
advising and training shop stewards and officials on equal
opportunities at work. She previously worked in a civil liber-
ties firm specializing in women's rights cases. She is co-author
of *Women's Rights* (Penguin Handbooks 1977; Third Edition
1981), and was educated at Weston-super-Mare Grammar
School and Manchester University, where she read Politics
and Modern History.

Since 1973 Larry Whitty has been head of the Research
Department at the General Municipal and Boilermakers'
Union, which has nearly a million members in manufacturing
industry and public services, over a third of them women. He
has been responsible for producing analysis and advice on
equal pay and equal rights and for producing GMB publica-
tions in the equality area. He had previously worked on in-
dustrial policy and technology in the Economic Department of
the TUC, in the Ministry of Technology, and in the aerospace
industry at the Atomic Energy Authority. He has a degree in
economics from Cambridge.

Tess Gill and Larry Whitty

WOMEN'S RIGHTS IN THE WORKPLACE

Know your rights:
the questions and the answers

Drawings by Cath Jackson

PENGUIN BOOKS

Penguin Books Ltd, Harmondsworth, Middlesex, England
Penguin Books, 40 West 23rd Street, New York, New York 10010, U.S.A.
Penguin Books Australia Ltd, Ringwood, Victoria, Australia
Penguin Books Canada Ltd, 2801 John Street, Markham, Ontario, Canada L3R 1B4
Penguin Books (N.Z.) Ltd, 182–190 Wairau Road, Auckland 10, New Zealand

First published 1983

Text copyright © Tess Gill and Larry Whitty, 1983
Drawings copyright © Cath Jackson, 1983
All rights reserved

Made and printed in Great Britain
by Cox & Wyman Ltd, Reading
Set in Linotron Times

CONTENTS

ACKNOWLEDGEMENTS

Many people, trade unions, and organizations have helped with this book besides those whose work is acknowledged in the text. We thank Christine Jackson for her help on career patterns, Annie Sedley for assistance on the part-time chapter, Jean Coussins for her expertise on maternity and child-care, David Wainwright for his on job evaluation.

Tess Woodcroft, Rod Robertson, Jayne Nelson and Alison Mitchell of NALGO gave valuable information on a wide range of issues, as did Keith Scribbens and Paula Lanning of NATFHE and Lynette Savings and Jenny Styles of BIFU. Judith Connors of GMB helped on workplace hazards, as did Sue Ward on pensions.

A particular vote of thanks goes to Fran Bennett for guiding us through tax and social security and to Elizabeth Ball for providing much needed information and ideas on positive action. Chris Pond of the Low Pay Unit advised on low-pay problems, and Mandy Snell on equal pay.

Mary Fisher typed more than one draft of most sections with patience and skill, and her hard work is most appreciated.

1

INTRODUCTION

In Britain today women are employed for most of their adult lives. The days when women had to choose between marriage, children, or a job have gone. Childbirth and child rearing are only an interruption in a lifetime of employment. It is not a question of choice for most women; they have to do paid work for most of their lives to avoid personal and family poverty. But it is women's workload inside the home which still decides their work outside.

Women are still educated and trained on the expectation that their paid job will take second place to their domestic role. Paid work is still designed for men without domestic responsibilities, and so women fit into it uneasily unless, once embarked on motherhood, they take the 'female' options of part-time jobs without training, prospects or high reward. Women who do not have children or the responsibility of caring for other relatives still suffer from the assumption that they are as other women.

Women work in a narrow range of comparatively badly paid jobs and mostly in occupations which are almost entirely restricted to their own sex. Their workplace tasks often reflect the tasks they do unpaid in the home. When they go into unisex occupations they usually remain in the lowest grades. The number of women in top jobs, professions, and skilled manual jobs remains minute.

Despite the facts that women make up 43 per cent of the working population at any one time and that the average woman spends over thirty years in a job, they are not expected to take working life seriously. Knowing employment rights, being a trade unionist, spending time and energy on achieving better pay, conditions, or a better job are still considered male pursuits.

And it is men who control the working environment. Men still run companies, nationalized industries and public services. One small trade union has a female general secretary, and only

one of the three largest unions, with over three million female members between them, has even one woman on its executive councils. Women negotiating on either side of national negotiating bodies are almost as rare as a man taking the minutes.

As a result women's pay and women's needs rarely rise to the top of the negotiating shopping list. Their demands remain largely unarticulated, unable to compete with the priorities of strong male groups.

Representatives of both sides of industry separate 'working' life and home life. For them it is separate. When they go home 'after a working day' they can, by and large, expect to find a meal ready and the children looked after. The person, wife or mother, who does it may also work outside the home, but for her the working day does not start or stop at the office or factory gate. It has begun well before and extends far beyond it. Her dual workload shapes her working life. She may work shorter hours, often in casual, temporary jobs, or even take in home work. She may be unable to make long-term plans, work overtime, travel away from home, or take on extra responsibility. When work in the home becomes overwhelming, because of childbirth, sick children or elderly relatives, or a breakdown in child-care arrangements, then it is the paid job that has to go.

The men who make the rules of employment and decide the rewards may acknowledge her second workload, but, rather than change the shape of jobs to cater for it, only classify her as 'not a real worker', a bad investment – someone to be used for lower-ranking disposable jobs, but not to be trained, promoted or valued.

Women have worked to overcome this sexual divide. The 1960s and 70s were a period of economic expansion when women expressed their anger at apparently equal education leading to unequal jobs and career opportunities. With better birth-control techniques, having children became largely a question of choice. Smaller families and rising living standards gave women more energy and time for life outside the home. The women's liberation movement emerged demanding equal pay and job opportunities, nurseries, free contraception and abortion on request.

Women in factories and offices demanded and took action for equal pay. Women seat-sewers at the Ford factory in Dagenham hit the headlines in a successful strike for upgrading. An organization of trade-union women was formed to campaign for equal pay. Britain's entry into the Common Market in 1973 entailed acceptance of the Treaty of Rome requirement that women be paid equally.

The Equal Pay Act was passed in 1970, but kept in cold storage until December 1975. It was an inadequate and limited measure, never designed to give more than a cosmetic face-lift to the chronic underpayment of women. Continuing pressure from the women's lobby caused both major political parties to commit themselves to a Sex Discrimination Act. It was finally passed by a Labour government in 1975 in a more comprehensive form than that proposed by the Conservatives. It tackled indirectly discriminatory practices as well as overt sex bars. It stopped short of legislation for positive steps to overcome the continuing disadvantage that women face as a result of their dual workload and the channelling of their ambitions, educational and occupational training to fit them for their 'female' work pattern.

The Equal Pay Act and the Sex Discrimination Act came into effect at the end of 1975. As a result, by 1982 women's earnings had crept up towards men's, and the gap narrowed to 28 per cent. There were fewer overt sex bars to jobs and a few brave women made their name by being the first female bricklayer, constructional engineer, jockey etc.

The legal profession extended its empire as tortuous decisions rolled out from Industrial Tribunals, the Employment Appeal Tribunal, Courts of Appeal and the European Court. It was soon all too evident that the laws were cleverly designed to hinder any wholehearted attempt to fuse male and female jobs or earnings.

The action of women workers such as those at the Trico windscreen wiper factory in North London and the Electrolux domestic appliances factory in Bedford showed that industrial action was often more successful than legal claims. Trade-union journals, especially those of white-collar unions who were competing for female membership, began to feature equal-pay

strikes and successes. The women's movement saw the unions rather than the law as the means to achieve change.

The agenda of the annual Women's TUC Conference changed. Women demanded that trade unions adapt to suit the third of their numbers who were female. The male image of trade unions was attacked, and sexist pin-ups in trade-union magazines were deplored. Bargaining priorities had to take on a female image, and positive action was demanded to allow women into a few of the trade-union driving seats. Persistent pressure and a fair amount of organization brought some return. The days when a female speaker at trade-union meetings expected a wolf whistle instead of attention have gone, and whole new areas of official policy, within individual unions and at the TUC, detail what is needed on equal pay, job opportunities, maternity leave, rights for part-timers, and positive action on representation within unions.

The late 1970s saw unemployment creeping up and public spending cut back. The onset of economic decline and of the desire to restrict government spending was marked by governmental concern for the 'strengthening of family life'.

The practical message of this thinly masked moral concern was that women were to bear the burden of economic decline. By going out to work they were responsible for teenagers running amok, old ladies being mugged, and schoolchildren truanting. As hospitals were shut, meals-on-wheels and school dinners withdrawn, as institutions discharged the elderly and the physically and mentally infirm, it was the unpaid labour of women in the home which would save the day. It followed that women did not have the same need or right to paid jobs. They should return to their neglected function of guardian of hearth and home.

The Conservative government elected in May 1979 confirmed this trend. It officially turned its back not just on policies of economic expansion but also on support for women with children working at all.

The cuts in public services hit women's job opportunities and increased their domestic workload. The government produced the ideology to justify their actions. Patrick Jenkin, the then Secretary of State for Social Services, said 'If the Good Lord

had intended us all having equal rights to go out to work and behave equally, he really wouldn't have created men and women.'

In the early 1980s unemployment continued to rise and women were often particularly badly hit. The gains made in the 1970s seemed in jeopardy. Yet some changes were too deep-seated to be easily reversed. Woman's role as lifelong wife and mother had been seriously questioned. Some men not only agreed theoretically that there was no objective reason why children and domestic work should be a female preserve but genuinely wanted to be active parents. Maternity-leave agreements were concrete proof that centuries of habit can change.

During the years of campaigning and struggling a new series of rights had been won which can still be exploited and built on by women in the workplace. With all their limitations, our equality laws still give ammunition to women who want to improve their employment prospects. The need for programmes of positive action on maternity, child-care, part-time work, opening up male areas of work to women by recruitment drives and training, has been widely adopted as an objective for trade unions and progressive management.

With equal rights on the statute book many women are not happy with the facts of life at work. Increasing numbers of women expect to maintain a job as their main source of income and independence. They may not be 'career women', with all its connotations, but they are certainly not working for pin money. They wish to retain independent status through childbirth and child rearing, and have the same opportunities for advancement as men.

This book aims to help by being a comprehensive and practical guide to women's jobs, pay and conditions. It focuses on women in the workplace, what their rights are, what changes are needed and how they can be achieved. But this is only an examination of half the picture. Fundamental change cannot be limited to the workplace. It depends on governments to extend social services, build nurseries, abolish discriminatory income-tax, social security and National-Insurance rules, and insist on educational syllabuses and teachers that counteract assumptions about

women's and men's roles and abilities. It requires men to relinquish the privilege of being served in the home and to share the responsibility and work involved, not just to help out by washing up. It would also commit them to be real parents, which should be a pleasure as well as hard work.

Changes in these directions would not eliminate individuality but allow it to flourish. If it was not presumed that women, whether in the home or not, are good at cooking, cleaning, sewing and child-care, those who are not would be allowed to express their real talents. If it was not presumed that men should pursue a job or career from the age of eighteen to sixty-five with only a few weeks' holiday a year, those who wanted to could take some years off to be a parent or do part-time work and not be less of a man or prejudice future job opportunities as a result.

This book is designed to arm women to take action and, despite all the difficulties, improve their lot. It is written so that the secrets of wage bargaining, promotion paths, and union life need not be the preserve of men. It aims to help women gain the expertise to bargain in the workplace, so that the women subjects to whom this book is devoted are no longer ignored.

2

WOMEN AT WORK

How many women work outside the home, and what kind of jobs do they have? Is the position of women in Britain different from that in other countries? Most women work in 'women's jobs', but did men and women always do different work, and what causes job segregation today? How many women work part-time or take work into their homes?

How many women work outside the home?

At any one time, more than half of the total of British women aged between sixteen and sixty have jobs outside the home. They comprise 43 per cent of the workforce. Looked at from the woman's point of view, nearly every adult woman has a job except when engaged in child bearing, rearing, or caring for another relative or dependant. Married women have flooded back to work since the Second World War. In 1931 only one married woman in ten was employed. Now more than four in ten have jobs, most of them returning to employment after having children. Over the past twenty years the number of women employed has grown by just under two million, while male jobs have fallen by 800,000. This increase in women's jobs has now stopped. As the recession worsened in the 1980s the rate of women's unemployment was soaring.

Britain has roughly the same number of women working as other West European countries, but far more of them work part-time. Part-time workers are an extremely exploited section of the workforce. They are badly paid, have fewer holidays and are often not in sick-pay and pension schemes. They have less protection from the law, and are less likely to be in trade unions than full-time workers. Each section in this book refers to part-timers, but there is also a chapter dealing particularly with them (Chapter 12).

What about home workers?

There are still many women who take paid work into their homes. Estimates suggest that they number over two million, and there may well be more. Most home workers work long hours on repetitive tasks, and often have to provide their own machinery. Their wages are usually pitiful and other benefits non-existent. They have very little legal protection. Chapter 13 looks at their position in more detail.

What jobs do women do?

Over half of all women workers are employed in the public or private services such as the National Health Service, local government, education, hotels, catering, hairdressing, retail shops, and banks and financial institutions. Within manufacturing, women are concentrated in three sectors: food, drink and tobacco; electrical and electronic engineering; and textiles and clothing. Six in ten women employed full-time are in white-collar (i.e. non-manual) occupations, while most men are manual workers. Just over half of women part-time workers are in manual jobs.

So despite our equality laws women workers are still confined to jobs thought of as 'women's jobs'. They also rarely rise above the lowest grades.

Among white-collar (i.e. non-manual) workers, three quarters of all clerical staff are women, but fewer than one in ten is a manager. Among twenty manual workers there is only one skilled woman worker, while in 'female industries' women dominate in the unskilled and semi-skilled grades. This division of jobs between men and women is termed 'job segregation'.

Despite the Sex Discrimination Act, which came into effect in December 1975 (see p. 159), there has been little change. While unemployment has caused some men to move into 'women's' jobs, there has been little entry by women into 'men's' jobs.

Job segregation remains almost unchallenged.

Did men and women always do different jobs?

When Adam delved and Eve span,
Who was then the gentleman?

So John Ball queried the division of society into classes. But the division of labour between the sexes was considered 'natural'. In the fourteenth century, when he lived, it was also considered normal for women to labour and contribute to the family income.

While some jobs were primarily male and others primarily female in Britain's pre-industrial subsistence economy, women participated in nearly every form of labour and craft. Once married they were in charge of the household, whether in the poverty-stricken hovel of the worker, where all food, clothes, fuel and so on were the result of painstaking family labour, or in the better-off home of the farmer or craftsman. In the latter, wives had an important business function, acting in effect as their husband's partner, and on his death often carrying on his business in their own right. The Industrial Revolution and the separation of home and work caused radical changes.

By the end of the nineteenth century women were more restricted in the work they did, and unlike earlier times marriage usually meant a radical change in economic status from contributing to the family income to almost complete dependence and an inability to participate in the main form of production or to earn more than a small supplement to the male wage. The new approach to economic activity was officially recognized when the census, which during the nineteenth century had included unpaid work in the household as an employment, ceased to do so. Those who did not work for a money wage no longer 'worked' at all.

Men no longer expected continuing economic participation from all members of the family in the production of the family wage; they had come to expect that they alone should earn enough to support their wives and children. This new burden increased their fear of cheap female labour, which, if allowed to compete, could take away their jobs and drag down their wage rates. All the material circumstances for continuing job segregation, married women's exclusion from the job market, and low pay for women had emerged.

The census report for 1851 noted that a quarter of all wives and two thirds of all widows had a specific occupation other than domestic work in the home; that declined to only one in ten married women in 1901 to 1931, then rose to one quarter of all married women aged fifteen to fifty-nine in 1951. In 1971 the overall proportion of women who worked was 43 per cent (the same as in 1861).

In the early years of this century few married women were working, but since the 1950s they have gradually returned to the labour market. By 1971 one in two married women worked. Smaller families, better home conditions and more domestic appliances had reduced domestic labour. Women had time to work outside the home, and if the family were to benefit from a consumer society their wages were needed. New job opportunities, particularly for unskilled and part-time work, were available.

What are women's working patterns today?

Most married women stop work in their twenties and return in their thirties. More married women work between forty-five and fifty-four than they did between fifteen and twenty-four. So while some women have jobs throughout their lives, and some cease on marriage and do not return, the normal working life of a woman who marries has become a two-stage career or working spell: a few years of employment prior to childbirth and a longer phase after the children go to school. The second stage is likely to include, if not entirely comprise, part-time working. This female pattern of work has profound consequences on job segregation. The first phase distinguishes women from men by the expectation, both of most women and of employers, that it is comparatively short-term, with an uncertain second phase. This militates against long-term training, career expectation, and concentration on achieving a decent job. The second phase usually starts out with the handicap in the current day job market of child-care responsibilities, leading to the job fitting round the work of the home rather than the reverse expectation of most males. Women therefore look for part-time work or temporary

work that can be dropped in periods of domestic crisis or even school holidays. Lack of training and experience are other handicaps which spring from years at home. The difficulties of starting what is in effect a new career when in one's thirties and rated as 'old' by a culture centred on male career patterns limit job opportunities (see p. 141).

Coming from years of earning nothing and usually being supported by a male wage, a woman in the second phase is likely to be over-grateful for a low wage rather than militantly pursuing the going rate for her labour. Lack of experience and confidence in selling her labour power makes her less likely to demand and get her true worth.

Because women's and men's jobs are so separate women often compare their wage levels with the wages of other women and not with the male rates for jobs of equivalent worth. The general household survey of 1978 showed that the level of satisfaction with their pay expressed by women earning over £4,000 per annum was similar to that of men earning over £6,000 per annum. Women whose annual income was over £4,000 were the top 11 per cent of female earners, and men with annual incomes of over £6,000 were the top 13 per cent of male earners.

Neither single women nor married women who continue in employment escape from the effects of the life pattern of the majority of their sisters. Employers see 'women's jobs' in terms of the majority and base their expectations on the prototype of the married woman who will drop out of her work when she has children and when she returns will have the domestic workload to cope with. Women themselves are affected by 'norms' which may limit their own abilities and opportunities. As explained on p. 136, many occupations are solely male, or overwhelmingly female, and a woman is not easily accepted into a 'male' job because she has a 'male' work pattern.

So when married women re-entered the labour market it was under different conditions and with different expectations from those of the equivalent males, and they were given different jobs. The extra jobs that women filled were in areas of very high female employment, in the National Health Service, social services, education, and private services such as secretarial jobs,

clerical jobs, cleaning and catering. Sales staff and packaging were other areas. Many of the jobs were part-time and without job security. Women worked in twilight shifts which closed down when work was slack, and on temporary work for temping office agencies and for outside cleaning and catering contractors in manual work, rather than for house-unionized employers. These jobs are facets of what is sometimes described as the secondary labour market.

3

UNEQUAL PAY

Teachers and white-collar women in the civil service and local authorities have had equal pay since the early 1960s. Most other women had to wait until the Equal Pay Act of 1970 was finally implemented in December 1975. In 1982, seven years later, women's average hourly earnings are still less than three quarters of men's (see Figure 3.1). This chapter looks at the reasons for this. Was the Equal Pay Act designed to give all women equal pay? What exactly is meant by equal pay? Do equal pay rates result in equal earnings? What situations does the Equal Pay Act cover, and when does it provide no remedy? Some employers use the loopholes to cheat women; what tricks do they use and with what effect? Part-time women workers may not be covered by the Act, and their average hourly earnings are lower (60 per cent of male manual full-time earnings, 50 per cent of non-manual).

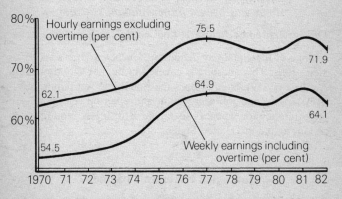

Figure 3.1: Women's pay as a percentage of men's 1970–82. *Source: New Earnings Survey* 1970–82.

What do we mean by equal pay?

There are a number of different approaches to equal pay and a number of ways of defining it. Here are the common definitions, starting with the most narrow and ending with the broadest.

1. Equal hourly pay for the same job

Such a definition would usually include the right to the same basic pay and other additional payments. This definition is adopted in EEC law in Article 119 of the Rome Treaty (see p. 406).

2. Equal pay for the same or broadly similar jobs

This is one definition in the Equal Pay Act.

3. Equal pay for work rated as being of equal value under a job-evaluation scheme

This is the other definition in the Equal Pay Act.

4. Equal pay for work of equal value (whether or not there has been a job-evaluation scheme)

This is required by Article 119 but not by the Equal Pay Act.

None of the equal-pay definitions touches women's access to men's jobs. This question is covered in the Sex Discrimination Act (see p. 159). Neither does the Equal Pay Act require positive steps to end job segregation and open up real equal job opportunities for women. So far no British law requires such action, unlike the United States.

How equal is women's pay now?

Women's total earnings are still less than two thirds of men's, and excluding overtime they are still earning less than three

quarters of men's wages. Part-time women workers earn even less than full-time women workers (see p. 170 for more on this).

How far women's earnings fall below men's varies from industry to industry and job to job, as Figure 3.2 illustrates. Non-manual women's earnings still lag far behind men's in non-manual jobs and in local and national government, where formal equal pay was conceded years before the Equal Pay Act came into effect. (See p. 35 for the reasons for this.) The narrowest gap is to be found among manual workers in the public sector and in transport, and among non-manual workers in education.

The gap between male and female earnings in Britain is larger than in most other West European countries. Only in Ireland do women fare worse.

These results come from comparing men's and women's average hourly earnings excluding overtime.

The comparison of 'average hourly earnings' compares all women with all men, whatever job they do. So it includes the comparison of typists with miners, school-meals assistants with heavy-goods-vehicle drivers, nurses with sales executives. At present, most women work at very different jobs from most men (see p. 136 on job segregation). Most men's jobs command more money than most female jobs, and it would usually be said that this is not due to discrimination against women but because the job of a miner, heavy-goods-vehicle driver, or sales executive is of more value than the job of a typist, school-meals assistant, or nurse. On any one comparison there might be disagreement. Many people might say a nurse's job was worth more than a driver's but less than a miner's. So the gap between men's and women's average hourly earnings in part reflects the different jobs they do and the value people put on them. For that element in the gap to disappear, either there would need to be the same number of women as men doing all jobs or overall the jobs women do would have to be rewarded equally with the jobs men do.

Hourly earnings can be made up of various forms of payment. In the simplest case earnings are the same as the basic or grade rate. The bank clerk is paid £384 a month on Grade 3 in her first year. A packer in a food factory is on a basic rate of £65 a week.

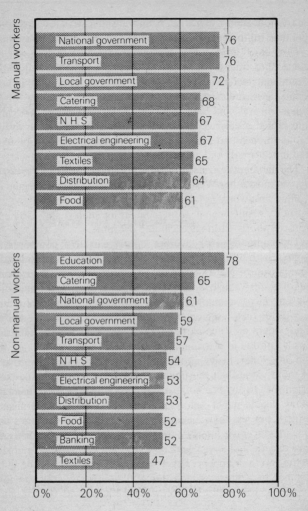

Figure 3.2: Women's pay as a percentage of men's 1982. *Source: New Earnings Survey* 1982.

But when the bank clerk has been there one year she goes up a point on an incremental scale to £14 a month above basic, and the packer is on a bonus which usually adds overall £13 a week to her wages. These extra payments, together with shift incremental increases and all other 'additional payments', are included in the average hourly earnings figure. So it is not only differences in jobs and basic rates which need to be examined to explain the difference in pay between men and women but also differences created when men receive more 'additional payments'.

Chapter 4 looks at each of these different forms of payment in turn.

What situations does the Equal Pay Act cover?

The Equal Pay Act, which came into force in 1975, provided for collective agreements to be implemented to abolish rates paid only to women. It also entitles you to equal pay where your work is the same or broadly similar to that of a man, or where your work has been evaluated as equal under a job-evaluation scheme. If your employer will not give you equal pay you can make a claim to an Industrial Tribunal (p. 408 describes how the tribunals work and how you can make a claim).

Claims to tribunals are few and successes fewer, as the law is complex and cases difficult to win. The best place to pursue your right to equal pay is in your workplace, using the support of other women and of your union. The Equal Pay Act's terms are limited. Many women are not able to use it. But this does not mean you cannot organize and gain better pay and conditions (see p. 93 for more on this).

Amending rates of pay in collective agreements or employers' pay structures

Before the Equal Pay Act, separate male and female rates for jobs were commonplace. It was usual, particularly in engineering, for there to be a skilled rate (male), a semi-skilled rate (male), and an unskilled rate (male); then below all three came

a 'female rate', whether for semi-skilled or unskilled work.

The Equal Pay Act had a very limited effect on such discrimi-
natory pay structures. It required any specifically female rate
in either a collective agreement negotiated with a union or an
employer's pay structure to be raised to at least the lowest male
rate. If there was a separate male and female rate for the same
categories of work, then the women's rate would be raised to
the male rate; but if there was a separate female rate for certain
categories of work and no male rate, the women's rate need only
be raised to the lowest male rate. If an employer failed to amend
a collective agreement or pay structure to comply with the
Act a union could refer the case to the Central Arbitration
Committee, which could order the appropriate amendment.

Between 1976 and 1979 unions referred to the Central Arbi-
tration Committee a number of cases where the employer had
tried to evade the spirit of the Act by renaming grades to delete
all reference to sex without bringing rates of pay for all or nearly
all women's grades up to the rates for men doing comparable
work. The Central Arbitration Committee often exceeded its
limited powers and ordered the employer to give women the rate
their job deserved.

This progressive approach was stopped in 1979 when one
aggrieved employer, Hymac Ltd, resenting being told to pay
their women their due, took the Central Arbitration Committee
on appeal before the High Court. The High Court upheld the
employer's argument that the Central Arbitration Committee
had no power to rewrite pay structures to give women equal pay
for work of equal value. If male/female rates had notionally dis-
appeared, the Central Arbitration Committee could do nothing
about the continuing pay discrimination. The Court said the only
possible exception was if the women's-only rates were virtually
untouched in all but name.

When can an individual claim equal pay?

The Equal Pay Act says you should be paid the same as a man
(1) when you are engaged in the same or broadly similar work,

or (2) when your work has been given the same value as a man's by a job-evaluation scheme. In 1983 a new right to claim equal pay for work of equal value when there has been no job-evaluation scheme at your workplace will be introduced (see p. 407).

'Pay' includes all forms of pay such as bonuses, shift payments and service payments as well as basic rates.

In addition to pay, any other terms and conditions of employment contained in your contract should be equal. These might include holidays, sick pay, or luncheon vouchers. Other terms and conditions are covered by the Sex Discrimination Act (see p. 159).

A man who is paid less than a woman can also claim equal pay, but, for obvious reasons, few do so.

In order to claim equal pay there has to be a man (or men) who has better pay or conditions than you with whom you can compare jobs. You and he must be working for the same employer. If you are not at the same workplace, you must both be employed on the same terms and conditions (for instance you may be covered by the same collective agreement negotiated by your trade union). You can claim, too, where the comparable man works for an 'associated' employer, that is another company with the same holding company as your employer, if that company has the same terms and conditions as your company.

You can compare yourself with a man who has recently left the job (for example if you want to claim equal pay with your predecessor).

You have to show that your work and the man's work is either the same or broadly similar, which means there may be differences in what you do and what he does but they must not be important enough to lead to a difference in pay.

You are entitled to equal pay if you can show that a job-evaluation study of a man's job and your job has said they are of equal value.

In either of these circumstances the Equal Pay Act says you have an 'equality clause' in your contract of employment. This entitles you to equal pay and conditions unless your employer

can show that your lower pay is genuinely due to a material difference other than sex between your case and his.

For example, if there is a system of service payments and you do the same work as a man but he has been there for twelve years and you for two, it would not be sex discrimination if you were paid at a lower rate. Nor is it sex discrimination if a male teacher is paid more than a woman teacher doing the same work not because he is male but because, unlike her, he has a degree and all teachers, male and female, with a degree get extra pay. However, because this part of the Act is vaguely worded it can also be used to prevent women getting equal pay on fairly flimsy excuses; p. 394 gives examples of this.

Does the Equal Pay Act cover all situations?

Workplaces

It covers all workplaces, however small.

Jobs

All jobs are included except the armed forces. Self-employed women can claim if paid less than a man. You will not be covered if you are employed wholly or mainly outside Great Britain.

Retirement

The Act excludes any term in your contract relating to retirement. This is said to be because of the earlier retirement age but has led to some unfair cases excluding women from equal benefit related to retirement. Despite this general exclusion the Social Security Act provides for equal access to pension schemes (see p. 238).

Maternity

Your employer is allowed to treat women differently because of pregnancy or childbirth, for example, by giving maternity leave (see p. 200).

Other laws

Employers are allowed to treat men and women differently in order to comply with other laws. The most important example concerns the Factories Act provisions limiting women's employment at night or on extended hours (see p. 253).

Has the Equal Pay Act been effective?

Figure 3.3 shows the progression towards equal pay since the Act was first passed in 1970. Between 1970 and December 1975 large numbers of collective agreements were amended to raise women's pay from the women's rate to a male rate, though often the lowest (see p. 26). In some workplaces men's and women's

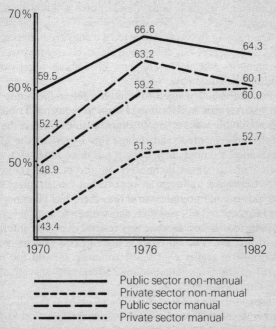

Figure 3.3: Progress to equality? 1970–82. *Source: New Earnings Survey* 1970–82.

work was job-evaluated, and women usually gained by this (see p. 120). It is the changes to collective agreements which are the major reason for the upward shift in women's earnings.

The impetus of the Act was spent by 1977, leaving a continuing gap of 28 per cent between male and female earnings (excluding overtime). The main reasons for these limits on movement towards equal pay are:

1. The Act was never intended to result in equal average earnings for men and women. It did not attempt to deal with men and women doing quite different jobs, except in the limited cases where a job-evaluation scheme gave their jobs the same rating. It did not provide for the removal of all discrimination in pay structures and agreements. The estimated cost of the Equal Pay Act was 4 per cent of the nation's wages bill. To have raised women's wages to equal those of men would have added 18 per cent.

2. The parts of the Act on individual claims are unnecessarily complex, as the previous description makes clear. Many women, trade unionists and employers know little about when women are entitled to equal pay.

3. For individual women to enforce their rights under the Equal Pay Act they have to bring claims to Industrial Tribunals. No responsibility was laid on government to check that the Act was fully implemented, and though this is part of the Equal Opportunities Commission's work it has done little. Not many women wish to single themselves out by making claims. It helps if they have trade-union support, but though many cases are supported, unfortunately in others there has been no local union help.

4. Industrial Tribunals were very restrictive in their interpretation of the law. Though this has been helped to some extent by decisions in higher courts, the tribunals are still too often ignorant of the law's intention and effects and unsympathetic to the woman's case.

5. When the Act was first passed many employers, rather than pay their women workers more, took deliberate action to minimize its effect. A recent report following an investigation by researchers from the London School of Economics on behalf of

the Department of Employment which looked at how equal pay was implemented in twenty-six organizations concluded that:

A few organisations did not comply with the Act for some of their employees (the report found six clear breaches of the Act and sixteen borderline cases among 26 companies). Far more organisations met the letter but not the spirit of the law in that they minimised their obligations under the law. Only a small minority took positive steps to ensure that they complied with the letter and the intent of the legislation.

Here are some of the ways employers 'minimised their obligations':

In removing women-only rates of pay

1. Raising the women-only grade from the bottom of the wages structure to the lowest male grade irrespective of the skill and value of the jobs concerned.

2. Leaving certain groups of women workers entirely outside the unisex grading structure and placing them on a separate lower rate.

Canteen workers were the main victims, because, before the abolition of the Industrial Staff Canteen Wages Council in 1974, they were often not covered by a pay agreement but were only paid the minimum Wages Council rate.

3. Renaming a 'women's grade' in terms of a unisex grade but still only employing women on that grade.

The LSE study found employers putting women on the basic time rate for the industry under a national agreement even though the lowest male rate in the company was higher; in another case the employer tried to put women on a 'basic pay' used to calculate men's holiday pay but below the actual male rate, but was stopped by union opposition.

This kind of action does not comply with the Equal Pay Act. The old 'women's grade' would at least be raised to the lowest male grade if the union took the case before the Central Arbitration Committee (see p. 26).

The transformation of a straightforward female-only rate into an apparently unisex but in fact disguised 'women's rate' can be

complex. It may be important to see what happened in your workplace or industry to help assess what your proper grading should be. Here is an example of this kind of misgrading given by the LSE study.

The multiple retail food industry
There were three stages to equal-pay implementation.
1. Before 1970 there were the following grades, with separate male and female rates for each grade.

> Grade 1: clerks (over twenty-three), including transport workers.
>
> Grade 2: clerks (under twenty-three), shop assistants, cashiers, van salesmen and warehouse workers.
>
> Grade 3: all other workers.

2. In August 1970 a job-classification scheme produced the following result.

> 1. Top rates for male jobs, e.g. butchers, cutters, provisions hands, fishmongers, and central warehouse workers.
> 2. Male shop assistants.
> 3. Female shop assistants.
> 4. Clerks, bookkeepers, and checkout operators.

3. In 1971 this classification was reduced to five grades:

> 1–3. Male jobs, e.g. butchers, cutters, fishmongers, warehousemen, stockmen and van salesmen.
>
> 4–5. Female jobs, checkout operators, bookkeepers, and counter sales assistants.

So while before equal pay female shop assistants and cashiers were in the same grade as van salesmen and warehouse workers, though on a female rate, the result of the equal-pay award was to segregate them into a lower grade and so keep them on a lower rate.

In artificially separating male and female jobs

4. Changing job titles even when male and female jobs remain the same (e.g. calling male packers 'storemen' and female packers 'light packers'); or being slightly more sophisticated

and changing job descriptions to exaggerate minor differences between the way men and women do the same or similar jobs such as emphasizing the 'heavy' or the 'flexible' element in the man's job.

5. Actually changing job content by adding requirements to the male job for flexibility, shift or night work, or extra tasks. Often none of the men, or not all of them, ever carried out these tasks in practice, but they were placed on a higher grade as a result.

Use of biased job-evaluation studies or distortion of the results

6. Many workplaces and industries used job-evaluation schemes to implement equal pay. This should have had the result of giving women equal pay for work of equal value and was in general better than merely deleting the female grade; but the LSE study found examples of sex-biased job evaluations. Female packers in a manufacturing job were given a lower basic rate after job evaluation because they only worked two shifts while most of the men worked three. But even the men who did not work three shifts got the higher rate. Women were also given a different job title, 'inspector packer' while men were called 'assistant machine men' because the men, or some of them, helped the female machine operators in feeding their machines. But on the night shift men doing the 'inspector packer' job were on the 'assistant machine operator's' rate, plus shift pay.

In the National Health Service, job evaluation resulted in two grades for cleaners; all the women were in Grade A and all the men in Grade B. This was justified because, it was said, *all* men did additional porterage jobs and heavier cleaning.

7. When a job-evaluation scheme did say the women's work was of equal value with the men's, moving the men concerned out of the job or grade before the scheme was implemented, sometimes using the 'red-circle' technique (see p. 132), or downgrading the women, or just refusing to implement job evaluation at all (see p. 115 for more on job evaluation).

Compensating men with extra payments

8. Making 'compensatory adjustments' to bonus pay to restore the differential between male and female pay. Men's bonus payments were increased or women's decreased (see p. 39 on bonuses).

9. Giving all the men 'merit' payments or other discretionary payments.

This kind of action has robbed many women of their equal-pay entitlement. Not many women realize exactly what happened at the time when equal pay was implemented in their workplace, though they may know that they are paid below their worth. Finding out is the first step to challenging underpayment and organizing for better pay. P. 82 deals with how to get at the facts; p. 93 makes suggestions as to change.

4

DISCRIMINATION IN THE WAGE PACKET

The Equal Pay Act was concerned mainly with achieving equal rates rather than equal earnings. Because women work different hours, and have different lengths of service and undertake different jobs, it was not expected that the Act would result in women's earnings overall becoming equal to men's.

Where is it that they still lose out? The pattern is different in different industries and occupations. In Chapter 5 there are some detailed examples from various industries and occupations to illustrate what the general picture could mean to you, and to help you work out what the situation is in your own workplace.

Which part of the pay packet do women lose out on?

The kind of pay packet varies from industry to industry, job to job, and the way women lose out varies too. Male manual workers depend more on bonus, shift payments and overtime to make up earnings, non-manual male workers on promotion, increments, service pay and merit pay.

How important is basic pay or grade?

Within most industries and jobs the largest cause of unequal pay is that women are concentrated in the lowest grades, in some cases because they do different and lower-graded jobs, i.e. job segregation (see p. 136), but in other cases because, although men and women start off on the same grade, the men, unlike the women, progress to higher-paid grades.

For example, a factory may employ female packers and process operators and male drivers and craftsmen; here it is job segregation that causes low pay. A bank may employ both men and women bank clerks, but it is only the men who progress beyond a certain grade. Here a discriminatory promotion pattern leaves

women in the lower grades. In many workplaces it is a mixture of both.

The third reason for women being on a lower grade or basic rate is that they do jobs which are similar to men's and of equal value but have been wrongly graded below a predominantly male grade.

Finding out what happened when equal pay was implemented at your workplace will help you decide if your job is wrongly graded. Suggestions as to what to do are given on p. 93.

Are incremental scales and service payments unfair?

In many white-collar jobs there are a number of incremental steps within each pay grade; employees move up one step on the scale each year. Both white-collar and manual workers may have service payments after so many years' service (commonly five). On the surface there is nothing discriminatory in such a system, but there are a number of ways in which women lose out!

1. Part-timers and those in temporary service may be excluded from incremental increases.

2. The lowest-grade jobs may have longer incremental scales with smaller steps than the higher-grade jobs. As most women are on the lowest grades they only progress slowly, with small increases, compared to the larger increases in the higher, mainly male, grades.

3. In some workplaces initial placing on the incremental grades is discretionary, so incoming men may be placed on a higher rung than incoming women. Men may also be given accelerated increments at management's discretion.

The London School of Economics study referred to in Chapter 3 attributes such favouritism to 'the influence of market pressures'. Reporting on one company it says:

There was discretion to hire above the bottom of the scale and also discretion to give 'accelerated increments', particularly in technical and professional grades where the male/female differentials were widest. The organisation's rates of pay were thought to be below market rates for men. Thus men may have joined at higher points in the scale and have been given accelerated increments as an inducement to stay. The organ-

isation concerned was seen as a good employer for women, with salary scales above those paid outside. There is evidence that in the administrative structure, higher entry salaries were paid to male than to female graduates.

4. Previous service usually does not count. So a woman returning after a break for childbirth has to start at the bottom rung again.

If service payments do not start until after a long period of service (e.g. ten years), many women will lose out because they are not able to build up the necessary period of continuous service.

Do flexibility/mobility payments discriminate against women?

In many production industries there are payments for 'willingness to work shift' or 'willingness to do overtime' or 'willingness to move to a different machine' or just a 'flexibility allowance'. These are usually negotiated at the workplace when management wishes to introduce new working methods. In time such extra payments are included in the basic grade rate.

Women may lose out on these payments because they are less likely to drive a hard bargain when management wants to introduce changes; and sometimes they are not represented or are not as well represented in the whole negotiating process as men (see p. 322).

Sometimes these payments are given to certain groups of men in order to maintain male/female differentials, irrespective of whether all or any of them actually work shifts, do overtime, or are flexible.

To avoid such payments being a disguised method of maintaining higher male rates, payment should be made to all workers who actually are mobile and flexible, not to a group on the basis of sex. Wherever possible, payments should be for performance, such as a premium or overtime rate. If there is to be a payment for willingness to be moved from department to department or to operate different machines, then it should be equally available to women; and women should be offered any training they may need to work the machines involved.

Do women lose out on attendance money?

An attendance payment is an extra annual or weekly supplement paid to workers who have a good attendance record. It is paid in some office jobs but is no longer common in industry or public services.

This system can be harsh for women who are forced to take time off for sick children or other domestic crises. The solution is to seek paid time off in such situations (see p. 112).

Even with the difficulties that women with family responsibilities face, their attendance record is not as bad as is commonly thought. The General Household Survey for 1978 showed that in every year from 1974 to 1978 it was only women aged twenty-five to thirty-four who were consistently (although marginally) more likely than men in the same age group to have been absent from work. By contrast, men aged fifty-five to sixty-four were consistently (although again only marginally) more likely than women in their age group to have been absent. Women's higher absences between twenty-five and thirty-four are attributed to looking after others who are ill, mainly children. The higher absence rates for men in the older age group were solely due to their own illnesses or accidents.

What other forms of payments are there?

There are a number of other payments paid at the discretion of management to individuals who are considered to have fulfilled certain criteria or have special responsibilities. For example, there are 'merit payments' or 'special responsibility allowances'. Payments of this kind are frequently used to get round the effect of the Equal Pay Act.

The LSE study compared the pay of two groups of store managers. Pay was said to be determined by branch turnover and 'merit'. Women managers of small units were found to have averaged 102.5 per cent of men's turnover but to earn only 92 per cent of men's pay. The same pattern occurred for women managers of medium-sized units. Checks on length of service and age revealed that men had shorter length of service and were younger. The basis of the 'merit' part of pay was unknown, but

the fact that management themselves thought they were vulnerable to equal-pay claims suggests that a significant portion of the differences in merit payment were sex-based.

Such discretionary payments can also be made in professions such as teaching, where special payments to keep 'key staff', who often tend to be male, are made in the form of a responsibility allowance.

Bonus

Bonus payments are almost entirely confined to manual jobs: see Table 4.1

Table 4.1: *How many women are on bonus?*

	Percentage receiving bonus		Proportion of gap in earnings (%)
	Men	Women	
All manual workers	45	32	9
Engineering	45	50	5
Food manufacturing	35	33	6
Local authorities	72	13	51
Catering	11	7	8
All non-manual workers	17	13	4

Source: New Earnings Survey 1982

What kinds of bonus schemes are there?

There are many variations, but these are the main forms:

1. *Piece-work*
Individual workers are paid according to numbers of items processed.

2. *Measured productivity bonus*
A 'standard' performance is timed (i.e. how long should it take a worker to produce a certain amount), and bonus is paid for production above that amount.

3. *Group bonus*

Instead of the bonus going to individual members it goes to the group. These are all *variable* bonuses, but they may include a minimum payment, irrespective of output, i.e. a *fixed element*.

4. *Fixed bonus*

An extra flat payment to all workers included in the scheme. As it is not payment by result it is not a bonus in the usual sense. It is usually a 'buy-off' for introducing a new system of working or sometimes a 'lead-in payment' until a proper bonus system is introduced.

Bonuses are usually negotiated by stewards for the particular group of workers concerned. In some workplaces negotiating bonuses and keeping up bonus payments are the main negotiating function of the stewards. If women are not represented by stewards, or do not make as much effort as the men to get a good bonus, they may either be excluded or get a bonus system with a higher standard performance or lower payments or both. Here are some examples of how this can happen:

Tightening of women's piece-work rates

The LSE study described a company where

The women work almost as long hours as the men (98%) and their work was closely related to the men's. Although on nearly the same basic rate of pay they earn less. During equal pay implementation, the rates on the women's jobs had been deliberately tightened to offset the cost of equal pay. This results in them earning only 59% of the men's gross weekly earnings and 61% of their average hourly earnings, although their basic rate of pay was 91.5% of the men's.

Unequal access to jobs yielding higher bonus earnings

Men and women are flexible over a range of jobs, but women do not have as much access as men to the jobs where high bonus earnings are possible. As a result, the same grade rate does not give them equal earnings.

Equal rates but different bonus schemes leading to unequal hourly earnings

Men are on the same base rate, but do different jobs. Because of their greater bargaining power they are on a different incentive scheme which allows for higher earnings. Unlike the women, men with outstanding performances earn an extra bonus. The women consistently achieved a high performance, the men rarely. Despite equal basic rates and the women's superior performance, their earnings continue to be lower than men's.

These examples show how men's greater bargaining strength or employers' actions can lead to women's and men's average hourly earnings being unequal even though they are on the same or almost equal basic rates and the women work just as hard. In many cases, it is unlikely that the women know what the men's bonus earnings are, either because of secrecy about earnings or because of physical separation of the men from the women. This is why there is a need to monitor earnings in connection with rates and to investigate bonus schemes in detail in order to achieve real equal pay.

It may be difficult to check on how your bonus compares with that of men doing similar work. Often women don't know the details of anyone else's bonus schemes. See p. 82 for ways of obtaining information.

Not all jobs are easily reduced to bonus schemes, and bonus schemes are not necessarily the best form of payment. Many of the jobs that women do involve caring for people, and speeding up the process or achieving a greater output is hardly the way you would want to go about such work. But if you are working in an occupation where men at your workplace are on bonus and you are not, it is time to ask questions.

If you are on bonus, do you earn as much from it as men in comparable jobs? (See p. 101 for more on what to do about your bonus scheme.)

Shift work

Shift work means that the working day is divided into more than one working spell. Table 4.2 shows how many men and women work shifts in different industries.

Table 4.2: *How many women work shifts?*

	Percentage who receive shift pay	
	Men	Women
All manual workers (1982)	23	12
Manufacturing manual	24	7
Electrical engineering manual	15	3
Food manufacturing manual	34	17
Local authorities manual	10	21
Catering manual	8	4
All non-manual workers	6	10

Source: New Earnings Survey 1981 (1982 as shown).

In manufacturing, far fewer women than men work shifts, largely because of the Factories Act limitations on the hours that women can work. Many women find it more convenient to work shorter hours or part-time. Where women are working shifts, part-time shift patterns are common.

In local authorities and the Health Service, the reverse is true: with no legal limitation, and many traditional female jobs, more women than men work shifts.

How important is shift pay to the pay packet?

For men working shifts it can amount to 20 per cent of their pay packet. In some industries it is an important component in the difference between male and female pay; in the chemical industry, for example, it accounts for 12 per cent of the difference.

What are the main shift patterns?

Shift	Who works it
Double day shift: usually 6 a.m. to 2 p.m. or 2 p.m. to 10 p.m.	Men and women equally in manufacturing industries.
Alternating shift: hours as above, but alternating.	Men and women equally in manufacturing industries.
Three shift – non-continuous (or *rotating shift*): 6 a.m. to 2 p.m., 2 p.m. to 10 p.m., 10 p.m. to 6 a.m.	Men (rarely women) in manufacturing industries.
Three shift – continuous (or *four-crew shift*): as above but going over the weekends and therefore involving rotating 'rest days' and an extra crew.	Men (very rarely women) in continuous-process industries, e.g. paper, glass, steel.
Permanent night shift	Men (very rarely women) in manufacturing industries
Split duty: a split system – usually 8 a.m. to 12 noon, 6 p.m. to 10 p.m.	Women in the Health Service, hotels.
Twilight shift: part-time shift – usually running from 6 p.m. to 10 p.m.	Women in manufacturing industries.

Are women paid equally for shift work?

If they are working alongside men on shifts women will get equal shift payments.

But the highest-paid shift work is on shift patterns and in industries where women do not work, e.g. heavy chemicals, gas and steel. In female industries such as textiles, shift payments are comparatively low.

How important are shorter hours for women?

Difference in basic hours

Full-time women manual workers work on average 38 hours a week, as against manual men's average of 39 hours. Non-manual women work an average of 36 hours, men 37.

The shorter hours are usually because women work in office and service jobs where the standard hours are less than in factories and in other male occupations. But in some cases 'female' jobs may be given a shorter standard week than 'male' jobs within the same workplace or industry. In hotels, for example, chambermaids work a 37½-hour week, while 'male' jobs such as portering entail a 39- or 40-hour week. This may often suit women, but it does mean they have no right to work or be paid for what are standard hours for men.

In some cases it can seem unfair. School-meals staff usually work a 36-hour week, whereas the standard working week for their grade is 39 hours. Refuse collectors under the same grading system are on a 'job and finish' basis and can often finish the week in far fewer than 36 hours. Yet they are paid at the full 39-hour rate.

In some industries such as food, although the 'standard working week' is 39 or 40 hours for both men and women, in practice the normal working time for men and women varies enormously, with men working ten- or twelve-hour shifts and paid on overtime rates after eight hours, and many of the women on part-time shifts of four or six hours.

Overtime

Differences in overtime

In manual work overtime pay is an important part of the difference between male and female earnings.

In 1982 35 per cent of men (49 per cent in manual jobs) worked an average of 8.1 hours' overtime a week, while only 12 per cent of women (16 per cent in manual jobs) worked an average of 4.1 hours' overtime.

Although the numbers of men and women working overtime have been dropping sharply because of the recession, when overtime is being worked the amount done by an individual is about the same as when the economy was booming.

What are the reasons for overtime working?

Overtime is worked for different reasons. It can be so regular that for many men it is part of the ordinary working week. It can fluctuate, but mean consistently long hours for some workers; or it may occur only in special circumstances. Table 4.3 shows the varying importance of male and female overtime in different industries.

Men normally work long overtime to make up for a low basic rate. While they continue to do so, both sexes suffer. If overtime is available men are less likely to fight for a decent basic rate. If women do not earn the overtime, they are on low wages.

Overtime needs to be reduced if women are to achieve equal

Table 4.3: *Overtime*

	Average overtime hours worked per week		*Difference in average overtime earnings*	*Proportion of gap in earnings (%)*
	Men	*Women*		
All manual workers	4.9	1.0	£14.40	27
Food manufacturing (manual)	7.6	1.8	£20.60	38
Electrical engineering (manual)	3.9	1.1	£11.50	25
Local-authority (manual)	3.6	0.9	£8.90	28
Catering (manual)	3.2	0.9	£3.70	17
All non-manual workers	1.2	0.4	£4.00	5

Source: New Earnings Survey 1982.

earnings and higher basic rates and men are to have more time for leisure and family. If men in your workplace work long overtime hours, the first step is to ask which men work it and on what basis. How much does it add to their wage packet? What reasons does management give for needing overtime? See p. 108 for more on what can be done to reduce overtime.

See p. 253 on legal limits on hours for women working in factories.

5

WOMEN IN THE WORKPLACE

Wherever you work it is likely that most women are paid considerably less than most men. It is also likely that you have very little idea what pay and conditions actually apply in your workplace, and how your pay compares exactly with most male workers.

The LSE Equal Pay and Opportunity Project found that women failed to recognize inequalities in pay, particularly for 'like work'. As men and women commonly did different jobs, women did not know the content of men's jobs, or what they were paid. Most men worked in different departments, often in different parts of the building.

Occasionally men may be doing similar jobs to you but are on the staff rather than paid weekly, or they may have different job titles. It is still common among non-unionized white-collar workers for pay to be fixed individually and for workers to be reluctant to tell anyone what they earn. This makes it easy for employers to maintain unequal pay for women, and low pay generally.

If you don't know how your pay is fixed, and are not involved in pay bargaining, it is difficult to assess your pay level. You may not even know that you are being paid below the minimum rate set by the workplace or a national agreement which covers you, or that you are covered by an agreement at all.

The reasons for unequal pay vary from industry to industry, workplace to workplace, and job to job. For women to be in a position to improve their pay and conditions they need to know not just that their pay is lower than men's, but why it is lower, what parts of the wage package are smaller, and how they can be increased.

To illustrate how differences in pay and conditions arise in particular industries and occupations, and the kind of information you would need to decide what caused inequality in your

own workplace, this section looks at seven women workers in different work situations. Between them they cover a large proportion of the different ways in which unequal pay arises. The examples show a typical picture of these kinds of workplaces but have been selected to highlight pay systems, hours of work and other conditions which can result in women getting a raw deal. Looking at these examples, especially the one closest to your own situation, should help you to understand the reasons for low pay and poor conditions in your workplace. Chapter 8 suggests what can be done in these situations to improve pay and the jobs women are doing. Chapter 19 looks at ways of improving the access of women to higher-paid male-dominated jobs.

The examples are:

1. An *assembly worker* in an *electronics factory*. Her situation is similar to that of about two million semi-skilled and unskilled women manual workers in engineering and related industries.

2. A *lecturer* in a *college of technology*, representing the position of 600,000 women in teaching.

3. A *part-time dinner lady*, working for a *local authority*. Her problems are similar to those of the 800,000 part-time workers in local authority service, and in some ways are relevant to all the 3 million women part-timers in Britain.

4. A *packer* in a *food factory*. There are about a quarter of a million women workers in the process industries, and a similar number of women working in packaging elsewhere.

5. A *bank clerk* in a *major clearing bank*, representing the 600,000 women employed in banking and insurance.

6. A *shorthand typist* in *administration*. There are 800,000 clerical workers in public services, and a roughly similar number in private services.

7. A *waitress* in a *licensed hotel*, representing the 400,000 women workers in hotels and catering.

The examples give information on the jobs these women do, the pay they receive and the pay amongst their employers' workforce as a whole – analysing men's and women's positions in the workforce. The distribution of jobs and earnings figures are typical of the kind of workplaces described. The earnings, wage and salary scales are those common in 1981; the problems women

faced remained unchanged when this book went to press in early 1983.

The assembly worker

She is fifty and has been working full-time for nine years in a small electronics factory in the east Midlands, having previously worked there part-time in the canteen. She also worked full-time at the factory twenty years ago before leaving to bring up her family.

The employer

The factory is part of a large British-owned multinational corporation, which took over the smaller firm that ran the factory until five years ago. The factory makes a single but complex component for civil and military telecommunications systems.

The job

She is now classified as an assembly worker (fixed duty) on semi-skilled Grade 3 (semi-skilled).

The hours

She works 39 hours per week, plus an average of two hours' overtime worked as and when required.

The pay

Her basic rate is £65 and she has bonus earnings of £15 per week on average. Her total earnings including overtime are £84.50.

Other terms and conditions

Holidays: 22 days at basic pay only.

Sick pay: 13 weeks at £12 a week, rising to 26 weeks after five years' service.

Pension: No occupational scheme.

Job security: no union agreement. During the last redundancies part-timers went first, and the only part-timers left are in the canteen.

The union

She is a member of the TGWU, as are all manual workers in the factory except craftsmen (who belong to the AUEW or EEPTU) and supervisors (who belong to ASTMS).

How pay is fixed

There is a national engineering agreement which sets minimum pay rates, holidays, hours etc. The actual pay rates are decided at the workplace between the shop stewards' committee and local management.

How much does she know about pay and conditions?

She knows the present pay grades were introduced in a job-evaluation scheme following the Equal Pay Act. She also knows that male assembly workers doing the same or similar work are classified in Grade 4 because some of them carry out heavier tasks and sometimes set up their machines.

She believes that male assembly workers earn more bonus than women assembly workers, although their jobs in practice are not very different. She knows that the men work considerably more overtime than the women.

The full picture

The full picture of the electronics factory is set out in Figure 5.1.

Canteen workers' rate

The canteen workers, all women, six of whom are part-time, are paid at a rate lower than the unskilled rate. (See p. 31 on how this can arise, and p. 97 on what can be done about it in this particular case.)

Semi-skilled grades

Semi-skilled workers are divided into two grades, with all the women on the lower grade. When the Equal Pay Act was implemented, job descriptions were written out which added extra tasks to the men's work and were used as an excuse to keep them in a higher grade on higher pay (see p. 32 for examples of this).

Bonus

Table 5.1 shows the difference in bonus earnings among semi-skilled workers. This arises because the bonus system for the women's machines was negotiated separately from the system for the men's machines and on less favourable terms. The men are guaranteed £10 a week fixed bonus, the women only £8. On the men's average performance of 110 they are paid £9.50, women only £4.50. (See p. 101 for more on this.)

Table 5.1: *Bonus earnings in the electronics factory*

	Standard performance	Average performance	Average Payment		
			Fixed	Variable	Total
Male assembly worker Grade 4	100	110	£10	£9.50	£19.50
Female assembly worker Grade 3	100	110	£8	£4.50	£12.50

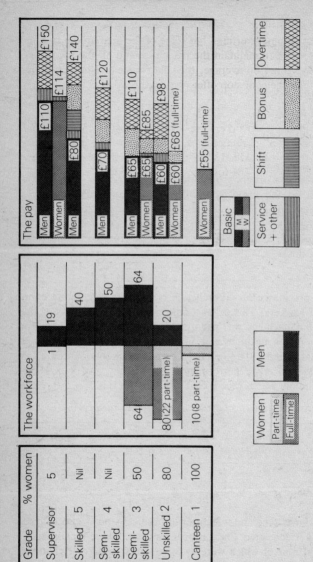

Figure 5.1: The electronics factory.

Overtime

She works some overtime, but some of the men are on systematic overtime to maintain the machines, and all the men work more overtime, on average, than the women. When overtime is cut, management stop offering it to the women first.

Skilled grades

The skilled-grade workers are all men. Most of them became craftsmen after apprenticeships, but there are five dilutees promoted from semi-skilled work under a special agreement a few years ago. (See p. 281 for access to skilled jobs.)

Supervisory jobs

The only female supervisor is in the canteen. All other supervisors are men who have served apprenticeships, even though this is not necessary for the job.

The lecturer

She is thirty-nine and a lecturer in business studies at a college of further education. She has been employed there for six years, the first four of which were as a part-timer while her children were small.

The employer

A college of further education in the north of England, run by the local education authority.

The job

She is graded as 'Lecturer 1', the lowest grade in the teaching staff of the college, and works in the Business Studies Department. There are five 'Lecturer 1' posts in the department, and three 'Senior Lecturers'. Over half the lecturers in both grades are women. There are no women above senior lecturer in that department.

The hours

Twenty-two hours per week class contact plus eight hours preparation and administration time. There is no overtime.

The pay

She is paid a salary of £6,627, which is on the seventh point of the Lecturer 1 incremental scale, which moves by annual increments from £5,034 to £8,658. Her part-time service has been taken into account. She has no additional payments.

Other terms and conditions

Holidays: 14 weeks at full salary. Part-timers get the same if they work more than twelve hours a week. Below twelve hours they are paid on a session or hourly rate, which does not give them sufficient allowance for preparation time.

Sick pay: 100 days on full pay, plus 100 days on half pay.

Pension: Good compulsory scheme for full-timers and part-timers over twelve hours. Employee's contribution 6 per cent.

Job security: She is employed by the local authority rather than the college, so can be moved to another college. The college must give the maximum possible notice. But there is no other agreed redundancy procedure.

The union

She is a member of the further education union, NATFHE, as are all her colleagues throughout the college.

How pay is fixed

Teachers' salaries are negotiated by the Burnham Committee for Further Education. Union negotiators meet local authority employers and representatives of the Department of Education. Recruitment, promotion and organization are dealt with by consultation at college level with the union representatives, and, if teaching and academic matters are involved, by the 'Academic Board', which includes teacher representatives.

How much does she know about pay and conditions?

She knows that although over half of her own Business Studies Department are women, including the part-timers, a man holds the post of Head of Department. She also knows that all other heads of department in the college are men, except in the Catering and Home Economics Department. She has a copy of the salary scale applying to her own grade and to all the other grades in her department and in the college.

The full picture

The full picture of the teaching staff in the college is set out in Figure 5.2.

Recruitment/grading

Fewer than one in five of the teaching staff are women, and over two thirds of them are on the lowest two grades, with only one female head of department.

Part-time workers

Part-time workers are all on the lowest grade. Some of them have had their weekly hours reduced below twelve, i.e. below

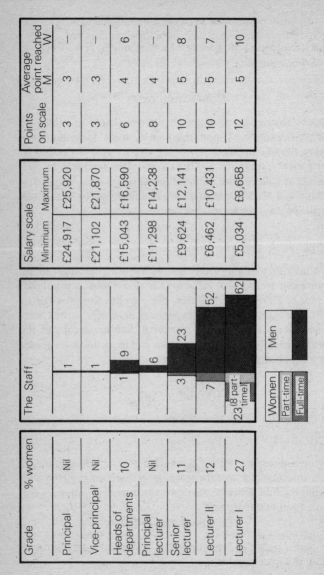

Figure 5.2: The teaching staff in the college of further education.

the level of legal protection (sixteen hours) and also below the level at which the college pays in full for holidays etc.

Job segregation
Women are concentrated in departments relating primarily to female skills such as catering and home economics.

Salary scales and increments
The lowest grade has the longest salary scale and the smallest increments (see p. 99).

Promotion
At all levels women have greater seniority than men. This suggests that they find promotion both within the college and to other teaching posts in other colleges much more difficult than men do. N.B. Other women employed in the college in administrative, clerical and secretarial jobs will face similar problems to those of the administrative staff at the polytechnic in the example below (p. 73).

The school-dinner lady

She works part-time, serving in the kitchen of a large primary school in Outer London.

The employer

An Outer London Borough which has responsibility for education and also for most other local-authority services, with a total manual workforce of over 4,000.

The job

Her job is termed 'Kitchen Assistant' and is Grade B on the manual workers' scale.

Her hours

She works 20 hours a week as a part-timer. Standard hours are 40, but the many women full-timers in school meals have a working week of 36 hours. She has no overtime.

The pay

She has a basic pay of £1.50 per hour (£30.50 for a 20-hour week), plus an Outer London Allowance of £2.28 (the full allowance is £4.56 or £237 a year). She receives no bonus pay, overtime or shift pay. There is now no service pay, this having been replaced by service-related holidays. Previously she would have been excluded from service pay because she works less than 35 hours.

Other terms and conditions

Holidays: A total of 22 days at full pay (including two customary holidays), which school-meals staff must take during school holidays. This rises to 24 days' total after five years' service and 27 after ten.

Sick pay: Four weeks at average earnings after six months, rising to 26 weeks after six years.

Pension: Good inflation-proof pension scheme compulsory to full-timers, but part-timers are not admitted. Employee's contribution 5 per cent.

Job security: School-meals staff are in an unusual position: between school years they are on a 'retainer' basis, which can be withdrawn. Other local-authority jobs are subject to job-security and redundancy arrangements covered by national guidelines, which in practice provide reasonable job security. School-dinner staff are therefore the most vulnerable of local-authority employees to public expenditure cuts.

The union

She is a member of NUPE. The rest of the manual workers at the school, caretakers, cleaners and kitchen staff, all belong either to NUPE or the GMB.

How pay is fixed

The grade rates are negotiated nationally by the National Joint Council (NJC) for local-authority manual workers. The employers' side is made up of representatives from local-authority associations. The trade-union side consists of national and local officers of the GMB, NUPE and TGWU. The London Allowance is negotiated at regional (provincial) level. The bonus schemes and work schedules are negotiated by local union officials and stewards within each local authority.

How much does she know about pay and conditions?

She is only aware of the workers who are in the school: teachers, school-meals ladies and the cooks who supervise them, a caretaker and the cleaning staff. Most of the school-meals and cleaning staff are part-time workers like herself. She knows very little about the wages structure under which she operates and the kind of workers it covers outside the school-meals area.

The full picture

The full picture of the manual workforce employed by the Borough is set out in Figure 5.3. The manual workers' grading struc-

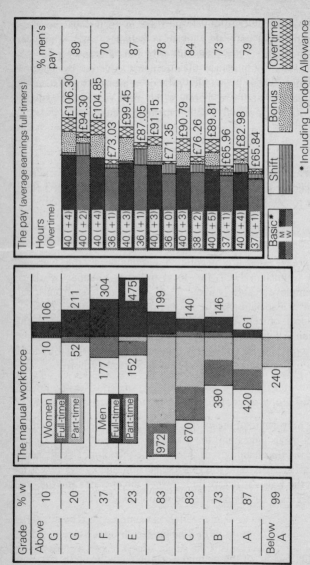

Figure 5.3: Local council manual workers.

ture in local authorities is extremely complicated. A lot of different workers are in Grade B, including labourers, who are all men, laundry workers and nursery assistants as well as school-meals staff. There are a total of seventy jobs, ranging from cleaner to HGV driver, allotted to the seven grades A to G. Basic rates vary from £56.90 on Grade A to £73.50 on Grade G. Three quarters of the workforce are women. Nearly 60 per cent are part-timers.

The figures for employment and earnings show:

1. Placing the jobs on grades

The jobs are graded on a national basis, originally based on a national job-evaluation scheme. Most women are in jobs on the lowest grades (see p. 373). This is particularly true of part-timers. Three quarters of part-time women are on Grade B and below. Three quarters of full-time men are on Grade D and above.

2. Job segregation

Men and women work mainly in different jobs and in different departments for the Council. Women are in school meals, residential homes, social services and cleaning; men are in parks and highways, cleansing and refuse.

3. Women's earnings

Although women receive the same basic grade rate as men in the same grade, their total earnings are consistently lower. Overall, the average total earnings for women are only £73, compared with £99 for men: i.e. women's pay is less than three quarters that of men. The proportion by grade varies from 73 per cent on Grade B (which is dominated by women) to 89 per cent on Grade G (where there are relatively few women). The average hourly earnings for part-time females are only £1.68, compared with £2.29 for full-time males. The reasons for these differences within grades are:

Bonus. Ten times as many men as women earn a bonus. The jobs women do are often not amenable to bonus (see p. 103); lack of bonus payments is the single largest reason for the lower female earnings.

Hours and overtime. Most women work either part-time or on a week of 36 or 38 hours, compared with a basic week of 40 hours for most men. There is systematic overtime attached to many male jobs; but women work only limited overtime (see p. 45).

Shift payments. In a local authority, women in certain jobs work more shifts and receive more shift pay than men (e.g. laundries and residential homes), but shift pay is low compared with the premia paid in male-dominated industries (see p. 43).

These differences in pay are illustrated in Table 5.2 by taking three workers all in Grade B: a road labourer (male), a laundry worker (female) and a full-time (36 hours) kitchen assistant (female).

Table 5.2: *Different occupations in the same grade*

	Basic (plus London Allowance)	Shift	Bonus	Overtime	Total
Road labourer (male)	£64.66 (40 hrs)	nil	£15.60	£9.01 (4 hrs)	£89.27
Laundry worker (female)	£64.66 (40 hrs)	£7.80	nil	£2.25 (1 hr)	£74.71
Kitchen assistant (female)	£54.09 (36 hrs)	nil	nil	nil	£54.09

The packer in a food factory

She is thirty-eight and has worked for ten years in the same job in a pie and cake factory.

The employer

A single factory employer making pies and cakes in a medium-sized factory in the north-west of England.

The job

Her grade title is 'Production worker'; she works in the packaging department on a packaging machine at the end of the pie-producing process.

The hours

She works 40 hours per week and very rarely does any overtime.

The pay

Her basic rate is £65 per week. She receives a service supplement of £4 a week because she has worked there over ten years (this would not apply if she were a part-timer). She is on a bonus scheme which gives her an average of £13 a week.

Other terms and conditions

Holidays: 20 paid days at last year's average earnings.

Sick pay: Four weeks at average earnings after one year's service, rising to 26 weeks after 20 years. Part-timers are excluded.

Pension: Occupational pension scheme compulsory for full-timers; part-timers are excluded. Employee's contribution 6 per cent.

Job security: No formal agreement. Traditionally the twilight shift is laid off first, then voluntary redundancies are asked for among day workers only, followed by a 'last-in, first-out' system.

The union

She is a member of the GMB, as are all workers in the factory except for the craftsmen (who are in the AUEW or EEPTU) and the foremen, who are not in a union.

How pay is fixed

There is a national agreement reached by the Food Manufacturing Joint Industrial Council, which sets minimum pay, hours, holidays etc. But actual conditions and rates of pay are fixed by workplace or company negotiations. GMB shop stewards negotiate for non-skilled workers. There is a craft negotiating committee of shop stewards from the craft unions for the skilled grades.

How much does she know about pay and conditions?

She knows that the majority of the day workers on production and packaging are women, and that all the part-time workers are women. All shift workers are men. The male shift workers work four twelve-hour shifts a week (recently reduced from five shifts, with pay maintained by an adjustment in their basic rate). There is also the all-female twilight shift on production and packaging from 6 p.m. until 10 p.m. She knows that shift workers earn far more than day workers, and that men on day work get higher bonus earnings than women and work any overtime that is going.

The full picture

She is aware of the general situation in the factory. She has been around long enough to know how it operates and has been active in the union. But even so she will not know the earnings position in detail. Some of the facts about the workforce and the earnings they receive are set out in Figure 5.4.

Wage differences

Grade rates and earnings depend on the nature of the shift and on sex. Workers on twilight shift, production day workers and

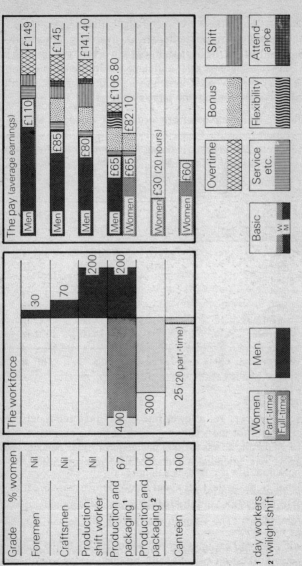

The pay (average earnings)

Men	£110 £149
Men	£85 £145
Men	£80 £141.40
Men	£65 £106.80
Women	£65 £82.10
Women	£30 (20 hours)
Women	£60

Legend: Basic · Overtime · Bonus · Shift · Attendance · Flexibility · Service etc.
W M

The workforce

30	70	200	200
400	300	25 (20 part-time)	

Women Part-time Full-time Men

Grade	% women
Foremen	Nil
Craftsmen	Nil
Production shift worker	Nil
Production and packaging[1]	67
Production and packaging[2]	100
Canteen	100

[1] day workers
[2] twilight shift

Figure 5.4: The food factory.

production shift workers are all on roughly the same skill levels, but their earnings are very different. Day workers earn a higher basic rate than the twilight shift. Shift workers are on higher basic rate than day workers, and have a shift premium on top. Table 5.3 shows how total earnings vary in these grades, despite their being all at roughly the same skill level.

Table 5.3: *Average pay for production and packaging workers*

	Twilight shift (female part-time)	Production day worker (female)	Production day worker (male)	Production shift worker (male)
Hours: Basic	20	40	40	40
Overtime	–	–	4	8
Pay: Basic	£30.00	£65.00	£65.00	£80.00
Service	–	£4.00	£4.00	£4.00
Flexibility	–	–	£8.00	–
Shift	–	–	–	£18.50
Bonus	–	£13.10	£16.80	£18.90
Attendance	–	–	£4.00	£4.00
Overtime	–	–	£9.00	£16.00
TOTAL	£30.00	£82.10	£106.80	£141.40

Twilight shift

These part-timers get a lower rate of pay than full-timers, no shift payment for unsocial hours, and no bonus payments. Nor do they have any access to other payments or fringe benefits such as service pay, attendance allowance, sick pay or pension.

Skilled and supervisory jobs

All the skilled jobs are reserved for craftsmen who have served apprenticeships. The company has never had female apprentices.

There are no forewomen. The company says none have applied (see p. 140). The only woman in a supervisory position

is the canteen supervisor, who is only paid at the same rate as a production day worker.

Bonus

Only two thirds of the women day workers are on bonus, but all the men are. Women and men earn equally for the same performance under the bonus scheme, but the women's performance is lower on average. This is because their standard performance has probably been pitched too high, or because their place in the production line or in packaging makes them dependent on throughput from other sections. See p. 101 for details on bonus.

Overtime

Male shift workers are on four twelve-hour shifts a week, including eight hours a week systematic overtime. Some male production workers are scheduled to do regular overtime on maintenance jobs. Other overtime is traditionally offered to the men first. It is rare for women day workers to be offered any overtime, although some of them would welcome it, especially before Christmas.

Flexibility allowance

Male day workers have a 'flexibility allowance' of £8 to 'compensate' them for female day workers being on the same basic grade; this was introduced at the time when equal pay was implemented. Men are supposed to be mobile between departments and to cover for holidays, absences etc. In practice this makes little difference to their work.

Attendance allowance

There is an attendance allowance of £16 per month for those workers who are not over ten minutes late more than once in any month. Women and men are equally eligible, but some women find it more difficult always to be on time and to avoid uncertificated days off because of family commitments, children's illnesses etc.

The bank clerk

She is a bank clerk in a local branch of a large clearing bank. She has worked there for three years. Now twenty-two, she is thinking of having children but does not really wish to give up her job. She might, however, want part-time work.

The job

She is on Grade 2 (clerical general grade) in a grading structure with four clerical grades, above which there are four administrative and ten managerial grades. The bank has a system of career development, and she has been 'tiered' 'C' in terms of potential, which indicates she is capable of reaching Administrative level 1. Any career prospects will be jeopardized if she changes her career and disappear completely if she starts working part-time.

The pay

Her salary is £4,200, the third point of a scale going from £3,886 to £4,872 in eight annual steps. In addition to her basic salary she receives overtime payments, a Christmas bonus, a profit-sharing pay-out, and incremental increases which vary according to an annual performance appraisal.

The hours

She works 35 hours, which is the basic working week for all grades. Overtime is worked only as and when required. The average is two hours.

Other terms and conditions

Holidays: 20 days on full pay after one year, rising to 21 after five years and 22 after ten, 23 after fifteen and further additions.

Maternity leave: Basic state minimum.

Sick pay: Thirteen weeks on full pay on employment, rising to 25 weeks after five years.

Pension: Good non-contributory pension scheme, but those returning after breaking service have to start afresh. Employees who leave before the age of twenty-six or five years' service have no preserved pension, and as it is non-contributory they receive no cash payment.

Job security: No formal arrangements, although redundancies are now being experienced at the bank (so far by calling for volunteers).

Home loans: Available to married staff over twenty-three years, single over twenty-seven, but not to part-timers.

The union

She is a member of the banking union BIFU. Some employees are members of a rival staff body, CBU, which is a federation of staff associations.

How pay is fixed

Negotiations on clerical and managerial pay are with the Federation of London Clearing Banks; the rest is at company level between bank management and BIFU. There are no negotiations at the bank.

How much does she know about pay and conditions?

She knows that most of the women are on her grade or the grades immediately above or below her. The men recruited on to clerical grades seem to be promoted faster. She also knows that men have most of the administrative and managerial jobs.

The full picture

The full picture for the bank staff is set out in Figure 5.5. This does not include secretarial staff, who have a parallel structure involving seven grades. They may be able to transfer to counter-type work on the banking grades, but are very unlikely to achieve management status.

In the hierarchy of banking staff, women are heavily concentrated in the unappointed grades. Relatively few get on to the higher appointed bank clerk grades. Very few indeed make it to managerial level.

A number of managerial practices produce and maintain this segregation of 'job' bank staff (mainly women) and 'career' bank staff (mainly men).

Promotion

In all grades, more men than women get promotion. It follows that women stay longer in their grades, and so depend on salary incremental increases to improve their wages.

Tiering

Recruits are 'tiered' for potential at their initial interview; this is reviewed at the end of their probation period, again at a formal interview when they are twenty-two, and thereafter at five-year intervals. There are three tiers, A for those with middle or higher management potential, B for lower levels of management, and C for 'clerical for ever'. Staff are not told of their initial tiering. Management say it is for 'manpower planning purposes only'. They are informed of their tiering when they are twenty-two. Men get higher initial tiering and keep higher assessments than women.

	Grade	% women	The bank staff (Women / Men)		Promotion % (W / M)		Salary scale (Minimum / Maximum)	
Managers	M3 to M10	1	25	3,100	—	18	£14,750	?
	M2	2	20	1,100	—	17	£12,086	£14,500
	M3	3	25	850	9	42	£10,967	£13,189
Appointed	A4	3.5	45	1,200	12	29	£9,464	£11,865
	A3	3	55	1,850	10	16	£8,527	£10,905
	A2	7	140	1,750	7	20	£7,736	£9,430
	A1	9	210	2,100	11	22	£7,002	£8,651
Un-appointed	G4	17	750	3,600	6	13	£5,429	£6,936*
	G3	50	3,150	3,150	7	21	£4,604	£6,006*
	G2	69	10,600	4,700	6	18	£3,886	£4,872*
	G1	74	9,000	3,200	40	43	£3,236	£3,236*

Legend: Women — Full-time, Part-time; Men.

*25 per cent extra increments for 'good' performance;
50 per cent for 'outstanding'. In the unappointed grades
there are higher maxima for good or outstanding performance.

Figure 5.5: The bank. (Secretarial and specialist staff are not included.)

Tier	Men	Women
A	4%	0.5%
B	43%	6.5%
C	53%	93%

Qualifications

Career banking staff are expected to take the Institute of Banking examinations. It is possible to be promoted without these formal qualifications; men often are, but women very rarely. Yet there are a number of difficulties for women wishing to qualify. They are not given the same encouragement (see p. 154). Staff tiered as clerical material rarely get study leave. There is an upper age limit of twenty-three on ordinary study leave, and of thirty for attendance on the internal revision course. This operates against women who decide to try and break into career banking after their first few years, or who want to study when they return after having children. While management say they will use flexibility, the rules only appear to be varied for candidates they consider to have outstanding ability.

Part-timers

Part-time workers often lose out on bank-holiday payments as the banks avoid employing them on Mondays and give no payment in lieu.

They are excluded from house loans if they work fewer than thirty-two hours a week.

Some work fewer than sixteen hours a week and so have little legal protection unless they have been with the bank five years.

They do receive Christmas bonus, profit-sharing payments, and merit payments pro rata.

Re-entry scheme

The bank has recently started a scheme to facilitate former employees returning to work after having children. It is on an experimental basis and restricted to women whom the management consider to have 'career potential'. Over a five-year period 100 women will be allowed to return to the bank within their old

grade and preserving their old seniority. To qualify for consideration women must:

1. Be tiered A or above (only 0.5 per cent of female staff fall into this category);
2. Have a minimum of five years' previous service;
3. On re-entry, have at least twenty years to serve;
4. Have had no more than five years' 'gap' since previous full employment;
5. During the 'gap' period, have worked two weeks per year on relief duties.

The shorthand typist

She is twenty-three and has worked for nearly two years as a shorthand typist in a large polytechnic in London. She originally came as an 'agency typist' but after six months was offered a permanent job.

The employer

A large London polytechnic, operating under the ILEA but responsible for recruitment and management of both teaching and administrative and technical staffs.

The job

She is in the typing pool in the Student Record Section, working for several men and women in executive and administrative jobs. She is graded 'Clerical 2', as are most shorthand typists and secretary/typists, whether they are allocated to administrators or work in the typing pool. That grading is set by the local-government grading structure.

The hours

Like all other administrative staff in London, she works 36 hours a week. She does no overtime.

The pay

She is paid £3,918 (plus a London Allowance of £915) on a salary point 9 on the incremental salary scale (which is also point 9 on the national system). She was initially appointed at Grade 8 on the basis of her experience and has received one increment. (Grade 6 is the normal basic adult rate.) The full scale runs from £2,691 to £5,064 in fifteen steps. Both starting points and increments are at the discretion of local management, though increments are in practice annual, except that there is a 'bar' dependent on typing and shorthand speeds, and beyond point 10 on supervisory responsibility.

Other terms and conditions

Holidays: 22 days (including two 'extra statutory' days) at full salary, rising to 27 days after five years.

Sick pay: One month at full salary on employment, rising to two months at full salary and two months at half salary after a year, and six months at full salary and six months at half salary after five years.

Pension: Good inflation-proof pension, compulsory for full-timers, optional for part-timers. Employee's contribution 6 per cent.

Job security: No formal conditions on redundancy. There has never been any job loss. Any job losses that arose would be dealt with under the guidelines issued by the local authorities nationally.

The union

She is not a member of a union, but most clerical and administrative staff are in NALGO.

How pay is fixed

Pay and other terms and conditions in the polytechnic are based on grades within the national grading structure, which is negotiated nationally by the National Joint Council for Local Authorities (Administrative, Technical and Clerical Staffs). It is supplemented by an agreement at London level between the GLC and the ILEA and NALGO and the other staff unions which defines the placing of jobs on the scales. Management in the polytechnic has considerable discretion over the points at which people are recruited and their progression up the scale.

There is an all-union Consultative Committee in the poly, but it does not negotiate wages or conditions. Union members can raise their own grievances about salaries and promotion, and disciplinary matters. They would be represented by NALGO within the poly. Non-union members would have to deal with management on these matters themselves.

How much does she know about pay and conditions?

At present all the information she has is about her own 'Clerical 2' salary scale. She knows that the few men employed on her grade usually get promoted after a relatively short time to executive grades, where they are in charge of records, statistics and other information in their respective jobs. 'Promotion' to senior secretary or to supervisor of typing pool means moving up a few notches on the salary scale rather than being moved to a different grade.

The full picture

The full picture of the administrative staff in the poly as a whole is set out in Figure 5.6.

Grading

The national 'spinal-column' system provides the steps for all typists and secretaries, who in the polytechnic system are classified as Clerical Grade 2. The only recognition of responsibility is by being put on a higher point on the scale. This does not really recognize the considerable responsibility taken by typing supervisors or individual secretaries who act as administrative assistants to senior administrators.

Incremental scales

There are far more steps on the salary range for the lowest grades than for the highest, and there are various 'bars' of qualification (e.g. for shorthand speed) or for responsibility that limit progress to the top of the scale for the lower grades.

 N.B. On these two points, there has recently (1981) been a change in the national 'spinal-column' system of grading, but this has yet to be fully reflected in practice at the kind of level we are talking about and in the grading system applicable to polytechnics.

Lack of promotion

Most women are employed on the clerical grade and never get promotion. There are only very limited career or training opportunities for them. Men seem to get promoted far quicker.

The hotel waitress

She works in the restaurant of a medium-sized licensed hotel on the south coast. She has worked there only for a few months.

The employer

A small chain of hotels in the south of England.

Grade	% women
Admin. D	Nil
Admin. C	Nil
Admin. B	Nil
Exec. 2	57
Admin. A	62
Exec. 1	59
Clerical 2	90
Clerical 1	100

The staff (bars): 3; 6; 15; 8; 9; 8; 20; 12; 12; 59; 92 (20 part-time); 12 (4 part-time); 10

Legend: Men · Women Full-time · Part-time

Points on 'spinal column'*	Salary scale† Minimum	Maximum	Number of points	Av. point reached M	W
40/43	£10,581	£11,517	4	4	–
35/39	£9,261	£10,275	5	4	–
24/34	£6,501	£8,991	11	5	9
24/27	£6,501	£7,137	4	2	3
13/23	£4,764	£6,333	11	4	7
9/23	£4,206	£6,333	15	7	9
6/18	£3,798	£5,526‡	13	3	8
1/15	£2,691	£5,064	15	–	3

* National grade structure.
† All have an additional London Allowance of £915.
‡ Subject to efficiency and responsibility bars.

Figure 5.6: The polytechnic administrative staff. (Technical grades are not included.)

The job

She works in the restaurant under a head waiter.

The hours

She works a split roster, which means she serves breakfast and morning coffee from seven until eleven in the morning, and then returns from seven until eleven in the evening to serve dinner. She also works two weekends a month, with days off during the week in lieu. She 'lives in' in the hotel.

The pay

Her wages per week are £43.60. £14 is deducted from the legal minimum wage (see p. 363) of £57.60½ for the cost to her employer of her 'living in' and meals taken on duty. She receives about £8 a week in tips paid in addition to the set service charge. The service charge is not distributed to the staff at all. But the additional tips are pooled and distributed by means of a 'tronc' to all the staff concerned with the cooking and serving of the meals.

Overtime

She receives no overtime pay. Management expect her on occasions to work extra hours. As she lives on the premises

she is easily available and they do not have to fix it in advance. They give her a day off in lieu, but decide which day she can take off.

Other terms and conditions

Holidays: 20 days at basic pay, to be taken at management's discretion outside the peak period.

Sick pay scheme: None.

Pension scheme: Only for senior staff.

Job-security arrangement: None.

The union

None of the workers in the hotel is in a union. Management just tells workers what they are going to be paid. The employer claims to observe the legal minimum rate set by the Licensed Residential Wages Council. Part-timers and casual workers often get less.

How pay is fixed

There are no negotiations of wages. Management is legally obliged to pay the Wages Council minimum rate (see p. 363). Individual wages are fixed by individual agreements with management.

How much does she know about pay and condiditions?

Apart from her own wages, she knows very little about how pay is decided in the hotel. She may have a general idea that waiters get higher pay than she does, but she has no idea how this is calculated or paid.

The full picture

The full picture is shown in Table 5.4 There are no set pay scales or grades. Individual wages are set in an *ad hoc* way. Wages are

Level	Job	Numbers*		Average wages†		% men's pay
		Men	Women	Men	Women	
General management	General manager + assistants	4	1	£250	£150	60
Departmental management	Restaurant manager	1	–			
	Chef de cuisine	1	–			
	Banqueting manager	1	–	£142.50	£90	63
	Head reception	1	–			
	Head housekeeper	–	1			
Trainees	Trainee managers	2	1	£85	£85	100
Head stewards etc.	Head steward	1	–			
	Head waiter	1	–	£137.50	–	–
	Chef de parti	2	–			
Maintenance	Electricians etc.	7	–	£120.75	–	–
Service staff	Commis chef	8 (1 part-time)	–	£100	–	
	Receptionist	2	12 (2 part-time)	£85	£66	77
Porters, waiters and cleaning staff	Night porters	5	–	£105	–	
	Waiter/waitress	9	21 (11 part-time)	£81	£48	
	Bar staff	4 (2 part-time)	8 (5 part-time)	£80	£47.50	58
	Kitchen assistant / Kitchen porter	10	7	£70.50	£48	
	Chambermaids	–	18 (10 part-time)	–	£46	

*Casual staff not included †Figures *after* deductions for board and lodging

Table 5.4: *The hotel.*

related to the 'department', e.g. front office, porters, house-keeping, kitchen, restaurant, bar staff etc.

Basic pay
Women are paid on or slightly above the Wages Council rate, but nearly all the men are paid considerably more. Some part-time staff get less than the legal minimum rate.

Additional payments
Male waiting and bar staff do the same jobs as women, but get additional payments. Management may call them merit payments, but they seem to be just a way of preventing male staff from leaving.

Supervisory staff/management
Are nearly all men, even in areas like reception where the majority of the staff are women. Equally the chefs and the higher catering grades are men, though there are women in the general management and trainee management grades.

The problems for women are:

1. Lack of unionization leading to individual wage rates, a system which makes discrimination easy to carry out and difficult to spot.
 2. Low basic pay – also the result of lack of unionization.
 3. Unpaid overtime.
 4. Lack of access for women to supervisory management positions or higher-graded jobs.

6

HOW TO GET AT THE FACTS

It is not easy to get the kind of information on your own work-place that was provided for each example in the last chapter. It is very rare even for a well-organized union committee to have as much information. They would know about wage rates in general, but usually not about male/female distribution in the grades. When there are additional payments, merit, responsibility, bonus etc., they would probably not have the overall result. If you ask whether part-timers have equal access to all forms of payment and other benefits, they would not necessarily know the answer without doing some research. So this section gives some suggestions on how to find the information you need to judge whether women are getting equal pay or access to highly graded jobs. See Chapter 19 on positive action for more information on job descriptions and job segregation.

How do you find out whether you are getting equal pay?

You will need to compare your wages and your job with those of a man who is doing similar work or is on the same grade as you (see p. 26). You can do this by comparing wage slips, asking your shop steward for information, or asking the wages office.

Comparing wage slips

All wage slips must by law show gross pay, deductions and net pay.

It is gross pay you need to compare, so you can ignore the net figures.

The employer does not have to tell you what the deductions are for each time you are paid or how the total deduction is made

up, as long as you are given an annual statement setting out the details.

So your wage slip may not show how much of your pay is basic or grade rate, how much service, bonus etc. If it doesn't, your slip will tell you no more than the wage slips for two manual workers in the electronics factory, A and B in Figure 6.1. They only tell you that Fred Smith is paid more than Kathleen Jones but not how the difference arises.

Some wage slips, particularly in larger factories, are more informative. For example, wage slip C in Figure 6.1 belonging to Kathleen Jones, when compared to wage slip D, belonging to Fred Smith, shows:

1. His basic pay is £4 more than hers. Either he is on a different grade, or he has an additional payment (such as flexibility payment) consolidated into his grade rate.

2. He is earning £6 a week more on bonus.

3. He has earned eight hours' overtime this week; she has only earned two.

4. Having worked there for more than ten years he has £4 service supplement; she has none.

If you were in this position, despite the similarity of your work you would find he earns over £20 more than you. You would need to find out why your basic rate and earnings on bonus were lower. You would want to take action together with other women workers to get more pay.

Swapping pay slips is a rather hit-and-miss way of getting information. Your pay slip may not be informative enough, and even when it is it will only tell you about an individual's pay, not about women's as a group or men's as a group.

To take it further, if you are in a union ask your shop steward or staff representative for this kind of information. If she does not know, ask for it to be raised at the union committee. They will probably have to ask management for the information, if necessary bringing in a full-time union official. Point out that the union has a legal right to this kind of information (see p. 85).

If you can get no interest from the union, it may be that you do not have a staff representative or steward and need to get the women organized to elect a representative.

1. Simple wage slip

A

	Gross Pay	Company Pension	Tax	NI	Net Pay
KATHLEEN H. JONES (Mrs)	80.50	4.43	14.85	6.26	54.96

— Married woman

B

	Gross Pay	Company Pension (5½%)	Tax	NI	Net Pay
FREDk. J. SMITH	109.20	6.01	18.50	8.47	76.22

Married man No other allowances

2. Detailed wage slip

C

	Basic Pay	Bonus	Overtime	Service Increment	Gross Pay	Company Pension	Tax	NI	Net Pay
KATHLEEN H. JONES (Mrs)	60.00	16.00	4.50	—	80.50	4.43	14.85	6.26	54.96

D

	Basic Pay	Bonus	Overtime	Service Increment	Gross Pay	Company Pension	Tax	NI	Net Pay
FREDk. J. SMITH	64.00	22.00	19.20	4.00	109.20	6.01	18.50	8.47	76.22

Figure 6.1: Compare pay slips.

If you know someone in the wages office they may be able to help by explaining how your pay is made up and checking on the pay of those men who are doing a similar job to yours.

What are the legal rights to information?

The Employment Protection Act says that your employer should provide your union with the collective bargaining information it requests if, without it, the union would be hindered to 'a material extent' in bargaining and if it would be in accordance with good industrial-relations practice to disclose the information. There is an official Code of Practice, published by ACAS, which gives guidance on what kind of information your employer should disclose. It suggests that you are entitled to information which would influence the formulation, presentation or pursuance of a claim or the conclusion of an agreement. So if you need the facts on men's and women's pay in order to make an equal-pay claim, this should be the kind of information that your employer must give you.

The Code gives examples of the kinds of information which can be relevant. Under 'Pay and Benefits' it includes: 'Principles and structure of payment systems; job evaluation systems and grading criteria; earnings and hours analysed according to work group, grade, plant, *sex, outworkers and home workers*, department or division, giving where appropriate, distributions and make-up of pay showing any additions to basic rate or salary; total pay bill; details of fringe benefits and non-wage labour costs.'

Under 'Conditions of Service' the Code includes: 'Policies on recruitment, redeployment, redundancy, training, *equal opportunity*, and *promotion; appraisal systems*, health, welfare and safety matters.'

Under '*Manpower*' the Code says disclosure could include 'numbers employed analysed according to grade, department, location, age and *sex*; labour turnover; absenteeism; overtime and short-time; manning standards, planned changes in work methods, materials, equipment or organisation; available manpower plans, investment plans.'

Do not, however, go overboard and ask for all the information under the sun. The Code points out that in 'providing information the employer is not required to produce original documents for inspection or copying. Nor is he required to compile or assemble information which would entail work or expenditure out of reasonable proportion to the value of the information in the conduct of collective bargaining.'

Your shop steward or full-time official should tell the company that the union needs the information to bargain about grading structures and pay for women workers, and that the request is covered by the ACAS Code of Practice.

Most managements will give a reasonable amount of information if the union is insistent, as they do not like being accused of acting unlawfully. If an employer refuses to give information then the union can make a complaint to the Central Arbitration Committee, which, failing conciliation, can make an order for disclosure of the information.

When the banking union BIFU needed information on women's grading, tiering, and pay in the National Westminster Bank, the bank at first refused to give it. Only when BIFU threatened to use the law to force the issue did the bank become co-operative. It entered into an equal-opportunities agreement and sought to reach agreement on giving the information the union wanted.

If you are not in a union, or if your union will not help you, you only have a legal right to information if you make a claim for equal pay or about sex discrimination to an Industrial Tribunal. You can then ask your employer for the information you need to prove your case, and if it is not supplied you can ask the Tribunal to order your employer to give it to you (see p. 408).

You could also ask the Equal Opportunities Commission to investigate your situation for you. If they think your employer is in breach of the Equal Pay Act or the Sex Discrimination Act they can carry out a formal investigation.

What information will you need?

If you are just comparing yourself with men doing similar work or on the same grade, you will need to know the make-up of wages of men and women on a particular grade or job as shown in Table 6.1.

You can use this form to ask for information, amending it according to the types of payment in your workplace.

If you are looking at the wider picture of the workforce, as set out in the examples, your request for information would need to cover a wider field.

Which grades of workers should be covered?

As in the examples in Chapter 5, you would probably want to cover all manual grades if you are a manual worker, plus the supervisory grades in order to see if women are being promoted. If staff, you will want all the staff grades, certainly up to the managerial level.

Table 6.1: *Information required for an equal-pay claim*

		Average pay for GRADE: JOB:					
	Numbers	Basic Rate	Service Pay, Merit, etc.	Bonus	Shift	Overtime	Total
MEN							
WOMEN							

Which departments and locations should be covered?

In a large concern you are unlikely to want information on all workers. In a local authority, for example, to examine detailed information on all the 5,000 manual workers would be a daunting task. So limit yourself to key locations or departments, at least to start with.

Should you list grades or occupations?

In some workplaces one grade will be more or less restricted to one job, in which case listing grades will do. In other workplaces, particularly on the manual side, one grade may cover a large number of different jobs. If this is the case, information just by grade won't tell you very much about men doing jobs similar to yours, or about how far men and women are segregated into different jobs. So information on occupations within grades will be far more useful.

It may be that your employer will be very reluctant to give you this kind of information. Many employers do not keep records which show up the distribution of male/female occupations and pay in this way, so it can involve them in quite a lot of work. They may also fear that, once armed with the information, the union will press for changes in grading structures and payment systems which will be from management's point of view both expensive and disruptive.

So be ready to persist, and if all the information you want is not available, start out with a limited request and gradually build on the information you receive. Chapter 19 deals with positive action in the workplace and suggests setting up an equal-opportunity committee, one of whose tasks would be to gather this kind of information on a regular basis.

HOW PAY IS FIXED

In order to improve wages, salaries and conditions you need to know who fixes them, when and where. Some are decided at your workplace, others at company level, others at national negotiating bodies on which a number of unions and employers are represented. Even if you are not a member it may still be the union which negotiates your pay and conditions; or if your workplace is not organized and not covered by a national agreement, it may just be up to your employer to decide what you get.

What are the different ways wages and conditions are decided?

If your management 'recognizes' a union or unions at your workplace, your wages and conditions will be decided in negotiations with the union either at workplace or company level or via an employers' organization at national level. An employer 'recognizes' a union when it negotiates any terms and conditions with the union either directly or via an employers' organization.

Two thirds of all workers have their wages and conditions decided this way. They include nearly all workers in the public services and nationalized industries and most manual workers in manufacturing industries.

Even if you are not a union member your wages and conditions are decided by the union if you work in such a workplace. In the examples in Chapter 5, the typist in the polytechnic is in this situation, while the assembly worker, the packer, the dinner lady and the lecturer are all union members and have their pay and conditions decided by union negotiations.

If your management does not recognize a union, even though there may be union members at your workplace, your wages and conditions will be fixed in one of the following ways:

1. Your employer follows the pay rates and conditions set by national negotiations between employers and unions for your industry or service.

About 10 to 15 per cent of workers are in this situation. They are mainly manual workers employed by small manufacturing firms.

2. You work in an industry covered by a wages council and your employer must by law pay you at least the wages-council rates and meet other conditions such as holidays set out in the wages council's order (see p. 363 for more on wages councils).

The hotel waitress in the example in Chapter 5 is in this category.

There are about three million workers, mainly women, working in wages council industries. Some of them will be working in unionized firms and be paid a negotiated rate above the wages-council minimum.

3. You work in a non-unionized workplace not covered by a wages council and your employer just decides what he is prepared to pay. This applies mainly to small firms and staff workers.

When a union is negotiating wages, where do negotiations take place?

Negotiations can take place at:

1. National level

Representatives of the employers' association or public service employers meet national representatives of the unions recognized in the industry or service on a body usually called the National Joint Industrial Council, which decides on basic rates, holidays, hours and so on.

For example, in the food industry representatives of the employers' associations in the industry meet the officials of the GMB, TGWU, and USDAW in the Food Manufacturing Industry JIC.

White-collar local-government workers' national terms are decided by NALGO and the white-collar sections of other

unions meeting the local-authority employers at the NJC for local authorities' administrative, professional, technical and clerical services.

2. Regional level

Occasionally national rates may be topped up by the regional negotiations. This level is only important in the public-service area, where additional payments and guidelines for bonus schemes for manual workers are decided at provincial councils for local-authority manual workers.

3. Corporate level

The management of large privately owned companies (for example clearing banks and large engineering companies) and nationalized corporations negotiate at national level with a union national negotiating committee, usually led by full-time national officers. On the union side there may also be executive members, regional officials or staff representatives and shop stewards.

In private companies this would either be, an alternative to participating in national negotiations or would top up national negotiated rates and deal with additional subjects such as pensions.

Some large companies, e.g. GEC, prefer to decentralize their negotiations, leaving it to local management to negotiate with the unions at plant level.

4. Local level

This is where your management negotiates at your workplace with your union committee, sometimes with the help of the local full-time official.

When your employer and union are party to national negotiations, there may still be local negotiations to improve on nationally negotiated rates of pay or other conditions, or to cover questions not dealt with in national negotiations, such as bonus and pensions.

Workplace union committees have different names, such as shop stewards' committee or staff representative committee, but comprise representatives elected by union members in particular areas of your workplace, or covering particular grades of the workforce. If you do not have a shop steward or staff representative covering your section of the workforce, electing one is the first step to being able to take part in what goes on.

When the union committee meets the management it is usually called a joint works negotiating committee or staff negotiating committee.

Here are some examples of how negotiations take place for particular groups of workers.

1. Workers in public services

Your pay and conditions are fixed at national level by the National Joint Industrial Council (known as the Whitley Council in the civil service and the NHS). Local negotiations have in the past mainly been restricted to cover only bonus for manual workers. But although you have to look to your national negotiating body for changes in national pay rates and alterations to grading structures, your local level may be important in seeking improvements to national agreements on maternity and in negotiating on equal opportunities and positive action (see p. 319 for details of advances made in local authorities on this).

Negotiations for a workplace nursery or for flexible working hours will also be at local level. Even when a national grading structure seems to trap you into low grades, local action and pressure can produce results (see p. 99 for an example of a typist taking action).

2. Manual workers in private industry

For most manual workers in manufacturing there is a two-tier system. The NJIC settles the minimum rates at national level, but improvements on these are negotiated at local level in your own factory, and it is these local negotiations which are the most important. So you need to feed information into the union both

at your workplace and in national negotiations. Alternatively, your employer, if a large private concern, may negotiate at corporate level and not decide anything much at your workplace.

3. White-collar workers in the private sector

There are usually no national negotiations, but your employer will either negotiate at corporate level, as do the clearing banks, in which case there may be room for local improvements, or at local level in your workplace.

What happens where there is no recognized union?

When management do not recognize a union they will decide what rates to pay, sometimes consulting the workers individually or via a staff or works consultative committee. These committees are usually set up to make the process look democratic, but power and decision-making remain firmly in management hands.

In this kind of set-up one worker often does not know what another is paid. Management may encourage secrecy by giving individual workers the impression that they are being paid more than their fellows. It is easy to keep wages low and women's lowest. Your employers' wish to retain existing staff often means paying more to men in order to prevent them from leaving, and when necessary paying more to bring men in from outside. The first task of a union in this kind of situation is to collect information on what everyone is paid, and then try to establish higher and fairer wage rates.

What happens if you work in a wages-council industry?

This is dealt with in detail on p. 363. There is a legal minimum wage and conditions which your employer must comply with. Payment is policed by a wages inspectorate which can prosecute underpaying employers, but, as explained on p. 365, enforcement is patchy and prosecution rare. If you think you are being paid below the wages-council rate you can bring in the inspectorate.

How do you find out which system fixed your wages?

You should either have a written contract of employment or a statement of terms and conditions. This document should tell you how your wages are fixed by referring to any relevant national agreement. (In the examples in Chapter 5, the dinner lady's statement of terms and conditions will refer to the Local Authority (Manual Workers) NJC; the assembly worker's contract of employment will refer to the national engineering agreement; and the lecturer's contract will refer to the Burnham Committee scale for further education.) This probably will not tell you whether certain rates of pay and other conditions are decided locally. If you are in a union, your shop steward or staff representative should know what is decided where. If you are not in a union and there is no union in your workplace, as explained above, it is likely that your employer does what he wants. A local union which covers workers in your industry should be able to tell you of any relevant national agreement with which your employer should comply (see p. 364 on how to check on wages-council rates).

8

NEGOTIATING A BETTER DEAL

This chapter draws together the main areas of action which will help to raise women's wages and improve their terms and conditions of employment. Some are actions that can be negotiated in the workplace, others will need to be raised at the national negotiating body. There are some problems like overtime that need a longer-term perspective, involving national decisions and possibly legislation.

It is one thing to decide yourself what needs to be done, and another to persuade your workmates and local trade-union body that it is important; and usually it is most difficult of all to win over the employer to paying out more money or improving conditions. There is no one path to success. P. 332 deals with the importance of women being represented in the union and on the negotiating bodies. Even a full presence at the negotiating table may not result in victory.

Women have on many occasions, from the dawn of trade unionism to the present, had to take industrial action to win

better pay or upgrading. It would take a book to describe their struggles. Here are just two examples from 1981. The strike by women workers at the Lee Jeans factory at Greenock against the closure of their factory was a landmark in the fight against the fatalistic approach to factory closures and redundancies. After many months of strike action they won; the factory was reopened and jobs were saved. In Liverpool 350 local-authority typists in NALGO struck for several months for better pay, equal status with the predominantly male clerical workers, and increased day-release and promotion opportunities. In December they went back to work having won their employers' agreement to go to arbitration.

When action by the national negotiating body is necessary, it often requires a lengthy campaign to persuade your local representatives to give priority to the interests of women members, so that they in turn raise it at national level. It may be necessary to raise the question through your union branches and at your union conference. Some unions now have special committees and conferences to represent the needs of women members (see p. 337 for details).

Basic grading

Chapter 3 on unequal pay, and Chapter 6 on how to find out the facts about equal-pay implementation in your workplace, give examples of the ways in which women do not receive equal pay for equal work. The placing of women on the lowest grade varies from blatant sex discrimination to more subtle ways of keeping women in their place.

Some changes directed at dealing with this kind of misgrading are:

1. When the lowest rate is predominantly female, with a separate, predominantly male unskilled or semi-skilled grade (e.g. in the electronics factory in Chapter 5), the grades need to be merged. In almost any wages structure where women predominate in the lowest grade, elimination of the lowest grade will be a substantial advantage to women (see p. 26 for arguments on when this is required by the Equal Pay Act).

2. When canteen workers are outside the main grading structure and on a lower rate than the lowest production rate (e.g. in the electronics and food factories) they need as a minimum to be brought up to the lowest production rate. If your employer has contracted out catering or cleaning, you need to insist that the catering workers employed by contractors are not paid less than the lowest-paid directly employed production worker (see p. 31).

3. If management tries to justify the difference between the two grades by saying that there are extra elements to the male job, for example flexibility or willingness to work shifts (as, e.g., in the food factory), examine whether the additional duties are real or sham. If real they should be rewarded when carried out and women should be given equal access to them, subject to suitable safeguards, for example to ensure that no workers are forced to do work that is too heavy for them (see p. 264). If a sham, they should be exposed as such and the job descriptions etc. corrected.

4. Check that shift workers are not on a higher basic rate than day workers doing the same job (as, e.g., in the food factory). If they are, negotiate the same basic rate for day workers.

5. Where a grading system has 'female' jobs in the lowest grades there is probably a major problem of lack of access for women to higher grades. But in addition it may well be that certain jobs are wrongly graded (e.g. secretary/typist in the polytechnic). Where there is no job-evaluation scheme you will need to decide whether you can upgrade women's jobs just by negotiation or whether having a job-evaluation exercise would help (see p. 118 for details and dangers). Remember it is the jobs the women are doing that are evaluated, so if they have been denied training and access to skilled work or responsibility, then their work will be given a lower grade. You may need to improve the job before agreeing to its being evaluated.

Where there are jobs established by a job evaluation, you will need to see details of why these jobs were originally placed in their grade and go for a regrading exercise with the purpose of eliminating any sex bias. In the polytechnic example you could

ask for the secretary/typists to be assigned as personal assistants to executive officers and graded on a secretarial grade.

Secretaries themselves are usually not properly rewarded for their skills and responsibilities. They often do the work of junior or indeed senior executives without recognition.

6. What you may need is a pay increase, not a change of grading. Women are in general just not paid enough for the work they do. To see if your job is being paid less than equivalent jobs elsewhere, you will need to do some research (see p. 000 for sources of information). For example, the Labour Research *Book of Wage Rates for 1982* includes the top basic rates as at July 1982. The best-paid clerical workers were:

Clerks (*lowest grade*)	*Copy typist*		*Secretaries*	
Shell	Kodak	£95.96	Shell	
Refinery £101.19			Refinery	£114.00
Post Office £97.69	Standard		Kodak	£106.10
	Telephones £91.72			

In 1981 a Labour Research Bargaining Report showed that men doing the same kind of work did consistently better: see Table 8.1. Armed with this kind of information, you may be able to gain support for more money for the work you do.

Table 8.1: *Hourly rates, excluding overtime*

	April 1980	*March 1981*
General clerks: men	£2.43	£2.73
women	£1.94	£2.18
Typists (excluding shorthand): women	£1.87	£2.10
Telephonists: men	£2.32	£2.61
women	£1.55	£2.08

Payments for service

Incremental scales

When the incremental scale is longer at the lower end than the higher, it needs to be reduced. In the polytechnic example in Chapter 5, it takes a typist fourteen years to reach the top of her scale, while higher administrative staff (mainly male) have only three rungs. Formal changes of this kind in the poly example would have to take place at national level, which might be a lengthy process.

The Typists Charter is a NALGO group of local-authority typists. In their bulletin they complain of the national typists' scale:

It is the lowest and the longest scale in local government . . . Lower than the clerks who are not required to have our skills in grammar, spelling and typing. Once you start work on the scale you are trapped for life.

Women start work at 16, on the first point on the scale and take 14 years to reach the maximum wage of £76.73 a week. If you start work at 21, it only takes you 10 years . . . that's if you are lucky. Some women never get as far as that.

And they reported on a show of industrial muscle in a local authority:

WANDSWORTH. A local claim for improvements in typists' conditions of service was submitted in Wandsworth in February 1979. The main points of the claim were:

1. to redesignate TM Grades onto Clerical Grades spinal column point 11–21 (not inclusive of London Weighting and Salary Supplement) according to type of work and skill required.

2. to establish training facilities for typists and Clerical Grades, i.e. day-release courses, short-term courses.

3. to evaluate secretarial post to the job and not to the status of the Chief Officer involved.

The claim was adopted at a mass meeting of typists and it was agreed that stewards in the departments obtain council-wide support from other members of staff.

The response from management was rather abortive with a vague promise that the Council would review typing services sometime at the end of the summer.

This was not received favourably by the typists and at a further mass meeting it was agreed that they would implement local industrial action in support of the claim on a 3-point strategy. The first phase consisted of an immediate work to rule which involved the following duties not being undertaken: photo copying, filing, stencilling, correcting errors, in either written or audio work, overtime; working at a speed greater than 35 wpm; no cover for secretaries or supervisors.

The second phase would be a blacking of all word-processing machines, and the third would be total strike action.

When this news reached the employers a meeting between Staff Side and Management was hurriedly convened and Management undertook to carry out a review immediately – agreeing to provide training facilities and to examine the differences which existed between designated secretaries and chief officers and directors. The work to rule was continued.

It was proposed at a Joint Staff Committee meeting in July that there should be three working levels for typing staff:

On level 1 a basic copy typist with some experience to be paid on the spinal salary point 1–10.

On level 2 the more experienced typist who takes some responsibility to be paid on the spinal salary points 11–14.

On level 3 those working in a secretarial capacity providing secretarial or administrative assistance to maybe a group of offices to be paid on spinal salary 14–18.

Other secretaries would continue to be graded on an individual basis according to their particular responsibilities.

These revised pay scales would be effective from 1st April 1979.

This offer was accepted. The offer in effect removed the first bar and ensured that only a few typists would, in fact, be below bar point 11.

Incremental scales may also have 'bars' when progression ceases to be automatic and becomes dependent on the management's discretion. In colleges there was such a bar for teachers until recently, and few women progressed beyond it. The union fought successfully for its removal. The Typists Charter reports on the bars in the national typists' scale.

At point 7 on the scale (£61.44 a week) you are often required to pass a proficiency test. If you pass, you can progress as far as point 10 (£67.27

a week). This requirement to pass a test is the 'qualifications test'. Progress beyond £67.27 a week is at the discretion of the Local Authority, your employing authority.

Some Councils (such as the London Borough of Camden) impose another proficiency test at this point. Others (such as Hertsmere in Herts) exert their discretion to allow no progress at all. Typists working vari-type machines are allowed through the bar. So you can be trapped on £67.27 a week for the rest of your working life . . . unless you get another job.

All such bars are likely to be unfavourable to women and should be opposed.

Service payments

Where there are lump-sum service payments, part-timers should be eligible. If women return after a break in service, their earlier service should be taken into account.

Service payments should start after a comparatively short period, say five years. When they start after a long period (as, e.g., in the food factory, where they started after ten years) many women fail to qualify.

Bonus schemes

Nearly half of men doing manual jobs depend on some form of bonus payments to supplement their basic rates, and those on bonus receive nearly a quarter of their wages as bonus payments. Women will lag behind unless they have equal access to bonus and equal payments from bonus schemes or, if their jobs are not suitable for bonus payments, some compensatory payment.

Bonus schemes are usually offered in exchange for productivity. They can mean faster, more intensive working, with subsequent job loss, so be careful. You will need to assess your particular situation before deciding whether a bonus scheme will benefit you or not. But when the basic grade rates are acceptable to male workers because bonus payments are a substantial addition, women will lose out if they do not either benefit

equally or negotiate bonus payments in return for an improvement on basic rates. Some female workers such as school-meals assistants have been traditionally kept out of bonus schemes for no good reason except for the expense to the employer (see p. 57 for the local-authority example of this).

Whatever the form of bonus scheme, try to include as many workers as possible. Bonus schemes which only cover a small number of workers may give them high payments but are the cause of division within the workforce and are unfair to those not included.

In most modern factories output depends not just on the efforts of you and your fellow-workers but also on what is happening elsewhere. An example of this is given in the food factory on p. 63, where there is a separate bonus scheme for women in packaging although they are dependent on throughput further up the system. In a comprehensive scheme, if delay was caused further up the line they would still receive bonus for the other production which was continued. Where the other workers raised production, allowing them to earn more on bonus, the whole factory would benefit.

What should you do if you are already on bonus?

1. *Check the facts.* If you don't know how the scheme works, ask your shop steward or the shop stewards' committee. If the men's scheme is different from yours, you will need to know how theirs works as well.

2. Is your standard performance pitched higher than the male standard performance? In other words, are you expected to produce more than equivalent male workers before you move from fixed earnings on to extra bonus payments? If your standard performance is equal to the men's you would expect the average performance of the women to be roughly equal to the average performance of the men over a period of, say, two months. In checking this you would need to allow for any specific reasons, such as disruption of supplies, that could affect the results. Ask the shop stewards' committee for the figures for the average performance on your bonus scheme and any bonus scheme covering male workers. They may not have this information, but they do

have the right to obtain it from management if it is needed for negotiations (see p. 85).

3. Are you paid the same for standard performance as men doing similar work or on the same grade?

The food factory and the electronics factory give different answers to this question (see pp. 51 and 67). In the food factory women get the same for standard performance as the men, but it appears their standard performance is pitched higher than the men's. In the electronics factory they are paid less for their standard performance. Either way, if the men and women are on the same grade or doing broadly similar work, the Equal Pay Act entitles women to an equal bonus scheme (see p. 27).

4. Are you paid as much for output above standard as men?

In the electronics factory the men not only have a higher fixed bonus but also earn more for their performance per point above standard performance. As the variable bonus is often related to the amount of the fixed bonus, women can lose out in both ways.

5. If the facts reveal discrimination of this kind, press your shop steward for an urgent improvement in your bonus scheme. If your steward or shop stewards' committee is reluctant to push it, remind them that the Equal Pay Act covers bonus schemes.

What can you do if your work is not suitable for a bonus scheme?

Not all jobs are suitable for bonus payments. This is particularly so in education, the social services and the Health Service, where women may be on the same grade as male manual workers yet earn substantially less because they are not covered by a bonus scheme. It is difficult to see how a nursery assistant's job could or should be subject to measured productivity. What would be measured? The size of the class or the number of children taken to the toilet? The same difficulties arise with teachers, nurses, and residential care assistants.

Unions representing these workers, such as the GMB and NUPE, have sometimes demanded a compensatory payment (often described as a 'lead-in payment') but so far with no success.

Shifts

What can you do about shift pay?

Women may not be able to work shifts at your workplace because of the operation of the Factory Acts (see p. 253 for details of how these work and how you can apply for an exemption order). If you are working shifts you may need to improve your shift pay.

1. *Work out what your shift pay is.* It may not be easy to compare your shift pay with shift pay in other jobs or industries. Shift pay is sometimes in addition to your hourly rate or weekly pay. Sometimes it is only added for those hours worked which are regarded as unsocial (before 6 a.m. and after 8 p.m.), in other cases it is a percentage addition to the grade rate of the workers concerned. The best way to calculate your shift pay is to work out what percentage your shift pay is of your basic hourly rate over the whole shift cycle.

For example, if your basic hourly rate is £1.50 an hour and your shift pay for an eight-hour shift is £4, that is 50p an hour; so your shift pay is 33 per cent of your hourly rate.

2. Compare your shift pay with average shift pay ·for your pattern of working. Shift pay varies according to the pattern of shift and the hours of the day worked, as well as from industry to industry (see p. 43 for details of shift patterns). Generally the more unsocial the hours worked, the higher the shift pay you would expect. So you need to compare your shift pay with similar shift patterns elsewhere.

Most women working shifts are paid well below this average figure. The pay is particularly bad on those shift patterns, such as split duty and twilight shift, which are almost entirely worked by women. In the hotel example (p. 76) the waitress receives no extra payment for working a 'split roster'. In the food factory the twilight shift workers get no shift pay *and* their basic rate is lower than that of other productive workers. In the local authority the rate for split duty is 5½p per hour, whereas the rate for double day shift worked by local-authority employees such as park attendants is 16p an hour.

If you are on a split duty you will be working roughly the same proportion of unsocial hours as a worker on double day working, so you should try to get the same rate.

Hours of work

Is flexitime a good idea?

What is flexitime? Under flexitime schemes the day is divided into 'flexitime', at the start and end of the working day and at lunchtime, and the 'core times' in between when everyone *must* be at work.

For example, you might be allowed to turn up for work at any time between 7.30 a.m. and 10 a.m., have to be at work between 10 a.m. and 12 noon, be allowed to take a lunch break of between 30 minutes and 2 hours between 12 noon and 2 p.m., have to be at work between 2 p.m. and 4 p.m., then be allowed to leave at any time between 4 and 6 p.m.

There are other rules to ensure you work on average the required number of hours a week, though with many schemes you can work less in one week as long as you make it up by working more over a period. For example, you might be allowed to work less than the standard hours by a maximum of five hours in any four-week period, as long as you made it up within the next four-week period; and you might be allowed a maximum of the same number of credit hours over the same period. Some schemes allow you to use credit hours to have an extra day or half-day's leave.

Flexitime can only work where there is a system for recording the hours each member of staff works. Sometimes this is done by the workers inserting a key into a machine on arrival and taking it out on departure. Or hours can just be recorded on a sheet. Flexitime will work differently in different workplaces. Some systems of working are not suitable for flexitime, others are. But there are some common advantages and disadvantages of flexitime which it is useful to consider before deciding whether you want it introduced and what safeguards you need to seek.

What are the advantages?

Flexitime has obvious advantages for women with child-care or domestic duties to cope with. Hours can be varied to take children to school or collect them. Long lunchtimes can be taken for visits to doctors or to do the week's shopping. School holidays or other special occasions can be helped by extra time off, worked for during the less busy periods.

Workers can choose to travel outside rush hours; if the weather is extra fine you can rush off home early to sunbathe; or after a hectic party you can legitimately arrive at work an hour or so later than usual.

What are the disadvantages?

Timing of work.
All your work is strictly timed, which can be an unwelcome restriction if you have worked in a fairly relaxed office atmosphere.

Losing paid time off.
If you are not careful to write in safeguards before agreeing to a scheme, you may find that previous practices such as giving you paid time off for dentists' or doctors' appointments may go. Management may say that now your hours are flexible you can fix your appointments so as to go in your own time.

Less social life.
When everyone comes and goes at different times and has different lunch hours, some of the sociability of old office life can disappear. Instead of communal coffee and tea breaks, and lunches together, people may concentrate on clocking up their hours as fast as they can and going off home. This individual pattern of working can also make it more difficult to hold union meetings and organize workers to improve pay and conditions.

Management pressure.
If management needs a particular time of the day covered, or if a manager likes his secretary to start early or stay late, some

members of the staff may find themselves under pressure to work inconvenient hours even though the scheme is meant to produce the opposite result.

No overtime.
Very often flexitime means no paid overtime except in emergencies. Management use it to cover those early and late hours previously paid at overtime rates.

Before agreeing to any flexitime scheme make sure that all the workforce has been consulted and has considered the possible drawbacks as well as the gains. Management may come up with a scheme which could be improved. Remember there is no one flexitime arrangement. There are endless variations, so you might as well put forward counter-proposals to get the kind of scheme you want.

How can working hours be reduced?

Reducing working hours for all workers benefits women. It gives them shorter hours in the jobs they do, and by shortening the hours they would be expected to work in other jobs, it opens up new working opportunities. As hours creep down, the old distinctions between full-time and part-time work fade, and discrimination against part-timers (see p. 164) is reduced. Working hours can be reduced by reducing or eliminating overtime, shortening the basic working week, lengthening annual holidays, bringing down the retirement age, extending day release or other time off for training, and increasing maternity and paternity leave, together with parental leave for children's illnesses.

It is often said that employers cannot afford to cut hours and maintain pay rates, yet British workers have the longest working hours in Europe and one of the lowest pay rates. With growing unemployment, reducing working hours is a campaign where the interests of women coincide with the real interests of male workers, though because many men fear that a cut in hours means a cut in the weekly wage packet it is not always easy to achieve a common purpose.

Women and men may also have different preferences as to how working hours should be reduced. Women usually prefer a shorter working day so they can leave home later and get home earlier *every* day. Men prefer going to work less often and working longer spells, so they go for 3×12 or 3×10 hours rather than 5×7 or 5×6 working spells, longer holidays, more whole days off etc. Unless care is taken to work for a common approach on how hours are to be cut, job segregation can be maintained and even extended by 'male' jobs being tied to 'male' working hours that most women find inconvenient, and vice versa.

What can be done to reduce overtime working?

You need to examine why overtime is being worked in your workplace and what form it takes in order to plan how to reduce it. Here are some suggestions on possible action for different situations. Reducing overtime is never easy, as it either means a loss of earnings for workers concerned, who cannot manage on less money, or, preferably, extra expense for the employer to maintain earnings. In any campaign to reduce overtime it needs to be linked to raising the basic rate of pay if you want to win support.

1. A useful starting point is a *joint working party*. Demand that the employers agree with the level of overtime being the subject of a 'joint study' with a view to eventually limiting overtime to genuinely necessary and emergency situations.

The employer may well agree to your proposal, since a working party is cheap enough to run; but although there will be no immediate gain, the principle of reduction in overtime hours will have been won. Make sure the working party not only looks at hours of work and at the work of those currently doing overtime but also at how the male workers depend on overtime to bring their wages up to a reasonable level and how women who cannot work overtime are underpaid. In some industries, for example chemicals, cement and building materials, there are already such working parties. Press for the working party to recommend

whichever of the following actions seems most suitable for your particular situation.

2. *Employing for cover*. If the main reason for overtime working is just to cover for absences or sickness you need to press for extra workers to be employed to do this work.

3. *Industry-wide limits on overtime*. In some industries, unions and employers have agreements on an upper limit on overtime working. For example, in engineering the limit is 30 hours in four weeks, in the textile finishing industry average weekly hours in any eight weeks cannot exceed 51. These limits are quite high but may well be exceeded in many workplaces. Find out from your steward if there is a limit in your industry. If so, is it being exceeded, or could it be reduced? If there is no limit could one be negotiated? A reduction or the introduction of a working limit would need national pressure from the unions. But the initiative has to start somewhere.

4. *Introducing extra shift workers*. Where overtime is part of shift working to provide an overlap between shifts, or to cover for sickness and absences, the introduction of an extra shift crew cuts overtime and provides jobs.

Equally, if the eight-hour basic working shift has been extended by overtime to ten or twelve hours, extra crews can eliminate the need for this overtime working. It is an expensive option for the employer.

Reducing standard hours

The best way to equality is to shorten the standard working week, not lengthen the female working week where it is shorter. The TUC is committed to reducing the standard working week from 40 hours to 35 hours. In the past two years over nine million workers have already reduced their basic week by 1, 2, 2½ or 3 hours. Many other employers have promised reductions in the future. If there have been no such moves in your workplace ask the union to pursue its claim for a 35-hour week. Often this demand will need to be raised with your union at national level.

Would a law limiting hours help?

Britain is the only major country in Western Europe without legislation restricting overtime. Our laws on working hours only cover women and young persons (see p. 253).

In other European countries laws restrict overtime working on an annual, weekly or daily basis, or restrict the total hours worked. For example, West Germany only allows 30 hours' overtime a year, and two hours a week, while France restricts total hours to 50. In Denmark all overtime must be compensated for by time off in lieu. Most of these laws allow for exceptions, and in some cases the *standard week* is longer than in Britain. Because the short-term economic advantage is always to work overtime and long hours, this is an area where the law can help force long-term gains for workers. It would need to be linked to raising the basic wage and phased in with wage rises to avoid hardship.

How can you improve your sick-pay scheme?

The law requiring your employer to pay you when you are sick is described on p. 113. In addition most employees will be covered by a sick-pay scheme, usually negotiated between the employer and the trade union, which will provide for payment during sickness in some circumstances.

When you are covered by a sick-pay scheme, the terms of the scheme become part of your contract of employment, and the Equal Pay Act says your employer must give you the same benefits as a man doing like work (see p. 27).

There is little direct discrimination against women in sick-pay schemes, but many exclude part-time women, and if you work in a non-unionized workplace, as many women do, you are unlikely to be covered by a sick-pay scheme at all.

1. Exclusion of part-timers

Many schemes cut out part-timers by laying down a lower hours limit, say eighteen hours a week. If you work fewer hours you get no sick pay. Some make it as many as thirty hours a week.

You need to try to include all part-timers in a sick-pay scheme, or, as a minimum demand, lower the threshold to as few hours a week as possible.

2. *Less favourable terms for part-timers*

Part-time workers are sometimes discriminated against in other ways, such as needing longer service to qualify, or having to wait more days off sick before being paid. They do not always get full pro rata pay.

3. *Requirement to work the day before going sick*

Some schemes only pay if you are at work the day before you go off sick. This can exclude part-time workers who do not work every day.

4. *Qualifying service*

(*i*) *To qualify at all*
Most schemes give you some sick pay as long as you have been working for your employer for at least six months. Most staff schemes allow you to qualify at once. But a few schemes still insist on long periods of qualifying service of up to five years. This makes it particularly difficult for women to qualify, and should be opposed.

(*ii*) *To qualify for maximum payment*
Many schemes, particularly manual, require long periods of qualifying service before you are entitled to maximum payment, and sometimes service as a part-timer does not count.

Over half of manual schemes require more than five years' service, which again makes it difficult for women to achieve the highest payment.

5. *Pregnancy*

Many schemes exclude pregnancy-related illnesses with clauses such as: 'Disability caused by or attributed to pregnancy (includ-

ing resultant childbirth, abortion or miscarriage) or any condition which results from pregnancy.'

The Labour Research Department's 'Sick Pay Guide' comments:

> Employers aim in clauses like this either to discourage women employees from getting pregnant, or to discourage female employment altogether. Failing both, it is a disgraceful attempt to penalise women whose pregnancies develop complications while they are still employed. It is a matter for negotiations whether this problem is dealt with in maternity agreements or sick pay schemes. The aim, either way, must be to make sure the 'exclusion list' does not include pregnancy.

Exclusions including pregnancy and related illnesses have now been found to be against the Equal Pay Act (see p. 208).

6. *Sick relatives*

Some of the best schemes give paid time off to look after sick relatives, including children. For example, the Imperial Tobacco scheme says:

> In cases where a wife, husband, or dependent relative, whom the employee is the only person capable of attending, is ill, and it is necessary for the employee to be in attendance at home, sick pay will be granted where the employee obtains a doctor's statement to the effect that it is essential for the employee to be absent from work to nurse or care for his or her dependants. For cases not covered by such a statement, employees will be allowed up to 5 days leave in any 12 month period with pay. Any days in excess of 5 will be unpaid.

Ten or fifteen days' paid leave is given in some national schemes or agreements, and sometimes there is an extended period of unpaid leave to nurse sick relatives. Local negotiations have extended the period of paid leave to twenty days in some cases.

If you can get your employer to agree to similar clauses it is a real step forward for employed mothers in particular, who at present often have to pretend to be ill themselves in order to stay at home to look after sick children.

7. Medical appointments

Most staff workers get paid time off for doctors' and dentists' visits when they are necessary in work time, but many manual schemes say that workers will not be paid. Many working women neglect their own health needs through lack of time, and they really benefit if these visits can be included. Visits for postnatal check-ups should be included either in the sick-pay scheme or in the maternity agreement (see p. 213).

Some sick-pay schemes or maternity agreements give paid leave for attendance for cervical or breast cancer screening. It is important that women are allowed to take time off for these visits, and any other attendance at health clinics, including visits for contraception and to 'well-woman' clinics.

When negotiating a better sick-pay scheme with your employer, remind him that any condition which discriminates against women even indirectly is normally contrary to the Equal Pay Act (see p. 171 on the Jenkins *v.* Kingsgate decision for details).

Employers' Statutory Sick Pay (*ESSP*)

From April 1983 employers must by law pay sick pay for the first eight weeks of absence in each tax year. National Insurance sickness benefit is only paid for sickness after the first eight weeks. Employers reclaim the full amount of sick pay from the government.

The amount of ESSP for 1983–4 is as follows:

Normal weekly earnings	Weekly rate of ESSP
Less than £32.50 (LEL)	–
£32.50 to £48.50	£40.25
£48.50 to £65	£33.75
£65 or more	£40.25

'LEL' is the lower earnings limit, or the level of weekly earnings at which National Insurance contributions become payable.

Tax and National Insurance contributions are deducted from payments, and there is no increase for dependants.

Payment is not dependent on National Insurance contribution record, so married women who pay the reduced contribution will receive ESSP.

All part-time workers qualify as long as their earnings are above the LEL.

You are entitled to ESSP from your first day at work but it is paid only on the fourth day off sick (the first three days are treated as waiting days). Days off sick count for ESSP and as waiting days only if they are 'qualifying days': these are usually all those days on which you normally work (e.g. Monday to Friday), but if you work varying hours or days you have to agree qualifying days with your employer. So a part-time worker working an average of three days per week could have qualifying days of Monday, Tuesday, and Wednesday every week regardless of whether she actually always worked those days.

You remain fully entitled to sick pay under your employer's sick-pay scheme to 'top up' ESSP or when you have received your eight weeks' entitlement.

Sources of information

(See pp. 419 for addresses not given here.)

Labour Research Department. Provides comprehensive information on pay and conditions.

Trades Union Congress. 'Women Workers Bulletin' and other reports available.

Industrial Relations Review and Report, 67 Maygrove Road, London NW6. Useful publications, but expensive.

Incomes Data Services, 140 Great Portland Street, London W1. Useful publications, but expensive.

Department of Employment. 'Employment Gazette' (monthly) and 'New Earnings Survey' (annually).

JOB EVALUATION AND SEX BIAS

Traditionally, rates of pay for particular jobs are decided by a whole number of factors such as skill, length of training required, organizational strength of the group of workers concerned, their class background, labour supply and demand for certain jobs, and whether employers are doing well or otherwise.

Highly paid professionals, predominantly white males, such as doctors, accountants, lawyers and university professors, have used some of these factors to keep their position at the top of the tree. White-collar employees, again overwhelmingly male, such as bank managers, top civil servants, administrators and business executives, have also achieved top earnings. Among manual workers, certain skilled male occupations from pit workers to electricians have organized themselves to win relatively high pay.

As it is not job content alone which determines pay levels, the earnings league is always changing. Miners' pay has been up, down and up again; so has civil servants'. Skilled engineering workers such as tool-makers and fitters were once at the top and have now fallen several places. Teachers, who used to be paid well above the average, now complain that those of their ex-pupils who find a job are paid more than them. As micro-technology loses some of its mystery, pay rates for the more mundane computer operators are drifting downwards. Market conditions and bargaining power are at least as important as job content, training and responsibility in deciding who gets paid what.

Women on the whole carry out jobs which are considered to have little skill and often do not need lengthy formal training. Even when they do, as with nursing, the pay does not reflect it. Skills such as typing have not been recognized in pay rewards. Women are less likely to be highly organized in a union or professional organization, and when they are members they are often not able to use their organization to achieve and maintain higher rates of pay. When their employer is doing well it usually leads to high profits rather than high wages.

So the traditional methods of deciding rates of pay have not worked in women's favour. Is job evaluation any better? Does it allow women to assert that their jobs are equivalent in terms of skill, responsibility, training requirements and efforts to that required for higher-paid male jobs?

What is job evaluation?

Job-evaluation schemes describe the content of each job, and place the various jobs in an agreed ranking order. It does not produce a scientific result where each job is paid according to its objective value.

There are three main stages:

1. Drawing up job descriptions showing the content of each job.

2. Assessing the value of each job and placing the jobs in an agreed order. This is the evaluation part of the process.

3. Placing the jobs in groups or grades.

Deciding what the content of each job is may be objective, but deciding which job is most valuable is not really an objective exercise. How do you decide the value of a high degree of skill against unpleasant or dirty conditions, or having a boring or repetitive or fiddly job, or working unsocial hours, or always having to be pleasant and obliging even when customers or the boss are rude and unreasonable.

Having skill and responsibility and putting up with unpleasant working conditions are all of value to the firm; all are necessary for the end product or service. Which is rewarded most does not depend on a scientific view but on what is seen as fair by the management. If the scheme is jointly run with the union, then the outcome will have to be agreed as fair by both. On the whole people think that the fair outcome is one which does not disturb the *status quo* too much. It must lead to wage rates that are not significantly lower than the rates for the same job elsewhere, or no one would do them. Neither would any employers be willing to pay rates much higher than those paid elsewhere.

Why is job evaluation used?

Job evaluation is usually introduced by management to produce changes they want. Certain jobs may be paid too highly, others at too low a rate, which makes replacement difficult. Job evaluation may persuade workers and trade unions that changes are objectively necessary and not just the result of arbitrary management decisions.

Job evaluation results in more orderly, consistent and open wage structures. Before job evaluation there may be no set wage rates or grades for particular jobs at all, but just individual rates for individual jobs. One worker may not know what the next worker is paid or why one is getting more or less than another. Or there may be set wage rates for most workers but with a minority on individual rates and dissatisfaction with differentials. Under a job-evaluation scheme, it should be the job which is evaluated, not the worker, so once the rating system has been established it should be equally applied to all workers. All workers

will normally have a job description and an explanation of the value attributed to various aspects of their job which has resulted in their being placed on a particular grade. For job evaluation to have this beneficial effect it is necessary that it is conducted openly and the system and results explained to the workforce. This is by no means always the case.

If you do know what tasks your job covers, why it is considered to be worth a certain amount, who is paid more or less than you and why, that is in itself an advance on secretive, haphazard methods of payment. If you do not agree with the result, at least the information may be available to allow you to challenge the evaluation of your job.

Do unions always agree with job evaluation?

Many trade unionists are very suspicious of job evaluation as they see it as a management technique which robs their shop stewards or staff representatives of the right to negotiate rates of pay according to well-established traditions. They probably either have experienced or fear complicated systems of job evaluation carried out by 'experts' assessing job contents, imposing values according to a system not fully understood, and upsetting hard-fought-for differentials. If management try to introduce job evaluation without full consultation and agreement such reactions may well prevent it.

Sometimes a job-evaluation exercise which involves workers in drawing up job descriptions and discussing their worth can lead to unexpected results. The famous strike for upgrading by women making seat covers at the Ford Motor Company in 1968, which is a landmark in the campaign for equal pay, followed a job-evaluation scheme by Urwick Orr.

Should job evaluation be run jointly by management and union?

When trade unions agree to job evaluation some seek full involvement in every stage of the evaluation. Others prefer to stay completely outside and leave their representatives free to

negotiate about the results. On occasions, trade unions may wish to be involved in some aspects but not others.

Most schemes will have steering committees which agree on the kind of scheme, how it is to be operated and other policy questions.

Then there are evaluation panels which do the actual assessment.

Finally there are the bodies who hear appeals and deal with the ongoing maintenance of the scheme (see p. 131).

If there is to be any trade-union involvement, it is better to be fully represented by having an equal number of seats on the joint steering committee; otherwise the important decisions which shape the eventual outcome will already have been taken.

There may be advantages in not having trade-union representatives involved in the actual evaluation process. Some trade unionists do not want to be too deeply involved because they fear it will make it difficult for them to represent members who are dissatisfied with the scheme. They may allow the evaluation to proceed under management control and then seek to negotiate any changes they want, or just negotiate the pay rates to be attached to the new grades. Alternatively the trade union may agree that worker representatives shall be drawn from the workforce to serve on the evaluation committee, but not as union representatives. This leaves the union representatives free to negotiate after the scheme has been completed.

Participation by union or worker representatives may not really mean joint control. Management usually brings in outside experts employed by management consultancies. Their schemes often seem very complicated and are explained in a jargon which can intimidate and mystify. While appearing to allow everyone to make their own decisions they can easily steer the results in a particular direction. The danger is that workers or union representatives who participate do not equally determine the outcome but feel that they do and so defend the results even when they are not always in other workers' best interests. Trade-union representatives need to be trained in job evaluation generally, so that they can argue for the kind of scheme which will suit

their workplace best. Trade-union courses cover job evaluation (see p. 345 for details).

Management briefs consultants on the difficulties it wants job evaluation to solve and how much money it can afford to spend. Consultants need to produce the goods, as it is management that pays them. So the union also needs to have a view of what outcome is desirable and understand the need to design a scheme to produce the broad results required. To minimize the risk of manipulation, if unions are going to participate in the evaluation, they need to be involved from beginning to end and to make sure that those participating are thoroughly trained in the scheme so they really understand how it operates.

What is in job evaluation for women?

Job evaluation was often used to implement the Equal Pay Act, and generally resulted in larger increases for women than merely placing them within a unisex grading structure with no attempt to evaluate their jobs (see p. 25 for more on how the Equal Pay Act was implemented).

Negotiations can achieve as good or better results than job evaluation, but more often than not negotiators have not been sufficiently concerned to raise female rates beyond the legal minimum required under the Equal Pay Act. If you have had equal pay introduced without a job-evaluation scheme, it is therefore worthwhile looking to see how a job-evaluation scheme might help you achieve higher rates of pay. Job evaluation never guarantees a good result for women. It all depends on the particular scheme and how it is operated. It can be a way to start a discussion about women's pay rates, as it involves explaining and justifying differentials. When women are discontented they may be able to use the opportunity to organize for their work to be accorded a higher value.

Job evaluation cannot solve problems except by providing a more open payment system for those jobs that women do, which may make it easier for them to argue for upgrading. Where women are employed in less skilled and less demanding work than men, it will not result in an even spread of women through-

out the grades. But there may well be certain 'women's' jobs that have been undervalued in the past and where significant upgrading can be won.

The key to making job evaluation work for women is understanding it from the start and being sufficiently organized and represented to ensure it is your tool, not just management's or male workers' (see p. 128 for safeguards for women).

What different forms of job evaluation are there?

There are different methods of carrying out job evaluation. They have in common an objective of examining the job and not the worker. The fact that Mary does her job as a typist well and Joan is an appalling telephonist should make no difference to the value attributed to the typist's job as against the telephonist's.

Here is a brief description of the common kinds of job-evaluation schemes.

1. Job ranking

This is the simplest kind; it does not evaluate jobs according to their content but just places them in an acceptable order. The different jobs are listed and then placed in their order according to their importance. For example, if you have a cleaner, toolmaker, machine minder, fitter and general labourer, they might be put in this order:

1. Toolmaker
2. Fitter
3. Machine minder
4. General labourer
5. Cleaner

If this was agreed, then the cleaner would be paid less than the labourer. But there would be no rational explanation for this outcome except that it was what the people who did the ranking thought was fair.

2. Paired comparison

There are variations on this method, such as whole job 'paired comparisons'. Each job is compared as a whole with each other in turn and points (0, 1 or 2) awarded by each evaluator according to whether she/he thinks its overall importance is judged to be less than, equal to or more than the other. Points awarded for each job are then totalled and a ranking order produced.

Job ranking and paired comparisons are described as 'non-analytical', as they compare whole jobs without breaking them down into tasks and responsibilities and scoring the different components. Comparing one whole job with another whole job, with no attempt at an objective standard of value, is most prone to reproduce traditional views of which jobs are most important. The E O C Guide describes these schemes as 'particularly prone to sex discrimination', and women would do well to avoid them when possible. They produce what is described as a 'felt fair' ranking order. This means that those who do the evaluating *feel* the result is fair, which is not surprising as it is the result of their decisions. To make sure the results are acceptable to the workforce the evaluation committee includes a high proportion of workers, and those running the scheme work at a 'high consensus', that is, as many people as possible agreeing to the ranking of a particular job.

In this context it can be very difficult to achieve upgrading of 'women's jobs'. Workers as well as management, some women as well as men, start with traditional views of a worth of a job. The value of analytical job-evaluation schemes is that to some extent at least they challenge those traditions by comparing actual job content, detailed according to its different components.

In job ranking and paired comparison it is very difficult to challenge the ranking of your job. If you say you don't agree you are likely to be told that 'all the assessors rank your job this way and you are asking for special favours'. The end result may be that women's jobs remain in their former low-ranking position. Furthermore, since this position now represents the choice of both the workforce and the management, any further change is increasingly difficult to achieve.

As well as being non-analytical, these schemes are also described as non-quantitative, because although they say that one job is worth more than another they do not say how much more. This makes it difficult to make rational decisions when it comes to grading and deciding on pay.

. 3. Job classification (*sometimes known as 'grade level description'*)

This method is used widely for office workers in the public sector, such as local authority staff. While other schemes start by looking at the content of each job and trying to evaluate them, placing them in order, and then separating them out in grades, this method starts by constructing a number of grades, describing the requirements of each grade, and then fits existing jobs into the structure.

An example of a simple job-classification system for typing jobs is as follows:

Grade	Job summary
1	Typing straightforward documents by simple copying from a clear manuscript. (35 w.p.m.)
2	Typing documents from material derived from a number of sources, tabulating and laying out work neatly, typing statements which necessitate some special skills such as may be needed for the preparation of masters for duplication. (45 w.p.m.)
3	Typing documents about technical matters which necessitate tabulation and careful layout, including working from corrected drafts to produce complicated statements of work and figures in finished form. (50 w.p.m.)
4	Typing by transcription from recorded speech or shorthand all forms of statements.
5	Private secretarial work of a limited character for an executive director of a small group of typists (say six).

The descriptions of the grades can downgrade women's work by specifying a 'male' element such as a technical or numeracy qualification or a task in a higher grade than an equivalent 'female' element, such as the understanding of her boss's work and responsibility involved in many secretarial jobs, which may be ignored completely (see p. 133). Women's skills are more likely to be learnt on the job; men more often have formal educational qualifications. This is one way in which, under a job classification that ignores the different skill levels required by women, female jobs may be placed in a few low grades, while men benefit from educational qualifications being a requirement of different and higher grades.

Classification systems can be more complicated than the example. Some sophisticated schemes incorporate many of the aspects of the points-rating scheme described opposite.

A simple scheme has the disadvantage of no real investigation into work content, while a more complicated scheme may work well for women if the points made below in relation to the points plan and the checklist are borne in mind.

4. Factor comparison

This method is not commonly used. 'Benchmark jobs' are chosen: that is, jobs taken as key jobs, with well-established rates of pay which are not in dispute. (Benchmark jobs can be used in any scheme.) These jobs are placed in their ranking order, and rates of pay are then established for all of them. The jobs are analysed according to factors such as mental requirements, physical requirements, responsibility, working conditions and skills. The rates of pay are then distributed between the different factors. Other jobs are then analysed, rated according to their factors and slotted in. The scheme is difficult to operate and difficult to apply. As it starts with accepting the rates of pay of key jobs and merely slots others in, it is difficult to upgrade women's jobs.

5. Points rating

This scheme is widely used, and most trade unions prefer it as the most systematic and open method. There are various forms of points rating, and some consultancies such as Urwick Orr have an adaptation called the profile method.

A point scheme can be tailor-made in outline for a particular workplace. Using detailed job descriptions, jobs are broken down into a number of factors called 'characteristics' by Urwick. The factors chosen will depend on the kind of jobs and their demands. Common main factors are skill, effort, responsibility, conditions. They may be further divided into sub-factors as follows:

Weighting	*Main factors*	*Sub-factors*
(49%)	Skill	a) Education
		b) Experience
		c) Initiative
(15%)	Effort	a) Physical demand
		b) Mental or visual demand
(25%)	Responsibility	a) For equipment or process
		b) For materials or products
		c) For safety of others
		d) For work of others
(11%)	Job conditions	a) Working conditions
		b) Hazards

Values then have to be attached to the factors, and those values subdivided among sub-factors. So in the example above, where skill is 49 per cent of the total, that 49 per cent may be subdivided so that education is 50 per cent, experience 30 per cent and initiative 20 per cent.

Each job is then marked according to an agreed score, often one to four levels for each factor and sub-factor: very high, high, moderate and basic.

Another adaptation of the points-rating system is the Hays

MSL scheme, which covers many white-collar employees and managers. Jobs are described in terms of accountability (results obtained), know-how (knowledge and experience) and problem-solving (the amount of thought required). Each of these main factors is subdivided and valued. Jobs are then compared to market rates for salaries for outside jobs. Because of the concentration on mental processes used in the job it is inclined to measure individual performance, and this may lead to sex bias when women are rated as less decisive, analytical, creative etc. – all highly subjective judgements.

The comparison with outside rates is also likely to work against women when they are in traditional female jobs or in

Table 9.1: *An example of discriminatory job factors*

Factors*	Maintenance fitter	Company nurse
Skill		
Experience in job	10	1
Training	5	7
Responsibility		
For money	0	0
For equipment and machinery	8	3
For safety	3	6
For work done by others	3	0
Effort		
Lifting requirement	4	2
Strength required	7	2
Sustained physical effort	5	1
Conditions		
Physical environment	6	0
Working position	6	0
Hazards	7	0
TOTAL	64	22

* Each factor is scored on a scale from 1 to 10. For simplicity no weights have been applied.

female sectors where rates elsewhere are low (see p. 373 on the need to compare skill for skill and use male comparisons for 'female' jobs).

It is important to understand that there are no set factors, sub-factors or weighting systems, though some systems are commonly used in much the same way. In each workplace or industry, factors are decided upon and values attributed in order to produce an acceptable result. If, when the scheme is tried out, it produces high-ranking jobs which in everyone else's view should be low-ranking, or vice versa, then the scheme is altered to produce another result. The marking system can be very complicated. Computers are often used to produce the final results. It is very important that you and your representatives understand it.

What factors are chosen and the scores given to them are crucial. If 'male' factors such as physical strength are scored high and 'female' elements such as dexterity or attention to detail are ignored or scored low, then obviously women will do badly.

Tables 9.1 and 9.2, from the E O C Guide, give clear examples of discriminatory job factors and how they could be corrected.

Table 9.2: *An example of less-biased job evaluation factors*

Factors*	Maintenance fitter	Company nurse
Basic knowledge	6	8
Complexity of task	6	7
Training	5	7
Responsibility for people	3	8
Responsibility for materials and equipment	8	6
Mental effort	5	6
Visual attention	6	6
Physical activity	8	5
Working conditions	6	1
TOTAL	53	54

* Each factor is scored on a scale from 1 to 10. For simplicity no weights have been applied.

The rating system in Table 9.1 is discriminatory because it contains many aspects of the male job and very few characteristics which relate to the female job. Moreover, some of the characteristics which relate to the male job are duplicated – for example, 'Strength required' duplicates to some extent 'Sustained physical effort' – with the result that a high score on one would very frequently be associated with a high score on the other. The same is true of 'Lifting requirement' and 'Strength required'. Note that the difference in scores on the factor 'Experience in job' completely outweighs the more significant difference in the factor 'Training'.

In the examples in Tables 9.1 and 9.2, the factors have not been weighted. Make sure that a male bias does not creep back in when weighting is decided upon. To avoid discrimination, neither very high weights nor very low should be given to factors which are the characteristics of jobs done predominantly by men or women.

What should you look for in a job-evaluation scheme?

1. Representation on the committees

Make sure that the committees deciding on the scheme and weighting the jobs include women representatives of the jobs that need to be upgraded, and try to ensure that upgrading of these jobs is accepted as necessary by other union representatives and if possible management.

2. Understanding the scheme

You or your representative must really understand how the scheme works. You should have training on it from the management or the consultants, and independent training from a trade union is also an advantage. Management should agree to paid time off for training. Make sure the need to avoid sex discrimination is raised in your training sessions. Circulate the EOC booklet to management and members of the committee (see p. 134).

3. Communicating the system

The scheme should be fully explained to the workforce at each stage. Every worker should not only be entitled to see her/his job-description ranking and how it is worked out but should also be allowed this information on other workers whose work is similar (see p. 85 on obtaining information).

4. Selecting benchmark jobs

Benchmark jobs (see p. 124) and their characteristics usually decide the factors, sub-factors and weighting used, and they form the structure of the ranking order; so they should include representatives from female jobs, and the ranking of those jobs should be watched with care to ensure a fair result for those jobs and others which follow.

5. Job descriptions

Most schemes depend on each job having a detailed job description. Where there are a number of people doing the same job, a representative job holder completes a job description, which then covers all the others.

A job is marked and then ranked according to the duties, responsibilities, skill and experience written down in the job description. Women sometimes do badly because they do not describe their job to the full or because they undersell the attributes they need to fulfil it. Take great care that you or your representative complete a full job description, leaving nothing out.

It helps if job descriptions are all written to an agreed detailed format and if each job holder is given notes of guidance telling them what information they should put down and the factors and sub-factors that will be used in the scheme.

If there are male employees doing similar jobs, see what their job descriptions say before you sign yours, and check to see you haven't left something out which they have put in. Also check

that their job descriptions do not include notional duties or requirements which they do not fulfil in practice, e.g. flexibility, willingness to work nights, deputize for foremen etc. If these remain unchallenged they may end up on a higher grade because of them. You will want them either deleted or added to your job description.

6. Job titles

In workplaces where both men and women perform what is in practice an identical job, one may still find the customary differentiation of the sexes appearing in the use of different job titles. For example:

Male job title	Female job title
Salesman	Shop assistant
Assistant manager	Manager's assistant
Technician	Operator

Titles such as these at the top of a job description will immediately suggest to the evaluation committee a picture of the work of a job which may not truly reflect its content. Try to make sure that if a job title may prejudice fair evaluation it is omitted or the same title is used for both male and female jobs.

Factors used

When a points assessment system is used, the choice of factors and sub-factors is very important (see p. 127).

Scores and weighting

Different score systems are used to mark jobs, and then variable weighting is applied to produce an acceptable result. The EOC Guide advises that 'deciding what these weights shall be is a highly subjective process, and it is easy for sex discrimination to appear in a job evaluation procedure as a result of discriminatory weighting being applied to the factors'.

What the evaluated rate covers

The new rate of pay arising from job evaluation should be the basic rate and not include payment for overtime or shift work. So whether or not men work overtime or shift should not affect their grading. Equally it will not affect bonus rates, piece rates or productivity payments, unless it is part of the deal that these are consolidated into the basic rate. You want to watch for comparable men restoring differentials by increasing these elements in their wage packet.

Dividing jobs into grades

After ranking of jobs is completed, management alone, or management and unions, decide where the grade lines should be. Job-evaluation experts often advise them. They could divide one grade from another just at the point where your job is. If your job gets 79 points and the men doing similar jobs are given 81 points, you will not get equal pay. If the grade line is at 78, you will.

There is no automatic right answer as to where grade lines should be. It is for management and union to decide. The fairest way is to look for a natural break in the ranking order, where one job is separated from another not just by a few marks, but where there is quite a gap.

Try to avoid any decision which cuts you off from similar male jobs ranked very slightly higher than yours, as this can be a backdoor way to re-introducing 'male' and 'female' grades.

Appeals and regrading

There should be a system of appeals for those dissatisfied with their original ranking, and regrading for those who say their job content has changed significantly. Sometimes a powerful group of male workers dissatisfied with the outcome of the exercise can use one or other to leap-frog into the grade above. Watch the outcome of appeals and regrading among comparable male

workers to prevent the re-emergence of differentials between you and them.

Red circles

It is often agreed before a scheme is implemented that individuals whose new grade has a lower rate of pay than their existing rate should have a 'personally protected rate' or be 'red-circled'. This means they keep their former rate of pay, which is either frozen to allow the new grade rate to catch up, or goes up more slowly than the general increase, or goes up in line with the general rate of increase. In the first two situations the red circle is temporary; in the last it will continue as long as the person concerned has that job. Any new person coming in will go on to the new lower rate. Sometimes the use of red circles can mean that, although the job-evaluation exercise has said that your job is of equal value to that of comparable men, you are still paid a lower rate than them because they are 'red-circled'. This may well be contrary to the Equal Pay Act (see p. 395).

Can you use a job evaluation if your firm never implements the result?

Sometimes a job-evaluation exercise when completed does not please management or union or the workforce and so is not used. But it may have resulted in certain women's jobs being evaluated as equal to certain male jobs where the male job holders are on a higher rate of pay. In this situation, even though it has not been implemented, the women concerned can use it to claim equal pay under the Equal Pay Act (see p. 394).

Can anyone but an 'expert' improve a job-evaluation scheme?

Do not be overawed by the jargon. With common sense and application you should be able to deal with the problems. Here is an example.

The job-evaluation scheme (a points factor system) for white-

collar workers in a London borough decided on the following main factors:

Education
Experience
Supervisory responsibility
Decisions made
Supervision received
Work complexity
Responsibility for assets
Contacts
Creative work and reports

A woman trade-union representative made the following criticisms of how the scheme would affect women employees.

1. As a ranking order of jobs was decided on first and factors and points decided afterwards, the *status quo* was preserved. Jobs that were traditionally considered to be undemanding or not highly skilled, such as typing, shorthand, switchboard operating, were still given points which confirmed their present low-ranking position. No chance was given for arguing that these jobs needed upgrading to reflect how taxing, skilled and technically demanding they are.

2. *Supervisory responsibility* only gave points for supervising employees. So the female social workers who supervised voluntary workers, old people, mentally and physically handicapped people, with all the special skills this involves, would get no points.

3. Level 2 under *Education* required among other things the ability to carry out routine calculations (including decimals and fractions). This would act as a bar to many typists, secretaries and telephonists. The ability to do decimals and fractions was not necessary for the jobs concerned, could not be carried out by many more highly qualified persons, and was not even required for higher levels.

4. *Decisions made.* Many secretaries 'hold the fort' while the boss is away. They in fact make important decisions, but it seemed unlikely that they would score well, as decision-making was not formally part of their job.

5. *Supervision received*. Level 1 said 'under constant supervision, work and performance constantly checked'. Such supervision may be unnecessarily inflicted on competent experienced clerical staff by supervisors with too little to do. This would restrict them to low marks under this heading.

6. *Work complexity*. Again, most clerical staff would receive low marks. The skill of the audio typist in producing well-laid-out work from a badly dictated tape was unlikely to be recognized. Points would not be given either for boredom caused by repetitive tasks or simple routines, nor for the skill and concentration necessary to function well in noisy, sometimes crowded typing pools or switchboard areas.

7. *Contacts*. Switchboard staff and receptionists are front-line contact with people of every level of importance and difficulty. It seemed doubtful whether this kind of contact would count.

8. *Creative work and reports*. Many typists and secretaries turn scrappy drafts into well-presented reports. Would their contribution be recognized?

Many of her points were accepted.

Sources of information

Job Evaluation Schemes Free of Sex Bias, Equal Opportunities Commission (free).

Job Evaluation, ACAS (free).

Mike Burns, *Understanding Job Evaluation*, IPM, 1978 (£6.50).

George Thomason, *Personnel Manager's Guide to Job Evaluation*, IPM, 1968.

Keith Scott, *Office Job Evaluation*, IAM, 1976 (members: £5.50, non-members; £7).

Ray Edwards and Stuart Paul, *Job Evaluation: A Guide for Trade Unionists*, APEX, 1978 (£2.50).

Job Evaluation: A Practical Guide for Managers, BIM, 1970 (£5).

E. Jacques, *Time Span Handbook* Heinemann, 1964 (£1.50).

T. Paterson, *Job Evaluation* (Volumes 1 and 2), Business Books, 1972.

Job Evaluation and Merit Rating, TUC, 1969.

J. Walker Morris, *Principles and Practice of Job Evaluation*, Heinemann, 1973 (£2).

A. Bowey, *Handbook of Salary and Wage Systems* (Chapters 5, 7, 15), Gower Press, 1975 (£11.25).

J. Doulton and D. Hay, *Managerial and Professional Staff Grading*, Allen & Unwin, 1969 (£1.05).

Deirdre Gill, *Job Evaluation in Practice*, IPM, 1976 (£6.50).

'Job Evaluation without Sex Discrimination', *Personnel Management*, Vol. 11, No. 2, February 1979, IPM (£1.10).

Irene Innes, *Job Evaluation*, Industrial Society, 1973 (£1.75).

Bryan Livy, *Job Evaluation: A Critical Review*, Allen & Unwin, 1979 (£5.25).

10
JOB SEGREGATION

Jobs are highly segregated between men and women, and, far from the barriers breaking down since the turn of the century, in some ways they have become more difficult to cross. There are more 'male' jobs and fewer women working in them. At the same time there is a tendency for more men to work in female jobs. This is likely to increase during a period of male unemployment.

As a recent Equal Opportunities Commission study explained, 'Men do not apply for women-only jobs, mainly because they are boring or ill-paid: women do not apply for men-only jobs mainly because they know they lack the necessary skill or training'.

The same study looked at what job segregation meant in individual workplaces and concluded that:

65 per cent of all jobs in an individual workplace are still single-sex jobs with no or very few members of the other sex.

21 per cent of all women work in totally segregated jobs with no men at all.

45 per cent of all men work in jobs where there are no women at all.

Only 17 per cent of all jobs are 'truly integrated' in that they have proportions lower than three quarters either of men or of women.

What do men and women do?

From a woman's point of view it might not matter that men had a greater range of jobs and that women were herded into a comparatively small number of jobs, if the jobs women did were equally rewarding and rewarded. This has never been so, and there is no sign of change in this direction.

Within each occupational group women tend to be over-

represented in the less-skilled, lower-status or lower-paid jobs, while men are over-represented in the highly skilled and managerial jobs. For example, 72 per cent of packers, labellers and related workers are women, while 84 per cent of warehousemen and storekeepers are men; 85 per cent of winders and reelers are women, while 93.5 per cent of textile dyers are men. Fifty-seven per cent of paper product makers are women, while 97.3 per cent of compositors are men.

Since the Sex Discrimination Act came into force in 1975, it has had no discernible impact. Figure 10.1 shows where women work and their increase and decrease since 1975. There is an increasing not declining trend for women to be at the bottom of the pay and skill ladder. This is true not just of unskilled jobs but also of upper administrative and managerial jobs.

Over two million women work as typists, secretaries, maids, nurses, canteen assistants and sewing machinists. The majority of restaurateurs, cooks, kitchen hands, bar staff, cleaners, hairdressers, laundry workers, clothing makers, waiting staff and housekeepers are also women. A major characteristic of jobs which are almost exclusively female is their similarity to the work which women do unpaid in the home.

Secretarial work is not strictly in this category, but the ancillary, wifely functions of many female office workers certainly are.

What are the results of job segregation?

Job segregation can lead to women's jobs falling into lower pay and lower skill ratings even when objectively they are worth more. Men are in a stronger bargaining position, they bargain for pay systems which yield the most money, and they push for their work to be rated as skilled.

For example, skill for skill a manufacturing firm may regard both an electrician and a good shorthand typist as being roughly equal. But the typist will earn less. The electrician's basic rate will be about £1.10 to £1.20 higher than the typist's. In addition, the electrician will have access to bonus, overtime and shift pay. A shorthand typist will work fewer hours than the electrician but

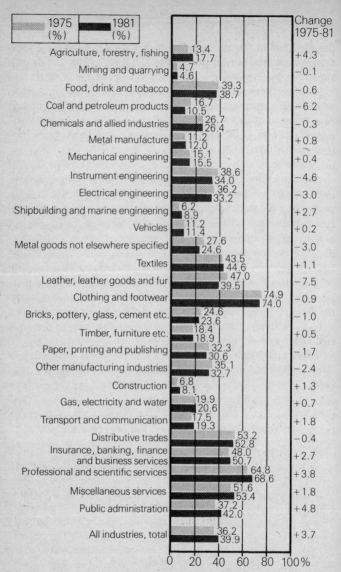

Figure 10.1: Women as a percentage of the industrial labour force 1975 and 1981. *Source: New Earnings Survey* 1975, 1981.

have little chance to improve on her basic salary. In almost any factory, all the electricians will be male and all the shorthand typists will be female.

It is true that women have been denied access to most skilled manual jobs. But in addition the skills of the jobs they do are often under-rated. Being graded as more skilled need not necessarily be because of any real differences in the kind of work undertaken, the kind of machinery worked, or the kind of manual skills required.

The skill rating of male and female jobs in the packaging industry is an example. Paper boxes are produced by women working on hand-fed machines, and the work is paid as unskilled labour. Both men and women produce paper cartons by a more automated process which is rated as semi-skilled. So the work done by women only, which if anything is more skilled, is rated lower than the work done by men and women.

Many male manual workers are also excluded from skilled jobs and can face almost equal problems of access to them if they have not served an apprenticeship. But female exclusion is more complete and is growing. In 1911 women performed 24 per cent of all manual jobs classified as skilled. By 1971 the figure had fallen to 13½ per cent.

The craft barriers and the apprenticeship system need to be overhauled to rid them of age bars, and other facets of sex discrimination. Positive action should be taken to open up craft training to women (see p. 281 for more on training and p. 301 on proposals for positive action).

Are some jobs just more suited to men or women?

If women or employers are asked why men or women do certain jobs, their replies will not vary much. Women's lack of skill and manual strength will rank high against them in male manual jobs, and for male white-collar jobs, women's lack of apparent ambition or of qualifications, and their inability to be mobile or work long hours will be counted against them. For jobs where no objective reason can be given, other excuses are found, such as tradition or the employers' view that women would not be

interested in applying in the first place. Women will often say that they never apply if they know they will not be accepted. When it comes to women's jobs, it will be the low pay and the boring, monotonous, fiddly nature of the work that will be said to put men off, plus, in areas like nursery nursing, lack of aptitude.

A research project into employers' attitudes in early 1979 found that in all but one industry employers gave women's lack of physical strength as the dominant reason for their exclusion. In most industries it was said to comprise over 80 per cent of the reasons. As the report said:

> It is very difficult to know whether physical strength is a real barrier or an imaginary constraint. While men may on average be physically stronger than women, there are many women who are physically stronger than weaker males.

A member of this research team, writing in *Employment Gazette* (November 1980), concluded that women would not be considered for 20 per cent of 'men-only' jobs and are thought not to have an equal chance in 29 per cent.

Action on a wide front is needed. Women are dominant in a quarter of the occupations, men in the remainder, not primarily because of women's inherent lack of capability to do men's jobs or even their special skills at female jobs, but because most women's role in domestic labour and child rearing has, through a historical process, effectively barred them from most male jobs. This exclusion is perpetuated by most women's continuing domestic role, involving a two-stage employment life and key years spent either outside the labour market or taking only a tenuous part-time role in it, and this 'feminine' working pattern colours employers' expectations of all women, despite any individual woman's plans.

This division between men's and women's jobs has little to do with individual choice and aptitude but is deeply rooted in both the organization of our domestic and child-rearing arrangements and the organization of our production and labour markets, so that heavy involvement in the former makes access to rewarding jobs in the latter exceedingly difficult.

11
WHY WOMEN DON'T HAVE CAREERS

What are career patterns?

Many woman do not think in terms of a career. They are satisfied if they get what is considered to be a 'good' job, and in time they look around for something better. When they are young, decisions about marriage and children loom larger than work, and often it is only when childbirth is over that women find the time and concentration to plan a future career at all.

It is true that 'careers' in the conventional sense are also an unknown phenomenon to many, probably most, men, particularly those in manual jobs, where segregation into skilled or unskilled work takes place at a very early age. The decision to be an apprentice, the key to a skilled manual job, has to be taken at the latest by eighteen, usually at sixteen, and thereafter changes in jobs are primarily horizontal, not promotional.

Where careers are possible, promotion is overwhelmingly a male prerogative, and the result is that industry and services are run by men if not wholly for men. In most concerns of any size there will be a recognizable career path. People (usually men) who get to the top will usually have been recruited at a certain level or in a certain job, with certain qualifications, may have gone through some in-service training, and will have worked in certain key 'development' posts. They will either have had a continuous career in the one concern or been recruited at a higher level already earmarked as a potential high flyer, or been brought in to a top job because of their management or specialist experience outside. In order to get their top job they will have to have been ambitious, and supported in their ambition by those who make decisions. They will also have probably worked long hours and been prepared to move as and when required. They will have to have been serviced at home. Obviously many people, including nearly all women, are unable to fulfil one and often many of these requirements.

Overt discrimination may only be a minor reason for women's under-attainment. Employers apparently committed to equal opportunities will not in practice promote their women employees while career expectations are a pattern built round male lives. What a study of *Women in the BBC* describes as 'years of benign neglect', which in the BBC left a legacy of few women, not just at the top but even at middle-management level, is sufficient to avoid discernible change.

This chapter takes a look at the kind of obstacles women have to cross to climb career ladders. How can the ladders be modified to suit lady climbers, and when should women who want better jobs adapt to present requirements?

Use of the word 'career' can itself arouse hostility. Perhaps women should not be interested in 'careers' at all. Is the very notion an inherently elitist element of the male hierarchies that women should have no part in? The difficulty with that approach is that in any society there are jobs with more responsibility and interest and rewards than others. At present those jobs are by and large reserved for one sex. They are often also the preserve of the better-off and the better-educated. If access to women was opened up, many of the blocks to other under-privileged groups would also be removed. As long as the career paths are widened, extra routes added, present barriers removed, elitism should be reduced. If on the other hand all that happens is that a few women are taught to tread the hitherto male road, leaving the majority of their sisters behind, little will have been gained.

How can you find out about career paths?

More often than not career patterns are not spelt out to new recruits, particularly if they are female. You hear about training that is offered, and promotion may be mentioned. But crucial information, such as whether your job is one which gives you any access to better jobs or is a dead end, what qualifications and working experience are required for promotion to certain jobs, the age at which you are expected to attain certain levels, and so on, is often only found out through the grapevine. This in itself may be difficult for women to tap.

You can certainly ask these kind of questions, either on interview or after you have started. Traditionally trade unions have not involved themselves directly in promotion, but your union may be able to help. Union officials' view of their job is usually to negotiate good terms and conditions for their members already in post, and to block the recruitment of unqualified personnel, or members of other unions, to their members' jobs. Unions may interfere if management changes promotion practices by, for example, recruiting to top jobs or technical posts from outside, thus threatening their own members' promotional possibilities.

The lack of trade-union involvement in opportunities for women to progress is gradually changing. For example, BIFU has published material detailing the apparently discriminatory career paths in the clearing banks. The ACTT's study *Patterns of Discrimination* (1974) looks in depth at the career opportunities for women technicians in film and television. NALGO has done a survey of its members to gather information on female promotion patterns. NATFHE has prepared guidance on interviewing procedures and gathered information on how its female members are treated (see p. 340). The civil service unions and broadcasting staff unions are now all involved in this field. So it is worth approaching your union for help.

The kind of questions you will need to ask will depend on your workplace. See p. 305 for the information you will need.

To plot typical career patterns, it helps to trace the background of present top-job holders and find out from management what qualifications and experience they demand. Written job descriptions, advertisements, instructions to interviewers, may assist.

Studies in career patterns usually depend on in-depth interviews to illuminate not only the obvious bars to most women, such as inadequate formal qualifications, but also the informal barriers and prejudiced assumptions which exclude women. In the absence of an outside research project or an internal positive-action programme (see p. 301), you are unlikely to have formal access to such information or the resources to conduct such a study. If you have the union behind you, meetings of

women (and men) and the use of questionnaires may help. Finding out about the attitudes of the personnel department, who select, individual supervisors, who appraise and recommend, and top managers, who set the tone, will also be of key importance. Placing their views on record without formal access may be difficult, though in some cases their prejudices may be all too evident.

What kind of career patterns are there?

Typical career paths take root in organizations over a long period of time. They may be formal and explicit, or less formal but accepted. Career patterns nearly always assume a forty-year continuous career, though not necessarily with the same concern. The average woman's absence from the labour market is her biggest handicap, but it is not her only one, and the significance of this absence is vastly exaggerated by managements.

To climb career ladders, ambition often has to show itself early. Young men may start part-time study or in-service training immediately after leaving school or college. Women often wake up to career opportunities later in life. Initial promotion to first-line supervision will take place for men in their mid-thirties. By then they will have completed their initial examinations or qualifications. There may then follow a period of essential work experience, often requiring geographical mobility.

Having an individual career path does not necessarily mean working for the same employer. Both men and women change jobs frequently, women's job mobility rate being slightly higher.

Percentage changing employers in previous year

	Males	Females
1973	14	18
1976	9	12
1979	11	13

In many cases men get promotion by applying for jobs elsewhere. They may stick to the same industry or service, hopping from local authority to local authority, or engineering firm to

engineering firm, or they may switch around, using previous administrative or managerial experience to sell themselves in a different field. Most concerns will recruit from outside as much as internally, though in some cases certain posts are usually filled from internal promotees.

While our career man is building up the essential prerequisites and experience and confidence for his future career, his equivalent woman has just given up her job entirely to rear children, or is nervously biting her nails wondering how long she can delay motherhood without her womb withering through disuse.

If she has decided to continue working through her child-bearing years, she is likely to be working part-time. If full-time she is most unlikely to be able to do more than hang on to her job by her fingernails, hoping to survive until her children are partly self-sufficient and not be totally submerged by fatigue and her domestic workload. It is possible she is among the very few women whose children are cared for equally by their father. This acceptance of their humanity is growing among our males, but it is still far too much of a rarity to be a significant factor affecting women's job prospects.

Of course not all women have children, but assumptions about women's career prospects, aptitudes, and ambitions are built around those who do. Those who don't still have to battle with preconceptions about their future and face the isolation of being among the very few who break through the female career plateau.

By his mid-thirties, after twelve to seventeen years' continuous service on a career path, our successful male could expect to achieve management status. Further promotion would depend on exceptional devotion to duty, hard work, and possibly buttering up the right people. Our woman meanwhile is emerging into daylight. Her children are at school, she has twenty-five to thirty years of working life ahead of her. She will be very lucky to find an employer who will recognize that her maturity, balance and organizational skills developed during her years at home or her earlier work experience have any relevance. Re-entry schemes for women are still exceedingly rare. National Westminster Bank has just started one.

The civil service, local authorities, universities, polytechnics, all employers with comparatively progressive attitudes towards women employees, have no such schemes formally. Among large private employers they are exceedingly rare.

The writers of the BBC study reported that:

Among women in industry whom we interviewed there was a consensus of opinion that one of the reasons that so few women managers or scientists returned to work in the two companies was that the employers presented them with an 'all or nothing' alternative. If they wanted to stay at work, and certainly if they wanted to be promoted, they had to continue to work in exactly the same way as they had before they had the baby. The twin demands of work and family in a competitive atmosphere were thought to be too great for most women, who usually left when they had babies.

If women have managed to remain in part-time work while rearing children this is sufficient in industry to end their promotional chances. Any step sideways from line management is seen as the end of the promotion line. Even in more apparently progressive employment areas such as the BBC, civil service and local authorities, any lengthy period of part-time work is a serious hurdle to future prospects.

What particular problems do women face?

Here are some of the common bars to women's job prospects.

1. Pre-entry qualifications

Some jobs require qualifications which women by and large do not have. An obvious example is an apprenticeship, the passport to a skilled manual job. While they are technically open to both girls and boys, in practice very few girls are encouraged to take one up, and if they do their chances of being taken on and surviving the course as often the only girl are comparatively slim (see p. 282). Though this is changing somewhat, progress is slow. It would assist if the age bar of eighteen was lifted; apprenticeships should be open to people of any age (see p. 286 for more on this).

In graduate recruitment a company may specify the need for particular degrees which few women have. The degree may or may not help in the job. For example, the study by the Ashridge Management College pointed out that in an office services division of a multinational organization supplying a wide range of products, including films, paper, and chemicals, graduate recruits with a science or mathematics degree were preferred. The qualification was not necessary for the job but excluded many women. They also found that a chemical marketing company advertising for senior staff specified technical qualifications and/or experience. When it came to selection these qualifications were not considered essential, and non-technically qualified men were appointed. Many women, though, would have been put off applying.

Even when there are no formal pre-entry qualifications, the lack of technical or scientific qualifications can be a serious handicap to later progression and flexibility. The ACTT study of women technicians in films and television found that before a girl left school she had her employment possibilities considerably reduced by not doing science or technology. This is compounded by the difficulty of subsequently finding an employer prepared to give her a job entitling her to day release for OND engineering, technology or City and Guilds exams. Lack of these qualifications makes women who then get a job in films or television under-confident and under-qualified to benefit from what technical training courses are offered. Women must break through this lifelong exclusion from technical know-how by demanding special training provision at later ages than is considered the norm. The Thames TV Positive Action Projects Report made provision of this kind of training for women one of its key recommendations (see p. 317).

2. Initial placing

Women may be recruited into lower-graded jobs than men with equivalent qualifications or women-only jobs with no promotion prospects. Typists and secretaries are obvious examples of workers with no career prospects, but jobs which from the outside

might appear exciting and promising can prove little better. The ACTT study pointed out that personal assistants, a typical female job, were 'just glorified secretaries', which is why they could never become floor managers and/or directors. The female jobs in the laboratories of positive examining and assembly work got no further than first-line supervisory grade of chargehand positive examiner or chargehand negative cutter. In contrast, a labour-relations manager of a television company said that 'none of our post boys stay post boys for more than two years, after that they move into editing or camera or sound'.

Clearing banks recruit boys and girls with O levels and A levels. But girls are more often recruited with O levels than boys, some with fewer subjects under their belt than boys. In the bank studied by Ashridge, three times as many boys had A levels than girls, while one quarter of the girls did not have the right O-level qualifications to take the bankers' exams. From the start, therefore, girls were placed in lower grades than boys, and this sexual division continued throughout their working life, helped on by women's lower expectations and their slower progression through the grades. Even when boys and girls had equivalent qualifications, girls generally started on a lower grade than boys.

Ashridge found that a tobacco manufacturing company recruited most women into junior jobs, which often did not lead to the range of experience necessary for promotion. Direct recruitment at higher levels in the department was predominantly achieved by men in some jobs such as journey representatives; and for district sales managers this was exclusively the case.

So the level at which you are recruited and the kind of post you enter are both of key importance. Even when working for an employer who might be expected to allow you to progress, you may be trapped. The BBC study found considerable resentment among women graduates who had believed that opportunities to move from secretarial work into production or training schemes were greater than they were. What opportunities there were appeared to be diminishing rather than increasing. The Association of Broadcasting Staffs reported: 'Even if a woman

applied for a training course which could be the prelude to a production career, she would be unlikely to succeed because her present job would probably be of low status'.

The authors of the report concluded that a woman might do better increasing her experience in a higher-status job outside the BBC and then applying for a training scheme or another post in the BBC.

3. In-service training

The reasons why women generally find it more difficult to progress in their jobs than men also lead to their obtaining less in-service training. In general they enter jobs at lower levels with fewer qualifications and less ambition. Less is expected of them. What training they are offered, e.g. day-release or TOPS courses in secretarial and clerical work and hairdressing, is likely to channel them into female jobs. Lack of scientific, technical or mathematical qualifications will make technical training difficult.

In banks, the important exams are the Institute of Bankers'. Ashridge found no girls taking them in the branches of a major clearing bank that they visited. A manufacturing company offered career-appraisal systems which identified training schemes. But in order to benefit, interviewees needed to be articulate, able to think clearly about their career and the route to achievement. Women in general were less likely to fulfil these criteria. Society's assumptions about their role, which is not challenged by schools career services, resulted in their being less clear in their own minds where they were going, and therefore they were less successful in getting the training requested. In this company, the more junior staff, data-preparation operators and progress clerks, who were all women, were less aware that there were any training opportunities at all.

There has been increasing awareness of the degree to which women lose out on training opportunities. Some industrial training boards have now special schemes for women (see p. 293), though they are little more than oases in the desert.

4. Age bars

The mere requirement to obtain qualifications or achieve pro-
motion by a certain age is a disadvantage to women in general.
Child bearing and child rearing, together with an early lack of
ambition and uncertainty as to where they are going, mean
women are likely to start their careers later and have them sub-
ject to interruptions. So age requirements, such as being under
eighteen to start an apprenticeship, or under thirty to train as
a factory inspector, exclude many women from opportunities
properly theirs. In a test case under the Sex Discrimination Act
a civil servant, Belinda Price, established that it was unlawful
indirect discrimination against women to have an age bar of
twenty-eight to entry to the executive officer grade of the civil
service. As a result, late in 1979 the civil service revised the age
limit for the executive officers' entry competition to forty-five
years of age, and commenced a review and consultations with
the staff side of the union on the very sizeable list of other
recruitment age limits. How far this process will go is not yet
certain.

If there are any such age bars for external recruitment, inter-
nal transfer or promotion, or access to training in your work-
place, use the Belinda Price case to argue that as well as being
undesirable such age bars are probably unlawful and should be
removed.

Informal age bars and discrimination against older women
wishing to re-enter jobs may be even more of a problem. The
expectation that you will have achieved the jumping-off level for
top jobs by your mid-thirties means that women returning to
work or full-time work in a junior grade at that age are handi-
capped in their future prospects.

The BIFU report on *Equal Opportunities in National West-
minster Bank Ltd* said 'The Bank operates a closed career struc-
ture which is age related and so all training is geared to age and
there are difficulties in escaping the system'. A conscious deci-
sion to set up alternative expectations needs to be fed into the
system. Those responsible for recruitment, career appraisals,

and promotion need to look kindly beyond bright young men to intelligent mature women.

THOROUGHLY MOBILE MILLY

5. Mobility and hours

Many career paths and rewarding, better-paid jobs require the ability to be geographically mobile or to work long or flexible hours. Women with child-care responsibilities are forced off track. Other women may be reluctant to place jobs before their private lives and social commitments; they may often be right, and some men may feel the same.

Yet sometimes expectations that women are not prepared to move or be available for the hours the job requires may unnecessarily exclude them.

Mobility may be seen as a decisive test in the career development of married women, and it may be assumed that they are all immobile. When Ashridge interviewed women supervisors and managers, many of them were willing to move, though a

common response was that their ability to do so would depend on whether or not their husband could get work in the area. With two-wage families becoming the norm, this is increasingly true of the male response too.

When bank employees were surveyed on their response to job offers which involved travelling further to work and/or moving house, the level of acceptance among women was always less than among men, but the difference was less for women in London than women in rural areas, where no doubt attitudes and practicalities militate against it. Clearing banks are one class of employer where willingness to move at short notice to any part of the country is a condition of service even for the most junior grades. Whether or not this is so in other organizations will depend on the organization and the career pattern involved. When an organization is spread geographically it is likely to look for high mobility. Many organizations expect their managerial staff to be willing to move house if required on promotion. According to the Ashridge study, in one such company investigation showed that some employees were promoted to regional director without moving, and mobility did not seem essential to the organization; but nevertheless a willingness to move still enhanced career prospects.

This illustrates that the requirement to move imposed in order to fill senior posts with experienced staff may in fact be unnecessary to the organization. If mobility is a problem in your company, you can argue for career progression to be planned on a regional rather than a national basis and point out that this would be to the advantage of your management in increasing the pool of prospective promotees by adding both women and also those men who need to consider their wives' jobs or their children's education.

If the difficulty is long or flexible hours then other solutions need to be sought. Often the hours can be split between two people (see p. 177 for more information on job sharing), or extra shifts or rotas can be brought in to reduce them. Where flexible hours are required, there is often no reason why some of the work could not be done at home. The *Women in Top Jobs* study found that this solution had been adopted for some married

women in senior positions in the civil service, who obtained
agreement from their superiors and colleagues that they should
leave early to be home with their children at tea-time, taking
any necessary work with them.

How important are attitudes?

Moving from one job to another requires initiative on the part
of the woman, and recognition of her potential on the part of
management. So both her state of mind and what is expected of
her are important and are emphasized in all studies on the
subject.

While women are less likely to identify their career needs early
on, it is not because they do not want better, more interesting
jobs, and this is true of shop-floor workers as well as their non-
manual sisters.

A study commissioned by the Clothing and Allied Products
Industry Training Board into aspirations of female shop-floor
workers found that nearly half would accept promotion if
offered; one in five would like to become skilled or be a super-
visor or manager; and most of them were willing to undergo
training, not only within the factory but also in a day-release or
evening class or on a one-week course. The minority who did
not want promotion or training were more likely to be older and
have husbands who would disapprove. Many of them blamed
managers' attitudes for their lack of opportunities. The women
did not just work for money. Most of them said they would go
to work even if they could afford not to; they rated interesting
work and friendliness before high earnings. When asked
what kind of jobs they were looking for, 'female' jobs such as
looking after children or hairdressing topped the popularity
stakes.

But these women would not normally be asked if they wanted
training or promotion, and indeed this survey did not provide
them with the opportunities they were seeking.

Career counselling or appraisal may be common coinage
among managements but it is almost always restricted to white-
collar staff. This study concluded that while managers express

a desire to see shop-floor workers ask for promotion and personal development, the workers generally felt unable to come forward in this way. 'They do not know what will happen if they do.'

Where there is formal career appraisal, women may fare little better. Some systems are openly biased against women. The Ashridge inquiry into the clearing bank found that when a tutor came to talk to recruits about taking the Institute of Bankers' examinations the encouragement given to men and women varied enormously.

During the induction course the tutor talked to the boys for half an hour about the exam. They were told to find their nearest college and get started. She ignored the girls, we were made to feel we weren't there . . . [Woman clerical]

Continuous encouragement is given to the boys to take the examinations, not much is said to the girls. They go on the terminal course and then settle to typing jobs or feeding forms to the computer. [Male clerical]

The stereotyped view of women in the bank was that they would all marry and then subsequently leave and have children. Women, it was thought, were not career-motivated, would not take examinations and did not warrant an investment as long-term management material. This was overwhelmingly the male view but also that of the senior women. 'Girls are not interested in careers. They are more interested in the contents of their deep freeze.'

Those senior women who did make it suffered isolation from other female colleagues and met practical difficulties, for instance in joining certain clubs in their communities and in penetrating the inner circle of businessmen, which are also experienced by professional women such as architects. Perhaps this isolation was one reason for their lack of support for younger women.

It may be that, in general, women's ambitions are different from men's. The BBC study found women less single-minded and ambitious than men, particularly at the start of their career. One senior woman producer said:

Having got a good job satisfies women as a thing in itself, rather than being a top person. I had been prepared to settle for where I was as long as people told me I was good at it. Many negative reasons forced me along. I was the first one through the net with a whole generation of girls behind me, and I felt responsible . . .

This view of women was also a conclusion of the *Women in Top Jobs* survey. But the authors of the BBC study did not conclude that this explained women's absence from the top ranks. Besides the practical barriers described earlier, male prejudice lurked in the undergrowth.

A lot of men are simply more comfortable having other men around. When I went to [a male-dominated department] it was very strange. They were so unused to women that they behaved in an almost courtly manner.

And there is the very common attitude that women can get to the top as long as they behave like men:

I see no reason why women can't do the top job. *But* you can't expect a young woman to be able to join an organisation and say 'I want a career which will give me a chance to be director general *and* give me a chance to have one baby or more and expect to come back and continue like a man . . . It would be grossly unfair to the organisation and to males.

The Ashridge survey found that managers often had a 'kindly protective attitude' to women about their 'real' interests and abilities and the types of work to which they are most suited. These attitudes made sure that women were channelled into traditionally female areas.

So women's under-confidence and lack of assertiveness can interact with male overt prejudice or paternalism to limit their advancement.

The *Management Development Programme for Women in the Textile Industry* also points out the difficulties for women in sex role stereotyping.

The image of a successful leader is a person who is aggressive, forceful, competitive, achievement-oriented, self-confident and independent. These traits tend to be more often associated with men than with women:

women are generally depicted as emotional, passive, dependent, nurturing, intuitive and submissive. Thus a woman manager finds herself in a double bind: if she displays the culturally defined trait of a woman, she is rejected as a manager; if she acts according to the male defined role of leader she is condemned as unfeminine.

The writers of this programme pointed to evidence which showed that while men stressed the need for planning not only career goals but also the methods of obtaining them, women worked hard and awaited the rewards of virtue. For women to move out of this passive attitude to their career planning they recommended 'assertiveness' training.

How can you prepare for an interview?

Many women feel they have been discriminated against in interviews for a job or promotion. Sometimes it is the sort of questions asked: 'Do you have children or intend to have them?' 'How will they be looked after?' 'What is your husband's attitude?' Or there may be off-putting descriptions of the job itself, emphasizing elements which might discourage you such as heavy lifting, carrying, climbing, travelling, getting dirty, breaking fingernails, overtime, or having to stay late to finish a job. If you apply for a job with a supervisory element it may be assumed that you would have more difficulty exerting authority than a

man, or if the job involves any technical know-how that you would not have the necessary knowledge and would be unable to learn.

Or, far from the questions annoying you, it may be the lack of them which is worrying. Men disappear into the interview room for thirty minutes, you were in and out in five. The lack of interest in your application seems obvious.

If you anticipate this kind of treatment there are certain steps you can take to prepare for the interview which may help, though if your interviewers really have closed minds you are on a loser already.

Most women undersell themselves, their qualifications, experience, and ability. On any written application for a job make sure you put in everything which may help, and prepare to emphasize it at the interview. Show confidence, even if you don't feel it. Most of us can do much more than we ever have the opportunity to find out. Work out how you will respond if asked questions about husbands, children, child-care etc. It would probably do no harm to point out calmly to your interviewers that whether or not you will have children and how you look after them is your own affair but they can rest assured it will not interfere with your job and you hope they will not be taking these matters into account because you are female, as this would be unlawful under the Sex Discrimination Act (see p. 404 for cases on this). Put them on the defensive by asking for an assurance that they are an equal-opportunity employer, and ask whether they are seeking to give their women employees equal opportunities.

In case interviewers try to put you off by emphasizing 'male' elements of the work, do your homework about the job before you go in. Find out what it actually involves, so you know whether they are exaggerating and can let them have your information by suggesting to them what the job actually involves. Ask what criteria they have for selection and then deal with each point in turn, pointing out your previous experience, abilities, qualifications etc. Make sure that they have all the information they need to assess you properly. If they seem doubtful of your physical strength or your administrative or supervisory abilities,

and if a medical report or a reference from your previous employer or previous head of department might help, offer to obtain these and ask them to defer a decision until they have seen them.

In case you are faced with a lack of questions, prepare to do some talking yourself, explaining why you want the job and why you think you can do it. Most interviews include the question 'Is there anything you want to ask us?' Be prepared for this by thinking of a few questions about job content, terms and conditions, training, or further prospects. If they do not ask it, ask your questions anyway. You can make a note of the answers, just as they make a note of what you say. This will show you are methodical, and if the job involves any administration or written reporting it may help to indicate your capabilities.

If after the interview you still feel it likely that they will discriminate against you, make a full note straightaway, recording exactly what occurred and what was said. This will be invaluable in raising the matter with your union and if necessary in making a legal complaint under the Sex Discrimination Act (see p. 408).

If you are not successful in your application and feel the decision is discriminatory, see Chapter 23 for how to make a legal complaint. If you are already in post and applying for promotion, raise the question with your union representative if you are a union member. You should have a grievance procedure. The first stage would normally be to raise the question with your immediate supervisor, then to call in your union representative. But in a matter like this, which will usually already have involved higher management in the interview process, it would be best to seek union support before raising it with management. If you are right in your suspicions, it is likely that other women will have had the same experience. A joint complaint is far more likely to carry weight, so try to find out if this is so. It will also help to have information on the comparative success rate of men and women applying for the job in question or similar jobs (see p. 305 for more on what information you might seek and p. 301 for positive action proposals). Even if you are not in post or a member of the union, the union may help you if you contact

them and give the reasons why you consider you have been discriminated against.

If raising this issue in the workplace yields no satisfactory result, you may want to consider taking it to an Industrial Tribunal. (See p. 408 for details of how to do this.) There is a three months' time limit after the refusal of a job within which your application must be received by an Industrial Tribunal, so bear this in mind.

Does the Sex Discrimination Act help to break down career barriers?

The Sex Discrimination Act, which came into effect in December 1975, made it unlawful for anyone to discriminate against you because of your sex or in the employment field because you are married. The areas covered are employment, including training bodies and trade unions, education, goods, facilities and services. The Act established the Equal Opportunities Commission and gave it powers to review equal opportunities generally and enforce the Act by helping individuals, carrying out investigations, issuing non-discrimination notices and, where there is persistent discrimination, obtaining injunctions against the discriminator.

What is meant by discrimination?

The Act covers both direct and indirect discrimination. If, because you are a woman, you are treated less favourably than a man has been, or than a man in your circumstances would be, you have been directly discriminated against. An employer who offers certain jobs only to men or who offers jobs to men at a higher rate of pay or with better conditions is directly discriminating against women.

If you are treated in an identical way to the way a man is or would be treated in your circumstances, you may still be indirectly discriminated against. It is indirect discrimination if:

1. There is a requirement or condition which applies or would be applied equally to a man;

2. A considerably smaller proportion of women than men can comply with the requirement or condition;

3. The discriminator cannot show it is justifiable to impose the requirement or condition on both sexes;

4. The woman can show it is to her detriment because she cannot comply with it.

The Belinda Price case is one of the few successful cases against indirect discrimination. The requirement or condition was that applicants for the executive officer grade in the Civil Service had to be under twenty-eight. A considerably smaller proportion of women could comply with it because most women drop out of full-time employment on having their first child and return to work full-time when they are over twenty-eight. The Civil Service could not justify it, as they could not show it was the only method of achieving an executive grade with a necessary proportion of younger recruits. Belinda Price could show it was to her detriment because she had left work to have her child and as a result was over twenty-eight when she applied for the job.

Although there have not been many cases of indirect discrimination brought to tribunals, it is an important concept aiming at employment practices which may not have been designed to exclude or discriminate against women but which have had that effect. Age bars and requirements of continuity or length of service could all be indirectly discriminatory unless they could be shown to be necessary for the job in question. Requirements for technical or scientific qualifications or for working experience in a male area which were not necessary for the job could also be found to be unlawful.

Denying part-time workers equal treatment in, for example, training opportunities or promotion will nearly always be indirect discrimination against women, as the overwhelming majority of part-time workers are women (see p. 169).

It is unlawful for an employer to discriminate directly or indirectly against you because you are married, but not because you are single. It is also unlawful if an employer discriminates against women because they have children. Any general policy which rests on an assumption that mothers are a bad employ-

ment risk is unlawful discrimination. An employer must look at each individual on her merits and not jump to conclusions because of her parental responsibilities.

Discriminatory treatment is unlawful in recruitment, arrangements for offering employment, interviews, job offers, or refusal to offer a job, promotion, transfer and training. If the job has fringe benefits which are not part of your contract of employment but 'concessionary', such as some free travel facilities, or loans for house purchase, these are also covered by the Sex Discrimination Act. If such benefits are contractual, discrimination is dealt with under the Equal Pay Act (see p. 389).

So if management indulges in discrimination in any of these areas you can certainly point out that it is unlawful and there is a legal sanction. Your employer is held ultimately responsible for the acts of individual managers or supervisors and consequently for any acts of discrimination that they may have committed in the course of their employment, albeit without his knowledge or authorization. If only out of self-interest, your employer should train all management personnel in their responsibilities to act in a non-discriminatory way. Nor can management get off the hook by saying that it is pressure from the workforce or a trade union that caused the discrimination. It remains unlawful for employers to give in to such pressure (see p. 402 for an example of this). Trade unions are themselves covered by the Sex Discrimination Act, and if they discriminate any member of the union can bring a legal claim against them (see p. 405).

There are many workplaces where bars to women's progress can be shown to be indirectly discriminatory in that in practice they exclude most women from access to a position, training, promotion etc. For example, employers are often not able to show that formal qualifications for a particular post, an age limit on training facilities or denying part-time workers access to higher-graded jobs are necessary, or that no other non-discriminatory method could be used to obtain the same objective.

When you identify barriers to women in your workplace, see if points 1 to 4 on p. 160 apply. Ask management what reasons

they put forward for applying the requirement or condition. Then consider whether the reasons are valid in so far as they show why the requirement or condition is necessary for these particular jobs or benefits. If you are satisfied you can show the reasons to be invalid, then do so, point by point. If you think there is something in them, you may still be able to suggest another non-discriminatory method to achieve the same objective. In the Belinda Price case the reason was age balance in the executive officer grade, but it was shown that a rigid age bar was not the only way to obtain younger recruits.

The reasons for specifying formal qualifications for a job would normally be to achieve a suitable standard of work. However, the qualifications may not relate to the work actually done, and even if they do, then other tests, or a chance for in-post employees to train, may quite possibly be able to achieve the same objective. Part-timers may be excluded from more responsible posts because management consider that full-time cover is essential. But job sharing or other working arrangements may be able to provide satisfactory cover.

When these arguments are marshalled they can be used in negotiations with management. You will have both positive proposals about what can be done and the threat that if they do not take action you may have the law on your side.

As the whole idea of indirect discrimination is not well understood by trade unionists, you may well have some persuading to do among your union colleagues (see p. 303 for suggestions about equal-opportunity committees).

P. 396 deals with the Sex Discrimination Act in more detail and explains how if you fail to sort out the problem in your workplace you can take complaints to Industrial Tribunals.

Chapter 19 on positive action looks at the organizational changes which can help to overcome all these barriers and the difficulties women face, and shows how to move towards taking positive steps for women's advancement. Make the necessary breakthrough for women. It is not sufficient to treat them like men, though in those organizations that still firmly channel

women into inferior jobs and keep them there, that would be an advance; a breakthrough must be made to plan working life for women. That is what positive action is about.

Sources of information

Employee potential – if used in the development of women, Ashridge Management College. IPM (£17.50).

Patterns of Discrimination against Women in the Film and Television Industries, Association of Cinematograph and Television Technicians, 1974.

N. Fogarty, Isobel Allen, Patricia Walters, *Women in Top Jobs 1968–1979*, Heinemann Educational Books, 1981 (£14).

Management Development Programme for Women in the Textile Industry, Manpower Services Commission, January 1981.

The Aspirations of Female Shopfloor Workers, Clothing and Allied Products Industry Training Board, 1979 (free).

Equal Opportunities in National Westminster Bank Ltd, BIFU, 1980.

12

WORKING PART-TIME

Introduction

We part-timers are treated as though we are some form of industrial leper, often poorly paid and always expendable in a redundancy situation. I feel outraged and shabby. It makes you feel different to everyone else. [Brenda Clarke, a part-time worker declared redundant by Eley Kynoch Company of Birmingham in 1981]

The rules governing working life seem designed for people who work full-time. What is full-time varies from job to job and workplace to workplace. For manual workers it is generally forty hours a week, though unions are gradually winning reductions in the working week to thirty-nine hours or less. For office workers thirty-six or thirty-five hours are quite normal.

Part-timers who work less than the normal working hours in their workplace often find themselves at a severe disadvantage. They seem to be outside many of the normal benefits of employment, whether those benefits are given by law or by the terms and conditions of employment in the workplace. For women workers this is a major problem area. Since the war, the increase in female employment has mainly been among part-timers. They make up a significant part of the workforce but they are still discriminated against and disadvantaged.

The rules need to be changed to recognize that working less than a full working week is not abnormal, and does not mean that your work is less valuable or that you are not a permanent part of the workforce who should share equally in all benefits.

To achieve these changes part-time workers must understand the rules and what needs to be changed.

How many part-timers are there?

Approximately four out of ten women in Britain work part-time.

Women are 85 per cent of all part-time workers. For the purpose of these official statistics part-timers are people who work not more than thirty hours a week. You may be treated as a part-timer in your workplace even if you exceed these hours. If the normal hours in your workplace are forty hours a week, you will be a part-timer if you work thirty-six hours.

Most women part-timers work half the hours of full-timers. The typical part-timer is a married woman with dependent children.

Where do they work?

Most part-timers work in the service industries. Nearly four out of ten work in catering, cleaning, hairdressing and other personal services; one in five work in clerical jobs, and many others are in education, welfare and health.

What are the part-timer's legal rights?

You are entitled to the same statutory employment rights as a full-timer as long as you work at least sixteen hours a week, or if you have been employed at least eight hours a week by the same employer for five years. You are then protected from unfair dismissal and entitled to redundancy pay if made redundant, and you can claim maternity pay and maternity leave in the same way as a full-time worker. You can also claim paid time off to go on union training courses or to act as a shop steward or staff representative in your workplace. You are entitled to written details of the terms and conditions of employment (see p. 417 for more details on legal rights).

If you work less than these hours, you still have certain legal rights which are not conditional on working a certain number of hours a week. You have full rights under the Equal Pay Act, Sex Discrimination Act and Race Discrimination Act. You are also protected from victimization or dismissal arising from trade-union activities. You can claim paid time for antenatal visits recommended by your doctor, midwife or health visitor (see p. 203).

Does it affect your rights if you do not work every week?

Some part-timers work one week on, one week off. Others may be employed on a casual basis and not work every week. To qualify for many legal rights you need to show that you have been 'continuously' employed by the same employer for a certain period of time. For example, you need to be employed for at least two years to qualify for a redundancy payment or maternity rights (see p. 417), and at least one year to be protected from unfair dismissal.

A recent case looked at a woman who worked for Lloyds Bank on a one-week-on one-week-off basis. During the week on, she worked thirty-five hours; during the week off, she did not work at all, and could not be required to by her employer. She had been employed for seven years when she became pregnant and asked for maternity leave. The bank said that it did not have to give her maternity rights because she had not been 'continuously' employed for the necessary period of two years. The first tribunal who heard her case agreed. They said that 'each week off' broke her service, as she was not required to work sixteen hours. She appealed against this decision, and the Employment Appeal Tribunal decided that she was entitled to maternity rights. They said that the week 'off' did not come under her contract of employment. She was protected by an exception to the general rule that a week not covered by your contract of employment breaks your service. This rule allows you to include weeks when you are absent from work in circumstances such that by arrangement or custom you are regarded as continuing in your employment. The Appeal Tribunal said that the bank regarded her as continuing in employment during weeks off, so her service counted as continuous. This is a useful decision which protects other part-timers who work for only one employer but by arrangement do not work every week. (As you can see, these rules are very complicated, and if you are in doubt as to your own position, seek advice from your union or a legal adviser.)

What are your rights if your contract of employment does not state how many hours a week you work?

To be 'continuously' employed you normally have to show that for each week you are covered by a contract of employment which requires you to work at least sixteen hours (or at least eight if you have been with the same employer for five years or more). Alternatively, if your contract does not say how many hours you must work, you can qualify if you have normally worked at least sixteen hours. You can pass this test if there are some weeks you have worked less than sixteen hours provided these are the exception to the general rule. There are no precise rules to what is 'normal', and if you brought a claim to a tribunal they would have to look at the facts of your case and come to a decision. In a recent case a barman had worked eighty-six weeks at more than the required number of hours and thirteen weeks at less. The Court decided that he had 'normally' worked over the required number of hours for a period of two years. He thus qualified for a redundancy payment. In cases of this kind it is for the employer to show that you have not been continuously employed, and if they cannot do so, you should win your case. However, if you think you might be in this kind of argument with your employer it is just as well to keep a record of the hours you do work each week so you can be certain you are not cheated.

Do you lose your legal rights if your employer reduces your hours of work?

If you have worked at least sixteen hours a week, or long enough to qualify for a particular right (e.g. one year for protection from unfair dismissal, two years for redundancy pay, maternity pay and maternity leave), you keep that qualification for up to six months even if during that period you are working less than sixteen hours, as long as you are working more than eight. After six months you lose protection. Remember you are protected if you are working over eight hours a week and have been with the same employer for five years.

What rights do you have to stop your employer changing your hours?

Your employer should seek your agreement to any change in hours and not just impose it on you. Your hours are part of your contract of employment, and changes should be mutually agreed. You should be given prior warning of any proposed changes and have time to think about them, and make any necessary arrangements. A proper period of consultation would be no less than the period of notice you are entitled to should you be dismissed (see p. 417).

The difficulty is that you may need your job more than your employer needs you. If you do not agree to changes, your employer may dismiss you (see p. 417 for details of the notice he has to give you). You may be able to claim unfair dismissal if your employer has been unreasonable, but this is most unlikely to result in your being given your job back. If you are a union member, make sure you bring the union in as soon as your employer suggests changing your hours in a way you don't like. Once you have either agreed or said no, it may be difficult for your union to do anything for you.

Is it fair to select part-time workers first for a redundancy?

Often when workers have to be made redundant it is part-timers who lose their jobs first. Employers and full-time workers may assume that you do not need your job so much if you work part-time, but for part-time workers this seems most unfair.

Who loses their job in a redundancy will depend on a variety of circumstances. Two key questions will be whose jobs are no longer needed, and what agreement there is with the union as to the method of selection. In many redundancies volunteers are called for and there is no need for anyone to lose their job unwillingly. Where selection is necessary it is often the custom that it is on a last-in first-out basis.

Where there is an agreement with a union, then the employer should normally follow that agreement, though not if it provides

for part-timers first, as this is probably unlawful (see below). If you are selected in spite of the agreement, you will have a claim for unfair dismissal.

Unfortunately some unions have entered into agreements with employers that part-timers should go first. Brenda Clarke, whose feelings on the treatment of part-time workers introduced this chapter, was declared redundant along with nineteen other part-time workers in 1981 under an agreement between the TGWU at local level and her employer which said: 'Part-time workers in the unit with redundancies to go before full-timers'. So although she had been with the firm for fourteen and a half years she was made redundant before full-time workers who had been there only a year or two. Her job (a.m. gatekeeper) and that of another part-timer (p.m. gatekeeper) were to be given to a full-time worker who would otherwise have been made redundant. Only after part-timers were made redundant were full-time workers selected on a last-in first-out basis. Brenda contacted the NCCL Rights for Women Unit (see p. 420 for the address) who agreed to take her case and that of a fellow-worker, Marie Powell, to test the law. In September 1982 the Employment Appeal Tribunal decided that the company had unlawfully indirectly discriminated against both women because:

1. They had required employees to work full-time in order to qualify for a last-in first-out selection.

2. The proportion of women who could comply with that requirement was considerably smaller than the proportion of men who could do so.

3. Neither woman could comply with the requirement. The tribunal decided that although Brenda, unlike Marie, did not have children who prevented her working full-time, this made no difference, as at the time of her selection for redundancy she worked part-time and could not comply.

4. The company had not justified selecting part-timers first by producing sound reasons which would convince right-thinking people.

5. As 80 per cent of part-time workers were women, taking part-timers first was grossly discriminatory. It was quite different to a last-in first-out selection, which was lawful, as even if

women's domestic duties meant that more women than men were selected for redundancy the discriminatory effect was limited.

If you feel you are being unfairly selected for redundancy in this way, point out this ruling to your union and your employer. You can also use the T U C Part-Timers' Charter if you need to persuade your union to take your case seriously. (See p. 408 for information on how to bring sex-discrimination cases to Industrial Tribunals.)

What are your rights under your contract of employment?

Part-timers have to keep in mind two sets of rights. There are your statutory rights (described above) covered by Acts of Parliament. There are also the rights established by your terms and conditions of employment. You may be entitled to full statutory rights because you work at least sixteen hours a week yet find out that you are not getting the same treatment as full-timers at work. This is because under your terms and conditions of employment you are still treated as a part-timer. Many part-timers are discriminated against in holiday arrangements, sick pay and pension rights, for example. These are all matters decided by your terms and conditions of employment, not by Acts of Parliament.

Are you entitled to the same rate of pay as full-timers?

On average, part-timers receive lower hourly earnings than full-time workers, as Table 12.1 shows. This is usually not because full-timers doing the same work are paid more per hour but because part-timers work in low-wage areas and badly paid jobs. But you may find that you are on a lower hourly rate than a full-timer doing the same work.

Mrs Handley, a machinist on £1.61 an hour for a working week of twenty-six hours and forty minutes, brought an equal-pay claim to an Industrial Tribunal, comparing herself to a male full-time machinist on £1.67 an hour. Her claim failed because

Table 12.1: *Hourly earnings (excluding overtime)*

	Manual	Non-manual
Part-time female	£1.69 (63%*)	£2.14 (51%)
Full-time female	£1.88 (70%)	£2.59 (62%)
Full-time male	£2.69	£4.20

* Figures in brackets show percentages of full-time male earnings. (*Source: New Earnings Survey* 1981.)

it was said that there was a material difference between her and the men in that machinery lay idle when she was not at work. In her particular case she was able to claim overtime rates if she worked beyond twenty-six hours and forty minutes, while the full-timers could not claim overtime rates until they had exceeded forty hours.

In a similar case, Jeanette Jenkins, employed as a special machinist, claimed equal pay with a male full-time worker. Her employer, Kingsgate (Clothing Productions) Ltd, paid all part-time employees 10 per cent less than the equivalent full-time rate. The company said the difference was because of the need to:

1. discourage absenteeism;
2. ensure that the expensive machinery in the factory was being used to its fullest extent; and
3. encourage greater productivity.

The Equal Opportunities Commission took her case to the European Court of Justice under Article 119 of the Treaty of Rome (see p. 406). The European Court said that lower rates for part-timers were not lawful if they were merely a disguised way of obtaining cheap female labour, and that the British Court should examine the employer's motives. The Employment Appeal Tribunal interpreted the European judgement to allow lower rates for part-time workers who are mainly women, doing similar work or work graded as equal to full-time workers including men only if:

1. the employer did not intend to discriminate against women by paying part-timers less; and

2. he can show that the difference in pay between full-timers and part-timers is reasonably necessary to obtain some result (other than cheap female labour) which the employer desires for economic or other reasons.

The Appeal Tribunal said that it was not clear in Jeanette Jenkins's case if lower pay would achieve the employer's objectives of reducing absenteeism or ensuring maximum use of machinery, so the case was sent back to the Industrial Tribunal to decide on these points.

This case is useful in establishing that in most situations lower rates of pay for part-time workers will be unlawful. If you are on lower rates of pay, bring this case to the attention of your union and ask them to use it to negotiate equal rates for you. And as the Equal Pay Act applies to all other terms and conditions of employment, you can also use this case to argue for equal treatment on holidays, sick pay and other fringe benefits. (See p. 408 for details on how you can take your employer to an Industrial Tribunal if he is in breach of the Equal Pay Act.)

What sort of payments should you look out for?

Here is a list of payments which part-time workers often do not receive. Check how you are treated. You should ask for 'pro-rata' treatment; that is, if the amount of the payment is determined by how many hours you work, you should receive the right amount for your hours (see p. 175 for trade-union policy on this and suggestions for getting your union's support).

Shift payments

Most workers working on shifts that include unsocial hours (after 6 p.m. and before 8 a.m.) receive a shift premium. The level of premium varies with the industry and the kind of shift. For example, the average shift premium for a double day shift (6 a.m. to 2 p.m. and 2 p.m. to 10 p.m.) is 12 per cent on top of the basic rate.

Some part-time shift workers, such as factory workers on dawn and twilight shifts, early-morning cleaners and health

service workers, have unsocial hours, but they rarely receive a premium (see p. 42 for more details on shift payments).

Overtime and weekend payments

Most full-time manual workers expect to be paid time and a half for work over their normal hours in the week, time and a half for Saturday working and double time for Sundays and public holidays. Part-timers may also be paid overtime rates (see Mrs Handley's case, p. 170); but more often they will not receive overtime or weekend payments.

Merit payments

Any merit-payment system is likely to be disadvantageous for women (see p. 38) as these payments are in the gift of management, with no automatic entitlement on certain conditions. It is usual to exclude part-timers from consideration for merit payments. This seems particularly unfair; the quality of your work is not reduced because you do not work full-time. Many part-timers feel they work harder when they are at work than full-timers.

Service increments

If you are unlikely to be promoted – and this is true of most part-timers – a long-service payment may be the only way to a wage rise. Unfortunately, many employers do not allow part-timers to qualify. For example, part-timers in most manual jobs in the private sector are excluded from service payments, whereas in the public sector part-time teachers and cleaners among others are entitled to service increments.

Minimum earnings level

In factories where there is a bonus system of payment the unions try to negotiate a minimum earnings level below which no one's hourly/weekly earnings can fall even if the bonus cannot be

earned through shortage of work or because they are not on a bonus job. But again part-timers may not qualify. If there is a minimum earnings level at your workplace, try to include part-timers on an hourly or pro-rata basis.

What about fringe benefits?

Employers often excuse low pay by pointing to the good 'fringe benefits' their workers receive, such as paid sick leave, holidays and pensions. Yet part-time workers, although low-paid, are often excluded or discriminated against in these areas too. Here are the main fringe benefits and the ways in which part-timers often lose out.

Holidays

There is no legal entitlement to holidays, other than bank holidays if they fall on your normal working day or, if the work is covered by a wages council, holidays included in the wages-council order (see p. 363).

While full-time workers, with very rare exceptions, have agreements with their employer for paid annual leave, this is not always true of part-time workers. A Low Pay Unit survey found nearly one in four not entitled to paid holidays. Many of these worked in pubs and bars where the wages-council order says that the employer does not have to provide paid holidays for workers who work less than eighteen hours a week, which is true of more than one in three barmaids.

This is an area where the law might well require a minimum period of paid holidays for everyone. In the meantime the only way to get paid holidays is to organize with other workers, raise it in your union, and obtain your employer's agreement.

Some part-time workers may not work Mondays at all, or not work Mondays regularly. When a bank holiday is not a day on which they would normally work there is no automatic obligation on the employer to pay them for it, or give them a paid day's holiday off in lieu. This is something to look out for when seeking a part-time job.

Company pension schemes

This is another area of discrimination against part-time workers. If your workplace has a pension scheme, it is unlikely that you will find that part-timers are included (see p. 239 for more on this).

Meal breaks

Some employers regard avoiding meal breaks as a major advantage in having part-time labour. The laws making a meal break obligatory apply only to factories, where they cover women only, and to shops, where they cover all workers (see p. 254 for details). In other workplaces, whether there are meal breaks and how long they are is for the employer to decide or to be agreed with the union.

A maximum of four and a half hours' work in factories and five hours' work in shops can be allowed without a break. Many part-time workers' normal spell does not exceed these hours, and they can therefore be employed without any breaks at all. In 1967 the Confederation of British Industry gave employers this advice on part-timers: 'the careful arrangement of shift starting times can make better use of capital equipment, since no allowance for long meal breaks need be made'.

Working with no break having travelled to work and having to travel home can be both tiring and taxing to health. Even a short teabreak can make all the difference. If you have no break, see if you can get support to campaign for one.

Do trade unions help part-timers?

Trade unions used not to consider part-timers worth bothering with. Some were actively hostile, believing them a threat to full-time workers. This is no longer the official position (see p. 180 for TUC Priorities for Part-Time Workers).

As with many other policies adopted at national level by trade unions, it takes time for it to be understood and acted upon at grass roots; don't be surprised if your local union representative

has not heard of the Part-Timers' Charter. It is up to you to raise it in your workplace and at your branch. In most cases the only way to improve your terms and conditions is to raise the question with your union and make sure the position of part-timers is pressed in negotiations (see p. 322 for more on unions).

Part-time workers who become active in their union may find it particularly difficult to attend union training courses because they are timetabled for a full working day. For part-time workers whose domestic commitments only allow them to get away for their normal working hours it can be not only very difficult but possibly expensive because of the need to pay for child-care. Some unions, for example NUPE, have tried to get round this problem by running some part-time training courses to cater for part-time workers. If your union hasn't got round to this, raise it.

What are the pros and cons of temping?

One major form of part-time work for women is office temping. There is little information on how many temps there are, but in 1976 the Federation of Personnel Services estimated that there were 600,000 working for agencies, though outside London the demand has been dropping since 1973. Most temps work as secretaries, shorthand typists, or copy/audio typists.

When Fiona McNally carried out a survey of temps in 1971–2 she found that a major reason for temping was the need for flexible working hours to cope with domestic arrangements. Temping allows you to take time off for school holidays, when your children are ill or have to visit the dentist, and you can ask to work school hours only. If this kind of flexibility was more often available in ordinary employment, demand for temping would be substantially reduced.

Another advantage of temping would seem to be the variety of work and the sense of freedom and control; temps did not feel under an obligation to please the people above them because they were not staying long anyway. There did not seem a lot of choice as to where temps could work; nearly half of those

surveyed said that they just went where they were sent unless they made very special objections. Pay was not seen as an advantage. Only the young temp who would not be on the full rate in regular employment is on the whole likely to benefit financially from a temping job.

As against flexible working hours, some variety of work, and lack of control, a number of disadvantages emerged. The most common was lack of job security. One third of the temps had been out of work, and others worried about whether or not work would turn up. If it turned up only at the last moment, a half or whole day's pay might be missed.

And while some temps like the variety of workplace and jobs done, others find the continuously changing working environment and fellow-workers a strain. Equally some temps find their work boring and lacking responsibility; over one half of those surveyed thought their skills were not being fully utilized: 'Bosses keep the interesting jobs for permanent staff and don't like to show you anything new.'

Temps do notoriously badly on benefits other than pay. They rarely have paid holidays and virtually never sick pay or pensions. When the lack of these benefits is taken into account, temps' pay is by no means high enough to compensate.

Years of temping counts against you later in life. You will not qualify for a company pension, and may well not have the contribution record to qualify for a state one. You will not be covered if you are sick and you have none of the benefits of long service.

Job sharing

What is job sharing?

Job sharing is dividing a full-time job into two part-time jobs. The sharers are jointly responsible for the full-time post and share the full-time pay and benefits. Job sharers should each have their own contract of employment. Their legal rights are the same as those of other part-time workers.

What are the advantages of job sharing?

It can open up more responsible and taxing jobs, where daily responsibility is required, for part-timers who are not able to work every day.

Unlike other part-time workers, job sharers should always have equal terms and conditions to the full-timers as they have a half share in a full-time job. One difficult area may be pensions, where the normal rules excluding those working less than a certain number of hours a week may apply. This is so for job sharers in banks, for example. Where there is split week working, the one not working Mondays may lose out on bank holidays. Some employers solve this by taking a half day's annual leave away from the sharer who works Mondays and giving it to the other one.

The employer can benefit by having two people's ideas, experience, and special knowledge for the price of one. Although each is only there part-time, their combined expertise can be of real extra value.

Absenteeism and problems of cover during illnesses and holidays can also be minimized. Job sharers can visit doctors and dentists in the time when they are not working, and often when they are ill or on holiday they will be at least partly covered by the other. From the job sharer's point of view you want to watch out that this advantage is not exploited at your expense.

What kind of jobs are available on a job-sharing basis?

In Britain it is still a comparatively new idea, whereas in the United States it has been around longer and is more common. Here the biggest job-sharing employers at present are the banks, with all the main banks operating the scheme quite widely. Other job sharers vary from clerical workers to doctors. The Lothian Health Board, which has an arrangement for two doctors to share a full-time hospital post, says that this saves the £40,000 it costs to train a new doctor by allowing women doctors with children to keep their posts. Job sharing is also found in the insurance field, local authorities, voluntary sectors, univer-

sities. Job sharing seems particularly suitable for librarians; the House of Commons library has eight job sharers.

How is the job split?

This will depend on the particular arrangement. One week off and one week on is the most common pattern in banks; in other areas the split week is preferred. The split day is most uncommon, having the disadvantage of requiring as much travelling time and expenses as a full-time job.

Finding a job share

Some of the larger employers such as banks advertise for job sharers. If you cannot find a job-share vacancy you will need to persuade either your current employer or a prospective employer that it is a good idea. Job sharing may seem attractive as a way of returning to a job you like after having a baby. You may not feel like coping with a full-time job and the baby but you recognize that your present job requires full-time attention. In these circumstances if you find a job-share partner and work out how you could share you might be able to persuade your employer that it would work out and would avoid the loss of your skill and experience.

Alternatively you first find your job-share partner and jointly approach an employer or employment agency. If you do not know a suitable partner you can advertise in a local or specialist press or apply to a job-sharing register (see the details on p. 181).

Will you need to spend much time liaising with your job partner?

This depends on your job. Clerical jobs in banks may require nothing more than an occasional note or telephone call, whereas if you work in the social services or as a doctor, or a research or law centre worker, for example, considerable co-operation will be required. If you get on with your job partner this can be an added advantage to the job. Being able to discuss your work

with someone and work closely together can ease worries and give added enjoyment – particularly for part-timers, who rarely have time to chat over lunch or in the pub after work.

What happens when a job sharer leaves?

This can usually be solved by recruiting another sharer. But find out before you accept a job just what your employer proposes. Most employers advertise the vacant post; some will first offer the remaining employee the job on a full-time basis.

The government Job Splitting Scheme

From January 1983 employers who split a full-time job into two part-time jobs of at least fifteen hours a week will receive a grant of £750. The split jobs must be filled by the worker who did the full job, or another employee who would otherwise be made redundant, or an unemployed person. Another full-time worker can be given a split job if their job is to be filled by a worker about to be made redundant or an unemployed person.

Unlike genuine job sharing, this scheme seems unlikely to advance the status and prospects of part-time women. The scheme is designed to reduce unemployment and unemployment pay by creating more part-time jobs, but as it is at the expense of present full-time jobs it may be unpopular with workers faced with the option of no job or halving their hours of work and pay. Equally the unemployed may find they are only offered a part-time job that leaves them in poverty. As the jobs can be for only fifteen hours a week, job-split workers may find themselves without any legal protection (see p. 167).

TUC priorities for part-time workers

The TUC has set out priorities for unions to observe in agreements negotiated with employers. These include:

1. Hourly wage rates equivalent to those paid to full-time workers.

2. Entitlement to benefits such as sick pay, pensions and paid holidays on the same basis as full-time workers.

3. Allowances such as London weighting.
4. Pension rights.
5. Inclusion in job security agreements.
6. Adequate meal and tea breaks.
7. Inclusion in training schemes and no bar on promotion.
8. Extra payments for working unsocial hours.
9. No discrimination between part-time and full-time workers in redundancy agreements.

Sources of information

Part-time Trap, Low Pay Unit, 1978 (80p).
Ann Sedley, *Part-time Workers Need Full-time Rights*, NCCL (75p).
Job Sharing: A Guide for Employees, The Job Sharing Project, 77 Balfour Street, London SE17 (45p).
Job-sharing registers:
London and Home Counties: c/o 15 Matcham Road, London E11.
Sheffield and around: c/o Sheffield Careers and Appointments Service, AUEW House, Furnival Gate, Sheffield S1 3HE (enclose stamped addressed envelope).

13

PAID WORK AT HOME

There are no accurate figures of how many women take paid work into their home, but it is clear that there are many hundreds of thousands. Home working, once the predominant form of production before the Industrial Revolution, is now almost hidden and forgotten. Our laws protecting other workers rarely cover home workers. Very few are in trade unions. If you are now a home worker you are likely to be isolated from other home workers and in-house employees, usually coping with the care of children, or sick relatives, or your own ill health. Your benefits are few and your problems many. This chapter looks at what kind of work you do, your pay and conditions of work, and the health and safety problems you face. What kind of employer benefits from cheap work in the home? Are your wages low because your employer cannot afford more? Does the law offer you any protection and can it be improved? What are the hidden costs of home working, the advantages and disadvantages?

Why do women do home work?

There are many kinds of home workers, including disabled people, pensioners, child-minders. Some women factory workers take work home from the same factory when they start a family. Immigrant women may do the work because they speak no English. Some home workers take work in all the year round, others only before Christmas or holidays to make a bit extra.

A survey of ninety home workers in West Yorkshire carried out in 1980 by Sheila Allen and Julia Graham found that eighty-five had dependent children living with them; forty-eight had children under five years of age. Three were over sixty and did home working to supplement their pensions and also looked after their grandchildren in school holidays. One was a single nineteen-year-old Pakistani who could not find a job and took work in to contribute to the family income. Nine of the women were either in poor health themselves or had a sick or elderly relative to care for.

Home working was sometimes combined with part-time work outside the home. Fifteen home workers who did both had children under eleven years old. Sheila Allen described their working day as 'staggering'. They were employed, did home working and the domestic labour of looking after husband and children and running their homes on tiny budgets. The overwhelming reasons given by them were economic. In many cases those with younger children had husbands who were on short time, redundant or sick.

You may do home working because, although you no longer have small children, your family expect you to be at home to look after them, to get their tea and so on. Many women spend a lifetime looking after other members of the family and feel they cannot do work outside the home as they would fall down on their duties.

Is there a legal definition?

Yes. The Wages Council Act defines a home worker as:

An individual who contracts with a person, not being a professional

client of his, for the purposes of that person's business, for the execution of any work (other than the production or creation of any literary, dramatic, artistic, or musical work) to be done in domestic premises not under the control or management of the person with whom he contracts.

So if you are doing work for someone in your home or the home of someone else (not the person who is giving you the work), you would be a home worker for the purpose of the wages council.

What do wages councils do for home workers?

Chapter 21 describes wages councils in detail. Not all home workers are covered by a wages-council order. In the West Yorkshire survey only twenty-two out of ninety home workers were. The main wages councils and the kind of work they cover are described on p. 364. Wages-council orders set minimum pay rates for home workers, but no other minimum terms and conditions. The wages-council orders exclude home workers from other requirements such as holidays and hours. If you are not covered by a wages council there is no legal minimum rate. You really need a union to improve your pay and conditions.

What is the minimum pay rate?

As explained on p. 364, wages-council minimum rates are called the Statutory Minimum Remuneration (SMR). It is against the law for employers to pay below the rates. If they get caught out, they can be fined. The Wages Inspectorate is employed to enforce the wages-council orders and see that the minimum rate is paid. There are far too few of them to do the job, and with public expenditure cutbacks the numbers are falling. Even when they do find employers breaking the law, they rarely prosecute them.

So in practice unless you, or your union if you are in one, insist on not being paid less than the SMR, no one else is likely to help, though you can contact the Low Pay Unit (see p. 418). Your employer can of course pay you above the SMR. It sets

the lowest legal rates, not the highest. And the rates are low.

How is SMR calculated?

The usual way of calculating a SMR is on the number of hours worked (a time rate). But as home workers are always paid on a piece-work basis, most wages-council orders provide for the time rate to be converted into a piece-work rate. The way this is done is to assess how many pieces an ordinary worker gets through in an hour, then work out the rate per piece so the ordinary piece-worker earns as much as an ordinary time worker. This is not an easy task, as workers' speeds differ one from another, and a fresh calculation has to be done for each different piece of production. Also home workers are often doing different jobs from in-workers, so there is no ordinary worker on time rates who could be used to calculate piece-work rates. Even when there is, it may be almost impossible to be as productive when working at home, often in poor conditions and with distractions such as children, as when working in a factory; so you are likely to earn less than an in-worker.

Some wages councils avoid the problem by setting a specific home-working rate which is distinct from the in-work rate.

Partly because of the difficulty of establishing what the legal minimum rate is, and partly because lack of inspection and enforcement allows bad employers to get away with underpaying, most home workers are paid below the minimum rate. An official study on home workers in the toy manufacturing industry in 1977 concluded 'a high proportion of homeworkers appear to be earning well below the rate laid down by the Wages Council'. Sixteen home workers out of twenty-two in West Yorkshire were paid below the SMR.

Does your employer have to meet your expenses for working?

Yes. The Wages Council Act says that the minimum wage rate is calculated after allowing for necessary expenditure, if any, in

connection with the employment. So if you spend £1.50 a week on electricity for your sewing machine, that should be paid in addition to the minimum wage rate. In practice most employers either do not know about this requirement or they ignore it.

Many home workers under-estimate the real expenses of working at home. Besides electricity, rental cost for machines and tools, and the costs of any materials they may have to purchase, there is also the extra cost of heating and lighting, travel to collect or fetch work, and phone calls. These are all costs which you are entitled to ask your employer to pay if you are covered by a wages council. But, as with any other attempt to improve your pay and conditions, you may fear a withdrawal of work if you raise a complaint.

Can you claim expenses against tax?

Professional workers at home can claim these kinds of costs against tax. Most home workers do not earn enough to pay tax, but if you do pay tax on a self-employed (Schedule D) basis remember to itemize all these expenses and ask for them to be taken into account. If you pay tax on a PAYE basis the rules are stricter and you can only deduct expenses which 'wholly and necessarily arise from your employment'. You should still be able to claim.

How many home workers are there?

The best survey, by Peter Townsend in 1968–9, suggested that there were 250,000, but this is probably an under-estimate. It certainly did not include the 130,000 child-minders, who are probably the largest group.

What industries do they work in?

All branches of the textile industry, clothing, knitting, hosiery, lace making, textiles, toy making, footwear, decorative material, button making, jewellery, engineering work such as locks, keys,

packaging work, and clerical work such as typing envelopes, addressing and punching computer cards.

Who employs home workers?

Not all home workers know who really employs them. The person who supplies the work is usually a 'middle man' employed or contracted to a main contractor, who in turn may supply a larger concern. The West Yorkshire survey found that a third of the seventy firms who supplied home work were in the clothing and footwear industries; the remaining two thirds were from a wide range of industries including food, chemicals, textiles, paper, printing, distribution, insurance and banking. Most of the firms were national or international organizations or sub-contracted to them; only a minority of employers were small local outfits. Large concerns paid no better than small traders. In one case a clothing machinist got better rates working for a small firm than her counterparts whose work was supplied by national companies.

Who does the work?

Many home workers share the work they take in with members of the immediate family and other relatives. Sharing with mothers, mothers-in-law and sisters is common. Children also work and are sometimes paid. Sheila Allen reports on an eight-year-old stacking greeting cards for three hours every night so his mother could pack them. She got 38p an hour and gave him 50p for several nights' work. Another home worker paid each of her four children, aged between five and eleven, ½p for every teddy bear they turned right side out after she had machined them. She was paid 9p a teddy bear.

If you do share your work, this can be used as a reason to say you were not 'employed' but self-employed (see p. 190).

Do you have the same legal rights as other workers?

Probably not, as most home workers are not legally 'employees' but self-employed.

Legal protection from unfair dismissal, payment on redundancy, rights to notice, paid maternity leave, all depend on being employed.

If you are like most home workers, you will consider yourself employed if you think about it at all. But your employer is likely to treat you as self-employed. Most employers do not pay National Insurance or deduct tax even if you earn enough to be over the tax limit. Neither do they give home workers any written statements telling them whether they are employed or self-employed. (See p. 191 for more on tax and National Insurance.)

When is a home worker 'employed' in law?

To be 'employed' in law you have usually to work regularly for one employer and work under his control and direction. So, for example, if you do hairdressing in your home you are not an employee of your customers. In law you have a contract for services with them but not a contract of service (which means you are employed). If you are a home worker you may or may not work just for one employer, and you may not work regularly. Although you are not under his control and he does not organize your work in the same way as he would if you were working in a factory, you probably do not have much choice of how you do the work. If it is not done according to orders you won't get paid.

If you share the work with other members of the family and relatives, this can be used as a reason to say that you are not employed.

In order to qualify for protection from unfair dismissal, redundancy pay or the other legal rights mentioned, you have to build up a period of continuous service with one employer. For these purposes service only counts when you are working over sixteen hours a week, or if your hours are under sixteen but over eight a week, you must be employed for five years. This is another snag for many home workers. If they only work periodically, those weeks when they are not working more than sixteen hours will probably break the continuity of employment and prevent them having any legal rights.

Here are two examples of home workers who were employed according to the law.

Mrs D'Ambogio worked as a machinist at a factory for three months and then asked if she could work at home for the same employer. Her employer agreed, supplied her with a sewing machine and all the necessary material. The agreement was that she would work for at least forty hours a week, which she did until the factory closed down. Her employer deducted tax and National Insurance. On closure she claimed redundancy pay, but the Department of Employment told her that she was self-employed and so not entitled. She took her case to an Industrial Tribunal. The Department of Employment produced an Inland Revenue memo which said 'outworkers are not treated as employees as they are not bound by the conditions of normal employment. They work for any number of principals, do the work when they like, and for such hours as they want. No notice is legally required from either party of termination'.

The tribunal disagreed. They said that as the factory owner called each day with work, and Mrs D'Ambogio worked at least as many hours as she did in the factory, she was an employee and was entitled to redundancy pay.

Mrs Cope worked at home for seven years making heels for shoes. The company supplied her each day with material. She worked according to their instructions. She usually worked five days a week, at least sixteen hours a week. There were occasional breaks in the work when demand was low. Her employers did not deduct tax or National Insurance or give holiday pay or sick pay. They told her she had to provide adequate ventilation as she was working with highly inflammable glue.

She claimed she had been unfairly dismissed. Her employers said she was not 'employed' as it was up to them whether or not work was provided and up to her whether she accepted it.

The Industrial Tribunal decided that if Mrs Cope had refused to do work when it was offered 'the relationship would have rapidly been terminated'. They said that the company decided 'the thing to be done, the manner of performance, the means of performance, and in reality the time and place of performance.' They said she was employed.

How do you work out whether you are employed in law?

It is not possible to give a straightforward yes or no answer to the question whether anyone is officially employed, because a whole number of factors have to be looked at, as in the cases above. But the more of the following questions you can say yes to, the more likely it is you would count as being employed.

Do you work only for one employer?

Do you work regularly each week, with only occasional breaks?

Do you work at least sixteen hours a week? (Or have you worked over eight hours a week for five years?)

Do you have to do your work according to instructions?

Does your employer deduct tax?

Does your employer deduct National Insurance contributions?

Do you do your work yourself (as against sub-contracting part to friends or relatives)?

What can be done to give home workers legal protection?

The law needs changing so that home workers have all the legal protection of other workers. In 1979 Frank White MP introduced a 'Home Workers (Protection) Bill' in the House of Commons, which if passed would have had this effect and made employers keep proper records of home workers, and pay the going rate for the work they did. The trade unions supported the Bill, but it did not get sufficient support in Parliament to be passed. The TUC has now adopted a Code of Practice for home workers. It says:

1. Employers should tell home workers the hourly rate which is paid in their industry or, where the same work is being carried out in a factory owned by the employer, in the factory.

2. Workers should be paid the same hourly rate as for the industry concerned.

3. When deciding the rate for home working the employer should take into account any poorer equipment and machinery

provided to the home worker than to a worker in a factory or office.

4. The employer should meet travelling, postage, electricity, maintenance, machine rental expenses. He should also pay the cost of providing any tools and equipment.

5. Home workers should become employees of the company concerned, and the employer should deduct tax and National Insurance contributions from the home worker's salary and give proper itemized wage statements.

6. Employers should register all home workers with the local authority, and these lists should be available for inspection by trade-union representatives.

7. Home workers should join the appropriate trade union and be included in negotiations.

8. Home workers should get all the fringe benefits available to factory-based employees and where possible be able to make use of any social facilities.

9. Home workers should have paid holidays, the pay being based on their earnings.

10. They should have the same opportunity as factory workers for training and retraining. Employers should give shop stewards and safety representatives and home workers details of rates and methods of pay, names and addresses of home workers and the volume and regularity of work.

11. Home workers should receive regular work where possible and if work is not going to be provided, then trade unions should press the employer to give the home worker advance notice as to availability of work.

Home workers and National Insurance

If you are officially classed as self-employed this means that your employer does not pay National Insurance for you. You must pay your own contributions (either through special stamps bought from the post office or by direct-debit arrangement with the DHSS). This Class 2 contribution costs £4.40 per week and entitles you to claim a retirement pension, sickness benefit,

and maternity benefit. (You cannot claim these if you do not pay or get an exemption.)

You can apply for exemption from National Insurance if you earn less than £1,690 a year (remember this is after you have taken all your expenses, electricity etc. into account). Ask at the Social Security office for a Certificate of Exemption from National Insurance contribution.

Because National Insurance is quite complicated, you would be wise to check any doubts about your situation with your nearest welfare rights agency.

If you are claiming social security you are allowed to earn £4 a week with no difference to the amount of supplementary benefit you receive. This £4 a week is calculated after you have taken money from your wages to cover your overheads. So if you are paid £7 and you spend £3 for heating, lighting and machine hire, your actual wage for purposes of social security would be £4.

Can home workers join unions?

Many home workers may be interested in joining a union which could help them get better pay and look after their interests. In a recent survey of home workers, just under half said they would join a trade union, though none of them were members.

Because home workers are working in their homes they are more cut off than most workers from trade unions. They may also fear joining one and appearing a trouble-maker in case their employer refuses them work. As explained above, they lack the legal protection from unfair dismissal or victimization that ordinary workers have.

But some unions, such as the National Union of Tailors and Garment Workers, the GMB, the Hosiery and Knitwear Workers' Union, and the TGWU, have home workers as members.

GMB have a home workers' branch in the West Country among glove makers. One of the branch's first tasks was helping a member when the DHSS claimed she owed £300 National Insurance contribution. The union said the employer was

responsible; he should have paid the employer's contributions and deducted hers from her wages for any period she earned over the limit.

If you want to join a union, phone the TUC to ask for your appropriate union.

Unions are trying to get more information on home workers so they can contact them and offer membership. They are pressing for local authorities to keep lists of home workers, which employers would have to supply and keep up to date. Such lists should be open to authorized trade-union officials as well as the Wages Inspectorate. At the moment, employers in certain industries are meant to give local authorities lists and supply Factory Inspectorates with names. Most employers ignore this request. Even if they do keep these records, they do not have to provide any information to trade unions.

What arguments can you use to make your employer pay you more?

If you want to organize for higher pay it is best to get together with other home workers; or better still join a union which covers in-workers employed by the same employer, so they are able to get in-workers to back your claim.

There are a number of ways in which your employer benefits from your working at home, and these are all arguments for saying you should be paid more.

1. He does not provide a workplace, heating, lighting, or any other facilities such as a canteen.

2. He probably will not pay National Insurance contributions, PAYE deductions, or other employers' expenses such as redundancy fund contributions, or a training board levy.

3. The biggest savings are the notoriously low wages. What is more, he only pays for the work he needs doing. In-house workers cannot be paid only for available work, however little it may be. It takes time for them to be temporarily laid off or put on short time, and usually something has to be paid. With home workers there is no such difficulty.

What legal protection is there from health risks?

The Health and Safety at Work Act 1974 says that your employer, or the supplier of the work you do, should not expose you to health risks by giving you work to do which is a danger, either because the articles or substances are not safe or because the process you have to do places you at risk. The Factory Inspectors or Environmental Health Officers can inspect home workers' premises to check on safety, but they rarely do. Besides there being far too few of them, they have very little information on where home workers live and what they do.

The law also says that you are entitled to know of any risks attached to the articles, chemicals, or other substances that you use. If you ask the suppliers in writing, they must give you this information under Section 6 of the Health and Safety at Work Act. But hardly any home worker would ask, for fear of being thought a trouble-maker.

These inadequate safeguards for home workers may soon be strengthened. In 1980 the Health and Safety Executive recommended that the law should be changed so that employers must give the local authority regular statements on the addresses of home workers and details of the type of work, materials and equipment given out. Unfortunately they have said that this information would not be necessary for office work, and it seems unlikely that there would be a proper method of checking on the records or the safety of the work. Neither do the proposals say that home workers should be given more information on risks involved and safeguards needed.

What can you do if you think your work is unsafe?

You can contact the Health and Safety Executive and ask them to call and see what you do, and tell you if the substances you use are a danger. But because there are so few of these officials you may have to wait a long time for any response.

If you are a union member, your union should give you advice. Most of them have someone responsible for health and safety

either at regional level or at head office. If you are not a union member it may be a good reason to join and get help (see p. 322).

There is a Women and Work Hazards Group, which has supplied some of the information in this section; they will answer letters and give what help they can (address on p. 199).

Child-minders

What is a child-minder?

Someone who looks after pre-school-age children in her own home and charges fees to parents.

How many are there?

In March 1981 there were 43,000 child-minders registered to look after some 106,000 children. The numbers of unregistered child-minders are not known. Estimates vary from 50,000 to 300,000.

What is a registered child-minder?

The Health Services and Public Health Act 1968 says that all child-minders should be registered with the local-authority Social Services Department. A child-minder is defined as a person who looks after a child to whom she is not related for reward and in her own home for more than a total of two hours a day.

If you telephone your local council and ask to be registered, they will send someone round to look at your home. They will want to make sure it is safe, has fireguards, secure gates into the road, adequate heating, water and so on. They will tell you how many children you can mind. The usual number is three including your own children. At the moment many councils do no more to help you. They will keep a list of all registered child-minders and refer mothers looking for minders to you. They do not usually help you to get decent money for your work. Neither

do they provide toys, training or other facilities (see p. 198 for the exceptions).

If you fail to register you can be prosecuted and fined or receive a short prison sentence. In practice prosecutions are rare.

What will you get paid?

It is up to you to arrange a payment with each mother that leaves her child with you. There is no recommended or general rate of payment. A Low Pay Unit survey in 1980 found the normal range of payment to be £10 to £25. The average gross income for minders looking after children full-time was £28.37. Minders had to meet considerable expenses out of this sum, including the cost of heating, food, equipment, such as prams and high chairs, toys, fares, play-group fees, entertainment, cleaning equipment and wear and tear on the house. The average figure for expenses given by minders was £12.53 a week.

The problem is that the mothers who pay you are themselves usually badly paid. So you are in a poverty trap. This drives many child-minders to look after more children than they are allowed to. It is one reason why child-minders do not register, hoping they can cram more children into their homes and the council will not find out about them. In many areas, councils do not enforce the law strictly and take no steps to clamp down on unregistered child-minders. The more children you have, however, the more difficult it is for you to look after them properly.

Is there a union for child-minders?

The National Union of Public Employees has child-minders among its members. It finds that many of them have never been visited by a social worker and do not know how to contact the Area Social Services Manager, who is theoretically in charge of them. The union aims to build up better contact between child-minders and the local authority so the child-minders know where they can go if they have difficulties, such as children being ill-treated by their parents and being left with them.

In 1975 NUPE published a Child Minder's Charter which called for direct employment of child-minders by the local authority, a substantial increase in rates of pay, training of child-minders, and official guidance to both child-minders and parents.

Is there no way you can get better pay and help as a child-minder?

Child-minders themselves are organizing into groups, and a National Child Minding Association (address on p. 199) has been set up to improve conditions for minders. Its aims are:

1. To foster and promote the provision of educational, happy, secure and stimulating day-care facilities for young children and to encourage the recognition of child-minding as a positive part of this provision.

2. To encourage contact and communication between child-minders, mainly by publication of a quarterly newsletter.

3. To encourage the setting up of local groups.

4. To provide help and advice to those looking after other people's children, so that the quality of the service to children may be improved.

The association recommends a written contract or agreement and provides members with a model. In December 1980 it had over 5,000 members and a national office run by five part-time staff. Its national Executive Committee is made up of elected child-minders representing twelve different regions of the country. Members meet together in local groups or drop-in centres. Many of them feel that child-minding is under-rated and bears an unwarranted stigma, which they hope the association will help to remove. The Low Pay Unit survey found that many child-minders obviously enjoyed their work despite its low pay and quoted this child-minder in Cheshire as typical: 'I love it. I enjoy teaching the children I mind and feel proud I am helping them and their parents. I think it's the most important job, and should be much better paid.'

Some councils do more than others to help child-minders. Some of the toy library schemes lend equipment and have infor-

mal discussion groups for registered child-minders, with drop-in centres.

In Edinburgh and the London Borough of Lambeth some child-minders are directly employed by the local authority and are provided with training and extra help. In Lambeth thirteen child-minders were employed to provide care for thirty children from the 450 cases on the priority waiting list for nursery places. They were paid the salary of a trainee nursery nurse, plus 50p for each child which was expected to cover their costs, heating etc. They were also given a training course and allocated a social worker to assist them. In a local nursery there is a room available for their use, and they were encouraged to take children in their care to a local play-group or One O'clock Club. Such a scheme is expensive, however, compared with the usual neglect of child-minders and is unlikely to be expanded when social workers are being cut. In the London Borough of Wandsworth the local branch of the Child Minding Association employed fifteen child-minders in 1983 funded by an urban aid grant.

Some authorities run training courses, often at drop-in centres, where the children can be cared for. A few local authorities arrange and pay for an insurance policy to insure child-minders against liability for accidents with the children while they are in their care. But most child-minders will need to insure themselves. Child-minders are entitled to a third of a pint of milk per child per day. You have to buy the milk and reclaim the cost from the DHSS.

Are there any future plans for helping child-minders?

The only way child-minders will get significantly better pay and conditions is if they become directly employed by the local authority on a proper wage and with the usual other benefits such as holidays, sick pay, National Insurance and pension rights. In addition, they should have allowances to help them cover the cost of heating, toys, books, wear and tear on their homes and a telephone. The TUC in its policy on helping the under-fives has recommended these steps. They also want child-

minders properly trained and given constant back-up assistance by social workers.

Sources of information

The London Homeworking Campaign, 2 Cable Street, London E1 (01 481 0510).

Women and Work Hazards Group, c/o BSSRS, 9 Poland Street, London W1 (01 437 2728).

Homeworking Officer, London Borough of Hackney, Economic Development Unit, 1/11 Hoxton Street, London N1 (01 729 3712).

Unions which have shown an interest in recruiting and helping home workers are:

General and Municipal Workers Union, Thorne House, Ruxley Ridge, Claygate, Esher, Surrey.

National Union of Hosiery and Knitwear Workers, 55 New Walk, Leicester.

National Union of Tailors and Garment Workers, Radlet House, West Hill, Apsley Guise, Milton Keynes, Bucks.

A broadsheet on *Health hazards and home workers* produced jointly by London Homeworking Campaign and the Women and Work Hazards Group is available free to all home workers from the London Homeworking Campaign.

The National Child Minding Association, 13 London Road, Bromley (01 464 6164).

14

MATERNITY RIGHTS

Should you have children?

How will it affect your job, your income, and your independence? Can you afford to have children if you stop work? Will you be able to continue working if you want to? These questions are becoming increasingly difficult to answer.

In the bad old days it was straightforward enough. You were expected to have children when you got married (if not before) and to give up your job. The exceptions were the very rich, who had nannies, and the very poor, who had to struggle along somehow.

Now two wages are essential to most couples to maintain a reasonable standard of living. If you are going it alone, job retention may be number-one priority.

It is not only the money. You may be very reluctant to give up the friendships, sociability and financial independence for full-time motherhood.

So you need to know what are your rights to keep your job during maternity. Is it really possible to come back? What maternity pay are you entitled to? You will need to look at what the law says and what your workplace agreement says, if you have one. You will also need to know about National Insurance benefits.

Of course you may not want to come back to work after having a baby. Some women look forward to being at home with children and find that the company of other mothers and the lack of work restrictions more than compensate for the comparative poverty. If you are among them you still need to know about maternity pay and your rights to come back, just in case anything goes wrong with the baby or you change your mind or your circumstances. You may also be interested in the section on maternity agreements which provide for long periods off work, say three years, with the right to return.

Because if and when to have children is such a difficult decision, and because these days children can on the whole be planned, many women take years to make up their minds. You might as well use this time fruitfully by trying to ensure that you are in the best position to keep your job, have as much time as you want at home with the baby, and be paid for as long as possible.

This will possibly mean choosing a job which already has good maternity arrangements, or trying to negotiate for better maternity arrangements at your present job from which you will be able to benefit.

You may want to return part-time and need to see if part-time jobs are available and how they will affect your job rights, seniority and promotion (see p. 164 for information on part-timers). In some occupations you may be able to arrange job sharing.

A father's rights to time off with pay when the child is born and longer paternity leave to share child-care are rightly becoming more important. So this chapter will also cover fathers' rights or the lack of them.

You will need an assertive frame of mind. There are still plenty of people around who say you will regret anything but total surrender to your female destiny. Try reading about child-care (see p. 230 for suggestions). There is nothing 'natural' about a mother looking after a child alone for eight or twelve hours a day within four walls. It is only in today's Western urban society that this happens. More social forms of child-care, with the mother remaining engaged in social work of one kind or another, are far more normal.

What do you need to know?

To work out your rights you need to know what the law says about maternity pay, maternity leave, your right to return to your job and protection from unfair dismissal. You also need to know of any special maternity arrangements at your workplace. You cannot be given less favourable maternity terms than those provided by the law, but if your employer has agreed to make

more generous provision in some respects then you can claim them. For example, the law says your employer must pay you six weeks' maternity pay. Before the law came into effect, local-government conditions of employment already provided for eighteen weeks' maternity pay, though not all at full pay. Local-government employees therefore can claim six weeks' pay under the law (see p. 204 for how this is calculated) and a further twelve weeks because of their conditions of service.

Can your employer dismiss you during pregnancy?

The law gives special protection to women who are dismissed because they are pregnant or for any reason connected with their pregnancy, provided they have been employed for at least twelve months by the same employer at the time of their dismissal. This would cover you if you were dismissed when recovering from a miscarriage, for example, or because your employer disapproved of single parenthood. Pregnancy dismissals are legally 'unfair' and entitle women to ask for their job back, or for compensation and their maternity pay. If this happens to you before you have been employed for twelve months, you may be protected by the Sex Discrimination Act.

What is a 'fair' dismissal during pregnancy?

The only circumstances allowing your employer to dismiss you because of your pregnancy are:

1. You are unable to carry out your normal duties adequately; this should only apply to a heavy physical job. *Or*

2. You were dismissed because of legal provisions making it unlawful to employ you during pregnancy; the regulations forbidding the employment of pregnant women cover work in lead processes or involving the use of radiation exposure. *And*

3. There is no alternative work your employer can offer you.

What are your rights if you are 'fairly' dismissed?

If your employer dismisses you in these circumstances you are still entitled to maternity pay and to return to your job after maternity leave. Although you have been dismissed, if you return your service will be regarded as unbroken, as for other women who come back to their jobs (see p. 206).

What are your rights to antenatal leave?

You will need time off work during your pregnancy to visit your doctor and hospital. Proper prenatal check-ups and attending relaxation classes are most important for your health and that of your baby. Until recently many working women were reluctant to lose money and annoy their employer by going to hospital during working hours. Since 1980 you have the right to paid time off for such visits.

Whatever your length of service, and even if you do not work full-time, your employer must not unreasonably refuse you time off for an appointment. The appointment must be made on the advice of your GP, midwife or health visitor. It can be at any place; for example, you might attend classes arranged by the National Childbirth Trust held in a private house rather than a hospital or doctor's surgery. After the first appointment, if your employer asks to see a medical certificate as to your pregnancy or an appointment card or other evidence that you have made the appointment, you must produce these documents for his inspection.

You should receive your normal hourly earnings for the time you are away from work.

When are you entitled to maternity pay and leave?

To be able to claim maternity pay and leave you must:

1. Have been employed by the same employer for at least two years at eleven weeks before the expected date of birth. You must have worked for at least sixteen hours a week, or if your hours were under sixteen but eight a week you must have been

with the same employer for at least five years. Thus many part-timers are excluded. If your pregnancy lasts at least twenty-eight weeks you are entitled to pay even if you have a miscarriage or your baby is still-born.

2. Still be employed at eleven weeks before the expected date of birth. So if for example your doctor tells you eighteen weeks before the birth that you should stop working, do not resign; go on sick leave. It does not matter that you are not still working as long as your employment has not ended. If your employer dismisses you, it is probably unfair (see p. 212).

3. Write to your employer at least three weeks before you start your maternity leave to inform him that you are leaving and why. You will then be entitled to maternity pay. If you want your job kept open for you, you must also tell your employer that you intend to return and the expected week of confinement. If he asks for a medical certificate to confirm the expected date of confinement you must give him one. If you do not say you intend to return to your job, you lose your right to do so. If you do say you intend to but later change your mind, your employer cannot penalize you in any way or claim back your six weeks' maternity pay. Often it is difficult to be sure, as it may depend on how you feel and what child-care arrangements you can make. If you are in doubt, the only advice that can be given is to say you intend to return. If you later decide not to, then tell your employer as soon as possible to avoid unnecessary inconvenience to him and your fellow-workers.

How much pay will you get?

Your employer must pay you six weeks' maternity pay at 90 per cent of your earnings less the flat-rate state maternity allowance. Your employer recovers maternity pay from a Maternity Pay Fund administered by the government. Your earnings do not include overtime but do include all other payments from your employer, including bonus. You may not do so well if you rely heavily on tips from customers, as these will not be included. The flat-rate state maternity allowance will be deducted even if

you are not entitled to it, for example because you have only been paying the married woman's contribution. Your maternity pay is taxed. (The government has power to alter the 90-per-cent level either up or down.)

When is it paid?

The payment cannot start earlier than eleven weeks before the expected birth date. It will be paid for the first six weeks of your maternity leave, which will normally start eleven weeks before the birth, but could start later. You can ask your employer to pay it as a lump sum (in which case the tax is more favourable), but you have no right to insist.

Maternity grant

This is a sum of £25 to help with the immediate costs of having a baby. It has been fixed at £25 since 1969, a ridiculously low sum compared with what you need and what is paid in some other European countries.

Maternity allowance

This is a weekly allowance paid for eleven weeks before your baby is due and for seven weeks after it is actually born, with a minimum total of eighteen weeks. If your baby is born later than expected, you will get maternity allowance for longer. It is not paid while you are doing paid work. If therefore you continue in your job after eleven weeks before the expected date of your baby's birth you will be losing maternity allowance you could otherwise receive.

You can claim it whether you are single or married, but you can only claim it on your own insurance.

How much do you get?

The standard rate is £25.00 a week. If you don't have the full number of contributions you will get less. You can claim

additional allowances for your dependent children, but if you are married you cannot claim for the children unless your husband is disabled or incapable of work.

When does maternity leave start?

You can decide when to start your maternity leave. Most women leave work eleven weeks before the birth as that is the date from which you can claim state maternity allowance. But you may want to continue working after eleven weeks before the birth, for example because you are not entitled to maternity allowance. Then you are legally entitled to do so even if your contract of employment says you must stop at eleven weeks before the birth. Your employer can only stop you if you cannot adequately carry out your duties.

Remember you cannot leave work earlier than eleven weeks before the birth without losing your right to maternity pay and leave (see p. 204).

Returning to work

If you wish to return to your job, you can do so at any stage up to twenty-nine weeks from the birth. You can delay your return for up to four more weeks for medical reasons as long as before the twenty-nine weeks are up you give your employer a medical certificate confirming you are unfit to work for medical reasons. If you have already fixed a date of return and then want to delay, you must give your employer a medical certificate before that date.

You must give your employer three weeks' notice in writing of your intention to return. He can delay your return by up to four weeks so long as he informs you of the delay before the intended day of return, and tells you the reason and the date on which you can return.

He can also write to you at any time after seven weeks from the expected date of confinement and can ask you to confirm in writing that you still intend to return to work. If you get such a letter you must reply within fourteen days, or if this is not

possible (for example because you are abroad or in hospital) as soon as you can. If you fail to reply you can lose your rights to return to your job.

You might think this complicated procedure has been designed to put women off claiming their rights. Don't let it put you off.

Will you always get your job back?

The Conservative government weakened women's rights to return to work in 1980. Before the changes all women, whatever the size of their employer, were entitled to return to the job they were employed to do. This meant that while you might not get your actual job back your employer could only give you another job if it was no different in terms of the job title/grade/pay and other terms and conditions. If you were employed as a private secretary you could be re-employed as Mr Jones's secretary rather than Mr Smith's.

If you were employed as a process worker Grade 4, you could be given a job in a different department as long as you were still a Grade 4 process worker.

Now, while this is still the general situation, the employer can avoid re-employing you in your original job in the following circumstances:

1. *Small employers* who employ only five or fewer people do not have to re-employ women if they do not find it 'reasonably practicable' and they have no 'suitable alternative employment' to offer you (see the next paragraph for a definition of suitable alternative employment). As this is a new rule there are no examples yet of what circumstances would allow employers to use this excuse. It seems likely though that it will not be difficult for an employer to say it was too inconvenient to keep the job open.

2. *Other employers* can offer 'suitable alternative employment' to women instead of their original job. The new job must be *suitable for you to do*. This probably means the work must not be of a quite different kind or have an element in it which

you cannot do because of lack of training, skill or physical strength. This could prevent your employer offering jobs which would be impossible with a small baby because the hours were different, or the location was further away than your previous job. The capacity and place in which you are to be employed and other terms and conditions of employment cannot be *substantially less favourable* than your original job.

This will allow employers to offer jobs on lower pay and worse conditions as long as they are not *substantially* worse. It makes it important to ensure that your employer agrees always to give the original job back (see p. 213 for suggestions on this).

If a woman does not accept an alternative job which complies with all the conditions for 'suitable alternative employment', then she can be dismissed without compensation.

Will you have lost rights by being away on maternity leave?

Your continuity of service is not broken by your period of maternity leave. This means that you will be treated in all respects as if you had not been away. Your employer does not have to treat you as if you had worked during the six months. So unless there is a workplace agreement which says you accumulate holidays during this period, or that your employer pays pension contributions, you may for purposes such as these not be able to count these six months. But when it comes to claiming statutory rights such as redundancy pay if you were later made redundant, you can count the period of your maternity leave as adding to your total length of service (see p. 110 for more on sick pay and p. 231 for more on pensions).

Will you be allowed sick leave after maternity leave?

Some sick-pay schemes discriminate against pregnant women or those returning to work after childbirth by refusing paid sick leave required for reasons connected with pregnancy or childbirth. A case brought by Ms Coyne against her employers, the Export Credit Guarantee Department, a civil service depart-

ment, established that this is contrary to the Equal Pay Act. She complained that the civil service were treating her less well than men by not paying her sick leave for illness arising from the birth of her child, which delayed her return to work beyond the expiry of her three months' maternity leave.

The civil service maternity provisions stated that 'Further paid sick leave following maternity leave may not be allowed within a woman's normal allowance.'

The Industrial Tribunal said it was no excuse for the civil service to say the maternity clause was 'special treatment afforded to women' and thus excluded from the Equal Pay Act. The civil service was depriving women of their otherwise existing rights to sickness benefit. Women should be allowed sick leave following maternity leave within their normal allowances. The civil service department was not pleased. A senior officer was quoted in the national magazine *Now* as saying:

> The problem is if we accept the ruling it could end up with thousands of women taking their full sick leave entitlement after having a baby.
>
> The extra leave – both in actual wages and working hours lost – would cost God knows how much. And it would be the taxpayer who would have to pay for it. We'll study the published findings word by word, clause by clause, and if there is a chance we'll fight for that one paragraph all the way to the top.

Despite this unusual display of feeling, discretion was deemed the better part of valour and the decision was not appealed.

Workplace agreements

As explained on p. 201, your employer must give you your legal rights whatever your own contract of employment or your workplace agreements say. If he has agreed to more generous arrangements you will want to claim them. If your employer only gives the maternity pay and job-back rights provided by law, you may want to try and obtain improvements.

Some of the current workplace maternity agreements are summarized in Table 14.1 You will see, for example, that all civil servants (like local-authority and health-service employees) are entitled to more than six weeks' pay. Most nationalized

Table 14.1: *Some maternity agreements in the private and public sectors*

	Qualifying service	Maximum leave	Maternity pay	Conditions	Other notes
Longman Publishing	21 months	1 year	18 weeks' full pay	Return to work for 24 weeks	Return to work on a 3-day week basis for 4 weeks at full pay
Grand Metropolitan	2 years	40 weeks	13 weeks' full pay	None	
National Magazine Company	9 months	40 weeks	13 weeks' full pay	None	Further payment at employer's discretion
Roadchef	1 year 2 years 3 years 4 years 5 years 6 years over 7	40 weeks	2 weeks' full pay 10 weeks' full pay 12 weeks' full pay 14 weeks' full pay 16 weeks' full pay 18 weeks' full pay 20 weeks' full pay	None	

Rowntree Mackintosh	1 year	40 weeks	6 weeks' 90% pay	None	1 month postnatal leave if child dies
London Borough of Camden	1 year	40 weeks	16 weeks' full pay 24 weeks' ½ pay	Return to work	
BBC	1 year 2 years	18 weeks 40 weeks	13 weeks' full pay 1 week's pay for each 4 months of service up to 2 years	Return to work for 3 months	Further unpaid leave on medical or other reasonable grounds
Civil Service	1 year 2 years	6 months 40 weeks	3 months' full pay	Return to work for 3 months	Counts as sick leave.
British Nuclear Fuels	1 year 1 year 2 years	8 weeks 6 months 40 weeks	8 weeks' full pay 13 weeks' full pay	None Return to work for 3 months	Counts as sick leave
British Film Institute	1 year	40 weeks	3 months' full pay	Return to work	Counts as sick leave

Source: Labour Research Department 1980.

industries also pay more than the national minimum. It is still
comparatively rare in private firms but becoming more com-
mon.

Hardly any employers give women longer maternity leave
than twenty-nine weeks after the birth, though this is not so in
other countries.

To find out what you are entitled to, look at your contract of
employment.

How can you improve on your maternity rights in your workplace?

In order to improve your maternity arrangements you will need
to raise the issue with your union (or direct with your employer
if you haven't got one). See p. 89 for whether negotiations
on maternity arrangements will take place at your workplace
or nationally. It is best if you work with a group of fellow-
employees who also feel strongly about this issue.

What kind of improvements should you seek?

You will need to decide what improvements to seek. Here are
some suggestions:

	Present legal minimum terms	*Objectives*
Service requirement	2 years (at 11 weeks before birth)	1 year
Employees covered	Those working 16+ hours a week, or 8–16 hours for 5 years	All part-timers as well as full-timers
Length of payment	6 weeks (at 90% less flat-rate National Insurance benefits)	18 weeks at full pay .

	Present legal minimum terms	Objectives
Length of leave	29 weeks from birth, then return full-time	29 weeks but able to return part-time for further 6–9 months
Health care	Paid leave for antenatal visits	Paid leave for postnatal visits too
Job-back rights	Employer able to offer 'suitable alternative employment'	Employer to keep original job open, and to offer part-time work when requested
Paternity leave	None	2 weeks' paid leave

How do you prepare your case?

When you have decided which improvements you are seeking you will need to be able to justify them. If you are a union member, your shop steward or union official will do the negotiating, but you should still arm yourself with the facts and arguments to help them and persuade them and your fellow-workers that you have a good case.

Use agreements in similar workplaces

One argument for the improvements you are seeking is that other workplaces similar to your own already have them. Look at the list of agreements in Table 14.1. Using this you would be able to point out, if you worked in a publishing house, that the Longman agreement had shorter service qualifications and paid for longer than the legal minimum. If you worked in a hotel, you could point out the agreement at Grand Metropolitan hotels. This list only gives a few agreements. If your industry is not covered ask your union (see p. 322 for further information).

Do the costing

It may help to do a rough costing exercise to work out how much extra the improvements are likely to cost the employer.

Example of a costing exercise

Number qualifying. Your workplace has 400 employees. Over the last three years, an average of fourteen women who left to have babies had been there longer than one year, so number qualifying = 14.

Cost to management. Management claims back six weeks' pay at 9/10ths from the State Maternity Fund. If you are claiming eighteen weeks' pay at six weeks' at 9/10ths less benefit and twelve weeks at full pay less benefit, the cost to management for each woman is twelve weeks' pay less £22.50.

Average earnings are £75.00 a week, so cost to management is (£75 – £22.50 = £52.50) 14 × 12 × £52.50 = £8,820.

Total wage bill (at £75 per worker) = £30,000 per week = £1,560,000 p.a.

Addition: 0.56 per cent.

What arguments can you use?

You may meet opposition not so much because of practical difficulties but because fellow-workers do not agree with the idea of women coming back after maternity leave.

Some common complaints and answers to them are as follows.

Women should give up their jobs when they have children. Their proper place is in the home looking after them.

If you are a union member find out what your union policy is. It will almost certainly be in favour of improved maternity rights and may well have a model maternity agreement setting out its objectives. If it has no specific policy, point out that the TUC policy is for negotiated maternity agreements improving on the law and the rights of mothers to work. You can then argue

to your fellow-trade-union members, and if necessary to your shop steward, that everyone is entitled to his/her personal view on this but as members of the union and representative of members they should report the union policy to make it the woman's choice and not to attempt to choose for her. Point out that some women work because they prefer it to being at home full-time, but many more work in order to maintain themselves and their children. It is estimated that one in three families are kept above the supplementary benefit level by women's wages.

The law goes quite far enough. Why do you want more?

We need improvements if we are not to be a long way behind other European countries, which are constantly improving their laws. In 1980 the law was made worse, not better, so it is no good waiting for the government to bring in improvements. If we win improvements in the workplace, that can be an argument for bringing the law up to the standard of the better workplace agreements. We are already significantly behind standards in other European countries in making it a condition of maternity pay and right to return to the job that a woman should have been employed for two years with the same employer. No other European country has such a condition. Our length of maternity pay, six weeks, is also way below the European average. The legal provisions for maternity should be seen as a minimum to be improved on by negotiations, not a maximum. It is only by gradual improvement that workers have gained paid holidays, sick pay, pensions, and shorter hours. None of these conditions was provided for in law. All were seen as unreasonable demands in their time but are now regarded as necessary.

It costs too much. If the employer pays more on maternity there will be less on wages.

All that part of maternity pay that an employer must pay by law he reclaims from the State Maternity Fund (see p. 204). Each year, fewer than four in 100 women in employment stop work to have a baby, and only half of those who stop qualify for maternity pay and the right to return to work. Use the example of a costing exercise to work out what it is likely to cost your employer. You should be able to show that the additional cost will be a tiny amount compared with that spent on wages.

Finding a replacement during the pregnancy and leave period is too inconvenient, especially as more often than not those women who say they are coming back change their minds.

If an employee is off sick and an employer faces a similar problem without query, why should pregnancy be treated with less consideration? Only about one in four (one in ten in small firms) of those women who are working during their pregnancy say they will return. It is true that many of them do not return in the end. More often than not this is because the opportunities for them to return on shorter hours and the facilities for child-care are lacking. Those employers who provide part-time work, e.g. health and education authorities, have a higher return rate (nearly half the women return, as against the average of one in ten). If your employer wants to make sure that women will return he must make it attractive for them to do so.

It is unfair on the maternity replacement when the permanent worker returns.

Of course this can be a problem, though sensible arrangements for trying to find alternative work for the maternity replacement can usually minimize the difficulties. After all there are many temporary workers, usually to suit the employer's convenience and pocket (see p. 164 on this). Surely safeguarding a mother's job is a more worthwhile cause. All maternity replacements must be told why they are being given the job temporarily and that the woman concerned will be returning to it.

It makes equal opportunities and responsible jobs for women impossible when they keep having babies and disappearing for months.

Very few working women have more than two children. See above for how many women can expect to stop work because of pregnancy in any one year. Where the employer has a good maternity scheme and returning-to-work arrangements, he keeps experienced and trained staff. He does not have the expense of finding permanent replacements. Employers benefit from women having children. They are the future workforce. Why should employers not share in ensuring that mothers are financially and socially secure when they undertake such an important social task?

It is discrimination against men. Women can't have it both ways. Either they are equal or they are not.

Men can benefit too. Part of the claim is for paid paternity and allowed paternity leave. A longer-term aim would be for fathers to be able to take part of the leave instead of mothers if they wanted to. If only more men liked this idea, real sharing of child-care would be a lot nearer.

What about fathers?

There is no legal right to paternity leave, so if fathers are to obtain paid leave it must be through agreements with the employer. Many employers give concessionary leave for a few days at the time of the child's birth. The father has to ask permission; it is usually granted, but he has no right to it. Such concessionary leave is usually paid. Some employers have agreed to paternity leave as a condition of service.

It is suggested on p. 213 that you add a request for paternity leave to your negotiated aims. It is only right that fathers should be involved with their child's birth and around to help for at least the first week or two. In addition, male workers are far more likely to back your campaign for improved maternity rights if they also benefit.

Should fathers' rights stop at one or two weeks' leave?

Is the father's role the occasional helping hand or can he be a 'mother' as well? Women must be at home with their baby in the first few weeks, if only to recover physically from childbirth. Some mothers, though a minority, breast-feed, and they obviously need to be at home for longer. Breast-feeding aside, is there any good reason why maternity leave should not be paternity leave after those first few weeks? Many parents, both men and women, will not like the idea and in that case they would not choose it. But for fathers who want to be the one to look after the baby while it is small and mothers who want to return to work, leave arrangements which cater only for mothers seem unduly restrictive. So the longer-term aim should be to

permit either parent to opt for some of the parental leave.

Do you have to go back to work full-time?

The law does not provide for you to return part-time. Your rights to return to your job only cover you if you want the same job or 'other suitable employment' offered by the employer. Unfortunately you cannot demand to come back on shorter hours. This is why you need to include in your maternity agreement a commitment by your employer to offer part-time employment for at least two or three years. How possible this is and how details will be worked out must depend on the kind of job you were doing. You may be talking about an hour or so less in the day, or moving from a full-time shift to a part-time shift (see p. 164 for more on part-time work). In some workplaces job sharing may be the answer (see p. 177).

What do you do if your employer sacks you when you are pregnant, refuses you paid time off for antenatal care or refuses to pay you?

Not all women receive the maternity pay they are entitled to. Small employers especially do not always pay, and it is their employees, usually non-unionized, who are least likely to know their rights and be able to fight for them. If you do not receive your maternity pay despite your request, first of all make sure your employer is told of your entitlement by an official agency. If you are a union member it should be your union. If not, if you are in a big city there may be a law centre which gives free legal help; otherwise contact a solicitor and ask for him or her to write to your employer under the legal advice and assistance scheme. If you are not working you should not have to pay anything or anything much. An official solicitor's letter sometimes works wonders. Your library will have a list of solicitors indicating those which use the legal advice and assistance scheme. Your Citizens Advice Bureau should be able to help in this way.

You should take the same kind of steps if your employer refuses to give you paid time off for antenatal care.

If all this fails you will have to start a claim in the Industrial Tribunal. This must be done within three months of the refusal to pay.

What if your employer refuses to give you your job back?

If your employer refuses to give you your job back when you are entitled to it by law you can also bring a claim for unfair dismissal. You are treated as if you have been unfairly dismissed as from the date you intended to return. You must make your claim within three months of that date (see p. 408 for details).

What rights does the maternity replacement have?

Your employer may hire someone to take your place during your absence. He should tell her/him before they start work that they are only being employed to replace you during your absence and that you are expected to return not later than twenty-nine weeks from the birth of your baby. As long as the maternity replacement is given this information, the employer can use the fact that she or he is a maternity replacement as a reason to dismiss her/him when you return. However, for such a dismissal to be 'fair' the employer must also show that it is reasonable to dismiss her/him in all the circumstances. So if there were other jobs available that the maternity replacement could do, it would normally not be reasonable, as she/he should be offered an alternative job instead.

To be fair to the maternity replacement your workplace agreement should say that when the permanent employee returns the replacement will be offered any suitable employment, and only if there is none or she/he does not accept it will she/he be dismissed.

CHILDREN AND WORKPLACE NURSERIES

What kind of child-care arrangements are there?

Child-care arrangements are the biggest headache for most working mothers. In a recent survey (1979) of over 1,000 working mothers, better child-care arrangements, particularly workplace crèches or nurseries, were their number-one plea. The granny living round the corner and just waiting to look after the little ones is today a rarity. She is inclined to be working herself and enjoying a liberated life. Successive governments have failed to accept responsibility for ordering society so that there are enough nurseries and so that working hours fit in with child-care arrangements.

In 1977 more than one in four mothers of pre-school-age children were in work at any one time, and just over half of all mothers had had at least one job before their children reached school age.

Blind to these facts, governments persist in only allowing 'safety-net' provision in day nurseries. Only the children of single parents, sick mothers and those who for other reasons just cannot care for their children are considered a priority for places. The working mother outside these categories has to fend for herself among a maze of different arrangements: childminders, private nurseries, nursery centres, nursery schools, community nurseries, play-groups and workplace crèches. Most of these do not cover the full working day: which is why many women choose jobs where the hours fit the opening times of nurseries and schools.

Various forms of child-care come under different central and local-government departments, so there is no one place where you can go and find out what is available in your area, who could take your child, the cost and the suitability.

When your children start school, problems persist. Making

arrangements after school hours or when they are sick or on holiday can be even more difficult.

This chapter takes a detailed look at workplace nurseries. These may not be everyone's choice, but they are the only provision you can try to negotiate from your workplace.

Workplace nurseries

There are only eighty or ninety workplace nurseries in Britain. They may take as few as ten or as many as 120 children, usually between twenty and forty. The children are usually between the ages of two and five, though sometimes younger children will be accepted. How much parents will be charged by the employer varies widely from place to place. Charges are related to the wages of the employees at the workplace concerned. Some central London schemes used by higher-earning parents charge as much as £35 a week.

What are the advantages of a workplace nursery?

The hours are designed to fit your working hours. It means you only have the one journey to work, rather than first taking your child to a child-minder or nursery and then going on to work, which may mean a roundabout and inconvenient trip. Your child is always close to you, and you can see her or him in your lunch break if you want. Unlike child-minders, who may chop and change, a workplace nursery is a stable form of child-care unless the employer decides to close it, or you move. Unlike a day nursery you will not be means-tested to decide how much you pay, and the sum charged should not be too much to afford on your wages.

What are the disadvantages?

If you have to travel a long way to work and you work anti-social hours it may not be good for you or the child to have to take her or him with you. You may not like the idea of a nursery controlled by your employer; and if you lose your job

or decide to leave you also lose your nursery place. You may fear that the attraction of the workplace nursery will allow the employer to get away with low rates of pay and poor terms and conditions.

Unlike day nurseries and nursery schools and classes, there is no set training for staff, and in certain cases you may be worried about the standard of care for the children.

Negotiating a workplace nursery

As there are so few workplace nurseries you are unlikely to find one where you work; if you want one you have to campaign for it. In a period of unemployment, progress is difficult; the crucial reason for employers agreeing to provide a workplace nursery is shortage of labour. But you may be able to argue that your employer needs to retain skilled and valuable employees. Here are some suggestions as to what to do.

Gathering support

Your employer will need to know that the nursery is wanted and will be used. A difficulty in assessing demand is that if you just ask current workers whether they want a nursery you will be asking people who have in general already made child-care arrangements in order to be able to work. Often the greatest need is among prospective employees who at present are stuck at home with their children but would be able to come to work if there was a nursery. Even so, the first step is to ask existing employees if they would use a nursery for their children. You may want to send round a questionnaire to find out details of ages of children; you could also ask women employees whether they are intending to have children and if so whether a nursery would help them in continuing to work. Questionnaires can always be anonymous, as some women would not want their future plans made public.

A workplace nursery should be equally open to children of male workers. Remember to ask them if they would want to use it now or in the future. You may find a surprising amount of

support. If your employer is reluctant to make it available to men, point out that restricting it to women would be a breach of the Sex Discrimination Act.

Identifying prospective employees and showing their need for a workplace nursery is not easy. If your employer needs certain kinds of skills, you or your fellow-workers may know women who could fill those places if a nursery was available. Use general information, such as that provided in the book *Nurseries Now* (see p. 230), to back up your evidence of need.

You can also collect information on the existing nursery provision in your locality to point out how few places there are in day nurseries which cover working hours, and how long the waiting list for places with the local authority is.

Making sure your union supports you

If you belong to a union, you will want to obtain its support, as any workplace nursery will probably need to be negotiated by union representatives. If they support you, it will be far easier to make progress. If you are already an active trade unionist, perhaps a shop steward, you may find that campaigning for a nursery brings in many women who have not been involved in union issues before. A sub-committee of the shop stewards' committee may be a good way of involving women in the early campaigning stage. Some workplaces have set up a separate women's group, for example BBC Crèche Campaign. One difficulty in harnessing enthusiasm is that many working mothers have such a rushed day between work and children that even though they would really value the workplace nursery they do not have the time or energy to pursue a campaign. So careful planning of a committee which combines those who really need it with those who have a bit of time can help.

How should the nursery be run?

Most workplace nurseries are run by the employers, but you can ask for joint union/parental/employer control both in the setting up and in the day-to-day running of the nursery. A committee

of parents, union representatives and management would need to be set up to make sure that everyone is happy about how the nursery is run, and that agreement is reached over the building, equipment, staffing and selection of children. Having parents involved in the management of the nursery should lead to a good relationship between the parents and the staff, not an atmosphere where parents are kept at arm's length. Union involvement can ensure that the employer does not use the nursery as a way of inducing recruits on otherwise low pay and poor conditions but makes this only one of many positive measures to help women employees. (See Chapter 19 on positive action, p. 301.) Unions can also ensure that the staff working in the nursery are paid properly, according to the scale laid down for staff employed in local-authority day nurseries.

How should children be selected and charges set?

When planning your nursery you will need to decide how children should be selected if demand outstrips supply. You can have waiting lists, or you can allocate places according to the seniority of the employee. But either of these methods may mean that parents with the greatest need are left out. Any system of selection is bound to be hard on those excluded. If you cannot provide for all, the needs of the child and the parent, measured on a set scale, may be the fairest criterion. Fixing the charges can also present problems, particularly when earnings vary widely. A fee of £10 a week may be cheap to an employee on £150 a week but expensive to one on £75 a week. In these circumstances fees can be set at a percentage of salary rather than a fixed charge for everyone.

What are the advantages to companies of having a nursery?

A survey of workplace nurseries carried out by Income Data Services in September 1976 reported that 'the relationship of cost and the number of recruits may seem uneconomic as most nurseries are expensive and provide only 20 to 30 places, but the

small number of companies who have tried it have found it worthwhile. None we talked to would consider closing their crèches, even in a period of standstill in recruitment and in some cases redundancies.' The following benefits were mentioned:

1. Recruitment: it works.

2. Retention: mothers are reluctant to leave while the child is happily cared for and learning. The alternative to the mother is probably no job and no income.

3. Stability: not only do the employees stay, but they are likely to be more contented knowing the children are properly looked after.

4. Reduced absenteeism and sick leave: children normally like nursery and this encourages mothers to be at work whenever possible.

5. Career development for women: women have the opportunity to continue and expand their careers with the minimum interruption.

6. Retention of skill and experience: bringing back old staff and so retaining skills and knowledge taught to employees before they started their families.

7. Morale: firms found that the atmosphere improved all round. 'Canteen cook bakes special cakes, carpenter knocks up a few toys, different departments save paper or anything the children could use for collages, etc.'

What about running costs?

Most companies recover between a half and two thirds of the running costs from charges to parents. There should be one member of staff for every five children, plus a matron (though you may be able to manage with fewer staff if there are no children under two). They do not all have to be trained day nurses, though if children under two are accepted there should be a nurse to look after them. You will want most staff to be trained either as nursery nurses or as nursery teachers and paid at an appropriate rate.

One way of reducing costs to employers is for a number of them to share a nursery and the running costs involved. For

example, the Kingsway Nursery in central London, which was set up as a non-profit-making concern by a committee of parents, nursery staff and representatives from each workplace, is used by one local authority, two union headquarters, three TV companies, one magazine and one community action co-ordinating body . . . Costs are high because the premises are in central London, and in 1981 £300 per child per month was charged. Employers pay two thirds of the fees per week and parent/employees pay one third.

What can you say if your employer says no?

Here are some common arguments against workplace nurseries and answers to them, taken from *Workplace Nurseries: A Negotiating Kit* (published by NALGO).

Possible counter-arguments from employers and some suggested replies

(1) *People choose to have children, so they should pay for the costs themselves. After all, they get the benefits of having children.*
An argument used by conservatives in the 19th and early 20th centuries to oppose any kind of welfare state measure, but especially Family Allowances, free State Education and Tax Allowances for children. Fortunately most people realised that society as a whole benefits from somebody bringing up the next generation, and they voted in favour of measures that helped to spread the cost of having children amongst all of us.

(2) *Paying a grant to a nursery would only benefit those employees who could use it, and would therefore discriminate against those without children.*
Another oldie from the conservative opposition to any welfare state measure. Again, most people have rejected this argument, and have voted and bargained for sick pay, unemployment pay, the National Health Service, maternity pay, etc, on the grounds that society should help meet these costs, and that they might need the benefits themselves someday.

(3) *If I pay a grant to a nursery, why shouldn't I pay grants to the wives, relatives, or child-minders of my other employees with children?*
You could. But by contributing to a nursery, you are helping to provide an effective form of child care which

– is run by qualified and experienced child care workers who are not distracted by the job of running a home at the same time as giving care and attention to the children;
– gives children a stimulating social environment that is difficult to provide in the small family home;
– is situated nearby the parent who is working;
– offers the children more space, toys and variety than are usual at home;
– offers a range of adult figures that the child can choose to relate to;
– gives parents the chance to have some break from the 24-hour job of bringing up children to the benefit of both parents and children. (A recent study found that 40% of women at home with under-fives were under treatment for depression);
– is inspected by the Local Authority to ensure high standards.

We would not expect an employer to subsidise a nanny, any more than we would expect the State to pay for a child to have a tutor at home, or to attend a Public School.

(4) *But getting employers to subsidise nursery places is like getting them to pay the public school fees of their employees, isn't it?*
It isn't, because there is no universal provision of State Nurseries to which parents can choose not to send their children. There are not sufficient local authority nurseries for even those single-parent families, and other priority cases, who need them. Setting up private nurseries with the help of employer finance is just one step in the campaign to get more State nurseries.

(5) *We believe the State should provide nurseries, and not employers. Anyway, we thought trade unionists were against tying workers down to particular employers, and against giving employers more sanctions to use against their workers.*
We agree that the State should provide nurseries for all who want them, but we are interested in creating the conditions in which the State will agree to do it. The first step is to:
– get the demand for nursery facilities on the agenda of more people;
– win the arguments against the individual parents having to pay the full costs;
– persuade employers to pay two thirds of the cost of places as an interim step towards all employers paying a nursery levy (which they could recoup by helping to set up nurseries in return for a nursery grant);
– which will itself be an interim step towards the financing of State nurseries through the National Insurance or taxation system.

Once some employers are helping to finance nurseries they then have a mutual interest in sharing the burden with all other employers. The struggle to establish universal State education went through the same kind of process.

During the initial stages of this process it is true that those employers who help with Nursery finance will have greater control over their employees who benefit, and the threat of withdrawing the benefit, or of the sack, will be real. But the same could be said of any benefit that is negotiated from an employer; and the way to reduce the sanction is to get more, and finally all, employers to provide nursery facilities.

By not demanding some employer provision of nursery facilities, whilst waiting for the State to provide, we would be merely reinforcing the status quo.

(6) *I cannot afford a two-thirds block grant, but only a grant that's equivalent to one-third of the cost of places.*

That would not be sufficient to secure places at those Nurseries that are based on the two-thirds principle (e.g. the Kingsway Children's Centre). But a less than two-thirds grant is better than nothing, and could be used to secure places in those nurseries that up until now have been financed solely by parents, or from very low employer contributions.

Checklist for workplace nurseries

Here is a checklist of points you will want to consider to make sure that any workplace nursery is good for the children, parents and staff. It may make a basis for a leaflet to fellow-workers to explain your aims.

1. Open to pre-school-age children of all women and men employees.

2. Charges that all can afford.

3. Controlled jointly by employers/parents/unions.

4. Properly trained staff paid not less than local-authority day nurses.

5. Ratio of staff of one to five.

6. Good play facilities, including outside space and equipment.

7. Educational facilities for older children.

8. Facilities for breast-feeding.

9. Open to school-age children during school holidays.

10. Medical facilities; visits by doctors and nurses.

What about school-age children?

How to look after children during school holidays is a nightmare to many parents. It can be particularly difficult for lone parents with no one to share the load and too little money to pay for child-care. But the difficulty is larger than that. Large numbers of children are left to look after themselves during the working day, and their parents, particularly mothers, feel guilty and anxious. A study by Robin Simpson for the EOC, published in 1978, estimated that at least 300,000 five- to ten-year-olds and 375,000 eleven- to fifteen-year-olds are left during school holidays, and nearly as many are left after school.

As with the care of under-fives, successive governments have ignored the many surveys which have highlighted this situation and called for government action to provide day centres.

Robin Simpson points out the casualties and numbers of road accidents, home accidents and juvenile crime. More mundane, but avoidable, is the loneliness and boredom of the child and the worry and guilt of the mother.

Where can you send school-age children during holidays?

Some local authorities run play centres during school holidays and after school hours. Most of them are in London, where the ILEA caters for around 18,000 children both during holidays and after school.

Play centres are usually located in schools and have paid workers. The ILEA tries to make sure that every child lives within $1\frac{1}{2}$ miles of such a centre, but elsewhere they may be very scarce or non-existent. They make no charge but neither is there any help towards the cost of travelling to school. To find your nearest, ask at your school. Not all play centres are run by the local education authorities. In some areas it is the Social Services, Leisure and Amenities or Borough Engineers departments. There is no reliable register of what schemes there are, nor is there any governmental scheme to expand them.

As well as council centres, there may be holiday play schemes run by voluntary organizations. If your school does not know of them, your council Social Services Department should.

Sources of Information

Hughes, Mayall, Moss, Perry, Petrie and Pinkerton, *Nurseries Now*, Penguin, 1980 (£1.95).

Workplace Nurseries: A Negotiating Kit, NALGO, 1 Mabledon Place, London WC1 9AJ.

Robin Simpson, *Day Care for School Age Children*, EOC (free).

National Children Campaign, 17 Victoria Park Square, London E2 (01 981 1221).

16

WOMEN AND PENSION SCHEMES

ONCE UPON A TIME THERE LIVED AN ANT AND A CRICKET.

THE CRICKET WAS A CARE-FREE SOUL. SHE DANCED HER WAY FROM JOB TO JOB, WITH NO THOUGHT FOR THE MORROW.

THE ANT WORKED HARD, EVER MINDFUL OF THE FUTURE AND ANXIOUS TO AVOID A PENNILESS OLD AGE.

WHEN WINTER CAME THE ANT, EXHAUSTED FROM HER LABOURS, DROPPED DEAD.

NOT, HOWEVER, BEFORE SHE HAD MADE HER WILL LEAVING HER SAVINGS TO THE CRICKET.

AND THE CRICKET LIVED HAPPILY EVER AFTER.

MORAL: SOME CRICKETS HAVE ALL THE LUCK.

Pension schemes are a very complicated subject. This chapter is not a guide to all their complexities, but gives information on particular forms of discrimination against women in pension schemes and what kind of benefits you should try and obtain.

Why bother about pensions?

When you are young it is difficult to apply your mind to a pension. Retirement is such a long time off that it seems a waste of money and energy to campaign for a pension scheme which will eat into your present earnings. It is just as well to face up to the unpalatable fact that we all get older, and because of women's earlier retirement age and longer life expectancy most of us

depend for many years on our retirement income. Whereas nearly one man in three dies before retirement, this is true of only just over one in ten women.

Neither is it a subject you can sensibly defer until a little later, say until you are in your thirties. Both State and occupational pensions are based on a lifetime's earnings. This in itself makes it very difficult for women to benefit equally, since most of them do not earn consistently from leaving school until retirement. It does mean, however, that to benefit as much as possible you have to take your pension seriously when you start work.

To benefit from the State scheme you need to have been employed for most of your life except for years at home looking after children or an invalid (see p. 234) and to have been earning enough to pay National Insurance contributions. At the time of writing you start paying National Insurance contributions when you earn at least £29.50 a week. This figure, which changes from year to year, is known as the lower earnings limit. If you have only a patchy earnings record or have earned below this figure for a large part of your working life you may not be able to benefit from a State pension, nor usually from an occupational pension (see p. 241 for the cash benefits you might receive from an occupational pension). If you are married when you retire you will have to rely on your husband's pension, topped up by Supplementary Benefit if necessary. If single, you will need to claim Supplementary Benefit yourself.

What are the different forms of pensions?

All pensions are a form of deferred earnings. Everyone receives a 'basic' pension from the State. There is also an 'additional' State pension which you may draw, or you may draw the equivalent from your employer under an occupational scheme. An occupational scheme is one set up by your employer and often run by an insurance company. Your employer deducts part of your wages as your pension contribution (unless you are in a non-contributory scheme like the civil service scheme) and pays part himself. The scheme will have its own rules governing how much you pay and what pension you draw. Occupational

schemes sometimes provide an extra pension on top of the basic and additional State pension. So you may be in one of three situations:

1. You only pay National Insurance contributions to the State scheme, in which case you will only draw a State pension. If this is the case, your employer has 'contracted into' the State scheme and there is no occupational scheme.

2. You pay reduced contributions to the State scheme because your employer has 'contracted out' of it, in which case you will receive your basic pension from the State scheme and all your additional pension from your employer.

3. You will receive both the State basic and additional pension and also a further pension from your employer. These schemes are referred to as 'riding on top'. You're paying full contributions to the State and probably a contribution to an occupational scheme as well.

How do State pensions work?

To receive a full State pension you must either have paid or have been credited with National Insurance contributions for nine tenths of your working life.

You will pay a smaller contribution if your employer has contracted out of the State scheme because you will be paying into an occupational scheme as well. You pay 2·15 per cent less National Insurance contributions on earnings above the lower earnings limit and the full amount on your earnings below this. Your employer pays 4·1 per cent less. This amount is meant to provide almost the equivalent to an additional State pension from an occupational scheme.

If you are a married woman who pays the reduced National Insurance contribution (3·2 per cent), this does not count, and you will have to depend on your husband's pension. No one can start paying the 3·2 per cent rate now, but anyone who was already paying it in May 1977 can go on doing so until she is out of employment for two complete consecutive tax years or earns below the lower earnings limit for two years.

What happens if you are at home looking after children?

There are some periods when you are not earning but which still count towards your basic pension, though not towards your earnings-related pension.

The most important of these periods for women is the 'home responsibility' provision introduced by Barbara Castle's Social Security (Pensions) Act 1975. To benefit from 'home responsibility' you must have actually worked for at least twenty years, not necessarily continuously, and have been paying National Insurance contributions at the full rate. You have a home responsibility if you are at home looking after children under sixteen and receiving Child Benefit, or you are looking after someone who is getting an Attendance Allowance, or you are receiving Supplementary Benefit because you are looking after an invalid. Only complete tax years count.

If you are receiving Child Benefit those years will automatically count as years of home responsibility. When your pension entitlement is worked out, the Department of Health and Social Security will add in years you have been drawing Child Benefit as if they were years you were at work and contributing towards your basic pension. In order to benefit from years you were looking after an invalid or someone receiving an Attendance Allowance you must apply at the time to your local DHSS office.

If you want to stay at work while your husband or the father of your child stays at home, he can also claim credits as long as you sign the Child Benefit over to him. To do this, obtain the form from the post office, complete it and send it into your local social security office.

Will you lose pension rights because of unemployment and sickness?

If you sign on as unemployed, or you send a sick note into the social security office, you will be credited for any week you are unemployed or covered by a medical certificate for sickness or pregnancy.

What is the State additional scheme?

The additional State pension was introduced with the Social Security (Pensions) Act 1975, and began to operate in 1978, so, although the first full additional pension will be drawn in 1998, small additional pensions are already being paid.

You contribute $8\frac{3}{4}$ per cent of your earnings, up to a limit of £220 a week. If you are fortunate enough to earn more than £220 a week you do not pay contributions on the surplus. When you come to retire your earnings are then assessed from your P60s and revalued to counteract inflation; then the best twenty years are picked out and averaged, and you are paid one quarter of your earnings between the lower earnings limit (now £32.50 per week) and your actual earnings.

On average earnings and present-day figures this adds a few pounds a week to your basic pension, less if you have not worked for many years, but only of course so long as you have 'twenty best years'; and remember that periods of home responsibilities go only to the basic pension and not an additional one.

If your employer has contracted out of the State scheme will you get as good a pension?

The government has to approve contracted-out occupational schemes to ensure that they do not pay less than the State scheme. But the pension will be calculated on the last few years' earnings, not the best twenty years. It may also be calculated on *basic* earnings, as against total earnings. Either way is usually worse for manual workers than the best twenty years; but they may be better for women who are promoted or get better-paid, more responsible jobs comparatively late in life and whose previous earnings fluctuate. A contracted-out scheme is not allowed to pay you *less* than you would have had from the State, *whatever* its own rules say.

Are many women in occupational pension schemes?

Until fairly recently, women workers were commonly excluded from company pension schemes. Even if allowed to join, they

often had to have longer qualifying service or be older than men, as it was expected that they would leave on marriage or childbirth and would depend on their husband's pension in their old age. Since the Social Security (Pensions) Act 1975, employers have to give women employees equal access. The number of women employees in private occupational schemes has grown from 1,100,000 in 1975 to 1,400,000 in 1979. But the 1979 figure for men at 4,700,000 suggests that indirect ways of excluding women are common, and that many employers with a mainly female workforce do not bother with occupational schemes at all.

Are occupational schemes good for women?

There are drawbacks to occupational schemes for women. Your pension is decided according to what you pay in, and women generally contribute less than men, because of their earlier retirement age, gaps in their working life due to childbirth, and their lower earnings. While the State scheme compensates to some extent for women's life pattern by providing the same State basic pension irrespective of earlier retirement ages and having the 'home responsibility' scheme to provide for women's years at home, the occupational sector still operates on a strictly cash nexus basis. Here are some of the main reasons why women do not do well out of occupational schemes.

Earlier retirement age

The main reason for unequal benefits is women's lower retirement age rather than discrimination in the rules of the schemes. The State retirement age is of course sixty for women, sixty-five for men. This goes for most workplaces too, but not all. The civil service, for example, has a joint retirement age of sixty; so do teachers. TUC policy is that all should retire at sixty, but progress towards this aim is slow. While there are different retirement ages, women's occupational pensions will always be lower, as they will not be contributing for so long even if they work continuously.

All pension schemes must stipulate 'a normal retirement age'. The best policy is to aim for retirement age of sixty for all. Men's retirement age can be reduced gradually over a number of years; if this cannot be achieved a flexible retirement age can give the right either to retire at sixty for both sexes or to continue working to sixty-five.

Management are likely to say that reducing men's retirement age is too expensive. It is worthwhile finding out what the conditions are for top managers' pensions. They are likely to be able to retire at sixty, which will give you an added argument that the same should apply to the rest of the workforce.

Gaps in working life

At present if you spend some years at home looking after children and then return to work you are at a double disadvantage. The years of previous service will not normally count as qualifying service; but if you go back to the same employer (or one that is part of the same pension scheme), previous service of five years or more when contributions have not been refunded or transferred to another scheme could count.

The gap in your contributions will mean a substantially lower pension. There seems no chance that the equivalent of the State home responsibility scheme will be introduced into occupational pensions. The 1976 report of the Occupational Pension Board, when considering this problem, agreed with the CBI that occupational schemes should not be compelled to provide benefits for social reasons. They were against the employer having to bear the cost and said it would mean they were reluctant to employ women.

Lower earnings

If your earnings are below a certain level an occupational pension scheme is most unlikely to be of any benefit to you at all. As a rough rule of thumb, this is true if you earn less than double the lower earnings limit (£32.50 a week in 1983) throughout your working life.

Should you be forced to join a pension scheme?

Most schemes are compulsory and it is a term and condition of employment that you join and pay the standard contribution.

Some schemes are voluntary for people earning below a certain amount, on the basis that it is not really worthwhile for such workers to contribute.

If you are already employed at the time when a scheme is introduced, you cannot normally be compelled to join, as it is not part of your contract of employment. However, many employers just start deducting contributions, and unless you protect straight away you are deemed to have accepted the change.

The more people who join the scheme, the more it is cost-effective and will give you a better pension for your money. The more people who join, however, the more money your employer will have to pay by way of contributions, so he may be very happy to make it voluntary for those in 'women's' jobs or grades or part-timers. If your scheme is a good one it is best if it is compulsory, so everyone can benefit.

Do occupational schemes discriminate against women?

To date the law provides only for equal access, and there are many schemes which still treat women less favourably. Here are some common ways in which pension schemes discriminate and suggestions as to what can be done.

Access to pension schemes

Barbara Castle's Social Security (Pensions) Act 1975 gave women equal access rights to pension schemes, but the equal access rule only covered direct discrimination against women. It therefore became unlawful for a pension scheme to refuse to admit women, or to admit them only at a later age than men. It would also be unlawful to make it a condition of access that women had a longer period of service than men or to say that membership was compulsory for men and voluntary for women. Other conditions for admission to a scheme which in practice excluded

most women continued to be lawful; for example, it remains lawful to open a pension scheme for all those earning above a certain salary, even though they might all be men. It would also be lawful, though uncommon, to limit access to certain occupations, e.g. managerial or technical, excluding other occupations, e.g. clerical. Such access rules would result in nearly all women being excluded.

Many schemes exclude part-timers, who are nearly always women. The scheme may not allow in anyone who works fewer than the standard hours in the workplace, e.g. 40 hours a week. Or it may allow in all those working X hours a week (e.g. twenty-five); or it may make it compulsory for all full-timers and admit on a voluntary basis those who work above a certain number of hours but below the standard hours.

A scheme should allow all part-timers in, perhaps on a voluntary basis for those whose earnings are too low for them to achieve a decent pension. Benefits should be paid on a pro-rata basis.

What do you do if your employer says it is not worth your joining the scheme because it is 'integrated'?

The scheme is 'integrated' if a deduction is made to take account of the State pension you will be receiving. The deduction is either from your earnings before your pension is calculated or from your pension after calculation.

Employers argue that integration is fair because otherwise they would be contributing twice, once towards your State pension and once towards your occupational pension. So they deduct from the contribution to the occupational pension that element which they say you will receive from the State. For example, if your pension scheme guarantees you a retirement pension of one sixtieth of your annual earnings multiplied by a certain number of years of service, your company calculates that proportion of that one sixtieth formula you will receive in your State pension and then only contributes the balance to the occupational pension. Your occupational contribution is correspondingly less also. This has the effect that the company pays a lower proportion on earnings for lower-paid workers than it

does for higher-paid workers, so for women integration is usually a disadvantage. It is particularly a disadvantage to shorter-service workers if the deduction is made from the pension rather than from the earnings.

If your scheme is integrated it may not be worthwhile for the lower-paid to join, as so much of their earnings or pension will be deducted. The answer is to persuade your employer to end integration. If you cannot achieve this, seek to have integration based on deductions from earnings rather than from the pension, which is slightly less disadvantageous, and/or to reduce the level of deduction made. (For further details see Sue Ward's book *Pensions*.)

Can your employer pay you less because you are not contributing to a pension scheme?

Under the Lloyds Bank Pension Scheme all men clerical workers contributed, whatever their age, but women only started to contribute when they were twenty-five. Lloyds Bank paid the men under twenty-five an extra 5 per cent on their gross salary. This was then deducted and paid into the pension scheme. So men and women took home the same pay, but men benefited from the extra pension in due course, and from having a higher gross salary for purposes such as mortgage entitlement or calculation of redundancy pay.

Two women clerical officers, Susan Worringham and Margaret Humphries, brought a claim to an Industrial Tribunal under the Equal Pay Act. Their claim was turned down because the tribunal said the payment related to death or retirement and was therefore excluded from the Equal Pay Act. They appealed and their case went through the Employment Appeal Tribunal to the Court of Appeal and finally to the European Court of Justice. They argued before the European Court of Justice that the Equal Pay Act's exclusion of such payments was contrary to Article 119 of the Rome Treaty, which entitles women to equal pay for the same or equal work and has no exceptions. The European Court of Justice said that the employers' 5-per-cent payment was 'pay', therefore within Article 119. They said that

a claim to that effect could be brought in the British Courts despite our Equal Pay Act. This decision would apply to any contribution by an employer to a pension scheme if it was paid by way of gross salary, but this does not generally happen.

Death benefits in pension schemes

These can be either paid for death in service or on retirement.

1. In service

A scheme does not have to provide a lump-sum benefit on death in service, though it must provide a widow's pension if it is a contracted-out pension scheme.

Many schemes do have a lump-sum benefit. Such sums can be made up to four times the annual salary (or £5,000 if that is greater). The lump-sum benefit will be tax-free.

Trustees have a discretion to decide who will receive the payment. The sum is normally paid to the widow or other named individual. Women can name their husbands. Some schemes discriminate in giving a larger sum in benefit to men than women, or to married men than to single men or women. Such discrimination ignores the fact that many women have dependants, parents, husbands, children, etc. and it may not be only the married man whose earnings go to support the family.

Try to make sure your pension scheme gives equal benefits for women, and that all part-timers are also covered.

Whereas other parts of the pension scheme may be difficult to change, the death benefit payment is usually separately insured and changing it only means an increase in the premium.

You need also to check that nominating the person to benefit is simple to do, updated regularly, and is kept confidential.

2. On retirement

Many schemes also provide an option to commute part of the pension into a lump sum on retirement. In 1971 this was so in about one in three schemes. Most schemes make this offer to

both men and women on equal terms. When it comes to calculating the sum to be received, women usually receive a larger lump sum in relation to the amount of pension given up than men, as women's earlier retirement age and longer life expectancy mean that they would be drawing their pension for a longer time.

Additional voluntary contributions

Some schemes permit the purchase of additional benefits by the payment of increased contributions. Usually these are more expensive for women than men, for the same reasons, i.e. their earlier retirement age and longer life expectancy. But some unions have managed to negotiate equal contributions for their women members. This is so in the National Health Service.

What should you look for in cash benefit schemes?

Some schemes provide a lump sum on retirement rather than a pension. This can be popular with part-time workers who will not contribute enough to make a full pension worthwhile. It is usually paid in full after forty years' service, but some schemes allow an accelerated payment after twenty years. This means that you get the full sum after twenty years' service and no more for longer service. It is important for women that provision is made for an accelerated payment, as so many will not complete forty years. If you do not complete the specified period of service you only get a smaller lump sum.

What happens if you leave your job?

Women leave their jobs more often than men do, so this is an important question.

If you have contributed for more than five years you do not get your pension contributions back for any years after 1975. They are either kept in the pension scheme and paid to you when you retire, or they are transferred with you to the pension scheme of your new employer.

If you are in a contracted-out scheme you do not get your full contributions back even if you work fewer than five years. They may be kept in the pension scheme until you retire, or more usually a proportion is paid to reinstate you for the State pension. You will be paid a cash sum for any surplus after deduction of 10-per-cent income tax.

In 1981 the Occupational Pension Board called for better protection for people who change jobs, since the effects of the present system are disastrous for men and even worse for women.

If you leave your job often, and after service of fewer than five years, your pension is not preserved at all. When your contributions are kept in the pension scheme, the pension you will eventually be entitled to may only be related to your leaving salary, with no increase for inflation or the higher salary you would later earn owing to seniority or promotion. In 1980 only about half of all private-sector pensions were uprated at all, and on average they only gave 55–60 per cent of the cost-of-living increase. The present system is particularly unsatisfactory for women, as they are likely to pay a considerable proportion of their pension contributions when they are young and working full-time before having children. The Government Actuary has assessed that if women drew out of pension schemes their fair share of the contributions they have paid in, they should receive 30 per cent of the amount paid to men. They only receive 20 per cent.

In the future some radical change in pension schemes will be needed so that the contributions of employees who change employers and do not work full-time for forty years are fully utilized to provide a decent pension on retirement. Given the present unsatisfactory situation, seek to ensure that your pension scheme does uprate preserved pensions by the full cost of inflation.

Widows' and widowers' pensions

Contracted-out pension schemes must by law provide a widow's pension up to a certain level. The level set is equivalent to half the State additional pension. The other half is paid by the State.

This amount must be paid to the legal widow even if she was not living with the member and he wanted it paid to somebody else. If the pension scheme provides a more generous widow's pension, the surplus can be paid to someone else.

Private schemes do not have to provide widowers' pensions, though the State scheme does for a widower over retirement age when his wife dies. In 1979 a survey showed that in only just over half of the schemes was a widower's pension provided, and in these cases it was usually paid only if he was a dependant. In about one in five cases widowers automatically received a pension, irrespective of dependency. It is quite cheap to provide for widowers' pensions because few women die in service; the lower retirement age and longer life expectancy mean that most of us live well into our retirement. The Occupational Pension Board report in 1976 recommended that widowers' pensions should be introduced, but no action has been taken. The only equitable solution is to treat all employees and their spouses equally, regardless of sex. You may need to argue for widowers' pensions with consultants and insurance companies' representatives whom your employer will bring in to negotiations. They may be surprised to hear that you have gathered support for your view, so evidence that other women employees feel strongly on the issue will be helpful.

It may be argued against you that because women live longer than men, the extra risk of having to pay widows' pensions means that overall men and women are an equal cost. But in general these kinds of argument are not used to make one group of workers pay more or get less than another group of workers. For example, men doing heavy manual work will on average die sooner than men in better-paid sedentary work, yet this is not used as an argument for differential treatment in pension schemes.

What about provisions for widows?

Some pension schemes have a 'remarriage' clause taking the pension away if the widow remarries. Others deny a pension to a wife who has concluded a 'death-bed marriage', even if she

had lived with the man for years beforehand. Common-law wives may get nothing unless the pension scheme allows pensions to other dependants as well as widows or widowers. To make sure that your pension scheme is fair to all women, these provisions need to be challenged.

How are pregnancy and maternity treated?

Your absence from work because of pregnancy and maternity cannot by law break your membership of the pension scheme. You are protected by the Maternity Provisions in the Employment Act (see p. 208). As long as you return to the same employer your period of service will be counted as continuous. But unless your pension scheme provides for your employer to continue contributions during a period of unpaid absence, any week you are absent and not being paid will not count towards your pension entitlement. During weeks when you are receiving maternity pay, both you and your employer will continue paying the contributions.

Some schemes allow women returning to work to pay their contributions for the period they were away. On payment the employer pays his share. This should be pressed for in all pension schemes so that absence need not mean a lower pension on retirement. Ideally the employer pays all outstanding contributions, as women may well be short of money when they return to work. The Occupational Pension Board in 1976 reported one employer which did so. Other schemes, for example the NHS, make women pay their contributions even during a period of unpaid leave.

How do you find out about your pension scheme?

Your 'statement of terms and conditions' or contract of employment will tell you whether there is an occupational pension scheme and where you can get full details of the scheme. Every scheme should have a booklet explaining it; if you have not been given a copy, ask personnel or the pension department. This should explain what sort of scheme it is, the contribution rate,

and the benefits it provides. If you want advice on it, ask your shop steward. If she/he does not have the answer your head union office may be able to help.

The TUC and some individual unions, such as the GMB run courses on pension schemes. If you are a shop steward or staff representative, you are entitled to paid time off to attend. This is so even if, when you go to the course, your employer says the scheme is 'not negotiable', and you have not yet raised the matter in negotiations.

Mrs Young was a shop steward at Carr Fasteners Ltd in Yorkshire. Her company did not admit women to the company's pension scheme until the Social Security (Pensions) Act made it obligatory for them to be admitted on the same terms as men. When her women members had pension contributions stopped from their wages for the first time, they asked Mrs Young to explain the scheme to them; the management explanations did not satisfy them and Mrs Young could not help much herself. So she applied to go on the union's pension course lasting one week in a residential college. She asked her employer for paid time off. Her employers allowed her time off but refused to pay. The scheme, they said, was not negotiable, being administered by trustees, so information on pensions was not relevant to her industrial-relations duties as a steward. Not satisfied, she brought her claim for pay to an Industrial Tribunal, which agreed with the employer; but the Employment Appeal Tribunal said that Mrs Young had to explain the pension scheme to her members and prepare herself for future negotiations. Pensions were deferred pay and a proper matter for negotiations, and she should be paid and allowed to go on the course.

How do you go about changing your pension scheme?

Having gained sufficient information you need to consider how your scheme is run, and what member participation or rights of negotiations there are.

Pension schemes are administered by trustees who look after the pension funds, decide on investment policy and supervise the administration. The day-to-day running is done by paid per-

sonnel, usually a pension manager. However your company is organized in other areas, pension decisions will usually be highly centralized and taken at a corporate level. So even if wages and conditions are decided locally, pensions will be a head-office matter.

Some pension schemes will have one or more 'member trustees' chosen from among the workforce, though there is no legal obligation for worker participation in this way. Where there are member trustees they could be selected by a ballot of the whole workforce, or by indirect election by delegate conference or other union representative meeting, or sometimes they are jointly selected by management and unions. So raising questions with your member trustee, or indeed being one yourself, is one way to get your views heard. Member trustees can at least raise issues at trustees' meetings, though their power to change schemes is very restricted. The function of trustees is to administer schemes, not to change them. They can recommend changes to the employer, who has the final say.

Only some managements agree to negotiate about pensions. There is no good reason for this attitude, as it is generally accepted that pensions are deferred pay. After all the pension scheme deploys money taken from your earnings as well as your employer's contributions, and it is your standard of living that will be affected by their decision.

One of the difficulties over negotiations is that decisions about pensions will be taken at corporate level, whereas other negotiations may be at plant level, so no appropriate union/management structure for pension negotiations may exist. Gradually more companies are agreeing negotiating rights on pensions. Where negotiations do take place you will need to know who makes up the union side. It may be a national official or representatives from the combined shop-stewards' committee, or a national official plus lay representatives. You will then need to feed in your ideas through your local representatives. The first step may be to persuade them to give more information to you and other union members on the scheme, and to tell you how it discriminates against women. This in itself can be a useful start in building up pressure to change.

You will need to bear in mind that pension schemes will cover all unions in your workplace and company, so in campaigning for change they will need to be involved.

Pensions and equality – a checklist

1. Entry

(i) Legally your pension scheme *must* admit men and women on the same conditions of age, qualifying service, and whether entry is voluntary or compulsory.

(ii) But the scheme *can* legally be restricted to full-time workers only. Try to get *all part-time workers* included; if you can't, include part-timers in the *life assurance* at least.

(iii) The scheme *can* legally exclude people earning below a certain wage/salary level. Try to extend to *everyone*.

2. Retirement age

Most schemes have different retirement ages for men and women. Try to negotiate an *equal retirement age* by reducing the men's retirement age. If you can't, try for no actuarial reduction in the pensions of men retiring between sixty and sixty-five.

3. Different contribution rates

Some schemes still have different rates for men and women; often married men have to pay higher contributions. Contribution rates should be the *same* for everyone.

4. Benefits on death of member

Death benefits are sometimes higher for married men. They should be the *same* for everyone.

Some schemes give *widows'* pensions only, but impose *con-*

ditions (e.g. age limit, or remarriage or cohabitation clause). You should:

(i) try to get pensions for *widowers* too;

(ii) try to get the *conditions* removed;

(iii) negotiate for a pension for a *'nominated dependant'* if there is no spouse;

(iv) ensure that women should *also* get children's and orphans' pensions if these are paid.

5. *Maternity*

Women on maternity leave should be able to *keep their right* to a pension. If a woman comes back, there should be *no break* in 'pensionable service'. If the company is paying her wages, her contributions and the employer's should go on being deducted. If she is not being paid, she should be able to make up her contributions when she comes back, with the company paying theirs. She should have full life-assurance cover, including pregnancy and childbirth-related death.

Sources of information

Sue Ward, *Pensions*, Pluto Press, 1981 (£3.95).
Equal Status for Men and Women in Occupational Pension Schemes (the 1976 report of the Occupational Pension Board), HMSO (£2.60).

WORKPLACE HAZARDS

What are the main health and safety risks facing women at work?

The risks to your health will depend upon where you work. Many women who work in factories, transport, catering and some Health Service jobs will suffer from working long hours, often at anti-social times. You may work with dangerous machinery or be exposed to harmful substances, dusty conditions or fumes with no adequate ventilation. Noise levels in many industrial environments cause permanent hearing loss; eye-strain results from bad lighting when engaged on detailed work; lifting or moving heavy weights leads to back or other injuries.

Office work is apparently less hazardous and less likely to lead to accidents, but bad lighting, poor seating, fumes from the photocopier, unsafe filing cabinets, the newly discovered risks of VDUs, plus the overcrowding and generally bad working conditions of many small and not so small offices, too often lead to all kinds of ill health and stress.

Wherever women work many of them are likely to be partic-

ularly under stress because of their double workload. Many men whose physical working conditions may be as bad can at least put their feet up when they have gone home or go to the pub for relaxation. Many women, having done a hard stint at home before arriving at work, rush home at the end of the day to get the family meal and then do housework with little or no break at all. This makes it very important that the working day contains adequate rest spells and meal breaks when women workers do stop working, have a meal, socialize and relax. It may be the only opportunity they have until late-evening TV before bedtime.

This chapter does not detail all the workplace health risks and remedies. See p. 280 for fuller sources of information. It does look at how you can organize to improve your working conditions and describes some particular health and safety questions which face women. To make headway on health and safety issues you need a representative to raise the problems with management, information on what the risks are, and the involvement of other workers in deciding what improvements would help and then working to get them.

What are safety representatives and what can they do?

Safety representatives are the staff representatives or shop stewards for health and safety. If your employer recognizes your union (see p. 89) you have a legal right to elect a safety representative to represent you. Once management is told by the union who the safety representatives are for each department or section, they must let them investigate complaints, dangerous occurences, potential hazards and accidents. Safety representatives can also inspect the workplace every three months, or more often if there have been changes which make it necessary. They can get information from the employer on accidents, risks, and what substances are used in the workplace. Safety representatives are entitled to paid time off to attend trade-union training courses on health and safety and what their job is. All these rights are laid down in the Health and Safety at Work Act 1974, and the Safety Representatives and Safety Committee Regu-

lations 1977. The Regulations say that if the union wants a union/management safety committee to discuss safety issues, management must set one up.

If you do not have a union recognized at your workplace your employers should still involve you in health and safety questions and obtain your co-operation in improving safety standards. There is a free pamphlet, *Safety Committees* (HSC 8), which sets out these duties. Raising health and safety issues with your employer through a chosen representative may lead to your union being recognized and so allow it the full rights of having a safety representative.

What must your employer do to make your work safe?

The Health and Safety at Work Act says that your employer should ensure your safety, health and welfare at work. Inclusion of the word 'welfare' should cover wider questions such as antenatal leave arrangements, other paid leave for doctors' visits and health check-ups, and could cover protection from sexual harassment (see p. 269).

These general duties mean that your employer should provide safe equipment, safe ways of doing jobs; make sure that the use, storage and transport of substances is safe; and give you the information, instruction, training and supervision you need to work safely. For example, if you have to lift weights you should be trained to do it so you do not risk a back injury. If you are using a cleaning agent which should not touch your skin you should be warned of the risks and be given proper protective clothing.

Your employer must make sure that the workplace is safe, that the floor space is clear and clean, there are no trailing wires, and that entries and exits, stairs and passageways are not obstructed. The working environment should also be safe. This covers adequate ventilation, lighting and heating, and obliges the employer to make sure that noise levels and fumes are not dangerous.

All employers must have a written safety policy setting out what risks the workforce face, how they have planned to deal

with them, and which management personnel are responsible for carrying out the policy. It should include arrangements for training, record-keeping and investigation into accidents, and provide full information for safety representatives. If you have not seen your employer's safety policy, asking to see it and deciding whether it is adequate are the first step in improving your conditions. Your union can also negotiate a health and safety agreement, which can include safeguards not detailed in the law.

What laws treat women differently from men on health and safety grounds?

The Factories Act and some other Acts set maximum working hours for women factory workers and restrict their employment on shifts or night work. In a few industries there are legal limits on the weights that workers can lift, and those limits are lower for women than for men. There are also special provisions for limiting the exposure of women workers to certain substances which may cause reproductive hazards.

What are the limits on hours that factory women may work?

These limits can be found in the Factories Act 1961, Employment of Women, Young Persons and Children Act 1920, Hours of Employment (Conventions) Act 1936. The restrictions in the Factories Act apply only to women engaged in manual labour in factories; they exclude women cleaners and women in responsible supervisory positions who do not do manual work. The restrictions on hours that women can work are set out in Table 17.1. Some overtime is permitted (see Table 17.2), and there are a number of other exceptions to the general rules; the most important ones are:

1. Other overtime

Extra overtime within set limits can be permitted for seasonal work, cases of emergency, or by reference to an individual.

Table 17.1: *Factories Act 1961 – Employment of women and young persons in factories*

	Six-day week	Five-day week
Period of employment on weekdays	Not more than 11 hours between 7 a.m. and 8 p.m. (not after 6 p.m. for YPs under 16)	Not more than 12 hours between 7 a.m. and 8 p.m. (7 a.m. – 6 p.m. for YPs under 16)
Period of employment on short day	Not more than 6 hours between 7 a.m. and 1 p.m.	
Maximum daily working hours (excl. intervals)	9 hours	10 hours
Maximum weekly working hours (excl. intervals)	48 hours (44 for YPs under 16)	48 hours (44 hours for YPs under 16)
Maximum continuous spell without a break of at least $\frac{1}{2}$ hour	$4\frac{1}{2}$ hours (may be increased to 5 hours if 10-minute break allowed)	$4\frac{1}{2}$ hours

2. Early starting

Employers may be allowed to employ women from 6 a.m. rather than 7 a.m. for trade purposes or the convenience of the employees.

3. Double day shifts

The Secretary of State for Employment may authorize the permanent employment of women on a double day shift system, provided the shifts do not begin before 6 a.m. nor end after 10 p.m. (2 p.m. on Saturday) and the hours of each shift do not exceed an average of eight hours a day. Before authorization is granted, the workers concerned should be fully informed of the

Table 17.2: *Permitted overtime – women in all factories*

	Six-day week	Five-day week
Maximum amount per week for factory	6 hours	6 hours
Maximum amount per year for factory	100 hours in not more than 25 weeks per year	100 hours in not more than 25 weeks per year
Period of employment including overtime – weekday	Not more than 12 hours between 7 a.m. and 9 p.m. (8 p.m. for YPs)	Not more than 12 hours between 7 a.m. and 9 p.m. (8 p.m. for YPs)
Period of employment including overtime – Saturday	Not more than 6 hours between 7 a.m. and 1 p.m.	Not more than 4½ hours between 7 a.m. and 1 p.m. if no other overtime worked in that week
Maximum daily working hours	10 hours	10½ hours. No Saturday overtime if more than 10 hours worked in any day

proposed shift system and consulted by secret ballot. A majority must be in favour. In the case of a new factory which is about to be, or has recently been, established, the employer need not hold a ballot.

4. Special processes

Women may work for longer hours in laundries, bread and flour confectionery, preserving fish, fruit and vegetables, and in factories treating milk.

Before using any of these exceptions the employer must notify the District Inspector a week in advance and post a notice in the factory.

Can an employer obtain permission for women to work on nights and shifts outside these hours?

The law allows employers to apply to the Health and Safety Executive for 'exemption orders' which permit the employment of women on night work or shifts which start before 7 a.m. or continue after 8 p.m., or involve longer working spells than those normally permitted. *General exemption orders* cover a whole industry or section of industry. They are made by ministerial regulation on application by a Joint Industrial Council, Wages Council, a Conciliation Board or other organization representing employers or workers. At present there is only one general exemption order, which permits women in the cotton industry to be employed for a continuous spell of five hours without a break. *Special exemption orders* apply to individual factories and must be renewed every year. (See p. 259 for details on application.)

How many women are affected by legal limits on hours?

There are about 900,000 full-time women manual workers in production industries covered by the legal limits on hours. So nearly half of all female manual workers and 17 per cent of all women workers are affected.

Most women workers have no legal limits on the hours they work. Outside factories, many women employed in transport work before 7 a.m. and after 8 p.m., as do women workers in nursing, ancillary workers in hospitals, workers in residential homes, cleaners and kitchen workers. For these women there are no legal restrictions. Among women office workers, overtime and shift work is generally uncommon, but computer staff may have to work shifts on a regular basis with no legal restrictions.

Of those women who do work in factories many are covered by exemption orders and therefore work shifts.

In 1981 a total of 185,769 women were covered by special exemption orders to work hours outside the normal legal limit. Of these 57,709 women were on night shift, 31,206 on double day shifts (6 a.m. to 2 p.m. and 2 to 10 p.m.), and 47,103 on Sunday work.

In addition, around 80,000 workers have permanent authorization to work double day shifts; so nearly one in three of the women who are covered by the Factories Act are exempt in some way. This number has doubled over the last five years.

Is shift working bad for health?

Some health and safety experts consider that shift working is bad for workers; others say the evidence is inconclusive. Indications that it is bad for health include the higher rates of gastric and duodenal ulcers, more nervous disorders, and sleep disruption, particularly among older shift workers.

There is little evidence that women workers' health is more or less affected than men's by working shifts. It may be that the subject has not been properly studied. As in many other areas, experts are inclined to assume that workers are male.

Many women who work shifts try to fit the working pattern in with their family life. Often no working hours are positively convenient, so they choose the least awkward. They may decide to work the same shift as their husband, or a different one so he can care for the children. The difficulty with this is that there is very little time together with the children or on your own with your husband. You may literally pass in the night. Women with small children may go on to a part-time shift, returning to work all day when their children are older and expense overtakes physical care as the pressing need. A study of women workers in three factories in 1981 where some women worked a morning shift, some all day, and some evening, reported:

How to meet family commitments in relation to their job was a constant source of concern, giving the impression of finely balanced arrangements which, if disrupted or upset, could cause major problems. One company nurse mentioned several complaints of dysmenorrhoea, and emotional stress caused by worry about the welfare of children during the day, husbands, relatives and other cares. These, taken in conjunction with the pressures on the job itself – she had many cases of women 'wanting to get away from the line' with headaches and depression – led her to comment 'All women are under stress, but *have* to cope.'

One woman reported:

I think basically it is working full-time and then going home and you see things that haven't been done and have got to be done, and meals to be cooked. It's a bit of a drudgery, you know, doing two jobs. You can't sort of say, oh I am going out for the night. I suppose you could, you know, but, like, your husband will say, 'My mates asked me to go for a drink', and he's gone. He's had his dinner and he's gone. Whereas you think, oh I've a pile of ironing to do there; if I don't do it perhaps it won't get done, or something like that. I suppose you can make yourself a martyr and you shouldn't do really, should you, you know. But I think this all builds up inside you till you explode.

Most of the women interviewed received little assistance with housework from their husbands or older children. Ninety-three per cent of 394 women in one factory reported that, when not at work, the bulk of their time was taken up with housework, cooking and childcare.

None of these women were working nights or continuous shifts. If they had been it seems only too likely that their stress would be worse.

It is difficult to separate health risks from the social effects of working evenings and nights. Shift patterns vary in the degree of social disruption they cause. The most disruptive is a rotating continuous shift. Shift hours are continually changing, so no regular outside commitments or family patterns can be established, and your body never has the chance to accustom itself to your working day. Compared with this, a regular double day shift (6 a.m. to 2 p.m., or 2 to 10 p.m.) is not nearly so disrupting, though any shift which involves evening working robs you of the most social part of the day, the family evening meal, children's bedtimes, and social events. This is also true of 'split shift' working, common among workers in residential homes and hotels. Permanent night shift seems attractive to some as giving freedom in daylight hours. Work routine on nights is usually more lax, but very few night workers really feel healthy, and starting work at 10 p.m. prevents any social, union, or political activity which extends much beyond 9 p.m.

Shift workers on nights and rotating shifts are of course paid more than day workers, and when the money is essential, choice seems a luxury.

What say do women factory workers have as to whether they work shifts or nights?

Your employer can apply to the Health and Safety Executive for a special exemption order to cover your workplace. He must show that it is in the public interest, for the purpose of maintaining the efficiency of industry or transport. Note that your well-being and wishes are not grounds for application. Indeed, you have very few rights in the whole process. Your employer must say what arrangements have been made for supervising the women workers and what facilities will be available for meals and transport. A local inspector then has the job of checking the application and coming to the workplace to inspect the working conditions. He should talk to any representatives of the trade unions and consult a number of the women concerned. This is not laid down in the Act, but just a normal way of dealing with these applications. The inspector has the power to grant the order but not refuse it. If he meets strong objections from workers or the union, or if the application asks for very extended hours of work, he may refer it to the Health and Safety Executive Headquarters in London. In practice very few applications for an exemption order are refused, though if there are strong objections from the workforce the employer may withdraw the application.

An application may be granted on certain conditions such as that shift work will be on a volunteer basis or for new employees who have agreed to the new working when recruited. There are essential safeguards for existing workers, and you should press for them in all circumstances. You can also press for better canteen facilities and transport for those who do work shifts.

What can you do if your employer tries to make you work shifts?

If an exemption order is granted not on these conditions, your employer may seek to change the working hours of women workers so that they all have to work shifts or be available to work shifts when required. To change the hours of workers he

must either obtain their consent or if they do not agree give proper notice to end their existing contract and offer new contracts on the amended terms. If women refuse to work the new hours they are unlikely to be entitled either to redundancy pay or to unfair dismissal compensation as long as the employer can show that the change in working hours is necessary for efficient production and that he consulted the workers affected and tried to reach agreement.

As many women have chosen hours of work to fit in with their domestic arrangements they often find it very difficult to change to shift working. Often women workers do consider the quality of life outside work more important than earning more money or keeping their job. But this does not mean that they want to lose their job, or can afford to be without it. One result of widespread exemption orders is to narrow the employment opportunities of women who are not able to work on shifts.

Can you make your employer apply for an exemption order so that you can work on shifts?

As the law now stands, neither workers nor union can apply for exemption orders, only employers. You may be able to get your union to help you in pressing your employer to apply. You can point out that a special exemption order need not cover all women workers; particular women can be specified. Unfortunately neither the Sex Discrimination Act nor the Equal Pay Act requires an employer to apply for an exemption order when women ask for it to obtain access to particular jobs or equal pay. But the option is there. If you are pressing for an exemption order remember that if it covers all women it can have the effect of forcing other women to work hours which are unpopular with them.

Do we need the legal limits on women's working hours any longer?

Some organizations and individuals consider the whole concept of legal limitations on women's working hours is outmoded. They argue that now that women have equal pay and are pro-

tected from sex discrimination they should not be treated any differently from men.

The Equal Opportunities Commission recommends a repeal of the laws. If they were repealed it would have the effect of driving some women who do not want shift work out of factory work. The EOC recognizes this and says they should be given redundancy pay, but even if this recommendation was adopted they would still lose their jobs. Of those left, some would not want their new hours but be forced to accept them as an alternative to the sack.

The EOC also suggests a code of practice which would recommend that:

1. Shift work should be introduced only after the views of the workers affected are fully taken into account.

2. Other 'minimum welfare' conditions were met.

3. There was scope for hours preferences for workers with substantial domestic commitments, especially the care of young children.

The first two recommendations are already the requirements of the Health and Safety Executive, so would not be any advance. Such a code would be advisory only and not enforceable. There would be no guarantees that employers would follow its recommendations.

It is true that working conditions have improved immensely since the nineteenth century, but, as the description of the life of women factory workers on p. 257 illustrates, the dual workload is still an everyday fact of life which severely limits women's choice of working hours and the kinds of job they can do. If all legal restrictions on hours of work were removed it would be employers who decided which shift pattern they wanted, with no say for women workers. It would be more likely to result in shift patterns that many women could not work than to give them more lucrative job opportunities.

Could the legal restrictions on hours that factory women work be changed for the better?

Yet some changes are overdue. In their present form the legal restrictions prevent women's access to some better-paid and

more skilled manual jobs. They give women no right to apply for exemption orders. They add to divisions between the sexes, both at home and work. While women's job opportunities are restricted many men work shift patterns which make it difficult for them to play a full role at home or share in their family's social life.

There are a number of short-term improvements that could be made. Women in a workplace should be able to initiate applications for exemption when they wanted access to shift work. It should not be possible for an employer to excuse himself from meeting an equal-pay claim or allowing access to a particular job by saying that he was prevented from doing so by the Factories Act. He should be obliged to apply for an exemption order when necessary. Any exemption orders granted should give existing women employees the choice of retaining their present hours or going on shift work, when and if available.

Apprenticeship and any other employee training which requires shift working should automatically be exempt from restrictions for girls.

More fundamental improvements would be directed to restricting shift working for both sexes as far as possible. Greater automation is feared as causing unemployment, but one benefit should be a decreasing need for large numbers of workers to be robbed of a natural life pattern by the need constantly to mind machinery. British employers may say that moves to limit shift work are uneconomic and would make our industry even less competitive. But in Sweden night work is almost totally forbidden for both sexes unless there is an agreement negotiated with the union allowing it, or most workers in a workplace want it. In Norway it is allowed only for essential maintenance and continuous processes. In Germany and France exemptions are more difficult to obtain than here.

So there are such laws in most of Europe, and the EEC may soon pass a directive imposing it on all member countries. Many trade unionists have always argued that the legal limits on women working should be extended to all men. Now the trade unions are debating whether or not there should be a law limiting the working hours of all workers, male and female and whatever

the workplace. Such a law would improve working life for both sexes and ensure equal opportunities for women.

Where shift work is necessary, whether in factories, the health service, transport or elsewhere, it should be a condition of service that employees with domestic responsibilities have first option to hours which enable them to look after their children (or other dependent relatives, such as aged parents). In many workplaces where there is shift working, employees who are disabled or otherwise not fit to work shifts are given preferential access to day work. It should be possible to extend this treatment to those with small children or other family members needing care. Such a system, if open to either parent, would be a move away from the assumption that it is always the mother who has responsibility for child-care.

These changes, combined with wider child-care provisions, would create the circumstances for the present outdated restrictions based on sex to be repealed without adversely affecting women workers.

What legal restrictions are there on lifting weights?

Only a few industries have regulations setting limits on lifting. For women workers in woollen and worsted textiles and jute the maximum load is 65 lbs if compact weight, 50 lbs if not. In the pottery industry a 30-lb weight limit is set for a woman lifting on her own. Other factory workers, men and women, are covered by the rule in the Factories Act that no employees should carry, lift, or move a load likely to cause injury to them. The Health and Safety Executive proposes new regulations which would repeal the present limits and replace them with a general rule similar to the one in the Factories Act, backed up with practical suggestions as to what employers should do. It is not known when the new regulations will be passed.

How can you judge what lifting is safe?

The best general guide on lifting is provided by the International Labour Office. It recommends the following reasonable weight limits for occasional lifting by any method:

Age (years)	Men	Women
14–16	15 kg (33 lbs)	10 kg (22 lbs)
16–18	19 kg (42 lbs)	12 kg (25.5 lbs)
18–20	23 kg (51 lbs)	14 kg (31 lbs)
20–35	25 kg (55 lbs)	15 kg (33 lbs)
35–50	21 kg (46 lbs)	13 kg (29 lbs)
Over 50	16 kg (35 lbs)	10 kg (22 lbs)

If you lift frequently, reduce these figures by 25 per cent. Any worker lifting heavier loads should be specially selected and trained. Over a quarter of all accidents reported to the Health and Safety Executive are a result of lifting or moving goods, so care is worthwhile.

What can you do if you are asked to move or lift loads that are too heavy for you?

Any attempt to make a worker carry out a task which is too heavy for her or him is in breach of the rule in the Factories Act explained above. If your workplace has a union you should raise the complaint with your union safety representative. Most heavy tasks can be made lighter by breaking the loads down into smaller units, or by the use of mechanical lifting aids or more workers to lift. When lifting is required both sexes should be trained how to do it.

Can lifting requirements bar women from jobs or prevent them getting equal pay?

Sometimes when women ask for equal pay or want to do a higher-paid job previously done by men, they are put off by being told that in that case they will have to do all the heavy tasks that men do. This may mean that the help of the labourer to move heavy items is to be taken away, or that women are to be asked to do some tasks that have been previously restricted to men.

If tasks are too heavy for some women they are probably also too heavy for some men. So you should seek to reduce the heavy

element as suggested above. In the meantime do not let yourself be bullied into doing tasks too heavy for you. Lifting heavy weights does no one any good. Even if you don't seem to be affected by it at the time, you will probably suffer later on in life. When you look into it you will probably find that there are men who were not strong enough to do all the heavy tasks and have been allocated lighter work. You should be treated with equal consideration.

Exposure to dangerous substances

What special legal rules affect women?

There are regulations setting lower limits on women workers' exposure to radiation. This would affect some medical workers and those in the nuclear-power industry, for example. There is a stricter limit on the level of radiation that a pregnant woman can be exposed to, because of the danger of damage to the foetus.

There are also regulations governing the exposure of women to lead. These prevent their employment in certain manufacturing processes, insist on provision of protective clothing, welfare facilities and medical supervision in others, and set different limits in measuring their exposure. New regulations covering all these matters came into force in August 1981.

Are the present regulations adequate to protect women?

Recent information on the effects on men and women of exposure of dangerous substances shows that the present safeguards are inadequate, and they are rarely enforced.

It is now known that men's exposure is as dangerous as women's. Women's exposure can cause infertility, abortion, birth defects, genetic damage, behavioural disorders or disease in the children they are carrying or may carry. But men's exposure can result in damage to the sperm they produce, which in turn can result in the same disorders as if the woman had been exposed.

The TUC points out in its pamphlet *Women's Health at Risk*:

Female hospital operating room personnel exposed to anaesthetic gases suffer an increased rate of miscarriages and children with birth defects, but the children of male operating room personnel also show an increased risk of birth defects. The children of women who have worked with mercury or methyl-mercury do not show birth defects, but suffer abnormal behavioural disorders from adolescence. Oestrogen dusts in workplaces manufacturing contraceptive pills can cause gynae-comastia (growth of female breasts) in men, but also cause acute menstrual problems for women workers.

So any controls and regulations should cover both sexes. At present some rules aim to give special protection to pregnant women because of the risks to the developing foetus, but it is now realized that the foetus is most susceptible to damage from harmful agents between the twentieth and the thirtieth day after conception, when most women do not know that they are pregnant.

The best safety policy is the reduction of hazards at source rather than special limits on the exposure of pregnant women or screening out workers considered particularly at risk.

Where there is any risk, women who may become pregnant (most pregnancies are planned these days) and those who are pregnant should be offered safe alternative work with no loss of pay until pregnancy is over.

Make sure your safety representatives have full information on any possible reproductive hazards you may be exposed to.

How do you know that exposure to a substance is causing you harm?

Thousands of new substances and chemicals are being used in industry. While they are all meant to be tested for safety, it is almost impossible to get hold of the results of these tests, and difficult to interpret the results. So you may well not know what risks you are being subjected to.

Too often women's complaints are ignored or put down to 'female ailments'. In a factory making tennis balls, women workers complained of headaches and nausea for some time, but

no one took any notice. One day in 1980 a number of them col-
lapsed and had to be taken to hospital. They had been exposed
to toluene, a dangerous chemical. There was inadequate venti-
lation at the factory. The women refused to work until the
Health and Safety Inspectors and their union's safety experts
were called in and they were satisfied the danger had been
removed. Those affected had to sue the employer for compen-
sation. If you and your workmates feel unwell insist that the
cause is investigated and that you know precisely what sub-
stances you are working with.

Your safety representative has the right to ask your employer
for a full list of all substances used at work, the uses for which
the products are designed, their nature, their possible effects on
workers, and the safety procedures that should be followed.
Once your employer has told you what the substances are, your
safety representative can write direct to the manufacturer and
obtain further information. The GMB has produced a model
letter for its safety representatives to send, with a data sheet on
which the supplier can provide the information requested.

Can women be refused jobs because of health risks to them?

In a recent case, a woman employed as a heavy-goods-vehicle
driver to haul chemicals between chemical plants owned by ICI
was not allowed to transport dimethylformamide (DMF). The
company said this substance was dangerous to women of child-
bearing age because of its effect on the foetus. There was no
evidence that this woman planned to become pregnant. She was
twenty-three years old. She brought a claim under the Sex Dis-
crimination Act, but the Employment Appeal Tribunal said her
treatment was not unlawful as the employer had a legal duty
under the Health and Safety at Work Act 1974 to ensure, as far
as reasonably practicable, the health and safety at work of his
employees. The Sex Discrimination Act allows employers to
discriminate if it is necessary to comply with a previous Act of
Parliament.

The Appeal Tribunal said it was a matter for the employer to

decide whether or not to allow an employee to do a particular job for his or her protection or safety. This decision does seem to leave it wide open for employers to exclude women from jobs in circumstances such as this. It is particularly worrying in view of the increasing concern being expressed about the health effects of the 50,000 or so chemicals in use in industry today. If women are to be considered as 'baby machines' *irrespective of whether they do or do not want children*, there could be widespread banning of women from many jobs in industry, leaving the real problem (the chemical) as a continuing risk to the health and sperm production of the men still exposed.

If jobs are refused to women on these grounds, your safety representative should find out if the substance is also dangerous to men. It usually will be. If so, the employer's duties must be to remove or minimize the risk, not to debar women. It would be an unfair dismissal if a woman was sacked because the employer said her job was dangerous, unless there was no suitable alternative employment that could be offered to her.

What is meant by sexual harassment?

There is no formal definition of sexual harassment in Britain, where the subject is only beginning to be taken seriously. The United States Equal Opportunities Commission says that sexual harassment is a form of sex discrimination and is unlawful. They define it as including 'unwelcome sexual advances, requests for sexual favours, and other verbal or physical conduct of a sexual nature where it affects employment offers or decisions in employment or has the effect or unreasonably interfering with work performance or creating an offensive working environment'.

They say an employer will be held responsible if managers or supervisors sexually harass an employee or if she is harassed by co-workers when the employer knows or should have known of the conduct, unless the employer can show that she/he took 'immediate and appropriate corrective action'.

So sexual harassment does not include mutual flirtations, or fun and games which enliven many a dreary office. It is where a woman is subjected to unwanted and hurtful sexual advances,

usually by a superior, which make her working life unpleasant and may prevent promotion, damage job prospects or even force her to leave her job. The NCCL pamphlet defines it as 'repeated, unreciprocated and unwelcome comments, looks, jokes, suggestions or physical contact that might threaten a woman's job security or create a stressful or intimidatory working environment'.

Is sexual harassment a serious problem for women?

Information on how far it is a problem for British women is scant to date. But current interest in the question should soon give the answers. In October 1981 the *New Statesman* reported one of the first surveys in Britain, carried out jointly by Thames TV and NALGO:

The place picked for the survey was the Liverpool City Treasurer's Department where 160 of the 504 NALGO employees returned questionnaires on sexual harassment. 49 per cent were from men, and 51 per cent from women who, not surprisingly, took the survey more seriously. One woman commented: 'This survey is necessary but I'm afraid that most of the men in the office when they received the form just laughed, saying they couldn't understand any of the girls taking it seriously, especially in our office which is tiny and sports five nude calendars.'

52 per cent of the women said they had experienced unwanted sexual attention which had caused them discomfort in their workplace.

The more unexpected figure, perhaps, in the TV Eye survey was the 20 per cent of men who also complained of sexual harassment by other men. US data shows that 99 per cent of the 'harassers' are men and that homosexual harassment is not uncommon. This may simply point to the fact that sex is used to confirm or display power, which is usually held by older men.

Results of TV Eye survey

Questionnaires returned:
 Total (out of sample of
 504) 160
 Men 78 (49 per cent of total)
 Women 82 (51 per cent of total)

Number reporting sexual harassment:

Total	58 (36 per cent of total)
Men	16 (20 per cent of men)
Women	42 (52 per cent of women)

Forms of sexual harassment:

Staring or leering	50 per cent
Sexual remarks or teasing	48 per cent
Touching, brushing up against, grabbing	43 per cent
Propositions of love-making	17 per cent

Responses to sexual harassment:

Felt it was unimportant	24 per cent
Felt embarrassed	50 per cent
Felt angry	55 per cent
Felt embarrassed and/or angry	67 per cent

A survey by the European Commission asked whether women had found themselves the object of sexual advances or propositions which are more or less blackmail'. Seven per cent of British women said they had. In one survey of Federal employees in the United States, 42 per cent of 694,000 women and 15 per cent of 1,168,000 men said they had experienced some kind of sexual harassment. A survey by Canadian trade unions showed that between 70 and 88 per cent of working women experienced it in some form, and that *just under half* leave their job as a result.

What can you do if you are sexually harassed?

The first step is to bring out into the open. Many women do not do this, as they feel it is a personal problem which they alone must solve. They are embarrassed to talk about it and fear they will be the object of fun or hostility without receiving help from fellow-workers, the union or management. Often a man who has harassed you has also made unwelcome advances to other women. Talk to them and seek their help. With their support, directly confront the culprit and tell him to stop. If you don't

feel able to do this because he is your superior and you feel that he will take it out on you, or if this has no result, then raise it with your shop steward and ask your union to help. Keep a record of incidents that occur, in case you need it later on.

Will your union help?

Some unions are now realizing that they should be concerned about sexual harassment and help members who suffer from it. For example, NALGO has published a leaflet urging its members to campaign against sexual harassment, to include protection from it in equal-opportunity policies, to arrange for women shop stewards or branch representatives to represent individual women sufferers, and, if the matter cannot be resolved, to take it up as a formal grievance.

They have encouraged NALGO members to hold meetings for women only, so that they can talk freely, and have sent a questionnaire to their members whether or not they have been victims. They hope to compile a list of women representatives to whom victims can go for help and advice.

Most unions have not done so much, but you could raise the question at your branch meeting and ask the branch to send a resolution to your union's equal-opportunity committee or women's committee if there is one. The NCCL has suggested the following model resolution:

This branch recognizes that sexual harassment is a form of sex discrimination that can damage the morale, job security and prospects of women trade unionists. Because we recognize that sexual harassment is a very difficult topic for people to speak frankly on, this branch resolves:

a. To invite a visiting speaker to address the branch on what is sexual harassment and ways of combating it.

b. To inquire of our union head office whether they have drawn up guidelines on sexual harassment at work, and if they have not, to call them to engage in a consultation process and thereafter draw up guidelines.

c. To designate a woman branch member as 'Women's Rights Officer' so that members who have been discriminated against in any way know who to go to speak to in confidence.

d. To have an informal 'women-only' discussion among branch mem-

bers to try to establish whether a problem of sexual harassment exists in our workplace, and if so to bring back to the branch proposals on how to deal with it.

Ask your union to advise negotiators to add a sexual harassment clause to any equal-opportunities agreements or clauses they have negotiated with management. The employer should state that management will not tolerate sexual harassment and will treat it as a form of sex discrimination requiring disciplinary action against offenders. The employer should also take steps to inform all managers, supervisors and employees of this policy and ensure that it is to be taken seriously. Once this is done, it should inhibit sexual harassers and make it far easier for victims to raise the question.

Will direct action help?

Women are the usual victims of sexual harassment because of their relative powerlessness at work, combined with our sexual stereotyping that the male is the predator and the female prey. Often the tables can be turned if you fight back, particularly if you have other women to support you. One group of women, faced with a male personnel manager called Robin who was a regular and promiscuous harasser, told their manager that if he did not deal with him they would parade up and down outside the workplace with placards showing everything Cock Robin could do. The manager took prompt action. A swimming-pool attendant whose supervisor made her life a misery confided in her female colleagues, and together they told the other men to support them and tell him to stop. They did.

Does the law offer protection?

The Sex Discrimination Act does not specifically cover sexual harassment. To date there are no reported decisions as to whether women are protected from sexual harassment under the Act. If such a case were brought, it would only be won if the tribunal decided that the woman was being treated less favourably on the grounds of sex in that her employer was subjecting

her to a detriment or refusing her a benefit such as promotion because she did not comply with sexual demands. One question a tribunal would need to decide is whether the sexual harassment was treatment on the grounds of sex or personal victimization, in which case the Sex Discrimination Act offers no protection.

In the United States there have been successful cases of this kind, and women have been awarded considerable sums in compensation. But as the discrimination laws are different in the United States, success under American law is no guarantee of success here (see p. 159 for more on the Sex Discrimination Act).

There have been a few cases where women have claimed that their employers have unfairly dismissed them because of sexual harassment or because their boss's behaviour forced them to resign. For example, in 1980 Julie Hyatt was awarded £954 compensation for unfair dismissal when Richard Smith, her employer, sacked her for refusing his sexual advances. Two bar workers in Birmingham who left their jobs because of continual harassment successfully claimed they had been unfairly dismissed, and they received some compensation. Although they had left their jobs, they were entitled to unfair-dismissal compensation because it was their employer's conduct which had forced them to leave.

Proving such cases will often be difficult, however, and with all the attendant publicity and counter-accusations they are bound to be highly stressful.

Guidelines to employers and trade unions

The Equal Pay and Opportunity Campaign has issued the following guidelines.

Sexual harassment at work is degrading and insulting. Where an employer fails to act on a complaint of sexual harassment brought to his attention, it is also probably unlawful sex discrimination and grounds for claiming constructive dismissal.

Acts of sexual harassment include threats, demands or suggestions that an employee's work status depends upon tolerating or submitting to sexual advances. Sexual harassment also includes unwelcome sexual

attention such as sexual propositions, unnecessary touching, degrading comments or repeated jokes of a sexual nature.

To ensure that sexual harassment does not take place and that if it does it is dealt with effectively, E P O C recommends the following guidelines to employers and trade unions:

Employers, following discussions with trade unions where appropriate, should issue a written policy statement to all employees which makes clear that:

1. Sexual harassment of an employee by any other employee will not be tolerated and is contrary to the employer's policy.

2. The employer will take prompt corrective action upon becoming aware that incidents involving sexual harassment have taken place.

3. Sexual harassment will be grounds for disciplinary action.

4. Supervisors have an affirmative duty to maintain their workplace free from sexual harassment and intimidation.

5. Employees subject to sexual harassment should report such conduct to a specified management figure.

6. Supervisors should immediately report to a specified person any complaints of sexual harassment.

7. The employer's policy and the procedures to be followed will be communicated to employees as part of training and induction programmes.

Trade unions should:

1. Make members aware of the problem of sexual harassment at work.

2. Ensure that sexual harassment is treated as a serious threat to job security and individual rights.

3. Advise members on how to deal with the situation if sexually harassed.

4. Consider designating a particular individual or committee as a union contact for sexual harassment complaints.

5. Discuss the problem of sexual harassment with management and press management to adopt an effective policy.

6. Support members subjected to sexual harassment through the complaints procedure and, if necessary, in legal action.

What are the health risks of VDUs?

VDUs raise particular health risks. Although they are mainly a feature of new office technology, they are also being intro-

duced in many other workplaces, such as the reception areas of hotels. This can lead to the following hazards to operators:

1. Eye-strain: fatigue in the eye muscles giving rise to soreness, dry or burning sensations, and difficulty in focusing.

2. Stress: caused by isolation and being tired and controlled by the machine. Symptoms include irritability, headaches, loss of appetite.

3. Body fatigue: caused by sitting in possibly uncomfortable seats while concentrating for long periods on awkward equipment. Can give you headache, backache and neck-ache.

4. Noise, heat, electricity and possibly radiation from the machinery.

Here is a checklist on the installation and use of VDUs to help avoid these health risks.

General environment

Remember Section 2(2) (e) of the Health and Safety at Work Act says that it shall be the duty of employers to provide and maintain a working environment for his employees that is, so far as is reasonably practicable, safe without risks to health and adequate as regards facilities and arrangements for their welfare at work.

1. *Space* – is there enough for all the new equipment, giving workers easy access to the work station and to other areas? The law says each worker must have 400 cubic feet of space, not counting the space taken up by office machinery, chairs etc.

2. *Lighting* – is the *general background lighting* around 300 lux?
Is *local lighting* at the work station around 500 lux (but check with manufacturer's advice) for reading documents etc. and can it be switched on and off as required?
Is the colour of any artificial background lighting less than 3000°K?
Is the *glare* at the work station below the Illuminating Engineering Society's recommended glare index level of 16? (See IES 'Code for Interior Lighting' 1977.) Glare can be eliminated by removing the transparent screen of coloured glass from in front of the display tube; changing the positions of lights, or of the VDU; fitting lights with diffusers; lowering the brightness of lights; siting fluorescent light fittings parallel to the sides of VDUs and not parallel to the screen; using a nonreflective VDU screen.

3. *Temperature* – is this kept to around 21–23°C?

4. *Humidity* – is this kept to around a relative humidity of 45–55?

5. *Noise* – is this kept to less than 55 dbA where a high level of concentration is required, or to less than 65 dbA where routine tasks are performed?

6. *Radiation* – is the level kept well below the X-ray standard of 0.5 millirem/hour?

Other Conditions of Working

7. *Eye tests* – are all workers expected to work with VDUs provided with pre-employment eye examinations? The purpose is not to screen out workers without perfect vision – VDU work should be made acceptable to all workers – but to identify those who may need spectacles or trifocals etc.

Is the operation performed by the workers' own ophthalmic opticians, and are they aware of the type of VDU work to be performed? (The Association of Optical Practitioners has produced a standard referral form for your employer to fill in and send with you to the examination.) The use of vision screening with instruments is not a good substitute for full examinations by opticians.

Is the cost of any such examinations, and of any spectacles etc. needed for VDU work, paid for by the company?

Are there follow-up examinations 6 months after VDU starts, and thereafter every 2 years or whenever recommended by the optician or the worker?

8. *Work Breaks* – are there regular work breaks timed to *prevent* fatigue occurring rather than to allow *recovery* from fatigue? (The Post Office and CPSA have agreed a maximum spell of 100 minutes per day at the machine, with no spell being longer than 50 minutes without a 15 minute break.)

Is there provision for turning or screening off the screen when not in use?

9. *Manning* – is there sufficient manning to allow work breaks to be taken?

Equipment

10. *Keyboard* – is it stable enough to prevent movement in use?

Does the area around the keys have a matt finish to prevent glare?

Is the angle of the keyboard in the range of 5–15° and is the distance between the 'home row' of keys and the base of the keyboard 30 mm to reduce the physical stress to the member?

If the work of the VDU involves a great deal of numerical information is there an auxiliary numerical keyset laid out according to the numbering used on telephones, i.e. 1, 2, 3 on the top row?

Are the number of function keys limited to the jobs to be done on the VDU?

Is provision made for masking any function keys which are not in regular use?

Are any of the function keys which if accidentally pressed would produce serious consequences, located away from all other keys and require two hands to operate?

Can the keyboard be moved independently of the screen so that the best work position can be achieved?

11. *Screen* – is the level of *flicker* between 55–60 Hertz? (Expensive transformers are *not* needed to reach these levels from the electricity mains frequency of 50 Hertz. Manufacturers do make sets with refresh rates of 55–60 Hertz.)

Is the luminence of the characters at least 45 cd/m^2 and preferably between 80 and 160 cd/m^2 (cd/m^2 = candela per sq metre)?

Is the background luminence of the screen between 15–20 cd/m^2?

Is the character luminence and contrast adjustable?

Are the characters of the following dimensions, based on a 28" viewing distance:

minimum character height: 3.1–4.2 mm maximum character height for 5 × 7 dot matrix: 4.5. mm
width to height ratio of between 3:4–4:5
stroke to height ratio of 1:6–1:8
minimum number of 10 raster scan lines per character

12. *Display* – is all information displayed in the centre of the screen so that there are no distortions or blurred characters near the edges of the display?

13. *Colour* – are the screen and display coloured and not black and white?

14. *Desk* – is there sufficient space and good layout so that comfortable work postures are possible?

15. *Chair* – have the chairs adjustable backs and seats for both angle and height?

16. *Maintenance* – is all equipment regularly maintained, so that worn tubes, dirty light fittings and electrical components, etc. do not cause further hazards?

17. *Training* – are all operators provided with adequate training?

Figures 17.1 and 17.2, from the APEX *Guide to New Technology*, give more details on what to look out for in VDUs.

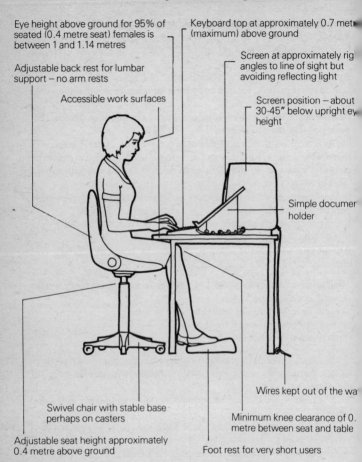

Eye height above ground for 95% of seated (0.4 metre seat) females is between 1 and 1.14 metres

Adjustable back rest for lumbar support – no arm rests

Accessible work surfaces

Keyboard top at approximately 0.7 metre (maximum) above ground

Screen at approximately right angles to line of sight but avoiding reflecting light

Screen position – about 30-45″ below upright eye height

Simple document holder

Wires kept out of the way

Swivel chair with stable base perhaps on casters

Minimum knee clearance of 0. metre between seat and table

Adjustable seat height approximately 0.4 metre above ground

Foot rest for very short users

Figure 17.1: Good work-station principles.

Luminance ratio between screen and rest of environment
should be no more than 1:10 — on a totally black screen
the characters appear to float in space and make it
difficult for the eye to accommodate properly

Adjustable screen allowing horizontal
and vertical adjustment

Legible keylegends. Small or obscurely
derived legends are difficult to read and
force the operator to re-accommodate

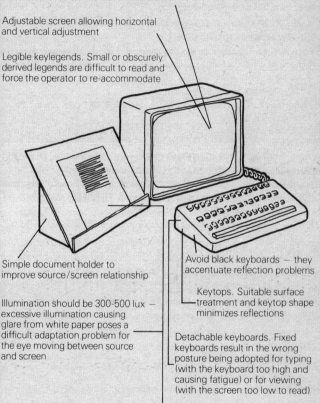

Simple document holder to
improve source/screen relationship

Avoid black keyboards — they
accentuate reflection problems

Keytops. Suitable surface
treatment and keytop shape
minimizes reflections

Illumination should be 300-500 lux —
excessive illumination causing
glare from white paper poses a
difficult adaptation problem for
the eye moving between source
and screen

Detachable keyboards. Fixed
keyboards result in the wrong
posture being adopted for typing
(with the keyboard too high and
causing fatigue) or for viewing
(with the screen too low to read)

Legible documents. Illegible source documents are
even more fatiguing and difficult to read when used
as a source for a VDU

Figure 17.2: Good keyboard and screen characteristics.

Sources of Information

Jeanne M. Stellman, *Women's Work, Women's Health*, available from Trade Union Book Service (TUBS), 265 Seven Sisters Road, London N4.

Jeanne M. Stellman and Susan Daum, *Work Is Dangerous to your Health*, available from TUBS.

Newsletter of the Women's Occupational Health Resource Center, School of Public Health, Columbia University, 60 Haven Avenue, 8–1, New York, NY 10032, USA (yearly subscription US dollars 12.00, students US dollars 6.00).

P. Kinnersley, *The Hazards of Work and How to Fight Them*, Pluto Press (£1.95).

Hazards Bulletin, published by BSSRS (yearly subscription £2.10 from TUBS).

Boston Women's Health Book Collective, *Our Bodies Ourselves*, Penguin, 1978 (£4.50).

Elspeth McVeigh, *Women's Work, Women's Health*, Labour Research Department, 78 Blackfriars Road, London SE1 8HF, May 1981.

Sexual Harrassment at Work, NCCL, 1982 (95p).

The Safety Representatives and Safety Committee Regulations, HMSO, 1977.

Women's Health at Risk, TUC, July 1981 (35p).

TRAINING – THE WAY OUT OF THE GHETTO

Lack of the right qualifications and training is one of the most important barriers to women entering many of the three quarters of all jobs which few women do. It also stops them progressing into more senior positions in unisex occupations such as banking, administration and insurance.

This chapter looks at the kind of training available to women who want to cross into male territory and examines what opportunities there are for education and training later in life. It does not set out to be a careers guide like Ruth Miller's *Equal Opportunities* (an excellent and comprehensive one, which we have used for some of the information in this chapter) or to deal with those kinds of training courses that are readily known and available for traditional women's jobs such as secretarial work and nursing.

What kinds of training do women have now?

Table 18.1 shows the kinds of training girl school-leavers have as compared to boys.

It is only a minority of either sex who enter any full-time educational training, but fewer girls than boys have training, and most of their training is in traditional 'female' skills such as teaching, catering, nursing, or secretarial work. For example, in 1979 more than 17,000 girls leaving school went on secretarial courses; the number of boys was about a hundred.

More boys than girls go straight from school into employment without further full-time education, but far more boys than girls get systematic on-job training. In 1978 366,294 boys and 84,010 girls were on non-advanced day-release courses. Most girls took job-specific courses such as shorthand or hairdressing; most of the boys went on courses which extended their skill range and job opportunities.

Table 18.1: *Destination of school-leavers by sex, England only, 1979*

	Number of boys (in thousands)	Percentage of boys	Number of girls (in thousands)	Percentage of girls
Degree courses	32.7	8.7	21.6	6.0
Teacher training	0.8	0.2	3.1	0.9
HND/HNC	1.4	0.4	1.0	0.3
OND/ONC	1.8	0.5	1.3	0.4
Catering	1.7	0.5	4.2	1.2
Nursing	0.1	–	5.4	1.5
Secretarial	0.1	–	17.4	4.8
A levels	7.6	2.0	8.5	2.3
O levels	5.0	1.3	6.3	1.7
Other further education courses	13.6	3.6	24.1	6.7
Temporary employment	3.5	0.9	2.6	0.7
Other employment*	308.8	81.9	264.8	73.5
All leavers	377.1	100.0	360.3	100.0

* Including those whose destinations were not known. (*Source:* Department of Education and Science, *Statistics of Education*, Volume 2, *School Leavers*, 1979.)

About one in five workplaces had apprenticeships or other schemes leading to formal qualifications for particular jobs, mainly in management, but only 3 per cent of apprentices and 2 per cent of trainee managers were women.

Only one girl in ten takes up an apprenticeship (mostly in hairdressing) as against one in three boys. Only 0.22 per cent of engineering craft apprentices are girls, although a third of the semi-skilled and unskilled operatives in engineering are women.

By the time most girls leave school, entry into non-traditional female areas will be denied them or made very difficult because they will have already dropped 'male subjects'. Maths and/or

Table 18.2: *Proportion of total O-level passes gained by boys and girls*

| | 1979 | | 1975 | |
	Boys	Girls	Boys	Girls
Engineering workshop	99.4	0.6	99.2	0.8
Mathematics	61.5	38.5	61.0	39.0
Physics	75.2	24.8	78.0	22.0
Biology	40.2	59.8	40.1	59.9
Chemistry	64.1	35.9	68.0	32.0
Technical drawing	97.3	2.7	98.5	1.5
Craft design and technology	97.1	2.9	98.5	1.5
Sociology	24.6	75.4	28.0	72.0
Commercial subjects	34.7	65.3	39.0	61.0
Cookery	1.8	98.2	1.0	99.0
Computer science	72.9	27.1	–	–

Source: Ruth Miller, *Equal Opportunities* (Penguin).

physics or another technical subject are a common requirement for a technician's training, and Table 18.2 shows that girls rarely have O-level passes in these subjects. Results for CSE, A level, and degree courses show a similar bias.

There are no overall records of the extent and kind of training given by industry. But a recent survey carried out for the Equal Opportunities Commission showed that some in-service training was provided for 80 per cent of the jobs covered, with one in five men and one in four women over eighteen receiving training. Most training was on-site and could be anything from some initial instruction from an experienced worker or supervisor or a few days' full-time training to a proper longer-term training course leading to some promotion prospects. Fewer than one in five men and fewer than one in ten women received off-the-job training, either *ad hoc* day-release, block-release or other forms of education.

TOPS (Training Opportunity Programme Schemes) is designed to give a second chance to people who lost out on training when young and want to retrain or switch jobs. These courses

could be a way to right the balance of training between the sexes, but although the Manpower Services Commission (MSC) recently expressed greater awareness of this need, the results are still broadly more of the same. The courses for unemployed youth (YOPS) show a similar picture.

The Sex Discrimination Act permits employers and training bodies to run special courses for women in male-dominated areas, but hardly any employers have shown an interest; and despite a better response from the training bodies the actual numbers of women benefiting are pathetically few.

It is now increasingly difficult to expand training for women when the job market is shrinking daily, the government is gradually disbanding training boards, and MSC funds are largely deployed in 'work-experience' schemes for the young unemployed rather than in training schemes. Yet, as discussed in greater detail in Chapter 22 on the new technology, there still are areas of expanding job opportunities where trained people are urgently required, and despite the overall recession every large concern still does train its employees for a wide variety of tasks, including managerial positions, and these training opportunities could be opened up to women.

Where can you get careers advice?

Schools all provide some kind of careers advice for older pupils. Pupils unsatisfied with the school service, anybody else up to the age of nineteen, and those over nineteen who are still in full-time education outside the universities, can go to any Careers Office for information and advice. (Look up 'Careers Service' in the telephone directory to find your nearest.)

Some careers officers will also help other adults who want a change in jobs or women returning to work; others say they must concentrate on helping young people. Many areas have information/counselling services specially for adults. Details are available at public libraries, Citizens Advice Bureaux, and Open University Regional Offices.

If you are a graduate of any age you can use the local university or polytechnic careers advisory services.

Can more girls become technicians or apprentices?

Training for a technician's job

You need a technician's training for jobs such as draughtsperson, production planner, estimator, technical salesperson, site engineer, surveyor, laboratory technician. You will need at least CSE Grade 2 or O level in maths, physics and English, and it helps to have technical drawing or engineering.

There are a number of training schemes. Before you accept a job, try to find out what kind of training your employer will give you. The most up-to-date training pattern is that recommended by the EITB (Engineering Industry Training Board), which starts with twelve months in a training centre covering basic engineering processes, including machining, fitting, welding, electrical wiring, electronic assembly, soldering and sheet-metal work. After the first year, training becomes more specialized and its length varies according to your entry qualifications and the level to which you train.

If you have CSEs it will take you three years on a part-time day-release course to get your TEC (Technical Engineering Certificate), which after further practical experience allows you to be registered as a technician (TEC CEI). If you have O levels or CSE Grade 1 you can qualify after a similar period of time for a diploma. Further courses can lead to a higher certificate. If you have A levels you can study straight away for a higher certificate.

You can take these courses later in life under the TOPS scheme (see below).

Craft apprenticeships

An apprenticeship is a formal period of training for skilled workers such as carpenters, plumbers, electricians, motor mechanics, toolmakers, craft machinists, fitters, bricklayers, plasterers and painters.

Machine-shop craftsmen, fitters and electricians in large organizations serve a three- to four-year apprenticeship. It is best if your employer operates the EITB's module training

scheme. The first year may be in a technical college, learning basic engineering processes, though often employers prefer day or block release. You are then trained in one or two skills on the job, with day release. You qualify for a certificate of engineering crafts and may be able to carry on training to become a technician. Motor mechanics and electricians in domestic repair and installation work usually have a four-year apprenticeship with day release for either City and Guilds certificates or for the tech awards.

If you wish to have an apprenticeship in the building crafts it is best to train with a firm operating the National Joint Training Scheme for Skilled Building Operatives. Your apprenticeship usually lasts for three years, with full-time off-the-job training for the first year, followed by day release and practical experience, leading to a City and Guilds craft certificate. Plumbers serve a four-year apprenticeship for basic and advanced craft certificates.

How do you get an apprenticeship?

This will be very difficult at present with the number of apprenticeships at an all-time low and competition keen. Firms accept application forms during the autumn and spring terms for people to start in the following September. They select applicants to come for a test, and those who do well are interviewed during December, January, February and March.

Ask your careers adviser at school if she or he has an application form for local firms or can tell you which firms to write to and ask for a form. The relevant industrial training board may also be able to help; some of them run special schemes (see p. 293).

What age do you have to be?

The maximum age for starting an apprenticeship is normally seventeen, and, as explained above, this means applying when you are sixteen. But the age bar for apprenticeships for electricians and plumbers has recently been raised from eighteen to twenty-one and in 'particular cases' twenty-four.

Apprenticeship schemes are decided upon by agreement between the craft trade unions and the employers' associations in engineering and construction, while in textiles and hairdressing the trade unions decide the terms with the education authorities, primarily the City and Guilds. The industrial training boards have an important say because they allocate grants. It is time all these bodies did more to eliminate unnecessary age bars. Girls are less likely than boys to think of applying for an apprenticeship, and by the time they have decided that this is what they want to do, they may be too old.

Is it difficult for a girl to be an apprentice/trainee technician?

Not if you are determined and are not put off by any family, 'friends' or teachers who tell you it is not a girl's job. As explained, you will need maths and preferably physics or another technical subject in CSEs or O levels. It also helps to be familiar with how things work, whether cars or washing machines.

Girls who apply for technicians' traineeships are likely to be welcomed by employers. The shortage of girl technicians means that girl trainees are likely to find themselves with few or no girl companions, though in some areas such as electronic engineering this will not be so. Girls entering craft apprenticeships are often even more isolated from their own sex, though they are not quite the rarity they used to be, and may find at least one or two female companions. Male attitudes towards them are likely to vary but providing they are tough and resilient enough to brazen out the initial surprise and jocularity, they may well find at least some helpful male fellow-trainees and trainers. And once they are trained their jobs will be better-paid, more interesting, and, despite the recession, will offer more prospects than most 'women's' jobs.

Other employer training

Most fair-sized employers will give some kind of 'on-the-job' training but it may only be a brief course to familiarize you with

the task that you have been employed to do, with little or no further prospects. When you take a job, ask what training there is. Girls are sometimes slow to take up training opportunities (see p. 149 on bank training). Far more boys than girls get systematic on-the-job training. For example, in the clothing industry young men are trained as cutters while young women are given a few weeks' training as machinists.

It is often argued that women do not want training or opportunities for advancement. Yet there is evidence that points the other way; see, for example, the survey of shop-floor workers mentioned on p. 153.

Extending on-the-job training has to be linked to extending job opportunities, so that being a clerk or typist, sales assistant or machinist is no longer a dead-end job but has some sort of prospects (see p. 312).

What training is there 'off the job'?

Day release

The 1944 Education Act says that employers should allow day release to young workers under eighteen and should look favourably at day release and block release for workers up to the age of twenty-one. Day-release courses are run at local further education colleges. Five times as many young men under eighteen are allowed day release as women. Most of those women who do go on day release attend courses in 'women's' work, such as hairdressing, catering, clerical and banking jobs. Girls should find out from their local college or their old school what day-release facilities there are and insist on going.

Block release

Women are also far less likely to go on block-release training courses, which might be for TEC, BEC qualifications or for specific topics such as operating new technology, or related to particular jobs such as banking. The barriers to women are familiar. They are less likely to know what they want early on, they are less likely to ask for release for training, and once

they have asked they are less likely to get it. In some areas such as banking, specific age barriers can also hinder progress (see p. 150).

What training do TOPS courses offer?

TOPS courses are run by the MSC and offer training for new skills and updating to people over nineteen who have been out of full-time education for at least two years. You can get details of TOPS courses from job centres and employment offices. TOPS courses are usually full-time, and last for anything from a month to a year depending on the subject. They are held at skill centres and colleges of further education. Unfortunately there at present no part-time courses under the TOPS scheme, which means that a lot of women are not able to take them up. More women need to ask for part-time courses, so that some are set up.

TOPS grants are higher than students' grants and are paid irrespective of what your husband may earn. They include allowances for child-care and dependants.

In addition to the normal TOPS courses, you can apply to the MSC for a TOPS grant for almost any full-time course which lasts at least a month and not more than a year; it should fit you for a job without the need for further training.

As Figure 18.1 shows, the overwhelming majority of the women on TOPS courses are still receiving clerical training. But this is not because these are the only courses available. The 1980 MSC Annual Report said nearly 27,500 women completed TOPS courses during the year, and although most of them were doing clerical and commercial subjects, a significant number trained for male-dominated subjects such as engineering, motor-vehicle repair and electronic wiring. About one in four of trainees on computer programming and operating courses were women, and increasing numbers of women were taking higher-level courses in management, science and technology, and welfare.

If you want a craft job (see p. 285) TOPS courses, usually lasting six months, are available at government skill centres, followed by at least a year's 'learnership'.

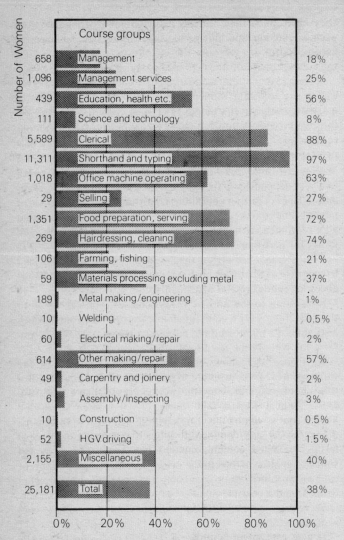

Figure 18.1: Women as a percentage of all adult TOPS completers by course groups 1980/81 (April to March). *Sources*: Training Opportunities Statistics provided by the Manpower Services Commission.

'Women in Manual Trades', a voluntary organization of women who work in craft jobs, asked over thirty women who had trained in this way how they found the training, and what were the attitudes of their instructors and fellow-trainees.

Some had met attempts to put them off at the interview stage. They were told that women were not accepted; or they were asked about physical strength ('You can carry a TV set?'): or they were required to do a six-week course at a rehabilitation centre, 'to prove you have hand skills'; or, on applying for a plastering course, they were told to reapply in six months' time – 'You are not strong enough'. Some were also expected to have had previous experience, although TOPS courses are meant to be open to all applicants without previous experience.

Once they got on the courses some of the women felt their instructors treated them the same as men, but one experienced an instructor who was 'sarcastic', sexist, unsympathetic; others had patronizing attitudes, were hostile or rude. Being the only woman was a 'hindrance' to many, not helped by having toilets a long way away, or having to have one built specially! When women were criticized because of the standard of their work, it often seemed to be because they were thought to be too slow. This could probably be due to over-caution and perfectionism, and in a few cases it led to the women being chucked off the course; but others got an extension of their training so that they could qualify. Women who asked for time off to look after sick children or to collect them from school reported an unsympathetic attitude. In one case, a woman got £10 a week for a housekeeper; but another woman was refused £7 for nursing fees.

Despite the considerable difficulties that some of the women faced, the course content generally found approval. They felt women could be helped by:

Child-care facilities
Pre-training courses
More women instructors/trainees
Shopping time
Longer assessment periods
Room for women to withdraw
Instructors having awareness of the different ways in which women operate.

There are technicians' TOPS courses in a vast variety of sub-
jects, including TEC (see p. 285) courses on things like micro-
processor applications; they are normally held at further
education colleges. TOPS grants are also available for manage-
ment courses at polytechnics in personnel, transport, market
management, and diplomas in management studies.

The EOC encourages any woman who feels she is being dis-
criminated against on the grounds of sex when she applies for
a TOPS course to contact them for assistance (see p. 419 for
address).

Does the law allow women-only training courses?

In general the Sex Discrimination Act does not allow training,
by training bodies or by employers, which discriminates in
favour of women or men. But the Act does permit training
bodies to take the following positive action in favour of women
(or men) when the circumstances apply:

1. Training women only for particular work if there have been
no or few women doing the work in question during the last year.
This could include specific training in skill and knowledge for
particular jobs that few women have done to date, such as man-
agement, craft skills, supervisory skills, and could also include
special career-development programmes and career counselling
for women.

2. Encouraging women only to take up such training chances,
by advertising campaigns or other means.

3. Running special courses for men or women who have not
been in regular full-time employment for a time because of
domestic or family responsibilities. These can include courses to
develop confidence and the basic skills necessary for a return to
employment, further training or retraining for women who have
redundant skills, courses including job sampling and work
experience, and guidance and counselling.

The industrial training boards, the MSC and other govern-
ment training departments can all run such courses, as can any
other body such as an employers' organization or educational

institute which is 'designated' (that is, given special permission by the Secretary of State for Employment).

Employers can also run special courses for women (or men) and encourage them to take up the courses if there have been few or no women employed by them in that particular work for the last twelve months. Positive discrimination is not allowed in recruitment or in giving women the jobs once they have been trained.

How many special training courses for women are there?

Unfortunately the Act only *allows* special women's training courses and does not *require* training bodies or employers to run them; and few do.

The only training board that has done more than hand out a few grants for, say, ten mechanics a year, or fifteen managers, is the EITB. They have schemes for girl technicians offering a grant of £5,000 to all employers who recruit and train girls as technicians over and above their normal intake of technician trainees. Fifty trained in 1981. There is also an in-site scheme by which 400 sixth-form girls in 1981 went on a week's residential programme where they met professional engineers and visited engineering plants. The in-site programme is offered at ten universities throughout Great Britain and is open to girls who have GCE O levels (or the equivalent) in maths and a science subject and are studying them at A levels. You can get details from the EITB (PO Box 176, 54 Clarendon Road, Watford, Herts).

While the number of women trained to be managers under industrial training boards is minute, if you want to get out of a rut it may be worth asking your employer to contact the board for your industry and see what is going on. For example, the Food, Drink and Tobacco Industrial Training Board awarded thirty grants of £500 to employers to help meet training costs incurred in the promotion of women to management. The women had to be over thirty, at a disadvantage in employment because of their lack of appropriate qualifications and experi-

ence, employed in a job which was not normally a source of potential managers or supervisors, or have been out of full-time employment for at least five years. The employers receiving the money had to give the women training approved by the board, usually lasting three months and including training both on and off the job. This is one example of a woman who qualified:

Mrs G is 31 years of age. She left school at 16 with one GCE in cookery. She had not subsequently obtained any other qualifications. She joined the company 14½ years ago as a company receptionist which post she held for 9 years. She then left to have a child and came back after 3 months on a part-time basis for Saturdays mornings only. When her child was old enough for nursery school, she increased her hours to three full days working in general office administration. During a general reorganisation of the office, it was decided to consolidate the personnel function under a personnel officer.

Until this time this function had been filled mainly by the Managing Director and his secretary with some areas farmed out to other departments. After discussion with Mrs G, a decision was taken to appoint her to the position of personnel officer and to provide her with the necessary training which includes external courses on personnel and legislation.

There is little chance of expanding this kind of training at present. In 1982 the Food, Drink and Tobacco Industrial Training Board, along with most other training boards covering female industries, were abolished. There are still training boards for the clothing, construction, engineering, road transport, hotel and catering, plastics and offshore oil industries, but even these face an uncertain future with reduced funding.

What training is open to the unemployed?

If you are over nineteen, the main opportunities are the TOPS courses, which are described in detail on p. 289.

For those under nineteen, a new Youth Training Scheme is being introduced in September 1983, replacing the Youth Opportunities Scheme.

This offers a twelve months' traineeship to all sixteen-year-olds. Three months of this are to be spent in off-the-job education and training. The trainee will receive a weekly allowance

of about £28. The government will pay the employer about £1,850 for each trainee, so when the trainee's allowance has been paid only £400 will be left to spend on training. It is no part of the plan to encourage the training of girls in technical or other non-traditional areas.

The scheme will help the government by removing sixteen-year-olds from the unemployment statistics, but it is doubtful whether many of them will receive adequate training.

It is feared that apprentices will find the training content of their first year downgraded to that of a youth trainee, so that employers can receive the government grant.

The previous youth training scheme, YOPS, was criticized for the lack of real training as well as the low pay and the high accident rate, caused by inadequate safety measures. The new scheme seems likely to follow the same pattern.

What training is available later in life?

All age bars in training discriminate against women. The Belinda Price case (see p. 150) indicates that they are probably a breach of the Sex Discrimination Act unless they can be shown to be necessary.

They also work against men who want to change jobs or improve their knowledge of skills later in life. Some age bars, such as those for apprentices, are long-established on a national scale and are difficult to change. There are many other forms of training where age limits are fixed and work against women, because they decide what they want to do later in life or because pregnancy and childhood interrupt a chosen training course. Ruth Miller in *Equal Opportunities* catalogues most of these age requirements for each job under a separate heading, 'Late Start'. For example, trainee factory inspectors are accepted after the age of thirty only if they have extensive or other relevant experience, which of course most women do not. Training to be an insurance official has an upper age limit, in practice, of thirty. However, there are other jobs, such as careers officers or personnel managers, where there is no such difficulty.

With the rapid changes in employment, technology and indus-

try, it would help the whole economy if training was seen as a continuous process rather than a once-and-for-all privilege for a few.

If you have the chance, seek your union's support to insist that your employer lays on courses at your own place of work which provide the following.

Updating training

To keep you up with current knowledge, skills, techniques and methods of operation so that you are ready to master changing technology and work organization and not end up on the scrap-heap.

Upgrading training

To train, for example, clerical workers for administrative and technical jobs or semi-skilled women for craft and technology jobs. With the new technology this is particularly important. As Chapter 22 argues, women need to receive training to run the new kinds of offices that microtechnology will produce. Training is needed in office systems, and systems design, and could also be given in promotion, sales and customer service with office-equipment manufacturers, in the maintenance of the new machinery, and in computer programming and computer systems.

Pre-promotion training

Women tend to be diffident about applying for promotion, and special training may be needed to give experience and confidence to lower grades of workers before they go for promotion to supervisory or higher management grades.

Returning to work after a break

Many women returning to work after having children feel they have little choice but to accept whatever part-time work is close

at hand. Usually it is unskilled and badly paid, often more so than the full-time jobs they had before having children. Yet there are some opportunities to obtain further education, training and career counselling and advice.

Many further education colleges run special 'alternative' O-level courses designed for mature students. They can be taken by means of one or two sessions a week.

There are also 're-entry' courses, which may be called 'Wider Opportunities for Women', 'New Opportunities for Women', 'New Directions' and so on. The content and level of the work and the hours involved vary. Some courses are designed mainly as 'confidence boosters' and to provide information and help to let you decide what kind of job to aim for. Others teach you how to study, a technique which rarely comes naturally after a few years at home, even if it did before. Others teach specific subjects. Most courses are for fewer than five days a week and are designed to fit in with school hours.

If there are none of these courses near you, write and ask your local further education college if they could start one. Many of these courses are set up as a result of local demand.

If committing yourself to regular attendance at a course is a problem, the Flexi Study Schemes may help. They are based on a correspondence course, but you have a tutor to write to or telephone or occasionally meet. The National Extension College (18 Brooklands Avenue, Cambridge) can give you details of these courses and GCE correspondence courses.

Universities and polytechnics will often accept 'mature students' (over twenty-one or twenty-three) who do not have the usual entry qualifications. There are also part-time degree courses at a number of universities and polytechnics, and the Open University courses have no entry requirements.

The TOPS courses described on p. 289 provide specific job training for returners.

What can unions do about training?

Some unions have specific policies on what kind of training union negotiators should ask employers to agree to. These can be

negotiated either at national level in partnership with industrial training boards or at workplace level with specific companies. For example, here is the TASS's policy on negotiating for equal opportunity in training:

SPECIFIC AREAS FOR NEGOTIATION WITH THE EMPLOYER

A. (i) Training and further education
The employer should be encouraged, in conjunction with the EITB and the Training Services Agency, to use the provision of the Sex Discrimination Act which allows special courses to be put on to enable females to enter traditionally male areas. The EITB course for girl technicians is the best example to date.

(ii) Day release
Day release should be negotiated for *all* 16–19 year olds. This will ensure that girls achieve equal access to further education.

(iii) Clerical workers
It is important that girls should have the opportunity to do office administration and business courses, not just typing and short-hand. The Business Education Council, set up by the Government to rationalise and develop business education in all its aspects, is now helping colleges to establish a wider range of courses and to replace outdated ones. They are widening opportunities for girls, and it is essential that employers are pressurised to give release for courses which are based on modern industry and provide a future for the students.

B. Negotiating for new entrants – apprentices
Only a tiny proportion of female apprentices are accepted. The aim should be to increase this.
 (i) All female applicants should be interviewed.
 (ii) Publicity material to be aimed at girls as well as boys.
 (iii) The employer should be asked to provide a 3–6 months bridging course to give girls the necessary scientific and technical background.
 (iv) Positive discrimination should be agreed upon where possible, e.g. an agreed proportion of all female applicants will be accepted for technical apprenticeships.

C. Training opportunities for staff over 19 and re-training opportunities for women returners
Large companies should be encouraged to co-operate with colleges

in putting on courses which introduce women to a range of job opportunities, not only those traditionally done by women.

Employment Agencies and *Counselling Services* must be trained to introduce women, seeking advice, to a wider range of possibilities.

NEGOTIATING FOR TRAINING OPPORTUNITIES

A. **Establish the facts**
 (i) Ask for full details of the distribution of men and women's jobs by grade and department. If this is refused and you cannot obtain the information through normal union practices, the Disclosure of Information Section of the Employment Protection Act can be used with advice from TASS.
 (ii) Negotiate full information on the company's training programme and their use of Government training grants. Companies frequently ignore their training responsibilities and can be ignorant about the grants that are available.

B. **Assess the company's training programme**
 (i) Does it discriminate against women?
 (ii) Does it give women new training opportunities?

C. **Negotiate an agreed proportion of members for Paid Education Leave.**
 (i) (a) *Paid Education Leave* must be negotiated using the new opportunities developing through the Business Education Council, so that women have opportunity to study courses in administration traditionally only undertaken by men.
 (b) *Technological change.* The introduction of new technology will change many areas of clerical work. Negotiations must include the right for Paid Education Leave for re-training. New skills must of course be rewarded.
 (ii) Companies should put on special courses for women to enable them to enter jobs traditionally done by men (see *Sex Discrimination Act*).
 (iii) Companies should provide *Conversion Courses* to enable women to get the necessary technical, scientific or vocational experience to attend existing courses with the agreement of relevant unions.

Find out what your union's policy is and see if it can be implemented with your employer. If your union does not have a training policy, or not one that relates specifically to women, it is an issue to be raised.

Sources of Information

Ruth Miller, *Equal Opportunities – A Careers Guide*, Penguin (£3.95).

Fresh Start – A guide to training opportunities, EOC (free).

A Guide to Equal Treatment of the Sexes in Careers Material, EOC (free).

Manpower Services Commission: *Annual Reports; Outlook on Training; Training Opportunities for Women* (all free).

The Aspirations of Female Shopfloor Workers, Clothing and Allied Products Industry Training Board, 1979 (free).

Train for a Better Job with TOPS, available from Jobcentres (free).

Handbook of Courses in Colleges and Institutes of Higher Education, NATFHE and Lund Humphries (available at reference libraries and careers offices).

HOW TO GO ABOUT POSITIVE ACTION

What are positive action programmes?

The chapters on job segregation and career barriers describe why men and women usually do different jobs and how the escape routes from low-paid ghettos are man-shaped.

Since Britain's Sex Discrimination Act came into force in December 1975 it has had little impact on the placing of men and women within the workforce. In the United States, the law goes further than forbidding discriminatory practices. It requires employers who have discriminated to take 'affirmative action' designed to propel women into hitherto male reserves. It allows positive discrimination in recruitment and promotion until set quotas of women in particular posts are filled.

Voluntary settlements of sex discrimination complaints can include affirmative action programmes with goals and timetables for female advancement. Employers are encouraged to achieve quotas and goals by taking steps to recruit, train, and select suitable female candidates, who probably would not have applied for the job, so it does not mean that an employer need appoint less able women in preference to better-qualified or more able men.

Government contracts say that contractors must give details of the sex and ethnic composition of their workforce together with the affirmative action they propose to overcome any under-representation of women and blacks in particular jobs and grades. Federal Enforcement Agencies can chase them up to see if they have made a 'good-faith' effort to reach any goals or targets. The ultimate sanction against defaulters is withdrawal of contract.

In contrast, our laws are negative in the sense that although they outlaw discrimination they do not require positive action to overcome the heritage of past discrimination and social

stereotyping of women which discourages them from applying for 'male' jobs or seeking promotion. Even when positive discrimination is permitted to train women for male jobs, employers and training bodies are not required to take special steps to train women, and very few do. The apparent failure of our negative laws, which allow positive discrimination only in training and only in very limited circumstances (see p. 292), and the example of this more aggressive approach, have led the Equal Opportunities Commission, trade unions, women's groups and progressive employers in Britain to adopt the call for equal-opportunity policies and programmes in the workplace which include positive assistance for women as well as eliminating hostile and discriminatory treatment.

The new approach demands that, as well as systematically eliminating discriminatory practices, management should take positive steps to encourage and help women move up the promotion ladder and step sideways into jobs hitherto reserved for men. Vigorous examination of recruitment, interviewing, promotion, and training patterns with a view to rooting out discrimination, whether intentional or not, is needed, as is an overhaul of job application forms, descriptions, and specifications to eradicate any overt discrimination and make them as encouraging and accessible to women applicants as possible.

Special training courses and extra encouragement to women to apply for traditional male posts should be part of the package. It is crucial that the disrupted working life caused by motherhood is no longer a permanently disabling handicap in the job stakes. So positive action programmes must include steps to adapt employment practices to fit the life of most women workers, rather than expect them to fit into employment patterns designed for men.

This requires steps such as:

Extended maternity leave (and paternity leave?).

The right to return to work after a break with no disadvantage in terms of grading, seniority and future prospects.

Provision of part-time work, job sharing, flexitime, or other working arrangements compatible with parenthood which do not limit you to low grades and no-hope jobs.

Nursery provision by the employer or financial assistance for child-care elsewhere, to include arrangements for after school and school holidays.

Time off during school holidays or when the children are ill.

Opening up of training facilities and promotional opportunities for women returning to work after having children.

In practice most men chop and change employers, and often the type of job they do, during their working life, so they also benefit if progression and perks at work are no longer tied to long continuous service. Employers' notions that only men are worth training because women leave jobs too quickly to be a good investment are not supported by the facts. Only slightly more women than men change jobs in any one year: in 1979, 11 per cent of men changed their jobs, 13 per cent of women.

How are a policy and programme set up?

Here are the usual steps that need to be taken; though the details and the order will depend on the particular set-up in the workplace concerned.

1. Winning commitment to be an equal-opportunity employer

You need to generate support and action around the issues so that union and management agree that change is needed. If you are in a non-union workplace it will be more difficult to achieve real change, and any initiative is likely to be management's alone. If your workplace is organized you need to win your union commitment to take the issue up (see p. 322 for more on operating in the union). It may help to gather some initial information on distribution of men and women within jobs and grades, possibly just within one department or section to start with, and hold a meeting of women workers on the issues of equal opportunities to generate some interest and support (see p. 82 on obtaining information).

2. At this stage you can ask that management agree and declare an equal-opportunity policy

The TUC clause which can be written into collective agreements is set out on p. 315 below. You should also ask management to agree to provide the union side with information and to place the whole question of equal opportunities on the agenda of the main negotiating committee for further discussion. You can leave the detailed plan of action until you have set up some form of equal-opportunity committee and obtained more information.

The level at which you operate will depend on your employer's set-up. Some companies adopt equal-opportunity policies at national or international level but local plants may not know they exist. If this is your employer's position, ask for it to be publicized and for a commitment to discuss how it can be implemented and strengthened. Local authorities deal with equal opportunities in each local authority, while the civil service has a national scheme. Banks discuss it at corporation level, but this leaves it open to local representatives to work on particular issues. You may be able to put pressure on your departmental manager to review interview and selection procedures without waiting for an overall equal-opportunity policy.

3. Setting up equal-opportunity committees

If your workplace is unionized your ordinary negotiating machinery may be able to take equal opportunities on board. It will usually get more attention and time, however, if a joint union/management equal-opportunity committee is set up. The union side will normally be a sub-committee of the main union negotiating committee. If, as will often be the case, this does not fully represent the main groups of women workers, extra women representatives will need to be co-opted.

The committee needs to be at the relevant negotiating level. For example, the union negotiating committees in banks are called 'institutional committees'. The National Westminster institutional committee has set up an equal-opportunity sub-committee, while in the Midland Bank women have been co-opted on to the institutional committee.

It is important that the union sub-committee reports back regularly to the main negotiating committee and works for its full agreement and commitment. If this does not happen the moment that the equal-opportunity programme requires real change and resources, the equal-opportunity sub-committee may find itself without any muscle.

In some organizations women-only meetings, which may include union and non-union members, have led to the setting up of a women's committee outside the formal trade-union structure as a female pressure group on union and management. There is such a women's committee in Thames TV (see p. 317), and in the BBC there was a women's crèche campaign. In some cases, such as the civil service and telecommunications, such pressure groups have been set up on a nationwide basis.

The meeting together of women to discuss issues and formulate demands is a good way of initiating enthusiasm and involvement, but informal groups and committees need to have links with the negotiating machinery if their demands are to be followed through. They should work to have women staff representatives or shop stewards who will represent their point of view elected to the main negotiating committee or co-opted on to a union equal-opportunity sub-committee.

4. Finding the facts

You will need information on the following areas:

1. Numbers of male and female employees by salary, grade and, in some circumstances, by occupation. Part-time workers should be identified.

2. Length of service overall and service on a particular grade or on a job, to check comparative promotion rates.

3. Numbers of men and women considered for promotion; numbers offered promotion; numbers accepted.

4. Age of employees by grade/job.

5. Types of on-the-job and external training, with numbers of male and female applications and acceptances.

6. Initial qualification and placing of recruits by grade/job.

7. Numbers of male and female applicants for each vacancy,

by grade; number of offers made and number of acceptances.

8. Numbers of women who have moved out of female seg-regated areas (e.g. secretarial).

9. Promotional paths to senior positions and certain key ones.

10. If the employer has career appraisal procedures which involve identifying 'high flyers' (or indeed the permanently earthbound), information on designations of women and men, and when and how these appraisals are carried out.

11. Any age bars to recruitment, transfer, training or pro-motion. Any differential treatment of part-time workers.

How you go about this will depend on the size of the organ-ization and the degree of cooperation from management. In many cases not all this information will be necessary, or certainly not to start with. Some managements will be able to produce what you want without too much difficulty. Large employers increasingly use computerized personnel systems which make the extraction of information quick and easy, but in some organ-izations it may be expensive and time-consuming (see p. 82 on obtaining information).

You will need to consider whether female applicants are less likely than men to be short-listed, interviewed or, if interviewed, selected for particular jobs. If there are large numbers of appli-cants for jobs, or if all applications and interviews by first-line management are dealt with informally, with little or no written information or record-keeping, it may be difficult to get full details. It is important if action is to be taken that you do not get bogged down by the need for vast amounts of information; you may need to use spot-checks or other informal methods.

Drawing up the programme for action

When you have the information you can decide on action points. It may be more effective to start with one or two priorities rather than a very wide-ranging programme which demands so much that everyone becomes discouraged by the slow progress. You need to provide women who are qualified and trained to do the 'male' jobs as well as stopping discrimination against female applicants. For example, if you train managers not to refuse

female applications for skilled manual work or white-collar technician jobs, you then need to provide a pool of women who have the qualifications and confidence to apply for these jobs. That may mean examining whether certain pre-entry qualifications for the male jobs are necessary or could be changed to make female entry easier. It may mean extending training provision for women, or expanding recruitment to new areas likely to pick up female applicants.

If the 'male jobs' require 'male' working hours, difficult shift patterns, compulsory overtime, or if they lack part-time opportunities or time off in school holidays, then removing discrimination should go hand in hand with attempts to reshape the jobs to suit most female workers.

When you have all-male areas it is very hard on just one woman to break through, but far easier for a group. Try to plan for a number of women to be appointed or trained together and to have some supportive union and management people they can turn to.

The programme for action will contain changes that union and management agree should be made. It might, for example, decide that certain male-only jobs should be open to women; that the present distribution of women and men in the grades should be changed so that women are proportionately represented in the higher grades; that company training facilities should equally benefit women, and special training courses for women should be set up; that in management posts women should be represented in industrial relations and line management, not just in personnel. All these decisions should be based on information showing what the present position of women is and what kind of changes women want.

Negotiating targets and timetables

As well as deciding what changes are needed, the equal-opportunity committee needs to plan how much change can be achieved over a certain period and then set targets and timetables. Once targets are set you have a yardstick by which to measure progress.

For example, if there have been no women in a certain job the equal-opportunity committee may decide that a realistic aim is to have one in ten women in post over, say, five years. That would then be written into the programme. Similar targets and timetables can be set for recruitment, training, and any other action points. It is impossible to lay down ground rules for setting targets or timetables; they must be governed by the particular circumstances, such as:

What are the present barriers to women applying or being accepted for the job?

How soon can they be overcome? (e.g. if training is needed, how long would it take?)

What is the turnover of labour, releasing vacancies for which women can apply?

Setting a target for women to advance need not mean discriminating against men. It need only mean deciding on an aim to be achieved by giving women the encouragement and help so far denied to them and removing discrimination against them. Except for positive discrimination in training (see p. 292), discrimination in favour of women by, for example, appointing them in preference to a man would normally be unlawful under the Sex Discrimination Act. But taking all the steps to assist women described on p. 302 would not go so far and would be entirely lawful. There is a distinction between targets and quotas. If a quota of women is fixed for a certain job, it may imply that only women will be accepted until the quota is filled. But if a target is decided on, discrimination against women will be removed and women will be encouraged and assisted to apply and do the job, and there need be no discrimination in their favour at the point of selection.

Monitoring

The assessment of progress is described as 'monitoring' the programme and will be the job of the equal-opportunity committee if you have one. Overall monitoring needs to be done on a regular basis, and immediate questions should be dealt with as they arise. Unions should have a role in monitoring and not just

receive management information. A regular flow of information to the committee on changes in the composition of the workforce, the number of female applicants, transfers, promotions etc. will be needed to allow it to monitor effectively. Comprehensive statistics are necessary, not vague statements that we have a woman here or there. The monitoring should result in regular reports on progress to the workforce, unions and management, and in positive proposals either endorsing the present programme or suggesting change.

What is in a positive action programme?

Here are the kind of action points which can be covered in a positive action programme.

1. Letting people know

The policy and programme must be communicated to managers, workers and unions. The training programme should in time cover management and union representatives, but notices and leaflets to workers spelling out the purpose of the proposed action helps. Workers' statements of terms and conditions of employment should contain details. Outside recruitment agencies used by the employer, job centres, employment agencies, schools and colleges all need to be informed.

They should be sent a copy of the policy and programme with instructions that it should be made clear to all applicants that all jobs really are open to both sexes.

2. Recruitment

The programme should specify sources of recruitment, to ensure that, for example, girls' schools are covered as well as boys'.

Advertisements and application forms should make it clear not only that the employer is an equal-opportunity employer, but that women applicants are welcome to traditional male jobs. Any illustrations should show women as well as men.

Informal recruitment methods, such as word-of-mouth noti-

fication of vacancies, and applications direct to the foreman or supervisor, can easily perpetuate job segregation. Open advertisements should be introduced, and job advertisements should be displayed in all departments and locations of the workforce. All those involved in meeting and selecting job applicants, from interviewing panels to telephonists, need to be trained on the policy and programme.

3. Selection procedures

Methods of selecting people for jobs differ from workplace to workplace. Small offices, shops or workshops are unlikely to have written job descriptions or interview procedures. The interview will be conducted by individuals and decisions made on an *ad hoc* basis.

Even large concerns may operate by largely informal methods, with the management selecting according to custom and tradition rather than properly thought-out criteria. In some places the workers have first option to recommend their relatives for vacancies.

Some large organizations have written job specifications for all positions, properly constituted interview panels, and written procedures for the conduct of interviews. Where procedures are already formally laid down, it is easier to scrutinize them for sex bias (intended or unintended) and change them to exclude sex discrimination and openly state the need to avoid unintentional sex bias. Instructions to personnel should forbid questions directed at family circumstances or designed to put off female applicants by undue stress on the heavy or technical side of the job.

Where procedures are informal the task is more difficult, as without written job specifications and procedures there is no yardstick to judge whether the individual who selects does so without sex bias. It is better, therefore, to write down job requirements and interview procedures. This may not always be easy to do.

It may help to avoid sex barriers if a woman can be present at interviews and if, when the programme is a joint one with

unions, the union representative can attend as an observer on request.

To check how selection is operated, records should be kept of sexes of applicants, those short-listed, those interviewed, and selection decisions with reasons. Again depending on numbers involved and office facilities available, this may be easier said than done, and some system of spot-checking may need to be instituted.

4. Job criteria

There may need to be changes in the requirements specified for particular jobs. If there are no written job descriptions or criteria, the first step is to set out in writing what the job actually entails. Otherwise it is too easy to have vague hidden assumptions about the right kind of (male) applicant based on who has done it in the past. Criteria for 'male' jobs need to be looked at to see what makes them unpopular or unattainable to women. Heavy or dirty parts of the job, or technical qualifications, or a requirement that the applicant has served an apprenticeship or worked on night duty, or had experience in a male department would all be possible bars to women applicants. Are these requirements really necessary to carry out the job? Can they be minimized, or can training or experience be provided to women so they can fill them? (See p. 146 for pre-entry qualifications.) If job tests are used, they should also be checked to see that they test the right things for the job and do not unnecessarily make it difficult for women to do as well as men. Sometimes the job title puts women off by implying it is done by a man; salesmen, postmen, milkmen and dustmen all need renaming.

In arguing for these changes it may be helpful to point out that these kind of problems are quite likely to be unlawful sex discrimination unless they are strictly necessary for the job concerned (see p. 159).

5. Transfer/promotion

Entry to certain jobs may be by transfer or promotion as well as, or instead of, direct recruitment. Career paths need to be

examined to see whether female entrants are effectively barred from mobility and, if they are, what changes need to be made. If there is a service qualification, consider how if affects women and how women returning from a break in employment are treated.

The methods of selection for transfer and promotion may need changing in the same way as the methods of selection of new employees.

6. Career counselling

Most women do not expect much job mobility, training, promotion or prospects for advancement. They may well expect a rebuff if they apply for a new job and under-estimate their own capabilities. The programme can tackle these handicaps by building in some method for women workers to know of all the prospects that are open to them and encouraging them to apply. Induction training of all new employees in the programme is useful. Even better is individual career counselling on a regular basis so that each employee is made to feel that she is encouraged to move on.

Some employers have such a system for staff employees, though they may only be counselled to take a typically 'female' career ending on grades below the average payment for the male entrant. Virtually no such counselling takes place for manual employees. This is partly the result, but also perhaps the cause, of the fact that most manual employees have no career prospects, and the best they can do is transfer to a slightly better-paid job or become the foreman.

Counselling therefore not only needs to take place but must combat the usual expectations of what women want and can do.

7. Training

Training is one area where positive discrimination, by means of women-only courses or special encouragement to women, is allowed (see p. 292). As well as specific training courses, consider temporary transfers or attachments to other departments

so that women can try out new jobs and gain the confidence that they could do them. Current training programmes will need to be checked and revised to open them up to women.

In a finance house the union (BIFU) set up a joint equal-opportunity committee one of whose first tasks was to 'question the traditional female support role and whether in the secretarial or clerical functions it often masks both the knowledge and capability to do the bosses' jobs. So, for example, a secretary to a marketing manager, or the senior clerical staff servicing a sales team, is only a small step away from being a proficient and productive member of the system they support.'

The company agreed that there should be positive discrimination in training so as to allow, for example, branch staff to leave the office and service agreements as a preliminary to full selling. Training schemes were set up to encourage middle management to select female staff for training and promotion opportunities and to raise the confidence and consciousness of female clerical and secretarial staff via career development training.

8. Other positive steps

These are the steps outlined on p. 302 to make working life fit most women and not force women to fit working life. To avoid sex bias they also need to be equally open to male employees. It may encourage men to take their proper share of child-care and housework if they too can have shorter hours, longer holidays, use of crèches etc.

Make sure that part-timers' access to transfer and promotion is looked into and that, if part-time work is available only for the lower grades, entry to higher-graded jobs, perhaps on a job-sharing basis, is considered.

One retail distribution chain which employs large numbers of women workers changed their training and promotion patterns to cater for part-timers.

Training
Used to be carried out during weekly sessions while the shop was closed. Few part-timers attended because of the hours they

worked. The training manual was changed to allow part-timers to follow it with on-the-job coaching without having to attend after work.

Personal development
Was altered so that part-timers could take on extra responsibilities for special tasks which were performed regularly but not necessarily daily.

Career progression
Was opened up to part-timers so that they could progress through several levels of shop assistant to cashier and deputy branch manager through the use of split jobs (see p. 000 for job sharing).

As well as more flexible hours to cope with school-age children and generous maternity arrangements, women may need unpaid leave during school holidays, sick leave when children are sick, and compassionate leave to deal with other family crises to encourage them to take on more responsible jobs knowing they can still cope with family responsibilities.

9. Trade union action

If these kinds of women's issues are to be seen as key bargaining questions by trade unions, it is very important that women are represented and are present at union meetings and able to stress their case (see p. 333 for more suggestions on this).

Who is in favour of such programmes?

There are varying degrees of support for positive action programmes.

The Equal Opportunities Commission

The EOC has an official guide on *Equal Opportunity Policies and Practices in Employment*, published in March 1978. This concentrates on eliminating discrimination from employment

practices and says almost nothing on the need for positive action in training or for any of the steps outlined above. The Commission has issued a leaflet for employers on the benefits of positive action.

Trade Unions

The TUC has for some years urged trade unions to include this equal-opportunities clause in their collective agreements:

The parties to this agreement are committed to the development of positive policies to promote equal opportunities in employment regardless of a worker's sex, marital status, creed, colour, race or ethnic origins. This principle will apply in respect of all conditions of work including pay, hours of work, holiday entitlement, overtime and shift work, work allocation, guaranteed earnings, sick pay, pensions, recruitment, training, promotion and redundancy. (Nothing in this clause is designed to undermine the protections for women workers in the Factories Act.)

The management undertake to draw opportunities for training and promotion to the attention of all eligible employees and to inform all employees of this agreement on equal opportunities.

The parties agree that they will review from time to time, through their joint machinery, the operation of the equal-opportunities policy.

If any employee considers that he or she is suffering from unequal treatment on the grounds of sex, marital status, creed, colour, race or ethnic origins, he or she may make a complaint which will be dealt with through the agreed procedure for dealing with grievances.

A report adopted by the 1981 Congress went further, recommending positive action within the unions and calling on them to back up the equal-opportunities clause by negotiating an equal-opportunity programme, detailing the steps which management and unions need to take to implement its aims. Trade unions are advised either to use their usual negotiating committees for this task or to set up a sub-committee or a separate equal-opportunities committee. Either way women representatives should be involved, or if there are not enough women elected as union representatives, then they should be co-opted for this purpose. The union side could do the negotiating with management at a joint equal-opportunity committee.

Most individual unions accepted the need for this kind of comprehensive positive action programme, though so far actual implementation of the policies has been rare.

Employers

The CBI has a model equal-opportunity clause which it recommends its members to adopt, though it does not commit the company to any action.

A survey of employers in 1979 reported that only 18 per cent of them had made any changes in employment policies and practices as a result of the Sex Discrimination Act. Nearly half said there had never been any discrimination, and more than one in five that there was no need for change. Over half of the employers said they had a policy of equal opportunities, though only 14 per cent had written it down and only 3 per cent had produced a copy. One half of those who said they had a policy also said it had made no difference, mainly because equal opportunities already existed.

When employers do adopt an equal-opportunity policy, and even write it down, it is often no more than a pledge that they will not unlawfully discriminate, and does not include any positive steps to assist women. Unless someone in management is responsible for implementing the policy, communicating it to managers, and training staff to carry it out, even the minimum objectives of a non-discriminatory equal-opportunity policy will not be achieved.

To date, only a handful of private employers in Britain have equal-opportunity policies, usually covering both race and sex. They include Sainsburys, Cadburys, and British Leyland. So far they have only achieved minor changes.

In the public sector the Race Relations Act requires local authorities to make arrangements to eliminate unlawful racial discrimination and promote equality of opportunity in carrying out their functions. As a result many local authorities have an equal-opportunity policy covering race, and these often cover sex as well, sometimes also including other disadvantaged groups

such as the disabled. Lambeth Council's policy also covers homo-
sexuals. As in the private sector, these policies can vary, and
it is only a minority that have a detailed programme negotiated
with the unions and actually committing the authority to action.
(see p. 319 for the example of the London Borough of Camden).

Local authorities could not only energetically pursue positive
action for their own employees but also make it a requirement
in their contracts that contractors have such policies and pro-
grammes. In 1981 the GLC were exploring how far they could
use these means to expand the use of positive action programmes
for women and ethnic minorities among their contractors.

How does positive action work out in practice?

Here are two examples of how positive action has been started:

1. A TV company

An outside consultant, Sadie Robarts, was jointly commissioned
by the National Council for Civil Liberties and the Equal
Opportunities Commission to research into the need for positive
action in Thames TV during 1979–80 and make proposals for
change.

Thames TV were concerned at the job segregation which had
been revealed by an earlier study into the industry by ACTT,
the television and film technicians' union. They wanted to
respond to pressure by Women in Media and the Women's
Broadcasting and Film Lobby, and felt that the company
might be missing out on the talents of its women employees.

Ms Robarts obtained details of the jobs and salaries of men
and women from the Staff Relations Department, where the
information is all computerized. Women were almost totally
absent from technical jobs and the upper managerial level. In
this, Thames was similar to other television companies. She had
in-depth interviews with twenty-one managers and supervisors.
She found out what the women thought by having meetings to
which all women employees were invited; she also separately

interviewed forty-three women who had either asked to be interviewed or had been suggested by others as feeling very strongly about the issues. These meetings led to a women's committee being set up to act as a pressure group on trade unions and employers, and to provide a support network for women in the company.

Interviews with the women showed that many secretarial and clerical workers wanted to be personal assistants or researchers (both mainly female jobs but not always open to clerical workers). PAs and researchers wanted to be producers or directors (mainly male jobs) and found lack of technical experience a bar. They demanded more information on the 'attachment' schemes which would allow them to work in a technical area on a temporary transfer to gain experience, and they stressed the need for more training. They wanted regular career assessments and appraisals. Their managers, whom they had to approach for approval before applying for promotion or transfer, were too often unsympathetic or discouraging, and it seemed that those women who had succeeded in making it into a male job were often distinguished by having a sympathetic manager, shop steward or supervisor. They also wanted a code of practice for interviews to stop questions such as:

'How would you cope with bad language on studio floor?'

'Do you expect concessions because you are a woman?'

'Do you burst into tears if a director shouts at you?'

'Once you women have babies you go all mumsy, don't you?'

Following recommendations made by Sadie Robarts, Thames agreed to set up a positive action programme to include:

1. The appointment of an executive director with overall responsibility for the programme.

2. The setting-up of a positive action committee with representatives from management, the women's committee, the union and non-union staff, to progress and develop the positive action project.

3. The introduction of training courses for management on equal opportunities, with emphasis on training personnel management staff.

4. A code of practice for interviewing.

5. Detailed monitoring of women's position within the company, covering job applications, appointments and promotion.

6. Making sure that women know of the training opportunities open to them by giving information and career counselling.

7. An examination of recruitment procedures, including job descriptions and job advertisements, to avoid discrimination.

8. The extension of child-care assistance.

2. A local authority

The London Borough of Camden has perhaps the most highly developed equal-opportunity policy and programme, introduced in 1978 with full trade-union participation. It covers ethnic minorities and the physically and mentally handicapped as well as women.

The Chief Executive (the council's most senior officer) and the departmental directors are responsible for carrying it out. A special Projects Officer is responsible for developing the policy, and there are a Training Officer with special responsibility for equal opportunities and a Disabled Persons' Adviser.

A monitoring committee has been set up with elected council members, representatives of non-manual and manual trade unionists, a representative from the Camden Committee for Community Relations and the EOC, plus senior staff from the Central Personnel Department. This committee checks on progress and discusses new issues raised by unions.

Job advertisements have been redesigned to encourage women to apply for non-traditional jobs. The job application form has a tear-off section on which the applicant fills in her or his sex and ethnic background; this section is detached for monitoring purposes before the form goes to the person drawing up the short-list. The main section of the form does not require christian names or marital status.

There is a written code of conduct for interviewers which forbids questions on family circumstances and requires selection to be made on the basis of ability to carry out the duties in a written

job description to be given to all interviewees. All interviewers have been specially trained.

Under the maternity scheme employees with two years' service who are planning to return to work are given sixteen weeks' leave at full pay and twenty-four weeks at half pay: the last eight weeks of half pay are withheld until after a period back at work. Those with less than two years' service get less. Since the introduction of the scheme the return rate of women on maternity leave has risen and is considerably higher than the national average. There is a staff nursery.

NALGO have been pressing for better procedures to allow women to return to work part-time. At present this is within a manager's discretion.

There is a self-reporting exercise to identify areas and jobs where women or black people are unrepresented. The employees are asked to complete forms in each department giving their sex, job titles, grade, etc. In 1981 this exercise still had to be completed, and career development policies and interviews designed.

A report given to 'Women in Action' in the New Year of 1981 showed that there was still a long way to go, especially perhaps for manual women, but that some progress had been achieved. Sue Watkins, a manual worker for the council, reported on the experience of some of her fellow-workers:

'When I rang up about the job they were really discouraging', said Anna, a carpenter in Camden's Building Department. 'They said things like "We don't pay you very much, you know" and that I could only go on the maintenance (repairs). They were doubtful whether I'd get day release.' When Anna got to her interview she found the Personnel Officer had forgotten about it, and Dee, another carpenter, had the same experience.

However, they found that an advantage of having such a hiring policy is that it can be taken up and pressure put on middle management to take women on, however reluctantly. Dee said she had found the union helpful:

'Vic Heath (UCATT convener for Camden Direct Works Department) would go down there and point out to Miss Dean they knew you had applied. You need their support.' Jinny, who worked for Camden for three years, agreed:

'If it hadn't been for the union it would have been much harder. They said they were glad to have me and would see I was all right and everything.'

Another woman had complained of being sexually harassed. The foreman took no notice, but Vic Heath arranged for her to be transferred to a friendlier site.

Although Camden's publicity leaflet talks of 'special training' to help women 'compete on equal footing' for jobs where they are now under-represented, none of the women Sue Watkins talked to had heard of this. She also reported that there is constant pressure to stop doing a 'man's job' and go and work in the office, answering the phone and filling in forms. She also found a tendency to operate a discriminatory division of labour. Most of the women carpenters had to fight hard to stop doing small repairs and get on to sites, and then they were often put on 'snagging', which is basically going round tidying up after the carpenter, planing the odd door and correcting floorboards.

However, Sue Watkins concludes: 'To be fair to Camden Council, though, it must be said that their policy probably goes as far as it can under the Sex Discrimination Act. Their maternity leave scheme is really good, and the nursery is a step forward. They really do advertise every job as open to anyone who has the skills, regardless of "sex, race and marital status".' But she felt that to achieve a far higher percentage of women in jobs where they are under-represented, there ought to be a quota of jobs to be filled by women, together with training programmes that really counter the demoralizing effects of being told you can't do a job well because you are a woman.

Sources of Information

Sadie Robarts, with Anna Coote and Elizabeth Ball, *Positive Action for Women: The Next Step*, NCCL (£2).
Report of the 51st TUC Women's Conference 1980–81.

WOMEN AND TRADE UNIONS

Britain is a highly unionized society. Eleven and a half million trade unionists belong to unions affiliated to the Trades Union Congress, and there are about half a million trade unionists in other trade unions and staff associations. So about half of all workers are in a union, a considerably higher proportion of the workforce than in France, West Germany or the USA, though lower than in Belgium, New Zealand or Scandinavia.

Pay and other terms and conditions in our major industries and public services are decided by negotiations between trade unions and employers. Unions have a wider influence than their membership. Their negotiations decide either directly or indirectly the pay and conditions of about 80 per cent of the workforce.

Increasingly trade unions have been a powerful force in deciding policies outside the narrow bargaining areas. Their political face has strategies and policies on almost every economic and social question. Their power means that unless women help to shape these policies their needs will undoubtedly be neglected.

Women's increase in the labour market has been reflected by an increase in the trade-union membership. Women are now one

third of trade-union members, with 3.7 million women in TUC-affiliated unions. So although they are still less unionized than men, there are sufficient women trade unionists to make unions reflect women's demands and needs.

Yet, as this chapter describes, trade unions are still over-whelmingly dominated by men. In this, trade unions are no different from other British institutions; industry, commerce, Parliament, the judiciary, police and army are all ruled by men; but in order to improve the jobs that women do, and the rewards they receive for doing them, access to trade-union decision-making is essential.

This chapter looks at women's under-representation on trade-union decision-making bodies and the reasons for it; the diffi-culties women face in becoming involved in trade-union work, and what changes would help to overcome them; how and when trade unions make their decisions. Are trade-union bargaining priorities right for women, or do they need to be changed? As you may not be a union member or know what union you should join, there is information on what unions there are and how to find out about them.

What is a trade union?

A trade union is an organization of workers established to defend and improve its members' terms and conditions at work and in society generally. Unions negotiate on behalf of their members and advise and assist members on wages, equal pay, conditions of work, industrial safety, unfair dismissal and redun-dancy. Unions provide benefits during strikes and sickness and legal assistance for members who have accidents or suffer indus-trial diseases.

How many women are in trade unions?

Table 20.1 (p. 328) lists the trade unions with the largest female membership. Six of them have more women members than men.

What kind of unions are there?

British unions are an untidy mixture of occupation, industry and general unions and organizations on a craft or skill basis. Some are white-collar, some manual; some manual unions have a white-collar section. To foreigners with a tidy union structure, usually on an industry basis, the British hotch-potch is most puzzling. Its explanation is rooted in British history and goes some way to explaining how women fit into unions and some of the problems they face.

Craft unions

Craft unions originally restricted membership to workers with a particular 'trade' or 'craft', which usually meant they had to serve an apprenticeship. There are some unions who were originally entirely craft but now have many unskilled members (e.g. the engineering union AUEW). Until the 1920s they largely excluded women, either directly or indirectly by requiring all members to have served an apprenticeship, which women were not permitted to do. There are still unions which are totally craft (e.g. the National Graphical Association in the print industry and the Patternmakers in engineering), but most craft unions now have non-craft sections.

Industrial unions

Unions which seek to organize all workers in a particular industry; for example the NUM in coalmining or the NUR in railways.

General unions

General unions recruit unskilled and semi-skilled workers in whatever industry or occupation they are working. General workers remained unorganized until the 1890s, having been excluded from the craft unions. They then formed their own unions. Slowly, and often unenthusiastically, they accepted

female members, though often also advocating that women should form their own unions.

White-collar and professional unions

Teachers and clerks were unionized at the turn of the century, and there are now a large number of unions for civil servants, local-government workers, teachers and office workers.

Are there any unions just for women?

In the late nineteenth century women formed their own unions, not from choice but in response to male exclusion. Outside the textile unions, most male trade unionists thought women should organize themselves if at all. The early history of women workers is a moving reminder of female militancy and determination to survive against incredible odds. Women then coped not only with arduous work, poverty, and the same long working hours as men on half men's wages, but most of their adult life was almost continual pregnancy, childbirth, child rearing. Leisure was an unknown experience. Yet they did organize. In the 1890s the National Federation of Women Workers under Mary McArthur gained a reputation for militancy if anything exceeding that of most male unions. Most male working-class opinion remained at best neutral to their efforts and was often hostile, but there were examples of groups of male workers, such as the dockers, supporting women's strikes.

The First World War brought the full-scale entry of women into the labour market. This was a sufficient challenge to previous prejudices for the male trade-union world officially to recognize women's place in the trade-union hierarchy. In 1920 the National Federation of Women Workers amended the proposed structure of the TUC General Council by adding an eighteenth group of unions representing women workers and gaining two seats for women on the General Council. The TUC also agreed to take over the work and role of the women's trade union league (a mini women's TUC). A women's committee of the General Council was formed to look after women's interests. In

the same year the National Federation of Women Workers voted to merge with the National Union of General Workers. Mary McArthur spoke in favour of this move, saying 'We are convinced that inside the National Union we shall be able to demonstrate the possibility of a great industrial organization of men and women, in which women are not submerged, but in which they take as active a part as men. That would be a great thing in the history of this country for it has never been done before.' But, as Sarah Boston records, 'Unfortunately Mary McArthur's hopes were not answered'. The most militant union in the history of women's organization became a mere district of the National Union. Far from the voice of women gaining the backing of a large industrial organization, by 1930 it had been so effectively silenced that the National Union of General and Municipal Workers did not send one woman delegate to that year's TUC Conference.

Women's brief emancipation during the First World War came under savage attack in the inter-war years as the Depression led to strident and persistent demands from male workers that women should give up their jobs. Without an effective independent female trade-union voice the fight-back was limited. Even the Second World War, with its repeat performance of women running industry, did not significantly raise the feminist profile.

Which unions are most important for women?

Soon after the Second World War working patterns and trade-union membership changed. As described on p. 16, the growth in public services and a consumer boom brought job opportunities for more women, and from the 1950s women entered the job market in increasing numbers, the majority of new female jobs being part-time. At the same time low-paid jobs, particularly in transport and health services, were occupied by immigrants from the Caribbean and elsewhere, with large numbers of women among them. Unions grew and new unions emerged to cater for the new shape of labour. In the 1960s and 70s the massive growth area of trade unions was in public services, the

new membership mainly women. White-collar unions such as NALGO and the civil-service unions mopped up clerical and administrative workers. By 1978 to 1980 the face of British trade unions had undergone an irreversible change, with 40 per cent of the total membership in the public services and 60 per cent of them women.

In the private sector the degree of unionization has been patchy. Unions made only partial inroads on the new female jobs. Women employed in large industrial undertakings were likely to be unionized, though there was often a continuing reluctance to touch part-timers, who were seen as a threat to 'real workers'. Women in small workplaces remained largely unorganized. Women's presence and power in trade unions broadly reflect the jobs they do and fall into the following categories:

1. Women remain absent from key groups of mainly manual workers in powerful industries and public corporations, mining, steel, engineering, oil-refining and tanker drivers, gas, electricity and water. These groups of workers and the unions or sections of unions who represent them can, because of their proximity to the means of production, 'pull the plug out' on the economy. They generally set the pace for each wage round on the level of wage settlements. They can provide 'the breakthrough for weaker groups of workers, who hope to be able to follow on.

2. Women are present and unionized in the public-service area, civil service, local government, health, education and teaching. In general these unions are aware of and respond to female pressures. They have made overt efforts to unionize women, including part-timers. Wages are negotiated nationally, and women need to feed into national negotiating process.

3. In the private-sector industries where women work, the picture is complex and it is difficult to generalize. Some areas are highly unionized, particularly large-scale manufacturing; some are unorganized. Unorganized sectors include most of the low-pay areas discussed on p. 359.

One factor which can increase difficulties for women is multi-unionism within a workplace. The craft/skilled jobs will be the province of the male-dominated craft unions. They may also

occasionally 'control' the supervisory jobs. The semi-skilled and unskilled jobs will be organized by the general unions. Even when a craft union, such as the engineering union, has many non-craft female members, it usually jealously guards access to skilled jobs from 'dilutees' (those who have not served their apprenticeship), whether male or female.

The white-collar areas in private industry and commerce are less likely to be unionized. Where they are (ASTMS, APEX, TASS being the three main unions), women are usually recognized as an important constituent, though male technicians and higher-grade administrative workers are often more chauvinist than the official trade-union attitude. Multi-unionism can still cause problems. As one example, in television ACTT organizes the technicians, researchers and production assistants, but the secretaries are in NATTKE. This is one additional difficulty in the way of secretaries progress to a better job.

What positions do women hold in trade unions?

Women's total membership of trade unions, almost a third of TUC-affiliated unions, is not reflected in the number of women

Table 20.1: *Women in unions 1980–81*

				Executive Members	
	Total	*Women*	*% Women*	*Total*	*Number of Women*
APEX	122,000	68,000	56	15	1 (8)
ASTMS	427,000	86,000	18*	24	2 (4)
FIFU	148,000	72,000	49	27	3 (13)
GMB	865,000	297,000	34	30	1 (14)
NALGO	796,000	408,000	51	70	15 (35)
NUPE	704,000	469,000	67	26	9 (17)
NUT	224,090	167,000	72*	44	4 (29)
NUTGW	82,000	74,000	90	15	6 (14)
TGWU	1,659,000	257,000	15	39	0 (6)
USDAW	437,864	277,000	62*	16	3 (10)

* 1980 figures. (*Sources:* TUC *Annual Report* 1980–81; individual unions.)

trade-union officers, senior shop stewards or conveners, or del-
egates at decision-making conferences. As Table 20.1 shows,
women are seriously under-represented in all major unions,
including those unions with a majority of women members. The
TGWU, with hundreds of thousands of female members, did
not have a single woman on the executive, the leading decision-
making body. The number of full-time women officials is gen-
erally negligible, with a slightly better representation among
some staff unions.

Women are generally absent, or represented only in a token
capacity, when most trade-union decisions are taken. Although
there are thousands of women shop stewards across the country
(the actual number is not known), when it comes to choosing
delegates for national conferences or union conferences, women
are inclined to disappear.

Why are unions dominated by men?

The usual reason given is that women don't want to be shop
stewards, branch officials or union delegates. Just as employers
say that the reason why they have no women managers, super-
visors, technicians, fitters or drivers is that no women apply for
the jobs, so male trade unionists look to women's reluctance to
explain their own monopoly of power.

Equally, it is still common coinage that women are less mili-
tant, unwilling to take industrial action or press their demands.
Just as p. 141 explains how many 'male' jobs are placed beyond
the reach of women, so with trade-union positions. Without
malice or design, but also without concern, men have shaped
trade-union life to suit those who have no child-care or
other domestic responsibilities and on an expectation that
every trade-union activist has endless evening hours to devote
to union work. If branch meetings aren't held in the evening,
then they will be arranged at Sunday lunchtime, considered
convenient as the wife is cooking lunch, and it takes place where
men meet, in the pub. Trade-union activists start being a shop
steward or staff representative in their early twenties and build
up experience, expertise and support when women are having
children. All the problems for women outlined above face

women trade unionists as well. To be an active militant you need to be on stand-by duty for emergency meetings after work, strike committees, early-morning pickets, trade-council meetings, delegations and conferences. To be on the union executive, you need to prepare yourself at weekend schools, on residential training courses and as a delegate to week-long congresses at the seaside resorts.

A shop steward's trade mark is verbal agility, thinking on your feet, marshalling your arguments, being persuasive, carrying a meeting and bargaining against professionals. If you are male these verbal skills are admired and encouraged from an early age, and chat at work, in the pub, or after union meetings helps you along. Educational experts find that women have more highly developed verbal skills than men but when they put them to use it is only too often put down as yapping, nagging, never giving him a moment's peace. A woman's social life outside the workplace and the years she usually spends at home with the children are centred on domestic life, where she is expected to be the peaceful housewife and not the aggressive negotiator. Some women, though, find their years at home a useful training-ground; a woman trade unionist quoted in Jane Stageman's book *Women in Trade Unions* said 'I learnt all the skills I need in this job in the family. In bringing up five kids I did all the things – I was a peacemaker, two-faced, bargainer and had to have a large voice.'

The major battle is to make male union members recognize that, far from women members asking for special treatment or privileges, it is men as a class who have ruled trade unions, along with other institutions, because of women's extra workload in the home. Fundamental changes will come when men (as some are gradually doing) share the responsibility and the work of child-care and domesticity and jointly plan and campaign for a work and trade-union life which assumes that everyone, not just women, has social responsibilities outside the workplace.

The union militant too often nods acceptance at this as a theory, but goes on to explain that the urgency and immediacy of trade-union work mean that these longer-term questions have to wait. Trade unions cannot be hampered by catering for people

who can only give them half their attention. It is one of the gains of the women's movement over the last ten years that this tunnel-vision has been dented at official level (see p. 000), but at the grass roots it is still far too predominant; many of our trade-union brothers have still to be convinced that a woman's job is more than a hobby, or an extra she indulges in when her real work at home does not take up all her time.

Are women better off without unions?

As unions are still run by men, it is easy to doubt if union membership is really the road to equality at work and improving pay and conditions. Yet the alternative of being non-unionized and unorganized is worse, and, under pressure, unions are slowly changing to reflect the needs of their women members.

Although there have been cases of unions at the workplace blocking women's claim to equal pay or failing to assist women to achieve upgrading, unorganized women have overall come off worse. A report published by the EOC in 1981 following a comprehensive survey of workplaces reported that establishments with trade-union recognition had a better record than those without it on the introduction of equal pay, the use of job-evaluation schemes, changes as a result of the Sex Discrimination Act, equal-opportunity policies, positive-discrimination schemes, pensions, sick pay, and equal rates and holiday entitlements for part-timers.

Trade unions are the only way for workers to organize together to improve things. Without them you can only approach your employer as an individual on a grace-and-favour basis. For every employer who turns up trumps, there are many more who find sound business reasons to maintain the *status quo*.

So what can be done?

An immediate action programme for reshaping union life to suit women must start at the union organization in the workplace and in the branch. It is the union organization in the workplace (shop stewards' committee or staff representatives' committee)

which is the base of the negotiating tree. Here crucial nego-
tiations may take place, or, if negotiations are conducted at
national level (see p. 90), it is activity and elections here which
decide the delegates to national delegate conferences or nego-
tiating bodies. Being active in the branch, experience as branch
secretary or committee member, lead to delegate positions at
conferences where union policy is decided. Experience in both
is often essential for future union full-time officials.

The changes that need to be made can be broadly divided into
organizational, bargaining priorities and attitudes. The particu-
lar changes will depend on how your union organizes and what
problems you and your fellow-women members face. Here are
some suggestions of steps that can help. For brevity the term
'shop steward' is used to include 'staff representative' and any
other term for an elected workplace representative; and 'shop
stewards' committee' is used for the workplace committee.

1. Representation of women in the workplace

Make every effort to ensure that there are women shop stewards
to represent the main groups of women workers. Too often
women workers do not have their own representatives, and part-
time shifts are particularly badly off. Women may lack the con-
fidence to stand as shop steward, not know how to go about
being elected; or the tradition has been that certain male
workers dominate the bargaining process. Airing and discussing
these problems is the number-one step to overcoming them. If
no woman can be found to be shop steward immediately, ask
the shop stewards' committee to co-opt at least two women until
some women have been elected (see below for bridging courses
to give women confidence to stand for election).

2. Representation of women in the branch

Low attendance at union branch meetings is endemic. Branches
sometimes consist just of members in large workplaces, meeting
at those workplaces, but most branches have members from a
number of different workplaces and meet elsewhere in the eve-

nings. Business is usually conducted so as to be both boring and incomprehensible to the novice, who is rarely given any idea of how to raise matters and become involved. To say anything at all can be an ordeal when you are not used to the strange world of agendas, minutes, correspondence, resolutions, and speaking through the chair.

The membership of branches varies enormously, from a hundred or so to several thousand. Some branches may be dominated by powerful male groups of workers and may never be attended by, or pay any attention to, the women members. Dustmen may dominate a local-authority branch, and school-meals assistants and home helps never attend. Craftsmen frequently dominate branch and workplace meetings in engineering, even when in the same union as women workers. In local government there are still many NALGO branches where senior management members, nearly all men, hog the discussion. As attendance is usually small, if a group of women workers do turn up and persist they can both force items of interest to them on the agenda and obtain election to the branch committee, which will take place annually at the AGM. It is often difficult, though, to gain sufficient interest and confidence among women in the branch for this to happen. If you want to have a try, see if you and a friend can go to a TUC bridging course to learn the skills. Be persistent, try to learn about procedures so that you can use them but aren't afraid of not following them, and will complain if you don't understand how the meeting is conducted. The union should be simple for every member to use.

3. Opportunity for women to get together

Women's lives, and often their working pattern, give them less chance to get together and discuss their work, the union, and what improvements they want. After work, they rush off home, while men are more likely to stop off for a chat in the pub. At lunchtime, if they have one, they often go shopping. Many part-timers and office workers often work straight through their working day, with no organized break when they can meet, in order to get home earlier.

Arranging a time when women can get together and discuss what they want can be a key to their general involvement in union life. For the first time, they identify common problems and find the confidence to plan action. Such meetings need not always be confined to union members (see p. 317). You are more likely to get a good attendance if meetings are held in the workplace and in work time if at all possible (see p. 335).

New Year 1982 saw the launch of a new initiative in women-only workplace groups. The GMB backed a project funded by the EOC employing Marguerite Dawson, whose idea it is to set up workplace discussion groups which meet once a fortnight during the working day to discuss how women feel about paid work, domestic work, and any other issues, including trade-union activities. The women meet in small groups of not more than ten and teach each other, rather than have outside experts, with help and information from Marguerite Dawson. Home helps and school-meals staff employed by Sheffield Council are given paid release to attend sessions during working hours, as are factory workers at the Sterling Winthrop chemical works in Chapeltown. Rowntree Mackintosh of York and a Leeds engineering firm, George Bray Ltd, are providing lunchtime facilities.

4. Giving more information on the union

Women members of unions (and many men) know little about how their union functions, where decisions are taken, who takes them, how you are elected or appointed to various positions, what policies the union has on bargaining issues and wider questions, how these are decided and how you can influence them. There is a major problem of communication, particularly between the larger unions and their members. For the activists, union training courses provide this information, but most women members will not go on courses. The branch is the unit of the union which should explain union policy. Women especially should be told how the union caters for its women members, about special committees, conferences, women officers and

where they can raise questions. But most union members will not go to branch meetings either, and real involvement is restricted to the workplace; so this kind of information also needs to be given at the workplace, if only in outline. An information meeting, plus simple leaflets or broadsheets, would help. Before important negotiations make sure the women are informed of the content and consulted as to whether or not their own demands are included.

5. *Time and place of meetings*

Arrange meetings in work time wherever possible. All inquiries show that this would remove a major block on women attending. This is often not possible on a regular basis, but management may concede an occasional meeting if you say that it is particularly important for women to attend. Pick an issue that management want to solve and say it is necessary to consult with women members and this can only be done if the meeting is in work time. Once having made a breakthrough, it may be possible to build on it and hold future meetings.

Make sure that part-time women and their representatives can attend meetings. Again if necessary have special meetings for them. The shop stewards' committee should give special help to part-time women representatives, who often feel isolated from the mainstream of union life and need extra support.

When meetings have to be outside work time, as branch meetings nearly always will be, consult women members as to the least inconvenient time. If there is a clash of interest between men and women, seek to alternate times rather than allow male interests to dominate. Check the place of the meetings to make it as convenient as possible. If it is difficult for women to travel, see if any help can be given with transport. Women are less likely to drive to meetings than men, and may be reluctant to go home alone at night. Going with a friend is important to many women, so discuss who can go with whom. Try to make sure the meeting place is not too off-putting for women; they may not like pubs, often because their husbands object to them going there.

6. Workplace bargaining priorities

Women's issues are just not dealt with seriously here, unlike the men's, which are taken up even to local conference if necessary.

Men see issues that we bring up as trivial and don't understand that they matter to women.

Men have all the say here and just won't listen to the women.
[from *Women in Trade Unions* by Jane Stageman]

The issues you consider important at work may not be key issues for men. You and other women may want shorter hours as a greater priority than higher pay. When it comes to pay, there may be differences in approach. You may want an across-the-board flat-rate increase, the men a percentage increase, or an increase widening differentials, or changes that would benefit those on bonus and overtime. You may feel that women are discriminated against in job opportunities, promotion, the way the bonus scheme works. You may want to press for time off in school holidays or when children are ill, and men stewards may consider these issues unimportant or demanding 'special treatment', even when they are vital for working mothers.

Find out from discussion with the women what they consider important. Perhaps use a questionnaire, then ask them to list subjects in order of priority. Then prepare yourself to persuade the men that they must give these issues equal ranking with the men's issues. If you are a steward for the women, make sure they know they must back you in your efforts. See Chapter 8 and Chapter 19 on positive action for the kind of bargaining priorities which generally help women.

7. Branch agendas

Branch meetings often fail to cover items of particular interest to women. Try to gain the agreement of the branch committee that they should do so, not just once a year but regularly, and that they make it their business to consult women on the branch committee and other active women in the branch so that there are reports on women's activities in the workplace, local com-

munities, and unions generally. When it comes to putting forward resolutions to union conferences etc., make an effort to find out which are the meetings where resolutions will be called for and decide on a resolution with your fellow-women.

8. Attitudes

All this work is made much more difficult if the men at your workplace and in your branch are either hostile to your efforts or patronizing and indifferent. One of the most difficult reactions to cope with is the way men sometimes allow you to speak but then ignore completely what you said and go on as if you hadn't spoken. Jane Stageman found regular complaints that men 'do not give us a chance to air our views'. If you have the support of other women and you tackle things as a group, it helps. When you want to raise something important, try to prepare it in advance; and make sure that you have support at the meeting and that another woman will come in after you have spoken to stress that the issue is important.

Do unions make any special arrangements for women?

The last ten years have seen increased activity by women members demanding that unions should reflect their needs and allow them to meet to discuss their views. It is now official TUC policy that trade unions should take positive steps to ensure that women are adequately represented on trade-union bodies (see p. 315 for the TUC Positive Action Charter). Here are some of the steps taken so far:

1. The TUC

The Trades Union Congress has had a Women's Advisory Committee and reserved seats for women on the General Council ever since the merger of the TUC and the Women's Trade Union League in 1920. (The General Council is the leading body of the TUC in between annual congresses.) The Women's Advisory Committee makes suggestions to the General Council

on policies and actions for women. There is also an Annual Women's Conference, with delegates from individual unions and trades councils. This conference elects eight members of the Women's Advisory Committee (the rest are nominated by the General Council) and passes resolutions which do not bind the General Council but are usually accepted as policy and acted upon. For example, it was after a number of resolutions on the need for positive action at the Women's Conference that the TUC Charter on Positive Action (p. 315) was drawn up. It was a resolution on the calling for a demonstration in defence of women's right to abortion which'led to the successful mass demonstration on abortion rights in 1979, led by the TUC General Council.

There are five seats reserved for women on the General Council (out of forty-three). Elections for all General Council seats take place annually at the TUC Congress, and men and women vote for the women's seats.

2. Individual unions

Some unions have reserved seats for women on their national executive committees. The AUEW Engineering Section, for example, reserves seven seats for women on its National Committee; and other examples are COHSE, NUPE, the Tobacco Workers. TSSA and AUEW–TASS. Some unions, for example the GMB, the TGWU and COHSE, have special conferences for women members or special conferences on equal rights.

Some unions have also published booklets for negotiators and full-time officers, and information sheets for members, on issues such as equal rights, bargaining for equality, maternity rights, and the Sex Discrimination Act. Unions particularly to the fore in this area include NUPE, USDAW, TGWU, GMB, AUEW–TASS, APEX, ACTT and BIFU

The particular arrangements will differ according to the structure, history and policy of particular unions. The structures of one general union covering manual workers (GMB) and one industrial staff union (AUEW–TASS) are described below. If

your union does not make any special arrangements these may give you some idea as to what to press for.

GMB (930,000 members; 300,000 women)

The GMWU has ten geographical regions with their own Regional Councils, Committees, and Regional Secretaries. The regions elect two representatives to the National Executive Council. Regional Secretaries also sit on the Executive. There is an Annual Congress which decides policy. The Executive is the ruling body between congresses. The union has had a women's officer since the merger of the Women's Trade Union Federation in 1920. She is now called the Equal Rights Officer and is a National Industrial Organizer. There are Regional Equal Rights Conferences with delegates from branches which send resolutions and elected delegates to a National Equal Rights Conference. The National Equal Rights Conference reports via the National Equal Rights Officer to the National Executive. In 1980 this structure was strengthened with the introduction of Regional Equal Rights Advisory Committees elected biannually by the Regional Advisory Conferences and with one Regional Committee member sitting on it. The Regional Committees were served by Regional Equal Rights Officers (some men and some women). The Regional Equal Rights Committees meet at least quarterly and elect representatives to a National Equal Rights Committee which also has two Executive members and the National Equal Rights Officer as Secretary. The National Equal Rights Committee advises the Executive Council. The terms of reference of the Regional Committees include recruitment, advising on and implementing policies on women at branch level. Each Regional Committee must have six women out of its eight elected members.

TASS (190,000 members; 25,000 women)

TASS is organized in twenty-six Divisions, each with a Divisional Committee. Divisions are grouped into twelve regions. Regions elect one representative each to the National Executive, which rules the union in between annual conferences. It has had Divisional Women's Committees comprising branch delegates, and a women's representative on its Divisional Committees ever

since the Female Tracers Union merged with its predecessor, the Association of Engineering and Shipbuilding Draughtsmen's Union, in 1920. One seat on its executive is reserved for a woman. In 1974 a Women's Officer was appointed. In 1983 a National Officer was given special responsibility for women in addition to industrial duties. In 1981 the National Women's Advisory Committee changed from Divisional representatives to Regional representatives. The Regional representatives are elected by the branches within each Region. The National Women's Advisory Committee elects one of its number to sit on the National Executive. A rule requirement of five years' continuous membership for those standing for any office in the union was removed in 1976, coinciding with a general move in the union away from the original craft base to an industrial white-collar membership.

A number of unions are adopting their own positive action programmes. In 1981 BIFU and NATFHE each published an analysis of the under-representation of women within their union and called for action to deal with it. Branches were told not to hold all meetings in the pub and to look into child-care problems. BIFU pointed out that men dominated their negotiating 'Institutional Committees' and recommended that each committee should name two individuals (one man and one woman) as responsible for equal opportunities, which should be a 'standing item on every agenda'.

NATFHE concluded 'There is little or no encouragement to women to stand for office. In most key offices women are under-represented. All too often women take the minutes and men carry out the negotiations.' Officials were told to approach women whenever a vacancy in office occurs, e.g. for Regional and Branch office and membership of Regional Committees, including salaries committees.

Do these special arrangements help?

Every year at the TUC Women's Conference there is a debate as to whether these arrangements help or hinder equal partici-

pation by women. Those women who oppose them say that women can make it on their own merits and that such arrangements, by hiving women off from mainstream union activity, inhibit their full participation in union life. Those in support, so far the majority, point out the failure of women to emerge on leading bodies of trade unions and argue that the disadvantage women still face requires positive action (see p. 301 for arguments as to positive action in the workplace).

More unions are setting up women's committees, appointing women's officers, and stressing the need positively to encourage female participation. As many of these arrangements are new, it is too early to say if they will be successful in increasing female participation in the unions and changing unions' bargaining priorities to reflect women's needs. One key question to ask about any such arrangements is how do they slot into the union's policy-making and negotiating bodies, and what pressure do they in practice bring to bear upon them?

What needs to be avoided is women's committees and women's officers that only talk to each other and make speeches at their annual union conferences and the Women's TUC. Even if they achieve the adoption of all the right policies which in theory commit their union to do more on equal pay, job opportunities, child-care and positive action, they will have little or no effect on what is happening around the negotiating table and in the union branch unless they have access to and participate in negotiations and branch life. It is difficult to move from formal adoption of the right policies to really committing union executives, leading bodies and full-time officers to change their mode of operation to put these policies into practice. Here are some suggestions of action that women's committees can take to implement policies; some of them are already being carried out in a number of unions.

1. Assisting women members and stewards in workplaces and branches with the kind of steps discussed on p. 332. Women's committees should provide information, encouragement and be ready to listen to, advise and help a woman member or steward who has difficulties.

2. Informing women members about trade-union training

courses they can attend, and running special women's schools.

3. Helping recruit women into unions in areas of low organization.

4. Finding out how many women are represented on the union's policy-making and negotiating bodies, and, when they are absent or under-represented, seeking the union's commitment to set targets for female representatives and make it the responsibility of the leading bodies of the union to achieve the targets.

5. Seeing how many full-time officials on the union are women. In most unions there are very few women officials, and the reasons are fairly obvious. The job requirements exclude most women by demanding geographical mobility, long hours, evening and weekend working, together with previous experience as a lay activist, and in some unions so many years' continuous membership. Thus women wishing to be trade-union officials face all the difficulties discussed in Chapter 11, 'Why Women Don't Have Careers'. In unions with very few women officials, the old-boy network and men-only atmosphere can make most women feel an outsider. This is only likely to be changed when the union decides that the need for women officers is important enough to make a very positive effort to recruit several women officials, demand that the male officials support them, and work out ways that they can do the job.

6. Asking for a number of seats on the executive to be reserved for women, if women are absent or under-represented. They would need to be voted on by the whole membership.

7. Raising the profile on negotiating for the needs of women members. Look at wage claims and see if they tackle low pay for women (see p. 359). Try to instigate action on job opportunities, promotion, and positive action. In many unions, formal acceptance of the right of women to work and to equal pay is in conflict with the male negotiators' 'common-sense' view that men need a family wage but women, if not working just for pin-money, are only supporting themselves. Wage claims for the low-paid are often backed up by the need for members to keep their families out of poverty, and Social Security entitlements for a man, dependent wife and two children are used to prove

the poverty line (see p. 359). This approach inevitably means there is less push for higher pay for women, because it is assumed their need is less, and both men and women members feel uncertain about women's entitlement. Women's committees must combat this approach. They can point out the facts: how few families fit in with the married man, dependent wife and two children model, and how essential women's wages are to keeping families out of poverty. They also need to assert women's right to a rate for the job regardless of sex, and they should point out that in the past men claiming a family wage and not supporting higher pay for women have not protected their jobs and pay but encouraged employers to displace men by using cheap female labour.

8. Pressing for reforms in the tax and Social Security systems to give full rights to women (see p. 354).

Arranging crèches or nurseries at meetings

One major difficulty facing women who want to be active is finding someone to look after the children so they can go to meetings. A persistent demand by feminist trade unionists is for crèches at meetings and conferences to cater for this need.

At some meetings, and particularly weekend conferences, crèches or other facilities for children may be essential and should always be offered. They need to be well-organized, with plenty of activities and preferably outings. Bad crèches can result in the children of active parents refusing to go. They are quick to object at being shut up in a dreary room all day so Mum can go to a meeting. But crèches will not always help women to go to meetings. Not many women will want or be able to bring children to an evening meeting, as it will be past their bedtime. The need is to have someone at home to look after them. While it should be possible to share this load with the father, the result of leaving it to such private arrangements is that many women are forced to stay at home. This difficulty can partly be helped by choosing the most convenient time for meetings, and if the needs of different members of the branch vary, the times of the meetings should vary, so that everyone can attend at least some

of them. It may be possible for mothers of young children to go out at seven or seven-thirty and leave the children with a baby-sitter, whereas if the meeting is at six-thirty they just have to be home to give them tea and put them to bed. These are all questions that should be explored.

Even where a formal crèche is not appropriate because there would be no general use for it, understanding and assistance to any woman who brings a baby or child to a meeting are always a priority.

Where there are day schools or training courses, part-time workers may be in particular difficulties if the hours are longer than their normal work times, and their usual child-minding arrangements are upset. They may need to bring children with them for the day and have a crèche available. Where there are school-age children this will not necessarily assist them, and the time of the training course may have to be cut to fit in with school hours.

How does the Sex Discrimination Act affect trade unions?

The Sex Discrimination Act makes it unlawful for a trade union to discriminate against a woman in the terms on which it admits her to membership, or by refusing her membership, or by expelling her. Discrimination in access to benefits, facilities and services of the trade union is also unlawful.

There are certain exceptions to the general rule that men and women must be treated equally which allow positive action in favour of women (or men). This applies if in the last twelve months there have been few or no women (or men) holding certain posts in trade unions, such as shop stewards or full-time officials.

Women-only training courses to help them take up posts in the trade union would then be allowed. There could be special encouragement to women to take up posts in trade unions, such as advertisements or notices directed at women only. The trade union can reserve seats for women on a body which is wholly or mainly elected, such as an executive committee, or can add on

extra seats for women to be elected or co-opted if the union considers it necessary to achieve a reasonable minimum number of women.

If elected seats are reserved for women, both men and women must be allowed to vote (see p. 338 for those unions which have taken advantage of positive action).

What kind of training do unions offer?

Most union training is done by individual trade unions or by the TUC with the assistance of local education colleges and WEA tutors. Most courses are restricted to shop stewards or union representatives, but if you are not a shop steward you may be able to attend a 'bridging course'. These are courses designed to encourage women to become active in their union and are run on a day-release basis.

Women-only courses

The TUC and some unions run their own basic courses for women members, either during the day or at weekends. Ask your shop steward or branch secretary where you can obtain information about your own union's courses. Write to the TUC for information on their courses.

The TUC bridging courses aim to encourage active women trade unionists to stand as shop stewards, as well as helping women shop stewards to become effective at their job. They vary in length from three to five days and are often only during school hours to help women attend. Most of the work is done in small groups of three or four so everyone can speak, and they concentrate on building confidence, sharing experience, and gaining practice in basic skills like handling grievances, taking part in meetings, giving reports, or drawing up a resolution. All the tutors are women.

Women who have attended report that the courses were very helpful in giving them the confidence to speak at their workplace and branch meetings. They find it easier to talk on a women-only course and can raise issues without fear of being ridiculed.

Once having been on a women-only course they feel ready to go on the mixed-sex ten-day introductory course.

Shop stewards have a legal right to paid time off. If you are not a shop steward and want to go on a bridging course, your union may be able to arrange it with your employer. But some women have had to use their holidays to attend.

Shop steward induction courses

In some workplaces you will be given a course of one or two days on how to become a shop steward. Or you may have to go to a local union office.

TUC day-release courses

If you are a shop steward, staff representative or safety representative, you will be eligible to attend ordinary TUC courses. These are run for women and men. You go one day a week for ten weeks. Basic shop steward training is given on a ten-day course, usually on a multi-union basis, though some courses are for particular industrial sectors, such as the civil service or NHS. There are also safety-representative courses and other specialist courses on the law, bargaining information, work study etc.

Union day schools and weekend schools

Most unions organize schools, usually in the various regions, on a wide range of topics from negotiating skills to wider policies and politics. Your branch secretary should have details.

Residential training

Some unions, such as ASTMS, GMB, EETPU, NUM, NUT and TGWU, run residential courses for shop stewards in their own training colleges or elsewhere. They cover the same sort of topics as the TUC course. Many women find it particularly difficult to attend courses for which they have to be away

from home for a week or more at a time. Generally the numbers of women attending such courses are low. It is important that all unions make sure that women members have the option of day-release courses.

How do you get time off from work to go on courses?

If you are a shop steward or other union representative you have the legal right to take time off to attend training courses recommended by your trade union, as long as they are relevant to your workplace duties as a union representative. Make sure you apply for time off well in advance. If your employer refuses to give you time off or to pay you during your absence, consult your full-time official.

If you are not a union member, how do you find out which union to join

If unions are recognized at your place of work, then there should be no difficulty finding out which union covers your particular job. In a few cases you have a choice, but generally the 'spheres of influence' within the workplace will have been fairly clearly defined. If you do have a choice of unions already on site, then talk to existing members of each union – preferably women members – and see what they think of their organization. Then get hold of the unions' recruitment literature and other publications from existing members or from their nearest local office if there is one. Study what they offer: their services, their benefits, and their contributions (by weekly or monthly subscriptions). Union subscriptions vary from about 30p per week to £1.20 or more per week. Remember there is usually a reduction for part-timers. Do not necessarily go for the cheapest, but consider the overall merits of the organization and what it has to offer, and what you think of its policies, as far as you know them, and of the national leadership. In particular, consider what you know of its attitudes and record on women workers.

If there is no sign of any union activity at all at your place of work, then you need to find out which is the most appropriate

union. The best guide is to see which union women workers doing a similar job in a similar firm in your locality belong to. If you cannot do that, then it might be helpful to contact your local Trades Council (probably in the telephone book) or the local Department of Employment office. You could also try calling the TUC in London (01 636 4030). In many work situations there are a number of unions which you could join.

You can contact unions direct. Check Table 20.2 against your own industry, and look up the addresses of the head offices of all unions that might be appropriate. Then contact the head offices and ask for the address of their nearest district, regional or branch office. Alternatively, you may be able to get the address from your local Trades Council or the local Department of Employment office. Either arrange to go and see them, or ask them to send someone to your place of work to recruit you and your colleagues. If there has not been a union organization there before, it is always better if there is a group of you all willing to join the union at the same time. If you are apprehensive that your employer might victimize you, or at least put a black mark against you if he sees you talking to union representatives, then it is best to arrange to meet at the union office, at home or at the home of one of your colleagues, or at a café or pub in the vicinity rather than at or near work. The union may send a 'lay member' (i.e. a branch secretary or other active member of the union who is working in the vicinity) or they may send a full-time recruitment officer or other full-time official. Ask whoever is coming from the union to bring with them recruitment literature and other information, including anything of special interest to potential women members. If you are asking a number of unions to contact you, so that you can make a choice, then be sure to ask how many members they have in similar positions in your firm, other locations of your firm, or any industry or service in which you work. Generally speaking, it is not a good idea to join a union that is very much in the minority in your particular industry. It is obviously best if other sympathetic workers all opt for the same union, so make sure you consult them and involve them fully.

Table 20.2: *Main unions by industrial sector*

	Manual workers	White-collar workers
1. Manufacturing		
Chemicals and plastics	GMB TGWU Craft unions*	ASTMS ACTSS (TGWU) MATSA (GMB)
Pharmaceuticals	GMB TGWU USDAW Craft unions	ASTMS MATSA (GMB)
Food and drink	GMB TGWU USDAW Craft unions	APEX ASTMS MATSA (GMB)
Tobacco	Tobacco Workers Union TGWU GMB	TWU MATSA (GMB)
Steel	ISTC TGWU GMB NUBlast Furnacemen	ISTC APEX MATSA (GMWU) ACTSS (TGB)
Other metal manufacture	GMB TGWU Craft unions	
Engineering	AUEW–Engineering GMB TGWU EPTU NSMM Craft unions	AUEW–TASS ASTMS APEX MATSA (GMB) ACTSS (TGWU) EESA (EEPTU)
Motors	TGWU AUEW–Engineering EEPTU Craft unions	ASTMS APEX AUEW–TASS
Shipbuilding	Boilermakers	EMA

	Manual workers	White-collar workers
	(ASB)	AUEW–TASS
	GMB	APEX
	Craft unions	
Aircraft	AUEW–Engineering	AUEW–TASS
	TGWU	APEX
	EEPTU	ASTMS
	Craft unions	
Metal goods	GMB	AUEW–TASS
	AUEW–Engineering	ASTMS
	TGWU	
	Small metal unions	
Textiles	AUTW (mainly	ASTMS
	cotton)	MATSA (GMB)
	NUDBTW (mainly	
	wool)	
	TGWU	
	GMB	
	Small textile unions†	
	Craft unions	
Clothing	NUTGW	
	NUHKW (Hosiery)	
Footwear	NUFLAT	
Timber and furniture	FTAT	
	TGWU	
	GMB	
Paper	SOGAT	ASTMS
	GMB	

2. Construction

Construction	UCATT
	TGWU
	GMB
	AUEW–
	Construction
	Craft unions

	Manual workers	White-collar workers
3. Primary industries		
Agriculture	NUAAW TGWU (Scotland)	
Coalmining	NUM	NUM (COSA) NACODS APEX BACM
Other mining and quarrying	GMB TGWU	
Oil	TGWU Craft unions	ASTMS ACTSS (TGWU)
4. Transport and communications		
Road transport	TGWU URTU	
Rail transport	NUR ASLEF	TSSA
Docks	TGWU	ACTSS (TGWU)
Sea transport	NUS Craft unions	MNALOA ROEU
Air transport	TGWU Craft unions	TGWU (ACTSS) APEX ASTMS BALPA MNALOA
Waterways	TGWU	
Communications	UCW POEU	UCW POEU CPSA SPOE POMSA SCPS
5. Public utilities		
Gas	GMB	NALGO MATSA (GMB)

	Manual workers	*White-collar workers*
Electricity	GMB EEPTU TGWU AUEW	NALGO EMA
Water	GMB NUPE TGWU	NALGO

6. Private services

	Manual workers	*White-collar workers*
Banking and finance		BIFU ASTMS
Private education and language schools	GMB	MATSA (GMB) NAS/UWT
Insurance		BIFU ASTMS APEX NUIW
Business services	GMB (Security)	MATSA (GMB) APEX ASTMS
Legal and other professional services		ACTSS (TGWU)
Distribution	USDAW GMB TGWU URTU	USDAW MATSA (GMB) ASTMS
General commerce		APEX ASTMS ACTSS (TGWU)
Scientific research		ASTMS
Hairdressing	USDAW	
Television and radio rental	GMB EEPTU	MATSA (GMB)
Laundries and dry cleaning	USDAW TGWU GMB	

	Manual workers	*White-collar workers*
Hotels	HCWU (GMB) TGWU NUR (ex-BR hotels)	HCWU (GMB) TSSA (ex-BR hotels)
Restaurants, pubs, cafés	USDAW TGWU GMB	NALHA
General tourism	GMB TGWU NUR (Railways)	APEX ASTMS MATSA (GMB) ACTSS
Theatre, cinema etc.	NATTKE ACTT EEPTU	Equity Musicians' Union
Broadcasting	ACTT ABS	ACTT ABS NUJ Equity Musicians' Union
Printing and publishing	SOGAT NATSOPA SLADE NGA	NATSOPA NUJ

7. *Public services*

National Health Service	NUPE COHSE GMB TGWU Craft unions	ASTMS NALGO COHSE NUPE MATSA (GMB)
Local government (excluding education)	GMB NUPE TGWU Craft unions	NALGO
Education	GMB NUPE	NUT NAS/UWT NALGO

	Manual workers	*White-collar workers*
Civil service	TGWU	CPSA
	GMWU	SCPS
	CSU	CSU
	Craft unions	FDA
		IPCS
		IRSF (Tax)

* 'Craft unions' means that in the industry concerned the unions only organize craftsmen specific to their union and their apprentices, e.g.

AUEW–Engineering Section	Mechanical trades
NUSMCHDE	Sheet-metal workers, apprentices etc.
EEPTU	Electricians, plumbers
UCATT	Joiners, painters, bricklayers
APAC	Pattern makers

† Small unions based on cotton (Lancashire) or wool (Yorkshire) or carpets (Kidderminster and Scotland).

What if there is already a staff association?

Staff associations usually have consultative functions only. And that usually means that the management inform the staff association what they are about to do, and are prepared to be influenced only on relatively minor items. Staff associations rarely have any negotiating rights. But equally importantly, since they are based solely in one company or one location, workers who belong to them have no support from their colleagues outside, and no specialist advice to turn to. Most staff associations were set up by management in order to avoid proper unionization. Workers who have only a staff association to represent them are usually in a much weaker position than those who have joined an independent trade union.

Some wider reforms that unions should support

Press your union to take up wider policy questions that affect women. For example, our tax, National Insurance and social

security systems, which crucially affect women's real income and standard of living, need a radical overhaul if women are to be given full rights as individuals, whether married or single. The concept of the male breadwinner and female dependant is out of date and should no longer be the starting-point for the collection of taxes or payment of benefits.

Reform should also aim to help the poorest section of the population, who are those with children, the elderly and the disabled. Recent changes in our tax and National Insurance systems have gone in the opposite direction.

If the tax cuts for the wealthy introduced in 1979 were reversed, exchequer money would be available for tax concessions to the low earners or to distribute in Child Benefit, pensions, and disability allowances.

Here are some changes that would achieve this aim:

1. Deducting less from the low-paid

At present, the low-paid pay a higher proportion of their income in tax and National Insurance than the higher-paid. Employers often pay part-time workers wages below the National Insurance threshold, so they do not have to pay any contributions and they are not entitled to any benefits. The system should ask less of the low-paid than the better-paid and bring the low-paid part-time worker into benefit at a contribution level they can afford.

2. Removing the contribution test

Many more women could claim benefit if entitlement just depended on being unemployed or off sick rather than on having paid a certain amount of contributions in the past.

3. Giving unemployment benefit to part-timers

Unemployment benefit should be available to part-time as well as full-time workers. At present part-timers are told they cannot register for unemployment benefit unless they were working at least thirty hours a week, though this may not be legally correct.

It should be made clear to part-time workers that they can claim benefit for those hours they normally work.

4. Ending discrimination against married women

The government is introducing some overdue reforms as a result of an EEC directive. From 1983 and 1984 both married and unmarried couples will be able to nominate either partner as the 'breadwinner' where they are both employed over eight hours a week, or registered for employment, or incapable of work, or a lone parent, or receiving Invalid Care Allowance, or in full-time education, or over retirement age, or any combination of these conditions. So only those women who are not employed and are not registered for employment (which will be true of many part-time workers not entitled to benefit) will be excluded from the right of nomination. Partners must jointly nominate a breadwinner, or if you fail to agree the Department of Social Security will decide for you. This will have the effect that 'breadwinner' women will be able to claim Supplementary Benefit and Family Income Supplement, neither of which can at present be claimed by married or cohabiting women.

The married or cohabiting woman will still be unable to qualify for Invalid Care Allowance paid to those looking after a disabled person, because it is assumed she would be at home anyway. And if disabled herself and therefore unemployed, she will remain unable to claim the non-contributory Invalidity Pension unless she can show she is incapable of housework (a test considered quite irrelevant for a man).

5. Abolishing the non-cohabitation rule

At present, if the DHSS officials believe that a woman is cohabiting with a man, her Supplementary Benefit (and her children's) is stopped. This rule exposes women to snoopers, implies that they only have sex for money, puts genuine relationships in jeopardy, and causes very real distress and poverty. The reforms the government has proposed will not end this practice. The rule needs abolishing, and women should only be asked to complete

the usual declaration about what income they receive, which would include any regular payment towards household expenses that a man did contribute.

6. Abolishing the married man's tax allowance and increasing child and other benefits

If the extra tax allowance now given to married men was abolished, it could be redistributed in child benefits and benefits to those at work caring for invalids, the disabled and the old. This would direct the money to the households in the greatest need.

In 1948, when child benefits were introduced, they were intended to approximate to the cost of a child. They have never approached that level and in 1982 are worth less in real terms than when they were first paid.

Higher child benefits are good for children and also for women, as they are paid straight to the mother.

7. Increasing the 'social wage'

Women need to have the social wage, nurseries, hospitals and social services, expanded. Reform of our taxation system should look at how the money is spent as well as collected.

These are all questions you can raise with your trade union. All trade unions have policies covering these areas, and women's voices need to be heard if their needs are to be taken into account.

Sources of information

Valerie Ellis, *The Role of Trade Unions in the Promotion of Equal Opportunities*, EOC, 1981 (free).

Anna Coote and Peter Kellner, *Women Workers and Union Power*, New Statesman, 1980 (£1.50).

Jane Stageman, *Women in Trade Unions*, Industrial Studies Unit, University of Hull (£1).

Equality? Report of a survey of NALGO members, NALGO, 1981.

Equality – The Next Step, Society of Civil and Public Servants, 1982.

Equality at Work – A GMB Guide for Negotiators, GMB, 1981.

Women's Handbook, TGWU, 1980 (45p).

Women Workers: Annual Reports of TUC Women's Conferences, available from the TUC (1981 *Report* £3).

Women Workers' Bulletins, produced regularly by the TUC (10p a copy).

Equality for Women – Proposals for Positive Action, BIFU, 1981.

Breaking Down the Barriers: How to increase women's participation in NATFHE, NATFHE.

CAN WE GET RID OF LOW PAY?

There are about 2.5 million low-paid full-time women workers, and as many part-timers in low-paid industries or low-paid jobs. This chapter looks at the low-paid and the industries where they work: how badly paid are they? Wages councils are meant to help the low-paid: are they effective? What other laws, such as a statutory minimum wage, would help? What kind of bargaining helps the low-paid? Do incomes policies offer a solution? The many low-paid women who are public-service workers face particular difficulties in taking action over pay. If they strike, the only sufferers are the public who they want to help. Is there some way their pay could be protected with the aid of 'comparability exercises'?

Many low-paid women face problems of unequal treatment and unequal pay compared with men which are dealt with elsewhere in this book. This chapter looks at measures to raise the pay of whole low-paid sectors or companies closer to the average. These two approaches need to be combined if low-paid women are really to benefit.

This chapter is not about redistribution of wealth, neither does it examine the incomes of the wealthy. Because low pay is usually defined in relation to average male earnings, the well-off disappear from view. It would need a more radical change in society than this chapter contemplates to bring them back into the picture. It may be that radical change offers the only real solution to most of the problems the low-paid face. In the meantime this chapter looks at how the present system works (or does not work) and makes some suggestions for improvement.

What do we mean by 'low pay'?

'Low pay' is a relative term, even though to those receiving it it must seem like absolute poverty. It can mean low pay either

in relation to average earnings or in relation to some standard measure of poverty such as Social Security payments. Both definitions have regularly been used in Britain. This chapter calls the first the 'relative-wage' definition and the second the 'poverty-line' definition.

The common 'relative-wage' definition of low pay is earnings below two thirds of the current average male earnings, including overtime and bonus pay. No account is taken of female earnings. In 1982 this gave a figure of £100 per week or about £2.50 per hour.

The 'poverty-line' definition is usually based on what a married man, with a wife who is not earning and two children, needs to earn at work in order to achieve the same net income as if he were drawing Supplementary Benefit. This calculation normally gives about the same result as the two-thirds approach.

This 'poverty-line' definition has been rejected by many women. Even for men it does not describe a typical situation. Although 22 per cent of all working-age households would fall into the category of single earner with at least one child, only 9 per cent are in precisely the position described by the formula. In very few of these cases would the single earner be a woman entitled to claim Supplementary Benefit for her husband.

If the calculation was of what a woman would need to earn to be as well-off as if she were on Supplementary Benefit, it would either result in a nil wage, because married women cannot claim, or there would be various different figures depending on whether she was a single woman, a lone parent, or whatever. The Social Security system is hopelessly sex-biased, and any argument about minimum wages that relies primarily on a Social Security definition is going to be very difficult to apply to women workers.

These difficulties are more important because this calculation is often used in union wage claims to set the minimum wage target in negotiations, and in claims to wages councils. Its use seems to encourage male claims to a 'family wage' and justify low earnings for women on the basis that they do not have to support a family. Partly because of these criticisms, some unions

are now dropping the 'poverty-line' argument and are relying solely on 'relative-wage' definitions of low pay.

When our Social Security system is re-jigged to eliminate sex discrimination it may be useful to reintroduce the poverty definition, though many consider that Social Security payments are too low to be an acceptable standard for a minimum wage.

How many low-paid workers are there?

In 1980 about 2.5 million women (2.7 million excluding overtime) and over 1 million men were low-paid full-time workers over the age of eighteen. Low pay is even more endemic among part-time women workers. Calculated on an hourly-paid basis, two thirds of all part-time women workers are low-paid, a further 2.5 million workers.

Are the numbers of low-paid workers increasing or falling?

The proportion of average earnings received by the lowest 10 per cent of manual men is the same now as it was in 1886. The figures for non-manual workers and women workers do not go back that far, but there is little evidence that they have done any better. About a million women came out of the low-pay bracket with the elimination of 'women's rates' when the Equal Pay Act was implemented. But overall the position of the low-paid does not seem to have improved much over the last hundred years.

Where do the low-paid work?

About half of the low-paid work in 'low-paid industries', that is, industries or services where there are generally low rates of pay. Within those industries women are still lower-paid than men. Table 21.1 shows the main low-paid industries employing women.

The rest of the low-paid work in industries and sectors where average wages are not so low. For example, there are many

Table 21.1: *Low-paid industries 1981*

	Total number of women employed (*including part-timers*) (*000s*)	Manual Women Workers (*full-time only*)		Non-manual Women Workers (*full-time only*)	
		Average Pay	*% below £80*	*Average pay*	*% below £80*
Textiles	198	£69.50	77	£72.40	74
Clothing	274	£65.40	83	£72.40	74
Distribution	1,596	£69.50	77	£73.10	74
Health Service	999	£74.40	69	£99.40	35
Education	1,271	£67.60	78	£138.00	9
Catering	580	£63.50	85	£77.00	62

Sources: D.E. Gazette 1981; New Earnings Survey 1981.

badly paid manual women in engineering and chemicals. Offices, laboratories and shops across the country hire super-exploited clerks, secretaries, assistants and technicians, although the general levels of pay in these industries are not low.

Is low pay due to low productivity?

While some low-paid industries such as textiles and clothing have had profit margins cut drastically by overseas competition, profitable firms in the same industries pay their workers little more. Other low-paid industries, such as hotels, the retail trade, and agriculture, are as profitable as, and sometimes more so than, industries which have avoided the low-pay tag.

The common characteristic that can be identified in low-pay industries is the weakness of the workforce. There are a number of factors which may inhibit a workforce from demanding and obtaining decent wages. A female workforce is less likely to have organized and fought for higher wages, as this book tries to explain. In some low-pay industries such as hotels, immigrant

workers, often on temporary contracts, and dependent on their employers for board and lodging as well as wages, are a crucial factor. The use of part-time and casual labour is common to many of these industries. Small firms or workplaces are common in low-pay areas and make it difficult for workers to organize. In agriculture, geographical isolation of the workers, the use of tied accommodation and the generally subservient tradition have made it difficult to raise wages.

In public services the worst-paid are the part-time females, who to date have been least likely to fight for higher wages. In catering there are many part-time workers, and the use of contract labour leads to temporary contracts and lack of security.

But areas of low pay can be changed. Sometimes more powerful groups of workers move in to support low-paid sections. For example, a unionized workplace demands in-house rates of pay and conditions for contract cleaners and catering workers, or a non-unionized industry becomes unionized, as has happened in road haulage and is beginning to happen in hotels. Whatever changes do occur, there will always be groups of workers at the bottom of the pay ladder, and therefore we need to look at what institutions, laws, and forms of bargaining and campaigning are likely to avoid poverty wages.

What is a wages council?

Wages councils were originally set up as 'trade boards' at the turn of the century to deal with the scandal of starvation wages and bad conditions in what were then known as the 'sweated trades' of textiles and clothing. Wages councils cover particular industries. Since the turn of the century, several wages councils have been created, and others have subsequently been abolished. Wages councils still cover some sectors of manufacturing, particularly clothing, and also large parts of the private service sectors. Over two million workers are covered by wages councils. But the industries they cover only account for about 20 per cent of all low-paid women, and 12 per cent of all low-paid men.

Each wages council consists of equal numbers of representatives from employers and trade unions, plus 'independent mem-

bers' (usually academics or lawyers), including an independent chairman. Their legal duty is to ensure a 'reasonable standard' of pay in the industry they cover. They do this by setting minimum wage rates, known as the 'statutory minimum rates' (SMR), for the industry and service, and certain minimum conditions such as holidays and hours. They issue wages-council 'orders' each year which set the SMR and other conditions for the industry, after having received representations from interested bodies. These rates are then legally enforceable. Employers who pay less than the SMR or who give worse terms and conditions are committing a criminal offence and can be prosecuted by the wages inspectorate, whose job it is to enforce wages-council orders.

Which workers are covered by wages councils?

The main areas covered by wages councils are:

Agricultural wages boards;

Retail distribution (retail food and retail non-food wages councils);

Clothing (at present there are fourteen wages councils, most of which will soon be merged into one clothing wages council);

Catering (licensed residential, i.e. large hotels and restaurants; licensed non-residential, i.e. pubs; unlicensed places of refreshment, i.e. cafés).

Which workplace is covered by which wages council is sometimes rather obscure, and you may need to check whether your workplace is covered with the Wages Inspectorate (see p. 421 for addresses and telephone numbers) or with one of the unions represented on the wages council. Remember that wages-council orders cover *all* workers employed in the industry concerned, including clerical and office workers, cleaners and canteen staff.

How can you find out whether you are being paid your legal minimum rate?

If you are covered by a wages council, information on the wages order should be displayed at your workplace. But although this

is required by law, it is estimated that one in four employers fail to put up the proper notice at all. Others put it in extremely obscure places. A study of hotel and catering wages councils found that only a very small minority of staff knew anything about wages councils or had ever seen a notice.

Wages-council orders are also notoriously difficult to understand. If you do not understand your order or are not sure if you are covered by one, then contact the Office of Wages Councils (see p. 421). But you may be rebuffed. Official policy is not to circulate wages-council orders to the general public, and you might do better to contact one of the unions represented on the wages council, or the Low Pay Unit (for address see p. 419).

What can you do if your employer pays you below the statutory minimum rate?

Underpayment is a major problem with the wages-council system. In 1978 workers were underpaid in one in three of the workplaces that were actually investigated by inspectors. The Low Pay Unit estimates that wages-council workers were underpaid £22 million in 1979. Because women's rates generally are closer to the SMR than are men's, their underpayment is worse. A survey of button manufacturers in 1978 found that all the cases of underpayment were amongst women. If you suspect you are being underpaid, contact the wages inspectorate direct (see p. 421) or contact one of the unions on the wages council, who will approach the wages inspectorate on your behalf.

You do not have to give the inspectors your name, and they can tell your employer they are conducting a random survey.

Can you be paid more than the SMR?

Some employers who are paying the SMR tell their workers that this is the 'legal' or 'union' rate and they are not allowed to pay more. This is untrue. An employer must pay not less than the SMR, but there is nothing to stop him paying *more*. Women in wages-council industries are on average paid 25 per cent above the SMR. Men are paid on average 100 per cent above. The

employer can pay a higher basic rate or introduce bonus schemes or fringe benefits not provided for in the wages-council order.

Do the wages councils help the low-paid?

Wages councils were set up as a way of increasing pay and conditions for unorganized workers in the worst-paid industries and services. The SMRs they have set vary quite widely. In August 1982 the lowest rate was £42 and the highest £60.82. The actual earnings for both men and women have continued to be very low compared with the national average.

Complaints made against wages councils include:

1. Wages councils often operate against the interests of workers because the 'independent' members usually side with the employer to out-vote the union. The result is low SMRs and poor provision for other terms and conditions.

2. There are too few of the wages inspectors who enforce the rate: 150 inspectors have to cover half a million establishments and three million workers, and they are also supposed to cover home workers (see p. 165). Fewer than one in twelve workplaces covered by wages councils is ever visited by inspectors during the year. The result is that many employers get away with breaking the law.

3. Employers who pay below the SMR are rarely prosecuted, and penalties are not high enough to be a deterrent. There were only ten prosecutions in 1981, despite the fact that wages inspectors reported 10,074 employers breaking the law. The eight employers convicted were fined an average of only £425.

4. Wages councils may discourage workers from joining trade unions by legislating for pay and conditions which unions would normally negotiate for.

Some trade unions have taken the view that all wages councils should be abolished, because, far from encouraging union organization and improving wages, they have had the opposite effect. But without wages councils, the wages of many low-paid workers would be even lower, and progress towards unionization is painfully slow. To abolish a wages council while few workers in the industry are in unions would be to remove the only safeguard

the workers have. Yet the present system is not satisfactory. Over a long period, wages councils have not resulted in low-paid industries catching up with better-paid ones, or in women's earnings catching up with men's. The minimum rates are still very low. Radical reform is necessary.

How can wages councils be improved?

Immediate improvements would be:

1. Writing wages-council orders in simple straightforward language.

2. Having notices explaining the order displayed prominently in *all* workplaces.

3. Increasing the number of wages inspectors (in 1981 the government was actually cutting them).

4. Taking more employers to court for underpayment, and increasing fines to deter law-breaking.

If unions actively campaigned to raise the SMRs while also organizing workers in the industry they can achieve improvements. The Hotel and Catering Workers Union section of the GMB has recently had recruitment drives in hotels and restaurants. They have campaigned against low wages and bad conditions in the industry and put more work into improving the terms of the wages-council orders by presenting detailed wage claims and arguing the case fully at the Licensed Residential Wages Council. As a result the SMR has been raised from 35 per cent of average male earnings in 1975 to 55 per cent in 1980. It is now higher than the unskilled wage in engineering.

If union organization increases, it will be possible to dismantle wages councils. The Wages Council Act provides that a wages council can be abolished if there is an adequate collective bargaining structure in the industry. The Employment Protection Act provided for a halfway-house stage of changing a wages council into a statutory joint industrial council (SJIC) where employers and unions negotiate rates without the presence of the independents. The agreed rate of pay would still be legally binding on all employers so the unorganized would be protected. So far no SJICs have been formed despite union requests. Yet

in industries such as hotels, toys and part of the clothing industry a SJIC would be a positive step forward.

In other areas of low pay not so far covered by a wages council, women's pay would rise if new wages councils were set up. Contract cleaning, contract catering, and business and office services are such areas. These workers could also be helped by a statutory minimum wage (see p. 373).

What about jobs not covered by wages councils?

There are pockets of low pay in relatively well-paid industries, often in small workplaces, which are not helped by wages councils. They can be helped by 'fair wages' laws which allow claims for the 'going rate' to be paid for the job concerned. The 'going rate' is the usual pay for the particular job in the industry and area concerned. For example, Schedule 11 of the Employment Protection Act 1975 said that even if a union was not recognized by the management, or if there was no union agreement, unions could claim on behalf of members that their pay should be raised to the minimum national rate for the industry negotiated between employers and unions. Where there was no national negotiated rate, the union could claim the 'going rate' actually paid in the district, which is always considerably higher.

However, Schedule 11 was repealed by the Conservative government in 1980, and there is now a right to claim the going rate only if the employer has a government contract. Such contracts must include a clause saying that fair wages will be paid under the Fair Wages Resolution of the House of Commons. You or your union can claim the 'going rate' whether or not you yourself are working on that particular contract, providing some of that contract work has been done in your workplace. Your complaint goes first of all to the Department of Employment, then, if it is not resolved, to arbitration before the Central Arbitration Committee. In June 1982 the government said that it was going to withdraw the Fair Wages Resolution.

Low-paid workers would be helped if the content of Schedule 11 was restored and improved, so all workers could claim the

going rate for their job in their district, whether or not there
were a negotiated minimum rate for their industry.

Are low-paid women better off with an incomes policy?

It is often claimed that the low-paid, and in particular low-paid
women, generally suffer during periods of free collective bar-
gaining and thrive on incomes policies. But do incomes policies
help the low-paid, and does their absence mean that those male
workers with industrial muscle forge ahead, trampling on their
weaker sisters and brothers?

Incomes policies are varied in form. Between 1966 and 1970
the Labour government imposed a series of incomes-policy
norms, mostly backed by legal powers and enforced by the
National Board of Prices and Incomes. Under the Heath govern-
ment between 1972 and 1974 there was a series of statutory
income limits backed up by the Pay Board. Between 1974 and
1977 under the last Labour government there was a series of
voluntary policies agreed with the TUC and known as the 'Social
Contract'. These were followed by unilateral government policies
between 1977 and 1979, though their legal enforcement was
indirect.

Most of these policies had special provisions for the low-paid.
Table 21.2 sets out the form of the policies and how they were
supposed to help the low-paid.

The effect of incomes policies on the low-paid can be meas-
ured in either absolute or relative terms. The absolute test is
whether in money terms the badly paid get more during incomes
policies than they do in free collective bargaining. The relative
test asks whether the differential between the incomes of the
low-paid and the better-paid narrowed.

In money terms, incomes policies based on wage restraint do
not help the low-paid. If an incomes policy limits the wage
increases for the miners or any other strong bargaining groups,
the extra increase they might have achieved under free collective
bargaining does not go to the nurses, the textile workers or
school cleaners. There is no mechanism within incomes policies
in a mixed economy for transferring payment forgone by one

Table 21.2: *Provisions for the low-paid in successive pay policies 1965–78*

Policy period	Pay restrictions	Provision for the low-paid
1965–6	3–3½% norm	Rises above the norm allowed for the low-paid
1966–7	6 months 'freeze' plus 6 months zero norm	None None
1967–8	Zero norm	Rises above the norm allowed for the low-paid
1968–9	Zero norm	Rises above the norm allowed for the low-paid
1969–70	2½–4½% norm	Rises above the norm allowed for the low-paid
1972–3	6 months freeze	None
1973–4	7 months £1 + 4%	Flat-rate element and flexible distribution of 4% increases within pay bargaining groups
	8 months £2.25 or 7% + threshold payments	Flat-rate element or flexible distribution of 7% increase within pay bargaining groups
1974–5	Voluntary restraint	Low-paid exempted; £30 a week minimum wage 'target' agreed with TUC
1975–6	£6 per week maximum	Flat-rate policy
1976–7	5%, £2.50 minimum, £4 maximum	Flat-rate element
1977–8	10%	None

Source: Low Pay Policies?, Low Pay Unit, October 1980.

group of workers to another group. Whilst some incomes policies have permitted larger increases in percentage terms for the low-paid than for the higher-paid, there has so far been no incomes policy that has said that in money terms the low-paid must be paid more.

Whether or not incomes policies lessen the differential between the low-paid and the better-paid depends on the kind of incomes policy enforced. Some incomes policies had rules

which should have given a relative advantage to the lower-paid, such as higher minimum increases for the lower-paid, or a flat-rate increase for all. But over the period 1966–79, when in all but two years there were incomes policies in force, the low-paid did not catch up, although most of the policies had some device of this sort. And the very lowest-paid actually fell further behind. This was for the following reasons:

1. Incomes policies limited *maximum* increases; there was no legal obligation on the employer to pay a *minimum* increase.

2. Higher-paid, mainly skilled manual workers were able to use exceptions for productivity deals during the incomes policies of 1966–70.

3. White-collar workers, including some of the highest-paid, were able to minimize the effect of incomes policy by a combination of job regrading and increased fringe benefits, and the maintenance of annual increments.

4. Low-paid women temporarily benefited by incomes-policy pay supplements like the £6 in 1975–6 which was not consolidated in the basic rate and so decreased the relative importance of bonus and other additional payments. But this was only a temporary effect which ended when consolidation took place and the ratio between the basic rate and other payments was restored.

During the 1966–79 period of incomes policies, the only significant drop in the numbers of the low-paid was among low-paid women between 1973 and 1976. The TUC target of £30 in 1974–5 and the flat-rate increase of £6 in the subsequent year's Social Contract played a part. But the main reason why low-paid women improved their position had nothing to do with 'incomes policy' as such, but was due to the eradication of the 'women's-only' rates in most collective agreements during the implementation of the Equal Pay Act. The total number of low-paid women fell by one million between 1970 and 1975.

So incomes policies as such have not generally helped the low-paid. But 'free collective bargaining' has not achieved a fair deal for the low-paid either. In relative terms they do not benefit. In some circumstances, the powerful groups may set the 'going rate' for the wages round at a higher rate than unions in more weakly

organized sectors could achieve, and this drags up the level of wage increases for at least the organized lower-paid workers. In 1980 and 1981, however, this has not happened because the economic recession has weakened the well-organized unions in the private sector, and the government is enforcing a tight undeclared incomes policy in the public sector on its own public-service workers.

The most successful period for improving the position of the low-paid was when the trade-union movement as a whole adopted its own target wage figure – the £30 minimum in 1974–5. This was the only year in which a large number of low-paid men and women in both the public and private sectors achieved something approaching the 'two-thirds' figure for their minimum wages. It is the low-paid who are not unionized, particularly in the private sector, who are worst off both under incomes policies and under free collective bargaining. Unionization is essential, though often it is not enough. It is also vital that women and low-paid workers are represented in the bargaining process by shop stewards or negotiating committees of their unions. Unless and until that happens neither incomes policies nor free collective bargaining will help the low-paid.

Do 'comparability exercises' help the low-paid?

Low-paid workers in the public services are unionized and have benefited as a result. But their lack of industrial muscle and their reluctance to take industrial action that would hurt the public have added to the problems of low pay and the under-rating of women's work in the public sector.

There has frequently been a demand for what is known as 'comparability', that is, a means of deciding the pay of public-service workers by comparing their wages with those for similar jobs or skill levels outside. This was seen by many as a way of curing low pay among public-service workers. The most long-lived of these initiatives was the Pay Research Unit covering the non-manual civil service. It did not fix wages; it examined wages in outside employment and reported to the negotiators, who then negotiated around those figures. This process was briefly

extended to the industrial (i.e. manual) civil servants. And in 1979 a rather different form of comparability was established via the so-called Clegg Commission, which reported on the pay of other groups of public servants, principally in local authorities, teaching and the National Health Service.

The Conservative government has abolished all such institutional forms of establishing 'comparability', on the ground that the systems were too expensive to the tax-payer. But for low-paid workers the record of such institutions was mixed. The Pay Research Unit system, by and large, gave slightly better wages for the lowest-paid civil servants because the system only compared them with staff employed by relatively 'good employers', and in the manual field it took a 'skill-for-skill' rather than 'job-for-job' approach. But the Clegg Commission compared the pay of low-paid manual women workers in the public services – cleaners and catering staff in schools and hospitals – with the pay of notoriously exploited women in similar private-sector jobs. So 'comparability' merely reproduced the sex bias of the labour market.

It would need a form of comparability based on a skill-for-skill comparison, and minimizing the effects of sex bias in the private sector to benefit the hundreds of thousands of low-paid women workers in the public services.

What is a 'statutory minimum wage'?

In many countries, in Europe and elsewhere, it is against the law to pay workers below a certain wage. In most cases the legal minimum wage is a minimum earnings level; that is, it includes bonus, increment, or other additional payments, except overtime. A statutory minimum wage usually applies to all industries and services. In contrast, the British approach has been to have legal minimum wages only for particular badly paid and poorly unionized industries via wages councils, and to express the minimum wage as a basic hourly rate (statutory minimum rate), which does not include any additional payments, rather than a minimum earnings level.

The level of statutory minimum wages varies from country to

country. It can be fixed by a reference.to Social Security entitlements or to average wages, or just by setting an arbitrary figure. In some cases it is indexed against prices. Sometimes it is fixed by government; sometimes it is negotiated between trade unions and employers. In those countries where the wages structure is decided by government it is simply the lowest wage fixed.

Would a statutory minimum wage work in Britain?

In Britain views vary on whether or not a statutory minimum wage would help the low-paid. Most unions have opposed the idea, but recently a number have changed their policy. NUPE, for instance, supports a minimum statutory rate at a level of no less than two thirds of average male earnings. They want it expressed as a rate, not as an earnings level. The Low Pay Unit is similarly in favour of a statutory minimum wage at this level. Neither the TUC nor the Labour Party has supported the idea, though in September 1982 the TUC undertook to consult trade unions as to whether they would support a statutory minimum wage of not less than £90 and linked to the lost of living.

Employers and the government, which is the largest employer in the country, are both opposed to a statutory minimum wage and howl with anguish at what it would cost. Cost would obviously depend on the level at which the rate was set; but doing anything for the lower-paid is bound to be expensive.

Some trade unionists argue against a legal minimum wage because they fear that low-paid workers might be discouraged from joining trade unions once their minimum earnings were establishing by law. Unions such as the TGWU oppose it because they fear that government and employers would insist on an incomes policy involving pay restraint for better-paid workers as the price for the cost of implementing the statutory minimum wage. Pressure in this direction is likely; but a determined trade-union movement need not succumb to it. Opponents of a statutory minimum wage also say that its existence could undermine the position of those low-paid workers who are unionized and have managed to get minimum rates slightly above the level at which the state would legislate, as their

employer would now see the legal minimum as the lowest rate to be implemented in the workplace.

Against these arguments it does seem that a statutory minimum wage, if at a level above the wages of many low-paid workers, would provide a safety net below which no worker's wages should fall. Unlike wages-council rates, everybody would know what the statutory minimum wage was, and that it applied to them, and it would therefore be easier to enforce.

How many workers would benefit from a statutory minimum wage and its general effect would depend both on the value of the wage and whether it was an earnings level or a basic rate.

Value

The value would obviously depend on the political climate in which the statutory minimum wage was passed and the kind of campaigning that had taken place to win it. Even a progressive government, prepared to do something for the low-paid, would be reluctant to set a statutory minimum wage at a level above the minimum rate for its own workers. In 1982 that was about £64. Even this level, well below the two-thirds level aimed at by NUPE, would be fiercely resisted by many employers as being above the lowest wages-council rates as well as the actual rates paid to millions of workers. Yet it seems from the experience of other countries that in a favourable climate, and with the right kind of pressure, higher statutory minimum wages can be won. Campaigning for a statutory minimum wage is one way to arouse concern for the low-paid and the desire to do something about their plight.

Earnings level or rate

Most male workers and many thousands of women workers make up their low basic rate by bonus and other additional payments as well as overtime. If a statutory minimum wage sets a minimum rate, then these extra payments would continue on top. If it is an earnings level for a standard working week, only overtime would not be included. As more low-paid men than

women earn a significant amount in additional payments, a statutory earnings level would have less effect on male wages than on low-paid women, and would therefore be considerably cheaper for employers than a statutory basic rate of the same amount.

Although campaigners in Britain have usually argued for a statutory minimum rate, there are significant advantages in a statutory minimum earnings level.

1. It can be set at a higher level for the same cost to the government and the employers.

2. It will raise the wages of those workers (mainly women) who are unable to offset a low basic rate by additional earnings.

3. While a statutory minimum wage immediately alters the basic rates in low-paid areas and thus leads to consequential claims, a statutory minimum earnings level has a more indirect effect on wages structures.

There are dangers even in a statutory minimum earnings level if employers use its implementation to argue that it establishes the lowest going rate in their industries or workplaces. It would need a clear and concerted trade-union campaign to avert this result.

These adverse results could be minimized by phasing in the statutory minimum earnings level and indexing it to median or average earnings. An extra safeguard would be to stipulate that it must keep up with price rises. The relative advantage to the low-paid would then not be lost through consequential claims.

A statutory minimum earnings level need not be seen as an alternative to making other improvements in wages councils or the going-rate legislation. It should certainly not be seen as an alternative to greater unionization and raising women's rates generally within low-paid industries. It is, however, a useful and necessary measure to outlaw the worst of poverty wages.

Sources of Information

For further information on the whole wages-council area, contact the Low Pay Unit, 9 Poland Street, London, W1V 3DG. They have pro- duced a wide range of pamphlets and information. Details of sub-

scription and affiliation to the Unit are available from the above address.

New Earnings Survey 1980 (and earlier years).

Low Pay – 1980s Style, Low Pay Review No. 4 (March 1980), Low Pay Unit.

Jean Coussins and Anna Coote, *Family in the Firing Line*, NCCL/CPAG, 1981.

Minimum Wages for Women, Low Pay Unit/EOC, September 1980.

Low Pay in the 80s (*1880 and 1980*), Low Pay Unit, December 1979.

Part-time Pittance, Low Pay Review No. 1 (June/July 1980), Low Pay Unit.

Policies for Low Pay, Low Pay Review No. 5 (June 1981), Low Pay Unit.

Royal Commission on the Distribution of Income and Wealth, Report No. 6: Lower Incomes, 1977.

Alan Fisher and Bernard Dix, *Low Pay*, Pitman, 1976.

EMPLOYMENT PROSPECTS AND NEW TECHNOLOGY

How does new technology affect the job market? Is it all gloom and doom, or is there a silver lining, more interesting jobs? Are new-technology agreements a workplace safeguard against job loss? Microtechnology creates jobs as well as destroying them; but will those new jobs be in Britain or abroad? What are the jobs of the future that today's woman should be staking her claim to?

Will new technology increase women's unemployment?

The whole story of human civilization hinges on the development and utilization of new technology. But the microchip revolution is different from earlier developments in that:

1. It is cheaper to install microchip equipment than to replace existing equipment. In offices, where introduction can be piecemeal, the initial expenditure can be comparatively low.

2. Once installed it is compact and simple to maintain, so it will need fewer technicians, maintenance workers, storemen, and security staff.

3. It will replace more white-collar workers than manual workers, whereas previous changes have hit manual workers.

When widely introduced it is likely to lead to the loss of mainly women's jobs in:

1. *Production*. Assembly and process jobs in fields such as the electronics industry, part of the food industry, bottling and packaging will go.

2. *Distribution*. Check-out, stocktaking and reordering can all be computerized. One woman in ten works in these areas.

3. *Office work*. These jobs will be at risk:

Mail-room clerks;

Filing clerks;

All clerical administrative workers whose jobs involve large amounts of information, collation and transcription, e.g. data preparation staff, inventory control, production control, progress chasers, invoicing clerks, recording of banking records and adjustment, pay offices and personnel records, record-keeping, particularly in local and central government;

Cashiers;

Printing and reprographic staff;

Typists and secretaries;

Supervisors and first-line managers.

These office tasks account for one in four of all women's jobs.

It is impossible to say how many jobs will be lost, as it depends on so many factors, such as whether the recession continues, whether British industry recovers, and, if it does, who invests in what and at what speed. How effective will unions be in protecting their members' jobs? What will government policy be to civil-service and local-government redundancies?

Introduction of new technology need not lead to any job loss in a particular concern if it coincides with expansion. Among the nine workplaces studied by Emma Bird for the Equal Opportunities Commission (1980), no secretarial or typing jobs had been lost in an oil-company head office and a finance organization, both of which were expanding their 'text production activity'. In service-intensive industries, the labour freed as a result of new technology may be devoted to customer satisfaction and not disposed of. But there will be large job losses

overall unless there is a complete reversal of the present economic decline. The scale of the losses has been the subject of some widely varying estimates, as the following forecasts illustrate.

Estimates of female office-job losses caused by microchips by 1990

250,000 typing and clerical jobs lost: *APEX, 1979*

10–20 per cent unemployment in typing, clerical and managerial jobs: *Barron and Curnow, 1979*

30 per cent of information-processing jobs lost: *Jenkins and Sherman, 1979*

40 per cent of clerical, administrative and financial jobs at risk: *EOC, 1979*

170,000 typing and clerical jobs lost: *EOC, 1979*

Modest changes in employment pattern in clerical, administrative and finance: *Department of Employment, 1979*

How will new technology change office work?

Microprocessor-based systems can transform all office functions, from receipt of information through to action and dispatch. The aim is to ensure that a task is done once only and the information entered at the immediate point where it arises, then automatically disseminated to all other points when and where required.

As microtechnology takes over the office world, there will be a mass expansion of word-processing to control clerical, administrative and managerial functions. There will be a major shift into direct entry of information into the office, via keyboards, OCR ('optical character recognition', by which a machine reads a document and transmits it to the central processor) and electronic filing systems. Finally paper can disappear, as 'electronic mail' transmitted from terminal to terminal becomes the norm.

At present the main innovation is the word-processor, already in many offices and spreading fast. The price is falling and its purchase is a viable undertaking for any office manager. It is a form of typewriter with a visual display unit, a memory, a data

processor and some form of print-out. It can print out text, correct it, edit it and display it selectively.

When office work is computerized many of the routine tasks go. Low-grade clerical work, data preparation, office copy-typing are no longer necessary. The jobs that are left, although fewer in number, can be more satisfying, requiring more skill and decision-making, and allowing greater flexibility.

Output per staff will grow, and from the increased productivity management could afford shorter and more flexible working hours. The job should be of higher status and pay and integrated into the administrative and managerial structure.

Unfortunately these positive results are so far a rarity. NALGO, the union for local-authority office staff, takes a gloomy view of the future:

The introduction of new technology, whilst it may create the need for reskilling in a few jobs (e.g. designing and programming the new systems), will deskill many more jobs. It will result in employees becoming machine minders with less opportunity for social interaction with other employees, reduced possibilities for displaying initiative, and offer a narrower range of activities to perform with consequently less opportunity to develop the skills and knowledge necessary for career enhancement and promotion. A gap will open up between those who are highly skilled and specialists of new technology and the majority of the workforce who will be doing boring, repetitive unskilled jobs. This polarisation can already be seen to occur in the distribution of office work where technological changes have been introduced. With the introduction of word processors secretaries will be split into purely 'administrative secretaries' and 'typing secretaries' (although eventually even these job descriptions will disappear) so that 'administrative secretaries' will have their jobs enhanced but the majority, the 'typing secretaries', will find their work less varied and more concentrated drudgery.

Emma Bird, who reported in 1980 on her investigation of fifty-one users of new technology and nine in-depth case studies, found:

1. Some increase in typists' pay, often to a 'specialist typing grade', but in most cases still below the salary of an average secretary.

2. No increase in flexible or part-time working. Although over

half of the women employed on the new technology would have preferred to work part-time, none of the employers planned to use the new technology this way.

3. Operators of word-processors and computer terminals reported a greater level of job satisfaction, due to:

reduction of work on standard texts;

high speed of throughput;

quality of output.

The best typists, however, felt deprived of the use of their expertise and the best word-processor operators were 'machine-oriented' staff.

Personal secretaries had their typing work reduced. But although this should have given them the chance to move into the administrative secretary's role, doing more responsible managerial tasks, Emma Bird found no examples of this progression in UK firms.

In many companies promotion to management requires extra qualifications on the secretary's part, particularly where the manager's job involves specialist knowledge. This can present a severe block to promotion for those secretaries who have no training other than typing and shorthand. It may be true that an intelligent but untrained secretary could quickly learn the extra skills required, but company promotion regulations often specify that formal qualifications are needed.

So it seems that those men selling word-processors and other office equipment sell it to the men who run offices to fit into the present social structures, not to change them. If women are to claw back any benefits from the microchip invasion of office life to compensate for the jobs that will go, it will require far-sighted determination and organization.

What should you do if management proposes introducing word-processors?

If the women in your workplace are to have a say in what happens and to benefit from the process, you need full information, consultation, joint decision-making, and guarantees on future

jobs and training, reduction in hours, and health and safety safeguards.

An Income Data survey found that management consulted the workforce only when they were unionized, so having a strong union organization is an important safeguard. A number of unions have model 'new-technology agreements' which write in the necessary steps and safeguards.

The starting-point in negotiating with management is that the introduction of new technology will increase the productivity of each worker and make the business more profitable or the service more efficient. You, the workers, should be entitled to benefit from the extra profits or efficiency. As the work will be done faster you should not have to work such long hours. You should be rewarded for learning to operate the new equipment by increased pay.

The other major problem is whether jobs will be lost. The best agreement is that the total workforce should be maintained. This can be very difficult to achieve if there is no need to increase output. Many unions have had to settle for some reduction in the workforce and press for it to be as limited as possible. You should certainly resist compulsory redundancies.

You need to keep ahead of the game. While management still want to introduce new machinery a united workforce with sensible, well-thought-out demands have the upper hand. Once the new system is in operation, it is more difficult to achieve results.

Here are some suggestions on what to ask for:

1. *Information*. What equipment does management intend to introduce; over what period; at what expense; what is the expected increase in output; what changes in numbers employed and work categories will there be?

2. *Job loss*. A guarantee that the total number of the workforce is maintained; or, if that is not possible, guarantees of limits on reduction, full utilization of the existing workforce to operate the new equipment, restrictions on bringing in new labour or contracting work out. In the United States, and in a few companies here, computer work is sometimes done from home; but unless there are stringent safeguards, these home

workers suffer the low pay, lack of job security and bad working conditions of home workers generally.

3. *Reduction in working time*. Here is your opportunity to go for a shortening in the basic week, longer holidays, early retirement, availability of part-time work, flexible working hours (see p. 105), and paid sick leave for parents whose children are ill (see p. 110). Make sure the part-time and flexi arrangements do not just apply to the lowest-paid jobs but extend to the higher-graded jobs, so women can advance up the structure.

4. *Payment*. Increased payment for those who train to operate the new machines. You will be worth more to your employer, and job satisfaction is not a substitute for earning your worth. As routine work diminishes, you will require greater skill and make more decisions and should be paid accordingly. This may require a new job-evaluation exercise. (If so, see p. 115.)

5. *Job content and training*. Agreement on reorganization of work, changes in job descriptions, job design and job structures. The new tasks needed to work the new equipment can be distributed among the workforce in various ways. If women are to benefit you will need to avoid segregation of jobs into 'machine-minders' and 'decision-makers'. Ask for proper training opportunities for women workers, going beyond a day or two of familiarization and allowing them scope to rise to more demanding jobs. Take the opportunity to examine what blocks, such as specialist qualifications, prevent women workers from entering previously male jobs or the new jobs that will be required, then seek ways to overcome them (see p. 137).

6. *Health and safety*. VDUs can cause eye-strain, and staff will need rest breaks and other safeguards. Managements should reach agreement with safety representatives on these aspects. Chapter 17 on health and safety gives details.

7. *Work measurement*. The microchip computer can measure and record your work along with everything else; but most workers don't like an electronic eye following their every movement. It wouldn't be so bad if top managers' working hours, perks and lunches were displayed on a VDU screen for all to see. So check on what work measurement is going to be used, and make sure that it will not lead to unjustified pressure to speed up.

Will the new technology create any jobs?

The introduction of new technology into existing workplaces will throw up new jobs. Many of the craftsmen's jobs will no longer be necessary, but new technical jobs running and maintaining the new machinery will be. The need for design staff, draughtsmen, architects' assistants, and building technicians will fall, but again new technicians will be needed. To date there is no sign that women are entering these new jobs in a big way. Information from the United States, where new technology is well in advance of here, shows the familiar picture of women having the overwhelming majority of the lowest-graded jobs and only a minority of the higher-graded ones. Comparable figures for the United Kingdom would be no better, and, at manager level, considerably worse. Almost any computer job is likely to be a job of the future. As Ruth Miller says in her careers guide *Equal Opportunities*, 'There are a vast number of types and levels of computer jobs. Because of the explosive growth of the technology, job titles, career paths, training structures and job hierarchies are vague, vary from one organization to another and are still evolving.' She divides computer jobs into the following groups:

1. Systems analyst/designer;
2. Applications programmer;
3. Software or Systems programmer;
4. Operator and data-preparation staff.

As well as creating new jobs in existing industries and workplaces, computer-based technology leads to new products and new manufacture in the communications area, domestic appliances, toys and leisure pursuits etc. Whether this will result in many more jobs being based in Britain remains to be seen. Britain has only one home-based main-frame computer company, ICL, which has had its government support cut. If new industry is built up in this area it would include a large number of data-processing jobs which could undoubtedly be done by women workers. But UK-based industry has today almost no presence in most of the products developed from the latest technology: electronics, calculators, word-processors, digital watches, tele-

vision games, and so on. Ninety per cent of such products are imported. Even so, new jobs will of course be created by the use of new technology in support staff, new services and the maintenance of new products. In the absence of a general economic expansion these are unlikely to offset the numbers of jobs lost.

Sources of information

Office Technology, APEX, 1979. *Automation and the Office Worker*, APEX, 1980.

Technological Change and Collective Bargaining, ASTMS, 1974.

Report of BIFU Micro-electronics Committee, BIFU, 1980.

New Technology – A Guide for Negotiators, TASS, 1978.

New Technology – A Guide for Negotiators, NALGO, 1980.

Journalists into Technology, NUJ, 1980.

New Technology Conference Report, SCPS, 1980.

Employment and Technology, TUC, 1979 (75p).

New Technology, GMB, 1980.

New Technology: Old Problem New Opportunities, TGWU, 1979.

Women and Computing, 1981, c/o A Woman's Place, 48 William IV Street, London WC2.

WHEN THE LAW CAN HELP

This section describes the Equal Pay Act and the Sex Discrimination Act, what they say and how they work. These acts set legal standards of equality. Men as well as women are protected from sex discrimination, but to avoid repetition this chapter describes the law as if it applied to women only.

The acts bind employers, trade unionists and individuals. The Sex Discrimination Act goes beyond employment to cover the provision of services, for example in banks, hotels, restaurants, and in education. These sections are described briefly and sources of further information given.

The first place to raise your rights under these acts is in your workplace, as described earlier in this book (see p. 25). If this does not succeed you may have to take your claim to an Industrial Tribunal. This chapter tells you how to make a claim, prepare your case, obtain assistance and present your claim at the tribunal.

To date, the laws have only had a limited success. The chapter on equal pay (p. 21) describes how women's pay is still well below male pay even for comparative work; women-only jobs and men-only jobs are still commonplace (see p. 136); and discrimination against women, both direct and indirect, is rife. When women have brought claims to Industrial Tribunals the success rate and amounts of compensation offered have been very low (see p. 410).

Even if the laws were perfect they could only play a limited role. Changes outside the workplace, in education and in home life are more important, as is the organization of women in trade unions and a reform of trade unions to reflect women's needs.

But having strong laws enforced to combat discrimination is still important. Many individuals and organizations, such as the EOC, the TUC and the NCCL, who have experienced the present laws consider that the British equality laws need

strengthening. Even the European Commission has said that our Equal Pay Act is not comprehensive enough to comply with Britain's obligations under European law. So reform is in the air, and this chapter looks at the kind of reforms that are necessary.

Which act do you use?

It is a historical accident rather than careful planning which has resulted in our having an Equal Pay Act and a Sex Discrimination Act. Having two acts, not one, causes difficulties. It makes the law more complicated, and in some situations it may not be clear which act covers a particular complaint. Another result is that some forms of discrimination are covered by neither act. This is because the Equal Pay Act, unlike the Sex Discrimination Act, has no provision for indirect discrimination. So if a woman is indirectly discriminated against in pay, she has no legal remedy.

The solution is to amalgamate the two acts. In the meantime, Figure 23.1 is a guide as to which kind of claim falls under which act.

Looking at the Equal Pay Act in more detail

The Equal Pay Act is described in outline on p. 25. Refer back for the general situations it covers and the kind of claims that can be made. This section looks at it in more detail.

What is meant by broadly similar work?

It is easy to know if you are doing the same work as a man but not so easy to decide whether it is close enough to be 'broadly similar' within the meaning of the act, and, if it is, whether the differences between what you do and what the man does are of 'practical importance in relation to the terms and conditions of employment'. If you satisfy these two criteria, then your work is described as 'like' work with the man and you are entitled to equal

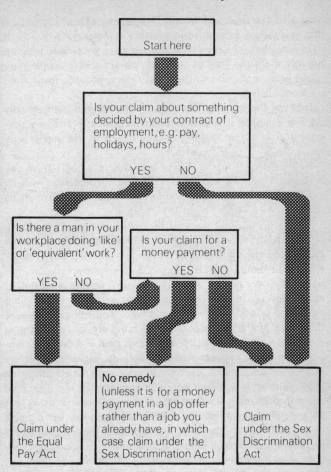

Figure 23.1: Which act do you use?

pay, unless your employer can show that the difference between your pay and the man's is not because of your sex but because of a 'material difference' between your case and his (see p. 28).

There have been a number of claims to the Industrial Tribunals and the Courts about what is meant by broadly similar

work and differences of practical importance. These cases show that you should approach the question in this way:

1. Make sure the man you are comparing yourself to is doing broadly the same kind of work as you are. For example, you might both be clerical workers, operators, packers, inspectors, cooks or chefs.

It is not the job title that counts but what you both actually do. For example, it does not matter that you are called a supervisor and he a foreman if you both have first-line supervisory responsibility over a department.

Neither does it matter if he works different hours from you or has a longer or shorter day. If you succeed, you will be entitled to the same basic hourly rate. Unsocial hours can be rewarded by a shift or night-work premium.

2. Having satisfied yourself that you are both in the same broad category of work, you then need to look in detail at each difference between the things that you do and the things that he does. You should include differences in responsibility that you both have over people, property, money or products. Look at each difference in turn, how important it is to the job, how often do you do it, and how long does it take. You will need to show that none of the differences would normally lead to the man receiving more pay or better conditions than you do. The comparison must be between what you both do, including responsibility that you actually exercise in your work. Any obligation in his contract which does not operate in practice should not be taken into account. For example, if the man's contract says that he is flexible, or mobile, or that he is required to work nights or deputize for the supervisor, but in practice these requirements are not called for, they should be discounted. In some cases they have been inserted in the man's contract to defeat any equal-pay claim, not because they are genuinely required.

Do not think your case is ruled out because there are a number of real differences between what you do and what the man does. You may still succeed. The Employment Appeal Tribunal upheld the claim of a cook, Mrs Lawton, for equal pay when she compared herself with two male chefs, although her job and theirs had the following differences:

i) She worked a forty-hour week, they a forty-five;

ii) She cooked lunch for between ten and twenty persons per day; they provided 350 meals a day for six sittings in the factory canteen;

iii) She worked in the directors' kitchen; they worked in the works' canteen. She was directly responsible to the Catering Manager; they were responsible to the Head Chef, who in turn was responsible to the Catering Manager.

Here are some decisions of other tribunals on equal-pay claims. They show the kind of decisions you can expect, though each tribunal must make up its own mind on the particular facts of each case, so different decisions on similar situations are possible.

Different duties which tribunals held were not of practical importance in relation to terms and conditions of employment

1. A female vet normally deals with small animals, the male vet with larger animals. But the female vet was required to deal with large animals when the male vet was not available.

2. Female mould operators work smaller machines, producing more parts, than male operatives. This difference was held not to lead to a different job specification in advertisements or to affect the skill, knowledge, or responsibility of the operative.

3. Female domestic cleaners working inside with no protective clothing and having to cover large areas claimed equal pay with labourers working outside, who were provided with protective clothing.

4. A female sales assistant in a men's-wear department claimed equal pay with a male assistant. It was said she could not measure men's inside legs because of customer embarrassment. She succeeded because the difference did not matter in practice, as the department sold ready-to-wear clothes.

5. Female bottle washers claimed equal pay with men who did additional tasks such as lifting cases, rolling casks. They succeeded, as there was no evidence that these tasks took up much time.

Different duties which tribunals
have found did justify higher pay

1. Female machinists claimed equal pay with male machinists
on the same machines. Male machinists also worked in other
departments, doing heavier and dirty work, to cover sickness
and holidays for about 30 per cent of their time. (Had the time
spent been less, or the work in the other departments not sig-
nificantly different from work in the machine shop, this decision
might have been different.)

2. A female office cleaner claimed equal pay with a
labourer/driver. Both of them had cleaning and tea-making
duties The company showed that the male's driving duties took
up 18 per cent of his time. The tribunal found the driving duties
to be of sufficiently substantial difference to justify higher pay.

3. A female photographic studio manager claimed equal pay
with a male studio supervisor, whose work was mainly man-
agerial and who was in charge of larger staff and larger weekly
takings than the woman's. He was also responsible for staff
training. The tribunal held that he had greater responsibility
than her and that his higher salary had been fixed by reference
to his additional supervisory obligations.

4. A female audit clerk claimed equal pay with a male. The
company argued that the male was doing work of greater com-
plexity and responsibility. The tribunal found that the male did
work for which the company could charge substantially higher
fees than that of the female.

Some cases where the tribunal found that
the man's different duties or responsibilities
were balanced by equivalent duties or responsibilities
undertaken by the woman

1. A male production foreman had greater skill and responsi-
bility, but a female foreman was entitled to equal pay because
she had greater versatility and personnel skills.

2. A male machine-shop operator worked on heavy castings,
but this was counterbalanced by a female machine-shop
operator's greater dexterity on small castings.

3. Pressure on a male pay-roll manager in charge of hourly

paid workers, due to the problems caused by public holidays and dealing with less amenable staff, was counterbalanced by pressure on a female pay-roll manager in charge of monthly, weekly and part-time workers, because she also dealt with the income-tax problems of both her department and the man's.

When can you claim your job is of equal value to a man's?

In 1983 the government published its proposals for an Order under the European Communities Act to allow women to claim equal pay for work of equal value, following a European Court ruling that women should be allowed to claim even if their job had not been job evaluated. These proposals are to come into effect in 1984. The woman would make her claim to an Industrial Tribunal, but she would not be allowed to proceed on this ground if the tribunal considered she could claim equal pay to that of a man doing the same or broadly similar work; the claim could also be dismissed if the tribunal thought it unreasonable, or if the employer could show a 'material difference' defence (which would be easier for the employer). If her claim was allowed to proceed, the tribunal's decision would be based on an 'independent' expert's report.

There is no way to ask for collective agreements, employers' pay structures or wages council orders to be amended to give equal pay for work of equal value. The proposals were criticized by the EOC, the trade unions and women's groups. NCCL said: 'Believe it or not, it's even worse than we feared. The intention behind the Order is clearly to deter women who have the temerity to claim that their job is as valuable as a man's.'

Until these changes a woman can only claim if there has been a job-evaluation study which evaluated her job and a man's under various headings (for instance effort, skill and decision) and said that her job was of equal value to his. If the job-evaluation scheme was openly discriminatory, in that it gave higher points to men than women for jobs of the same value, it could be challenged. In practice, job-evaluation schemes did not discriminate in such open ways. They could, however, be biased against women (see p. 115 for details).

The Court of Appeal decided in the case 'O'Brien *v.* Sim Chem Ltd' that women were entitled to equal pay once a job evaluation study had been completed which said their work was of equal value to a man's, even if that study had not been used by the employer to determine wage rates.

If you are doing broadly similar work or work of equal value to a man's, what differences between your case and his might justify a difference in your pay or conditions?

As explained on p. 28, even if you can show that your work justifies equal pay there may be circumstances where a man's higher pay can be shown to be due to a 'material difference' between your case and his other than a difference in sex. Examples were given of service increments and qualifications. According to the various Industrial Tribunal and Court cases on what this means, if your employer is to justify a higher rate of pay or better conditions for the man, he must show that the difference between your case and his is:

1. *Not a difference in the work you both do*, which should have been taken into account in deciding whether or not you do broadly similar work or work evaluated as equal.

2. *But a difference arising out of a personal comparison between you and the man*, for example, a qualification or seniority.

3. *The difference must be 'material', and the man's higher pay must be due to it.* For example, if no other personnel got paid more because of seniority, it would not be material to his higher pay that a man was more senior than you, nor would the higher pay be due to this factor.

4. *Not related to sex.* If the reason for the difference in pay put forward by the employer is an indirect form of sex discrimination, or the result of past discrimination, it will not do.

5. *Not the result of outside market forces.* This was decided in the Court of Appeal when granting the claim brought by Ms Fletcher, employed by Clay Cross (Quarry Services) Ltd, that she was entitled to equal pay with a Mr Tunnicliff who was

recruited from outside to do the same work as her and was given higher pay because of the salary he received in his previous job.

This case also makes clear that even when an employer does not intend to treat the woman differently because she is female, if the result of his action is that she is discriminated against, then his conduct is unlawful, whatever he intended.

6. *It may be that the man has been 'red-circled'.* Occasionally a worker is put on a special personal rate of pay which is higher than the appropriate rate for the job she or he is doing. This is described as being 'red-circled'. A common reason for red-circling workers is to gain acceptance for the introduction of a new pay structure, when the present rate of pay for certain jobs is higher than the new established rate. In such circumstances management may agree that all current job-holders will remain on their actual rates, while newcomers are put on the new rate. Such red circles are usually phased out by allowing the actual rate for the job slowly to catch up with the red-circle rate. Another reason for a red-circled rate would be that some workers have been moved from heavy or arduous work to lighter work because of ill health. In some workplaces they would be allowed to retain their former rate of pay.

There have been a number of equal-pay claims where an employer has said that the reason for the difference between a man's pay and a woman's pay is because the man is red-circled and the woman is not. If, but only if, the introduction and implementation of red-circling are not in any way discriminatory will this reason constitute a 'material difference' allowing the employer to retain the higher rate for the man.

7. *It may be that you work part-time.* See p. 164.

8. *It may be that you and the man are on different grades or rates as a result of a non-discriminatory grading or rating system.* As mentioned earlier, even if you can establish that you are doing like or equivalent work, your employer may be able to show that your different rating under the scheme is a material difference between your case and the man's case.

For example, Ms Wade, a policy clerk employed by National Vulcan Engineering Insurance Group Ltd, compared herself with a Mr McCann who did identical work but was put on a

higher pay scale under a merit-assessment scheme carried out by the company. The company graded employees according to skill, capacity and experience. The Court of Appeal examined the result of the management's assessment of employees and concluded that it operated fairly and did not discriminate against women, who were distributed evenly throughout the scale.

Looking at the Sex Discrimination Act in more detail

The Sex Discrimination Act is introduced on p. 159, where the definitions of direct and indirect discrimination are explained. This section describes the Act in more detail.

Can men bring claims under the Sex Discrimination Act?

The Act covers men in the same way as it covers women. Many men have brought claims under the Act, and they are just as successful in their applications as women.

Are all employers covered by the Act?

Neither employment in a private household nor employers who employ fewer than six people (not taking into account any people employed in a private household) are covered by the Act. All other employers are covered, including the Crown.

Are all workers covered?

Workers who work wholly or mainly outside Great Britain are not covered. If they work on a British ship, aircraft or hovercraft, they are covered unless they work wholly outside Great Britain.

All other workers are covered, whether employees, apprentices or contract workers, such as temporary typists hired out by an agency. You are covered if employed under a contract of service (as home workers are) or employed personally to do some work (as self-employed painters, decorators or hairdressers are).

Are all jobs covered?

There are special rules permitting some discrimination in the police force and in the employment of prison officers, midwives, miners and ministers of religion. Men and women police officers may be treated differently in requirements relating to height, uniform or equipment and allowances in lieu of uniform and equipment. It is unlawful, though, to discriminate in allocation of duties in the police force. Different height requirements for prison officers are permitted. Employers and training bodies can discriminate against women in favour of men who wish to become midwives; qualifying bodies and trade unions cannot. It remains unlawful to employ a woman as a miner if she spends a significant proportion of her time below ground. Women are still not legally entitled to complain if they are refused ordination in the Church of England or in the Roman Catholic Church.

In addition, employers may continue to discriminate if being a man or a woman is a 'genuine occupational qualification' for the jobs they are offering. Genuine occupational qualifications (GOQs) are carefully defined in the Act, and it is not open to an employer to expand them. For example, many employers and workers still think that it is lawful to refuse a job to a woman if there are no female toilets in the working area, or if the job requires some physical strength; but in both cases they are wrong. There are no GOQs in these cases: in the first case, toilets must be provided; in the second case, every woman must be given the same chance as a man to show she can do the job. An employer must not presume she is incapable because she is female.

The GOQs in the Act are when being a man or a woman is necessary because:

1. The 'essential nature' of the job calls for a man for reasons of 'physiology'. *Physical strength or stamina are specifically excluded*. But employing male or female models, for example, remains lawful.

2. Of the need for authenticity in dramatic performances or other entertainment (e.g. actors, singers, dancers).

3. Of the need to preserve decency or privacy because the job

is likely to involve physical contact with men in circumstances where they might reasonably object to it being carried out by a woman, or the holder of the job is likely to do his work in circumstances where men might reasonably object to the presence of a woman because they are in a state of undress or using sanitary facilities. This could cover masseurs and lavatory attendants. It may also cover changing-room attendants who help fix clothes, but see p. 399 for circumstances where an employer could not rely on this exception.

4. The nature or location of the job would make it impracticable for a female employee to live anywhere except in premises provided by the employer, where men are already living and where there is no separate sleeping accommodation for women, nor toilets or bathrooms which they could use in privacy. In a case like this, the employer can go on hiring men – but only if it would be unreasonable to expect him to provide separate facilities for women, for example because it would be prohibitively expensive or impossible to find extra rooms. This should apply on such premises as small ships, some lighthouses and remote work sites. So when Ms Wallace applied to P. & O. Liners for the post of cinema projectionist on board a cruise liner she was told she could not be offered the job because there was no available cabin accommodation for a female crew member. An Industrial Tribunal found she had been unlawfully discriminated against as it was reasonable to expect the company to provide her with accommodation.

5. The job is in a single-sex hospital, prison or old persons' home, children's home, mental home or any other place for people needing special care or supervision. But it must be 'reasonable', considering the 'essential character of the estabblishment', to insist that the particular job is held by a person of one sex. This is very vague, and it is hard to tell exactly what it means. It probably covers teachers and nurses in an institution but not, for instance, gardeners, cooks and caretakers. A man is allowed to be governor of a women's prison, but not vice versa.

6. The job provides individuals with personal welfare, education or similar services and these services can most effectively be provided by a man. This again is extremely vague and perhaps

is meant to cover probation officers, social workers and teachers.

7. The job must be done by a man because of legal restrictions on the employment of women (see p. 253 for details of restrictions on women being employed at night time or unsocial hours in factories, and certain health restrictions).

8. The job must be held by a man because it is likely to involve work outside the United Kingdom in a country 'whose laws or customs are such that the duties could not be performed effectively by a woman'. This allows discrimination in jobs such as salesmen travelling to Arab countries.

9. The job is one of two to be held by a married couple (for example, a brewery looking for a married couple to manage a public house).

Are there any limitations to an employer using a GOQ?

The Act says a GOQ cannot be used by an employer if:

1. When hiring a new worker, he already has enough workers of one sex to do the job; e.g. if hiring a changing-room assistant, when he already has enough male assistants to measure male customers he cannot use the requirement of measuring to deny the job to a woman.

2. He is applying it to all jobs in a particular department or category and not looking at each job individually to see what he will need that particular employee to do.

In what circumstances can you complain about discrimination?

Discrimination can occur in recruitment, transfer or promotion, training, access to benefits, facilities or services given by the employer, dismissal or other 'detriment'. Each of these areas is described below and examples of discrimination given.

Recruitment

This covers arrangements for offering employment, terms on which it is offered, or refusal or deliberately omitting to offer that employment.

Arrangements for offering employment

If when you apply for a job your application is treated less seriously than a man's, or, unlike the man's, your references, or a report from the department where you are working at present, are not obtained or in any other way your application is not given equal consideration, you can complain of discrimination. Although in general the Equal Opportunities Commission is given the responsibility of taking action against discriminatory advertisers, 'arrangements for recruitment' also includes advertisements, and it seems that individuals can complain to Industrial Tribunals where they have been discriminated against because of the wording in an advertisement. To succeed you would have to show that the advertisement's wording had adversely affected your chances of getting the job. If despite the advertisement you applied for the job and your application was treated equally, you would not succeed with your complaint. If an employer places advertisements in papers or magazines whose readership is mainly of one sex, this could be unlawful discrimination.

Interviews

Many women consider they are discriminated against at interviews by questions which ask them about their children, or imply that they would not be able to fulfil aspects of the job because of physical weakness or presumed weakness of character (see p. 156 for more on interviews). There have been a number of such claims under the Sex Discrimination Act by women, particularly when they are asked questions such as 'Are you planning to marry, start a family in the near future?' or 'How do you intend to look after your children?' In one case brought by a professional golfer, Ms Saunders, against Richmond-upon-Thames Borough Council, the Employment Appeal Tribunal said that it was not by itself unlawful to put special questions only to candidates of one sex. Such questions only go some way to show that the final choice might have been discriminatory. In this case, even though Ms Saunders was asked at her first interview whether she thought men would respond as well to a woman professional, whether the hours weren't too long and the

job too unglamorous, and whether she would be able to control troublesome male players, they said these questions did not prove discrimination. Nor did she succeed because her qualifications were as good as the successful male candidate's. The Appeal Tribunal said that the Industrial Tribunal was entitled to decide that her non-selection was due to the assessment of her character, not because she was treated less favourably as a woman.

Terms on which employment is covered
If when applying for a job you are offered terms and conditions less favourable than a male applicant is or would be offered, you can bring a complaint under the Sex Discrimination Act. Once you are in the job, complaints about terms and conditions must be brought under the Equal Pay Act. So when women catering assistants recruited to work in Shetland weren't offered free accommodation, free meals and free travel on their weeks off, these being perks which all male catering workers enjoyed, they successfully complained to an Industrial Tribunal. So did a woman security guard not offered the higher earnings male guards got on night shifts.

Refusal or deliberate omission to offer employment
This is what most women complain of. As in all these cases, the main difficulty is proving it before a tribunal (see p. 408). An employer will almost invariably provide a reason other than sex for refusal of an offer of employment.

Discrimination when employed

Promotion, transfer and training
This covers not only refusal of promotion but also transfer to less favourable jobs than men would be transferred to in similar circumstances. For example, Ms Sloan made a successful complaint against Strathclyde Regional Council when she was only offered alternative work leading to clerical positions while the men in her team were transferred to jobs where they could prove

their ability to be managers. Refusal by management to transfer women to 'male jobs' or, having transferred them, removing them from that job in circumstances where men would not be removed, is also unlawful discrimination. Audrey Humphrey succeeded before the Employment Appeal Tribunal on a complaint that because of pressure from male workers her employers had removed her from a 'male job' after she had been allowed to work on it for one shift. The Employment Appeal Tribunal said it was no excuse for the employers to say they were succumbing to pressure from the male workforce or from the trade union.

It may be that requirements or skills demanded for promotion are indirectly discriminatory. Ms Steel succeeded in a claim against the Post Office when she was not awarded a postman's 'walk' because her previous service as a postwoman didn't count for seniority purposes until 1969, only postman's previous service counting until that date.

It is unlawful for an employer to discriminate against a woman in offering training.

The EOC noted in their 1980 *Annual Report* that sex discrimination in promotion is more likely to take place in instances where there is no formal procedure for selection and where internal vacancies fail to be advertised. It seems that women in these circumstances are particularly vulnerable to being overlooked completely or bypassed in favour of their male colleagues, irrespective of merit. The one successful case noted for 1980 was a Ms Crocker who brought a claim against her employers, J. C. Banford, when they had chosen to promote a man with less experience than her because they said he had more long-term 'potential' than a female candidate like herself.

Benefits, facilities and services
This is an area where it may be difficult to decide whether the benefit, facility or service that you are not being given equal access to is a term and condition of employment governed by your contract, in which case your claim must be brought under the Equal Pay Act, or a concession or a perk, when you must bring your claim under the Sex Discrimination Act (see p. 389).

If your case goes to a tribunal, the tribunal will have to make a decision on the particular facts of your case, whether the matter in question is governed by your contract of employment or not. They will take into account any document, if it is written down in a statement of terms and conditions or written contract or union agreement. This will indicate if it is contractual. Sometimes it may become part of your contract by oral agreement or by custom and practice in the trade. In one case a tribunal decided that free travel facilities for employees' spouses were concessionary, as they weren't the subject of negotiations nor were they mentioned in any contractual document.

Benefits may include loans for house purchase, season tickets, free overalls, dress allowances, removal expenses and other house-to-house moving fees, car expenses, club membership, hairdressing, dental facilities, membership of BUPA, life insurance and so on. If you are not given equal access to overtime this would be denial of a benefit. Remember that it is also unlawful to discriminate against married employees, both directly and indirectly. So it would be unlawful indirect discrimination to restrict loans to employees with seven or more years' service if a complaint was brought by a married employee who had left work for a few years to have a family, unless the employer could show it was justifiable. But any complaint brought by an unmarried woman because, say, home loans were only given to married employees over twenty-two and unmarried employees over twenty-six would lose out because of the failure to prohibit discrimination against single people.

Detrimental treatment and dismissal
Being subjected to a 'detriment' by your employer must involve 'an element of something inherently adverse or hostile'. 'Dismissal' covers dismissing you because you are female, and it includes selecting women for redundancy on account of their sex. With the vast increase in redundancies the Equal Opportunities Commission reported in 1980 that for the first time almost one in five of the complaints they had received had concerned redundancy issues. In some of these cases women had complained that they had been selected for compulsory redun-

dancy out of turn. In one case that went before the Court of
Appeal, Ms Noble and others failed in their complaint because
the Court decided that the light work done by the women had
diminished, whereas the heavy work performed by the men had
not, and that in this situation the women's dismissal was justi-
fied. It seems there is no clear legal duty on an employer to offer
remaining work to men and women equally even if women are
prepared to attempt the heavier work remaining. Some women
have also brought complaints that they had not been allowed to
apply for voluntary redundancy equally with men.

Is it unlawful to discriminate against you because you have children?

As so much discrimination against women is because they have
children or because employers think they will have in the future,
this is a most important question. Fortunately, it has now been
decided that if you are refused a job or treated less favourably
by an employer because you have children this will be both direct
and indirect discrimination. Ms Hurley, who was married with
four young children, applied for a job as a waitress at 'Edward's
Bistro' in response to an advertisement which she saw in the
window. She was interviewed and accepted for the job by the
manager. But during her first evening at work the owner of the
restaurant, Mr Mustoe, turned up. He knew she had children,
and it was his policy not to employ women with young children
because in his experience they were unreliable. He dismissed
her. When she took her complaint to an Industrial Tribunal it
was not upheld because the tribunal said it was Mr Mustoe's
policy not to employ anyone, whether man or woman, who had
young children. They said that this requirement was not unlawful
indirect discrimination against married people because it was
justifiable in terms of the interests of the business. Ms Hurley
took her case to the Employment Appeal Tribunal who said that
she had been discriminated against both directly, because there
was no evidence that Mr Mustoe applied his policy to men, and
indirectly. Even if it is true that some women with small children
are less reliable than those without, it does not follow that in

order to achieve reliability it is necessary to exclude all women with children. An employer must investigate each case and not simply apply a rule of convenience or prejudice to exclude a whole class of women or married persons because some members of that class are not suitable employees. In the present case Mr Mustoe could have discovered whether Ms Hurley was reliable without imposing a blanket rule excluding all women with children. He could have taken up her references or asked her who would look after the children while she was at work.

Is it unlawful to discriminate against you because you work part-time?

It may be unlawful indirect discrimination to treat part-timers less favourably (see p. 169).

Victimization

It is unlawful to treat you less favourably than someone else would be treated in similar circumstances because you have:

1. brought proceedings under the Equal Pay Act or Sex Discrimination Act, whether against the person who is discriminating against you or not;

2. given evidence or information in connection with such proceedings;

3. done anything else under or because of the Sex Discrimination Act or Equal Pay Act;

4. made allegations that someone has breached either of the acts, as long as the allegation is not deliberately false; or are intending to do any of these things.

This legal protection against victimization would cover you if you were dismissed as a result of bringing a claim.

Trade unions

Trade unions, employers' organizations and professional organizations must not discriminate in deciding whom to admit to membership, or in the terms on which they offer membership,

by refusing to let women join, in the benefits and facilities offered, by expelling a person, or by any other unfavourable treatment. Trade unions can discriminate in favour of women in some circumstances (see p. 344).

Public appointments

The government must not discriminate against women in making appointments to public bodies such as boards of nationalized industries, area health authorities etc. Only the Equal Opportunities Commission can deal with any complaints about these government appointments.

EEC law

When Britain joined the Common Market in 1972 we became subject to EEC law, which is expressed in the Treaty of Rome and various directives issued by the European Commission.

What does EEC law say on equal pay and sex discrimination?

European law provides for equal pay for work of equal value without restricting this to circumstances where there has been a job-evaluation scheme. Unlike British law there is no exception for provisions relating to retirement. Neither is there a requirement that to claim equal pay you have to find a comparable man employed by the same employer and normally working at the same workplace.

In 1978 a Directive on equal treatment came into effect which covered the same areas as our Sex Discrimination Act, and although it excluded provisions relating to maternity it did not make any exceptions for retirement.

What effect has EEC law had on women's rights?

In two cases the European Court of Justice has expanded the circumstances in which women are entitled to equal pay.

Claiming equal pay with a predecessor

Ms McCarthy claimed equal pay with a man previously employed at her workplace. The British Court said she was limited under our Equal Pay Act to comparing herself with a man employed at the same time as her. The European Court disagreed and said that under Article 119 of the Treaty of Rome there was no such limitation and Ms McCarthy could compare herself with a man who had recently been employed at her workplace.

Employers' payment of pension contributions is additional salary

As explained on p. 240, in a pension case that European Court said that despite an exception in the British Equal Pay Act for provisions relating to retirement, when an employer pays additional salary in order to compensate an employee for a contribution to a pension scheme this is 'pay' under Article 119, and an employer must not discriminate against women.

Discrimination against part-timers

In addition the European Court has been asked to consider whether discrimination in pay against part-timers is contrary to Article 119 (see p. 171).

Job-evaluation schemes

The European Commission considers that our Equal Pay Act does not comply with Article 119 because it requires there to have been a job-evaluation scheme for a woman to claim equal pay for equal value. It issued a 'reasoned opinion' to the British government, setting out its views. When the government disagreed and said it was not prepared to amend the Act the European Commission went to the European Court (see p. 393).

Using Industrial Tribunals

What is an Industrial Tribunal?

Industrial Tribunals were set up to deal with disputes between workers and their employers. They were supposed not to be like law courts but to be informal, cheap and 'available to ordinary people without the need of a lawyer or expert adviser'.

Unfortunately they haven't worked out like this; they have become increasingly formal, legalistic and offputting to the ordinary worker. Although cases don't take as long as in court, months usually elapse between an application and a decision. But unlike a court you are still unlikely to have costs awarded against you, so the only cost you will incur is if you choose to instruct a lawyer (see p. 412).

Industrial Tribunals are chaired by a barrister or a solicitor. There are two other members of the tribunal. One is a nominee of employer's organizations, the other of trade unions; all three members have an equal say in the decisions.

Although still not quite as formal as a court, the proceedings are very similar. Evidence is given on oath; witnesses give their evidence in turn and are cross-examined in turn; the persons presenting cases can open proceedings and sum up. While a simple case may be disposed of quite quickly, perhaps in half a day, others may last for several days. Very often claims brought under the Equal Pay Act and the Sex Discrimination Act are complex, and bringing a case on your own without a representative can be difficult and worrying. Much will depend on the chairperson at the tribunal. If she or he makes an effort to assist you and put you at your ease you will find it much easier than a formal or even hostile approach.

In general you will be at a considerable disadvantage if you just turn up on your own and rely on the tribunal's goodwill and understanding. If you are in a union your union should be able to arrange representation. If not, you can get advice and assistance from a solicitor under what is described as the 'green-form' procedure, either at no cost or for a smallish charge, depending on your income. This will allow a solicitor to help you prepare your case for the tribunal hearing; some solicitors will even be

prepared to accompany you to the tribunal and advise you on how to put forward your case. The green-form procedure doesn't cover the cost of a solicitor actually representing you at the tribunal. Ask at your local Citizens Advice Bureau for the names of solicitors who could help, or look up solicitors dealing with your kind of case at your local library. If you are not being represented by a trade union or a lawyer, try to find a friend who has had experience of the way tribunals work.

What kind of cases do Industrial Tribunals deal with?

Industrial Tribunals deal with:

1. Complaints of discrimination on grounds of sex or marriage in employment and training, under the Sex Discrimination Act. (Other sex-discrimination cases go to the County Court.)

2. Applications for equal pay under the Equal Pay Act.

3. Complaints of unfair dismissal under the Employment Protection Act 1978.

4. Complaints relating to maternity pay and the right to return to work after childbirth under the Employment Protection Act.

5. Complaints relating to redundancies under the Redundancy Payments Act.

6. Complaints relating to failure to give paid leave for antenatal visits, trade-union training courses, or industrial relations duties.

How do you bring a complaint to a tribunal?

To make your complaint get the application form from your local job centre or Employment Office (address in the telephone directory under 'Employment Services Division' or 'Manpower Services Commission'). Fill it in and sent it to the Secretary of the Tribunals, Central Office of Industrial Tribunals, 93 Ebury Bridge Road, London SW1. (For Scotland the address is St Andrews House, 141 West Mile Street, Glasgow G1 2RU.) On the form, you have to name the employer against whom you are complaining; it is important to get this right. If, for instance, you have been discriminated against by the manager of the firm,

name the firm, *not* the manager; if you win, you are more likely to get compensation from a company than from an individual. The same is true if you have a complaint against an employment agency or trade union: name the organization, not the person you happened to deal with.

Even if you do not name the relevant act on the form, the tribunal will sort that out for you. Just describe what happened and say why you are lodging the complaint.

How difficult is it to win a case?

Few equal-pay and sex-discrimination cases succeed at Industrial Tribunals, and the number of successes is falling rather than rising year by year. Twenty-six equal-pay cases were heard in 1980; four of the decisions (15.4 per cent) were in favour of the applicants. The success rate for previous years was 16.6 per cent in 1979, 30 per cent in 1978, 25 per cent in 1977, 30 per cent in 1976. Fifty-five cases under the Sex Discrimination Act were heard in 1980; orders were made in favour of the applicants in fifteen of them. Many cases are settled at the conciliation stage: approximately 70 per cent of equal-pay cases and about a half of sex-discrimination cases. Not all of these settlements resulted in any payment for the applicants. About half of the cases under the Sex Discrimination Act are brought by men, and in 1980 four men received awards of compensation compared with only two women.

The low success rate is partly due to weaknesses in the law (see p. 416 for possible improvements) and to the difficulty of proving that you have been discriminated against; but another reason is that many of the tribunals are not sympathetic to women bringing these kind of complaints.

In order to succeed, you have to satisfy the tribunal that it is more likely than not that the employer acted unlawfully. This is called the 'balance-of-probabilities' burden of proof and is unlike criminal cases, where the prosecution has the harder task of proving the case 'beyond reasonable doubt'.

Who has to prove what at each stage of the case can vary:

1. Equal-pay cases

You have to prove that you are doing 'like work', i.e. broadly similar work with no differences of practical importance, or work evaluated as equal.

If you succeed you win your case *unless* your employer can show that there is a material difference between your case and the man you are comparing yourself with.

2. Sex-discrimination cases

You have to prove your case all the way; that is, you have to show that you have been treated less favourably than a man and that the reason for the less favourable treatment is that you are a woman and he is a man.

This is often very difficult, as you are unlikely to have any direct evidence of the employer's reason or motive – unless anyone in management was so stupid as to say 'We don't want a woman in the job' or something similar. This difficulty of proving motive is one reason why so few cases succeed.

So to back up your case you are likely to need *circumstantial* evidence, which shows a pattern of discriminatory behaviour. For example, it might help to show that no women have ever been appointed to the job in question, or that there is a lack of female promotion etc.

To help you obtain this kind of information you can use an official questionnaire issued under the Sex Discrimination Act, which you send to the employer either before you lodge your application at the Industrial Tribunal or within twenty-one days after your complaint has been received by the tribunal. Remember that even though you are using the questionnaire procedure you must lodge your complaint at the tribunal within three months of the act of discrimination. You can obtain this questionnaire from the Equal Opportunities Commission or free of charge from any employment office, job centre, or unemployment benefit office. Look at the information listed on p. 305 for ideas on the kind of questions you may need to ask to get circumstantial evidence. Questions will need to produce facts to help you in your particular case. This can be difficult to work out and it is best if you are helped by your union or other adviser

in completing the questionnaire. If your employer does not reply to your questions or if the tribunal considers that he has replied in an evasive way, the tribunal can use this as a reason to make a decision in your favour.

3. Unfair-dismissal cases

Your employer has to prove why he dismissed you and that the reason for the dismissal is either your misconduct or incapability to do the job, including sickness or redundancy, or because employing you would involve a breach of the law, or another substantial reason. The tribunal then has to decide whether it was fair in all the circumstances that he should have dismissed you for this reason.

Who should help you with your case?

If you belong to a trade union, ask your shop steward, branch secretary, or union official to help you with your case. Your union should arrange for someone to be present during the conciliation stage to present your case to the tribunal. If you are not being represented by your trade union you can get legal advice by going to a solicitor asking for advice under the 'green-form' procedure. You may get help by writing to the Equal Opportunities Commission (see p. 419 for address).

The 'conciliation' stage

The Advisory, Conciliation and Arbitration Service (ACAS) will receive a copy of your application form to the tribunal, and an officer will probably contact you and arrange a meeting. It is his job to try to settle the case between you and the employer without going to the tribunal. Most ACAS officials are men, and one investigation into how they operate suggested that they were more sympathetic to men complaining of sex discrimination than to women! So be careful before you settle a case at this stage. Don't be talked into it unless you are absolutely sure you have achieved the result you wanted. Do not take the officials' advice on the law without checking that it is correct.

If your case is not settled, a hearing date will be fixed by the tribunal and you will be given at least fourteen days' warning. If you or any important witnesses cannot manage the date fixed for the hearing, you can apply to have it changed. Write to the Clerk of the Tribunal as soon as possible. If you leave it until the day of the hearing or immediately before the hearing, you may be ordered to pay whatever costs the employer has lost by not being able to proceed as planned.

How do you prepare your case?

You need to have all relevant documents and letters, and if you have any witnesses to back up your story, make sure that they can attend the tribunal hearing. If all that your witnesses are prepared to do is to give you a letter, it will be hardly any use; you need them to be at the tribunal to give evidence themselves. Prepare your own evidence; decide what you wish to say, and what decision you wish the tribunal to make. It is essential that you turn up at the tribunal in person and give your own evidence.

What happens at the hearing?

The procedure is fairly formal, as explained on p. 408. Only 23 per cent of the lay members are women, but it is government policy to aim to have at least one woman on every tribunal hearing sex-discrimination and equal-pay cases. If you have to prove your case (see p. 411) you give your evidence first; if the employer has to prove the case, vice versa. After the end of the case, the tribunal can give its decision there and then, but it often 'reserves' its decision, which means that the members make up their minds later on, and the result is sent to you in writing.

What can the tribunal give you?

If you succeed in an equal-pay claim the tribunal can award you back pay for up to two years before the date when you lodged your application. The effect of the Industrial Tribunal's award

will be to amend your contract of employment so that in future you must receive equal pay.

If you succeed in a sex-discrimination case the Industrial Tribunal can make an order declaring what your rights are, require the employer to pay you compensation for any monetary loss you have suffered (e.g. loss of pay if the discrimination led to lack of promotion), or make a recommendation that the employer takes whatever action is necessary to deal with the discrimination within a certain period. For example, if he has failed to promote you because of discrimination, the tribunal can recommend that you be offered the next available post of a similar nature.

If you succeed in an unfair-dismissal case, the tribunal can award you a 'basic award', which is calculated on your years of service in the same way as redundancy pay. plus a 'compensatory award', which should make up for all loss of earnings to date and future loss of earnings if you are still unemployed, together with any expenses or other loss. It is therefore important to go to the tribunal with details of all monetary loss.

Costs

Normally in tribunal proceedings you pay any legal costs you have incurred, and so does the employer. But if the tribunal thinks that one side (you or the employer) has acted 'frivolously or vexatiously or otherwise unreasonably', it will order that side to pay the other's costs. This rarely happens.

What can you do if you lose?

It may be possible to have your case reviewed, but only if the tribunal staff made a mistake in handling your complaint, or you did not receive the notice of the hearing, or the tribunal made its decision in your absence or the employer's absence, or new evidence has become available which you could not have known about or foreseen at the time. You can also have a review if the 'interests of justice' require it. In practice it is difficult to obtain a review, and there must be good reasons. You must apply for

a review within fourteen days of the date when the tribunal's decision was registered (the date is shown on the copy of the decision you receive).

You can also *appeal* against the tribunal's decision if it has made a mistake in interpreting the law. You cannot appeal if it has come to a wrong view about the facts of your case. Your appeal goes to the Employment Appeal Tribunal and must be received within forty-two days of the date when the decision was registered (the date is shown on your copy of the decision). You will need expert advice on whether or not there has been a mistake of law and help in presenting your case to the Employment Appeal Tribunal. Your union should help you or arrange for you to be represented by a solicitor. If you are not obtaining help from your union, legal aid is available from a solicitor, and the Equal Opportunities Commission may assist.

What time limits are there?

1. Sex-discrimination cases

You must make an application to an Industrial Tribunal within three months of the act of discrimination. Within this date the tribunal must receive the originating application setting out the grounds of your complaint.

2. Equal-pay claims

You make a claim for ' equal pay any time while you are employed to the workplace concerned, or within six months of leaving.

3. Unfair-dismissal claims

The Industrial Tribunal must receive your originating application within three months of being dismissed. You are normally considered to be dismissed on the date that you leave the workplace: so if you are dismissed with notice, it is the date your notice expires; if you are sacked on the spot for gross misconduct, it is the date you leave; and if you are given money in lieu of notice, it is the date you stop working. An exception to this rule would be if you had been off sick for a long time and

received a letter from your employer informing you that you had
been dismissed while you were not at work.

What changes are needed in the law?

There are a lot of detailed amendments that can be suggested
to strengthen our equality laws. Here are some of the main
changes that would help. See the reading list on p. 418 for more
detailed suggestions.

1. The equality laws would be simpler and easier to under-
stand and would avoid loopholes if the Equal Pay Act and the
Sex Discrimination Act were amalgamated.

2. Indirect discrimination should apply to the Equal Pay Act
as it does to the Sex Discrimination Act. This is already the case
in our Race Relations Act, and there is no good reason why
women should not be equally protected when it comes to equal
pay.

3. Part-timers should be given a clear legal right to full pro-
rata benefits and equal hourly rates with full-timers doing similar
work.

4. The Central Arbitration Committee, which is better suited
to dealing with pay structures and grading in a workplace than
Industrial Tribunals, should be given power to deal with dis-
criminatory grading structures and make whatever changes are
needed to give women equal pay for work of equal value. Like
Industrial Tribunals, the Central Arbitration Committee is com-
posed of trade-union representatives, employers' representa-
tives, and 'independents', but it deals with matters in a less
legalistic way and it attempts to reach a decision which is accept-
able to all parties.

5. The Sex Discrimination Act should no longer exclude Acts
of Parliament, small employers, or retirement provisions, except
those necessary to deal with differential retirement age. Dis-
crimination against people who are single should be covered in
the same way as discrimination against married people.

6. When bringing a case under the Sex Discrimination Act a
woman should only have to show that she has been treated less

Legal Claims – A Checklist

	Length of service required	Time limit for claim
Rights which part-time workers cannot claim*		
Written particulars of employment	13 weeks	3 months
Unfair dismissal	52 weeks	3 months
Redundancy pay	2 years	6 months
Minimum notice** (claim goes to a County Court)	4 weeks	6 years
Maternity pay/reinstatement	2 years up to 11 weeks before expected date of birth	3 months
Guaranteed pay	4 weeks	3 months
Dismissal connected with medical suspension	4 weeks	3 months
Time off for trade-union duties/union activities	None	3 months
Time off before redundancy	2 years	3 months
Rights which part-time workers can claim*		
Equal Pay Act	–	6 months from leaving employer concerned
Sex Discrimination Act	–	3 months
Race Relations Act	–	3 months
Victimization or dismissal for trade-union activity	–	3 months
Antenatal leave	–	3 months
Time off for public duties	–	3 months
Wages below wages-council minimum conditions	–	6 years
Itemized pay statement	First pay day	3 months

* 'Part-time workers' here means workers employed for less than sixteen hours a week, or, if employed for at least five years, working for less than eight hours a week. See Chapter 12 for full details.

** Minimum notice: entitlement depends on length of service: 2 yrs = 2 wks; 3 yrs = 3 wks, etc., to a maximum of 12 yrs = 12 wks.

favourably, and then it should be for the employer to show that he did not discriminate against her because of her sex.

7. Tribunal members should either be specially selected for their sympathy and understanding of equality legislation or be properly trained in what the laws say and why they are necessary.

8. Positive action could be helped if employers had to take special steps to train women for posts where they are heavily under-represented, and if every large employer (say, over 100 employees) had to produce an equal-opportunity policy and a programme setting out the sex-composition of the workforce, by grade and job, and steps to overcome under-representation of women in particular areas.

For more information, see the EOC amendments to the Sex Discrimination Act and Equal Pay Act, available free from the EOC.

Sources of information

Jeremy McMullen, *Rights at Work*, Pluto Press (£2.25 paperback).
Bill Birtles and Patricia Hewitt, *Your Rights at Work*, NCCL (£1.50).
Anna Coote and Tess Gill, *Women's Rights – A Practical Guide*. Penguin (£3.95).
EOC Guides. The EOC has a number of publications on the Equal Pay Act and the Sex Discrimination Act. Most of them are free, and they are available from the EOC (address on p. 419).

ORGANIZATIONS FOR HELP AND ADVICE

Advisory, Conciliation and Arbitration Service, Head Office at Cleland House, Page Street, London SW1 (01 211 3000): for inquires about the employment provisions of the Sex Discrimination Act and the Equal Pay Act.

Central Arbitration Committee, 1 The Abbey Garden, Great College Street, London SW1 3SE (01 222 8571).

Child Poverty Action Group (CPAG), 1 Macklin Street, London WC2 (01 242 3225/9149): information on welfare benefits.

Citizens Advice Bureaux, headquarters at National Citizens' Advice Bureaux Council, 110 Drury Lane, London WC2 (01 836 9231): many bureaux throughout the country, which give advice on a wide range of subjects including legal aid, welfare benefits, landlord and tenant law, family law, consumer and other legal problems.

Citizens' Rights Office, 1 Macklin Street, London WC2 (01 405 4517): helps poorer families with legal problems such as appeals to tribunals and provides practical advice on welfare rights etc.

Commission for Racial Equality, Elliot House, Allington Street, London SW1 5EH (01 828 7022).

Employment Appeal Tribunal England and Wales, 4 St James's Square, London SW1Y 4JB (01 214 6000).

Employment Appeal Tribunal Scotland, 249 West George Street, Glasgow G2 4QE.

Employment Medical Advisory Service, 25 Chapel Street, London NW1 5TD (01 262 3277).

Equal Opportunities Commission, Overseas House, Quay Street, Manchester M3 3HN (061 833 9244).

Health and Safety Commission and Executive, Regina House, 259 Old Marylebone Road, London NW1 (01 723 1262): responsible for Health and Safety Inspectors.

Industrial Injuries Advisory Council, Friars House, Blackfriars Road, London SE1 (01 703 6380/4111/4161): advises on which diseases should be prescribed and entitle you to benefit.

Industrial Tribunals, Central Office: 93 Ebury Bridge Road, London SW1.

Joint Council for Welfare of Immigrants (JCWI), 44 Theobalds Road,

London WC1 (01 405 5527/8): advice and legal help for immigrants.

Labour Research Department, 78 Blackfriars Road, London SE1 8HF (01 928 3649).

Low Pay Unit, 4 Poland Street, London WC1.

Manpower Services Commission, Selkirk House, High Holborn, London WC1V 6PF (01 836 1213):

Employment Services Division (in charge of Jobcentres), 7 St Martin's Place, London WC2 4JH (01 930 7833);

Special Programmes Division (in charge of schemes for the unemployed), Selkirk House, High Holborn, London WC1V 6PF (01 836 1213);

Training Services Division, 162–168 Regent Street, London W1R 6DE (01 214 6000): in charge of training and TOPS.

National Council for Civil Liberties (NCCL), 23–25 Tabard Street, London SE1 (01 403 3888): campaigning organization for protection of civil rights; separate Rights for Women section, with special expertise in sex-discrimination and equal-pay legislation.

Neighbourhood Law Centres: for general information you can contact Law Centres Federation, 164 North Gower Street, London NW1 (01 387 8570).

Occupational Pension Board, Almack House, 26–28 King Street, London SW1Y 6RB (01 214 3000).

Scottish Trades Union Congress (STUC), Middleton House, 16 Woodlands Terrace, Glasgow G3 6DF (041 332 4946/7/8).

Trades Union Congress, Congress House, Great Russell Street, London WC1B 3LS (01 636 4030).

TUC Postal Courses Office, G. Horsman, Tillicoultry, Clackmannan, Scotland (0259 50248).

TUC Regional Education Officers:

Northern: F. E. Woodbridge, 31 Mosley Street, Newcastle upon Tyne (0632 321725).

East Midlands and East Anglia: J. S. Radford, 7 Gregory Boulevard, Nottingham NG7 6NB (0602 606076).

Yorkshire and Humberside: M. Ball, Blackgates House Annexe, Bradford Road, Tingley, Wakefield (0532 521037).

North-Western, A. J. Johnstone, Baird House, 41 Merton Road, Bootle, Merseyside (051 933 4403).

Midlands: P. Hughes, 1150 Stratford Road, Hall Green, Birmingham (021 777 7121).

South-Western: B. K. Preuss, Guildhall Chambers, 26 Broad Street, Bristol BS1 2HG (0272 20979).

South-Eastern: D. Gover, Education Department, TUC, Congress House, Great Russell Street, London WC1B 3LS (01 636 4030).

Wales: J. F. Hannaway, 13 Gelliwastad Road, Pontypridd, Glamorgan (0443 402677).

Scotland: L. Cairns, 16 Woodlands Terrace, Glasgow G3 6DF (041 332 2045).

Northern Ireland: F. Bunting (Information and Training Officer), Northern Ireland Committee. Irish Congress of Trade Unions, Congress House. 1/9 Castle Arcade. Belfast BT1 5AG (0232 41452).

UK Immigrants Advisory Service (UKIAS), Seventh Floor, Brettenham House, Savoy Street, London WC2 (01 240 5176): advice and help with immigration problems and appeals.

Wages Councils, Steel House, 11 Tothill Street, London SW1H 9NF (01 213 3881).

Wages Inspectorate:

Birmingham: 2 Duchess Place, Hagley Road, Birmingham B16 8NS (021 455 7111).

Brighton: Fifth Floor, 125 Queens Road, Brighton BN1 3WB (0273 23333).

Bristol: The Pithay, Bristol BS1 2NQ (0272 291071).

Cardiff: Companies House, Crown Way, Maindy, Cardiff CF4 3UW (0222 388 588).

Edinburgh: Pentland House, Robb's Loan, Edinburgh EH14 1UE (031 5568433).

Glasgow: 109 Waterloo Street, Glasgow G2 7BY (041 248 5427).

Hemel Hempstead: BP House, Hemel Hempstead, Hertfordshire HP1 1DW (0442 3714).

Ipswich: Princes Street, Ipswich, Suffolk IP1 1ND (0473 216046).

Leeds: City House, Leeds LS1 4JH (0532 38232).

London: Hanway House, Red Lion Square, London WC1R 4NH (01 405 8454).

Manchester: Quay House, Quay Street, Manchester M3 7JE (061 832 6506).

Newcastle upon Tyne: Wellbar House, Gallowgate, Newcastle upon Tyne NE1 4TP (0632 27575).

Nottingham; Castlegate House, Castle Gate, Nottingham NG1 7BW (0602 51944).

Wales Trades Union Council, G. Wright, Transport House, 1 Cathedral Road, Cardiff (0222 394521).

Woman's Place, 48 William IV Street, London WC2 (01 836 6081): for information (to women only) on the women's liberation movement and addresses of local groups. Open after 12 noon.

Women's Forum (National Council for Voluntary Organizations), 26 Bedford Square, London WC1 (01 636 4066): publishes a comprehensive list of women's organizations, price £1.20.

INDEX

Anna Coote and Tess Gill

WOMEN'S RIGHTS

'An excellent . . . shot in the arm for women's equality' – wrote the *Evening News* when *Women's Rights* was first published.

This third, revised and updated edition is as comprehensive as the first. The new sections deal with changes in the law regarding Maternity Rights, Child Benefit, the plight of battered women and the Equal Pay and Sex Discrimination Acts. Much of the rest of the guide has been expanded and revised.

'Sparkling guide to women's rights' – Lord Justice Scarman

Deirdre Saunders with Jane Reed

KITCHEN SINK, OR SWIM?

Women in the Eighties – The Choices

Can we afford women's rights in the eighties?

With the economic recession and government cuts, unemployment and the dawning microchip revolution, the eighties are already a time of increasing pressure on women to give up their struggle for jobs, and relinquish the rights and opportunities hard-won over the last few decades. But *will* women (with a sigh of post-feminist relief), sink back into the job security of home-making?

Researching this Pelican, the authors talked to women from all over Britain across the social and economic spectrum, both outside and attached to women's movements. Here they assess the position of women, their problems and hopes. Here too, in the face of reactionary government policy and evasion tactics from all political parties, they discuss exactly why we *cannot* afford to ignore the needs and rights of women in the eighties.

Also published by Penguins

Hughes, Mayall, Perry, Petrie and Pinkerton

NURSERIES NOW

A Fair Deal for Parents and Children

The need for nurseries is greater in Britain now than ever before. *Nurseries Now* combines a consumer's guide to what nurseries are available with a sensible critique of the gaps and anomalies in the present system. The authors emphasize the importance of equal opportunities, of more choice for parents in child-care, and of a greater involvement by men in their children's upbringing. Nurseries alone cannot achieve these aims, and the book also looks at some of the other measures needed, including radical changes in the employment patterns of both sexes.

Also published by Penguins

Janet Radcliffe Richards

THE SCEPTICAL FEMINIST

A Philosophical Enquiry

What should feminists be fighting for?

In this important and original study, Janet Radcliffe Richards demonstrates with incisive, systematic and often unexpected arguments the precise nature of the injustice women suffer, and exposes the fallacious arguments by which it has been justified. Her analysis leads her to considerable criticism of many commonly held feminist views, but from it emerges the outline of a new and more powerful feminism which sacrifices neither rationality nor radicalism.

'A superb piece of applied philosophy, the arguments clear and cogent, the writing lucid and elegant' – *The Times Literary Supplement*

'Intellectually sober and politically practical, yet gay, witty and dashing at the same time . . . It's a model of how to write a book on *any* topic; on a contentious subject like this *it's a triumph*' – *Sunday Times*

Beatrice Faust

WOMEN, SEX AND PORNOGRAPHY

What do women think of pornography?

Pornography is a topic that produces feverish responses, but women's reactions until now have been left unexamined. Even the responses of the women's movement have been contradictory. In this major new work, Beatrice Faust discusses the psychology of sexual differences and how they relate to differences in the sexual and erotic styles of men and women and the influence of culture.

In a frank and polemical analysis, Beatrice Faust explores the enormous social implications of these sexual differences, from novels, films and fashion to social behaviour patterns – and rape. She argues that pornography is neither pro- nor anti-woman. But it certainly presents a misleading view of woman's sexuality, and the solution is not censorship but sex education through bona fide erotica and the recognition of differences between male and female sexuality.

Luise Eichenbaum and Susie Orbach

OUTSIDE IN . . . INSIDE OUT

Is there a difference between the psychology of men and the psychology of women?

Susie Orbach (author of the world-famous *Fat is a Feminist Issue*) and Luise Eichenbaum together set up The Women's Therapy Centre in London.

Drawing on their experiences and their work there, the authors propose here a new developmental model of women's psychology which is different from current and accepted (and usually male-dominated) thinking. From its radical reappraisal of the mother–daughter relationship to its conclusions on gender identity and object theory, *Outside In . . . Inside Out* is a stimulating and exciting contribution to the field of women's studies.

Juliet Mitchell

PSYCHOANALYSIS AND FEMINISM

The author of the widely acclaimed *Woman's Estate* here reassesses Freudian psychoanalysis in an attempt to develop an understanding of the psychology of femininity and the ideological oppression of women.

Analysing sexuality, femininity and the family as they are treated in the works of Freud, Reich and Laing, she demonstrates that Freud's theories have much to offer women in the understanding of their sexuality, and compares him to Reich and Laing, whose contributions to the feminist cause, in her opinion, are less radical and more ephemeral.

'Juliet Mitchell has risked accusations of apostasy from her fellow feminists. Her book not only challenges orthodox feminism, however, it defies the conventions of social thought in the English-speaking countries . . . *Psychoanalysis and Feminism* is a brave and important book, and its influence will not be confined to feminists' – *New York Review of Books*

Marjorie Shostak

NISA

Breaking through the barriers of language and culture, Nisa told her life story, in her own words, to anthropologist, Marjorie Shostak. With dignity and humour she tells of her childhood, her adolescent discoveries of love and sex, her first marriage at the age of twelve, the exhilaration of giving birth alone, her lovers, and her grief for lost children.

'A book that draws you into the private life of a Kalahari woman and, at the same time, provides fresh and humane insights into alien institutions' – *New Society*